womanhood:
the bare reality

womanhood:
the bare reality

Laura Dodsworth

Womanhood: The Bare Reality

First published in 2019 by Pinter & Martin Ltd
Text and images copyright © Laura Dodsworth 2019

Laura Dodsworth has asserted her moral right to be identified
as the author of this work in accordance with the copyright,
designs and patents act of 1988.

Editor: Susan Last
Design: Blok Graphic, London

A catalogue record for this book is available from the British library.

Printed and bound in Poland by Hussar

Pinter & Martin Ltd
6 Effra Parade
London SW2 1PS

www.pinterandmartin.com
www.barereality.net

Contents

Foreword by Sarah Ditum **6**

Introduction **10**

The Stories **16**

Methodology **336**

Acknowledgements **336**

Please note that all the stories in *Womanhood* are
personal opinion. The views expressed are those of
the contributors and are not endorsed by the creator
or publisher. No book can replace the diagnostic
expertise and medical advice of a trusted physician.
Please consult your doctor before making any
decisions that may affect your health, particularly
if you suffer from any medical condition or have
any symptom that may require treatment.

Foreword

What is it, though? To Hamlet, with his head nestled on Ophelia's lap, it's 'nothing'. For a great deal of human history, a great many people have agreed with him that what women have is a space, a hole, a lack – that needs filling up with, inevitably, a man.

So pervasive is this absence that there isn't even really a name for it. 'Vulva' and 'vagina' sound off-puttingly medical in a way that 'penis' and 'testicles' don't. 'Dick' or 'cock' are fairly mild as swearing goes, but the C-word is a civility-shattering bomb. As the stories in this book show, the lack of an established female equivalent to 'willy' means that families generate an idiosyncratic private vocabulary to talk about that thing that can't be talked about.

What exists between a woman's legs and in her abdomen is a matter of such great silence, in fact, that even science hasn't got to grips with it. The structure of the vagina has barely been studied. The clitoris's existence has been denied and rediscovered in a cyclical pattern since the beginning of medicine. Even the pelvic floor, which women are so confidently enjoined to exercise, turns out to be an unknown realm: not a single thing, but a complex system of interrelated components, whose function is still little understood, despite the huge suffering of women who undergo tears or prolapses.

But while positive knowledge about the female body is remarkably limited, there is an endless supply of conviction that there's something wrong with it. Plastic surgeons to carve your labia into tidiness and 'rejuvenate' your vagina (which is to say, tighten it, despite the fact that we have no measure of what shape a vagina is 'supposed' to be). Cutters to excise your clitoris and make you a nice, manageable woman. 'Sex experts' to tell you that the kind of orgasm you have is inadequate or impossible, whether that's Freud insisting the clitoral orgasm is immature, or contemporary headlines declaring vaginal orgasms to be 'myths'. (But how can they know, when so little is known about the female body?)

You can speculate on exactly how this general ignorance came about. Is it that the men who make up the bulk of the medics and scientists were so enamoured of their own junk that they never thought to study what

women have instead? Is it that women have simply been deemed to be 'mysterious', and so left to remain that way? Is it a conspiracy by the forces of Big Penis (a.k.a. the patriarchy) to keep women down? With hardcore porn just a google away, we can see vulvas more easily than at any time before now, but the most explicit images tell us absolutely nothing about how it feels to be female.

Regardless of the intent behind it, the result is that women have been left voiceless when it comes to our own bodies. What you cannot name, you can't control. And from bad sex, to sexual violence, to traumatic childbirth, to women with endometriosis being dismissed as malingerers by unsympathetic doctors, that lack of knowledge and control is a profound force for ill in women's lives. So many of the women in *Womanhood* have stories that touch on these themes, because for so many women, the absence of speech and information about our anatomy has been filled up with shame and pain of various kinds. There is a vast communal reservoir of injustice which men will only fleetingly see, but in which all women swim, at least sometimes.

Which is why *Womanhood* is such a powerful project. Every woman who has taken part has spoken about something that, in every possible way, has been set off-limits by the society she lives in. The pictures are shocking at first. After all, the vulva is a body part that's almost never seen just being: when it's photographed, the subject is usually either sex or (less often) childbirth, but either way, never just the woman herself. In Laura's pictures, we can see the vulva on its own, and each one is different. There is no normal and there is no deviant: there are just women, each one with a story of what her body means.

The stories the women tell are even more intimate than the photographs. Many touch on the sad or the shocking, but they also describe pleasure and power. Overwhelmingly, you'll find both good and bad in the same interview, because women's lives are never singular. Some of the women in *Womanhood* talk about the tremendous power of conception and childbirth; some talk about the glorious reclamation of their own bodies after violence or stigma made them alienated from their

own flesh; and some talk about having the kind of fantastic, filthy sex that only comes from knowing your own body very, very well.

The words and pictures Laura has so sensitively recorded here make it seem incredible that anyone could ever have believed the vulva is a nothing. Despite the sexism that has held back knowledge about our bodies, women's own voices tell us so much. You get the feeling that participating in *Womanhood* has been revelatory for some, allowing them to talk about experiences rarely examined in daylight. Agreeing to be photographed and to talk so intimately is an act of generosity, but certainly not passivity. And reading it, too, is a revelation – a celebration – of everything that being female means.

Sarah Ditum

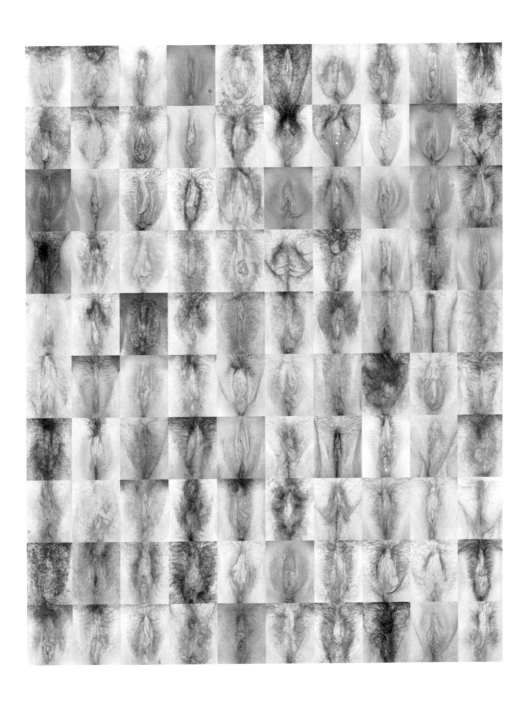

Introduction

Vagina, vulva, yoni, lady garden, fanny, pussy, beaver, foofoo, front bottom, snatch, muff, box, cunt: the words for this under-appreciated and misunderstood body part are variously under-whelming and devaluing. So many women avoid naming their 'bits' at all. No body part is as revered and feared, lusted after and hated – and yet it is mostly nameless. After the publication of *Manhood*, I found I had become a champion for men and their manhood. Asked many times by readers and journalists if I would turn my lens on women's private parts, I batted the idea away, thinking I had already examined women's stories through my first project and book, *Bare Reality*. Three events in one summer provoked me, and I realised *Womanhood* was the necessary, final part of an unexpected triptych.

I was heartbroken when I read about the numbers of girls in the UK enduring female genital mutilation (FGM), a brutal violence inflicted on girls to suppress their sexuality and 'keep women in their place'. I also listened to a report about girls as young as nine asking doctors for labiaplasty, because they were worried about how their vulvas looked. From smooth Barbie dolls to internet porn, girls and women are tyrannised by the ideal of a 'porn-perfect', pink, neat vagina. They grow up with a very narrow view of what they should look like, even though in reality there is an enormous range. Finally, I was irritated to read some health advice that referred to a vagina as a 'front hole'. Isn't it long past time we grew up and used the right words? Why is it necessary to assert the vagina is not the front hole, it's the middle hole, and it's not just a 'hole' anyway!

Undertaking *Womanhood* wasn't an easy decision. What would it be like to be in such an intimate situation with 100 women? I'm a straight woman; I'd never seen a vulva up close before. Would I feel awkward? Would she? Would anyone even say 'yes' to my latest left-field project? It meant overcoming my 'good girl' socialisation and internal self-censorship.

I reflected. I've been examined by midwives and gynaecologists, and lovers have gazed at my pussy; what's to fear? Ultimately I realised that I feared the intimacy with myself. When I committed to this work I had to face my own experiences of bad sex, assault, birth trauma, physical anxieties, shy pleasures, shame and fear. If *Bare Reality* and *Manhood* had

marked me out as a Creatrix with an interest in the taboo, what would *Womanhood* say about me as an artist and woman?

I chose to step beyond photographer and storyteller, and act as a kind of midwife myself, helping women to birth their own stories, creating and curating a radical and reverential inquiry into female experience. 100 women bare their most intimate and powerful body part and share related stories of pleasure, sex, pain, trauma, joy, motherhood, birth, menstruation, menopause, gender and sexuality. Talking about vulvas and vaginas grants access to our deepest shame, our fiercest pleasure, our most intimate moments and the most terrible traumas.

I have sensed in this project that the reveal is to ourselves. In *Manhood*, men stood before me, a woman, in a safe space, and bared their body and their souls. I think they wanted to be seen, physically and figuratively. But cocks are front and centre, there is no mystery. Penises are taboo, yes, but not hidden. For some women it was the very first time they had seen their vulva. It was nearly always the clearest view they have had. I think we women needed to see ourselves.

Some women held the camera with shaky hands and asked if they were normal, or if they were ugly. Some proudly declared their vulvas to be beautiful. Some were pragmatic, some were nonplussed. But they saw themselves. They saw their vulva as a living body part, isolated from any sexual or birthing or medical context. It just was, and it was part of them.

I hope that the photographs will help women of all ages, but especially young women, to realise that their vulva is normal the way it is, and to feel comfortable and proud in their own skin. The tidy pussy of porn is only one of a myriad of magnificent colourful cunts. I hope that women will occupy their vulva and vagina from a place of pleasure, not an anxious imagining through a lover's eyes. Not 'How do I look?' but 'How do I feel?'.

And on that, how beautiful to hear women fall in love with their vaginas and vulvas through their partner's perspective. We have a complicated relationship with the male gaze but, let's be honest, it's tricky to witness our vulvas for ourselves, legs awkwardly astride pocket mirrors, bums shuffled up close to full-length mirrors, or taking a selfie with the unflattering lens of a smart phone. Women told me how they knew they were beautiful because their partner, male or female, gazed at them, vulnerable and open, and told them.

Committing to *Womanhood* as both creator and anonymous participant signalled a personal flourishing I didn't anticipate. But that was only the beginning. Talking to 100 women profoundly changed

me, emotionally, sexually and creatively. Each story, each woman, each photograph added a momentum to a kind of karmic fast-forward of my understanding of womanhood, and myself as a woman.

I am a card-carrying feminist, a follower of #MeToo and #TimesUp, and yet I was stunned by the multiple stories of childhood grooming, sexual abuse, assault, rape, plain bad unsatisfactory sex, and medical and birth trauma that were so consistently and deftly woven into the tapestry of women's lives. Some friends suggested I would have to 'deal' with the anger these stories provoked when the project was over. Counselling? A ritual? A smudging ceremony? Different solutions, all well meant, were offered. But I never want to lose the ability to tap into this reservoir of rage. It provides a quiet, deep, warrior-like strength. I find it is there every time I need to politely but firmly assert an opinion or boundary. It will be there any time you need me to stand shoulder to shoulder with you.

I was saddened by the stories of bad sex, faked orgasms, women's pleasure put aside in favour of their partners; the performance in sex so commonly understood by women, but rarely admitted to. I recognise it. I've lived it. I was enraged by the accounts of assault and rape and wanted to fiercely protect the women who tenderly and bravely opened up to me.

I heard in gorgeous detail about the potential women have for pleasure, sensual delight and hot filthy sex, and listened admiringly to women who had cast shame and inhibition aside. I loved learning about the changes, still to come for me, from older post-menopausal women. I sympathised with women relating stories of menarche, menstruation, gynaecological conditions and cancers. My heart expanded with sympathy and pride when women told me about their children and births, miscarriage and infertility. Everyone in this world was born to a woman who endured the ultimate primal human experience. Birth may be everyday, but it's epic.

From the moment the last interview and shoot were complete, I felt a passionate aliveness bubbling up around the neat edges of my life. I knew I had changed at the very deepest levels forever. For the very first time, I deeply understood anger, sexuality, shame and sisterhood.

My relationship with my vulva and vagina has changed. Of course, I've now seen 100 vulvas up close, so I know how much variety there is in the female form. Beyond the physical, the real change in my relationship with my body, and my self, was catalysed by the intimacy with the women, the unique and tender access to their most private, painful, pleasurable and powerful experiences.

How do I feel now? I reject shame. Shame holds women down. Well, it holds us all down, doesn't it? This is as much about being human as being a woman. But shame is specifically utilised to suppress anger and sexuality in women. I am revelling in this new, powerful connection to deep drives. Somehow, I think I started emanating a little more power, a little more juiciness and I started to really 'see' the person in front of me. People started to see me a little differently. Unexpected offers, eyes opened, my own explorations took me on new sexual and emotional adventures. I am approaching perimenopause, just at the tipping point when society might deem me past my best, yet I feel freer, happier, more sexually potent, more in my prime, than ever before.

We are kept separate in modern life: nuclear families, long hours at work, relationships managed through phones. Our stories are an act of giving and receiving help. When you read this sisterhood of stories and witness these women's tender parts laid bare, I hope you find compassion and understanding for them and sense their power. Most of all, to all you bold, brave, beautiful women, and the men who love us, I hope you find compassion and understanding for yourself and find your own power.

I am a living embodied conclusion to *Womanhood*. The process of creating three sets of embodied stories and honest photography – *Bare Reality*, *Manhood*, and *Womanhood* – have changed me. I hope they change you a little too.

Let us reclaim our womanhood on our terms, in our own words and in our own image.

Laura Dodsworth

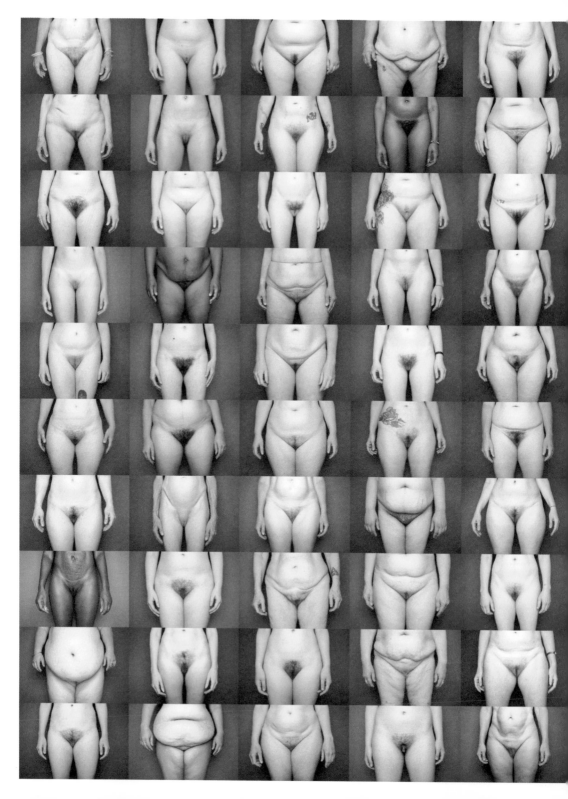

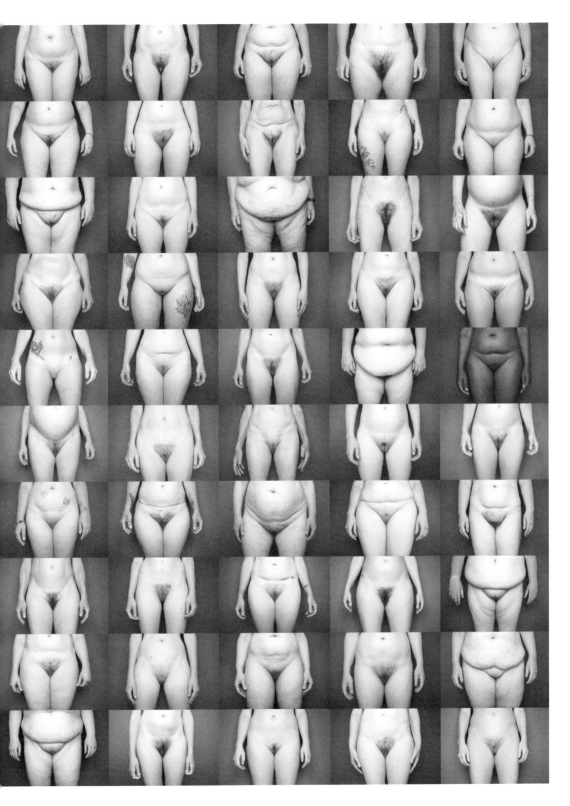

"A complete state of bliss"

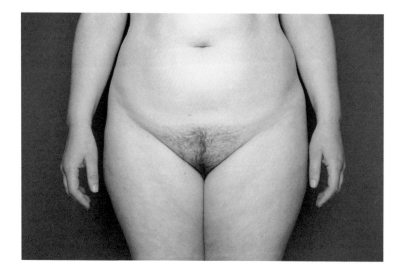

My pussy looks quite cute in the photo. I like the crop. If you saw more, with open legs, it might make me think of someone going down on someone. I'm not happy with the full frontal because of my body size, but it is what I look like.

I've always called it pussy or vagina but I'm trying to use the word 'vulva' more because I think it's more correct. I don't like cover-up words like 'flower'.

I have a pretty healthy relationship with her. I don't particularly care what my vagina looks like as long as it feels good. I don't think it's there to be looked at by other people or myself. It's there to make me feel aroused, enjoy sex, have a good sex life. It's much more fun now than it was when I was younger. It wasn't a part of my body that I really knew about and I was embarrassed to explore or understand.

I used to believe that my vagina was ugly and it smelled, so you just don't go there. I picked that up from hearing boys slating other girls for how they looked and smelled. I decided I didn't want to be thought about or talked in that way. I felt disappointed that that's what the chat was about. We were only teens. I wouldn't be surprised if the boys had never even seen a vagina; maybe they'd just heard older boys talking about them.

At the same time, I worked at Superdrug and there were so many feminine hygiene products for sale. I can remember thinking that they can't all be necessary. If you think about it from a chemical point of view, it's unhealthy.

My reference for vulvas and vaginas was as innocent and unhelpful as the sex pages in teenage magazines that used Barbie and Ken naked. They don't even have genitalia! As a girl you never see them in the changing rooms. I didn't know what reaction I would get from boyfriends.

One time I thought my boyfriend at university was going to go down on me, but what he did was lay his head on the top of my vulva and just stay there, hugging the side of my body. He was just comfortable; it wasn't worship or anything, but it was a completely different experience. And I thought, 'Woah, he's quite happy and so comfy there, he could kind of fall asleep down there.' Then he went down on me. He had a completely different way of seeing and being with female bodies. I felt appreciated, as if it was an honour for him and he really enjoyed going down on me. A whole different world opened up for me. Before that I'd been curtailing my pleasure because of embarrassment, which is such a shame.

That taught me to start exploring myself and use sex toys. It wasn't just about actual penetration, it was more about vibration or different ways of having pleasure, different ways of having orgasms.

I saw a documentary about labiaplasty and girls who were 14, 15, 16 wanted to be surgically 'enhanced', which is the wrong term entirely. I was just thinking, 'No, you get so much pleasure from those areas of your body, why would you remove them? Please don't do that.' But they were talking about having long lips and wanting to look neat and tidy.

My labia are brilliant. The pleasure starts there because it's on the outside so just warming up by touching them is really important before moving on to the clitoris. Labia aren't gorgeous, but I don't think dicks are that gorgeous either. Is there a need to be gorgeous? I'm not that arsed. When I'm going down on a man I'm not thinking he has a beautiful dick, it's about how much pleasure I can give him.

I can come really quickly, although that won't be a great orgasm. I rub

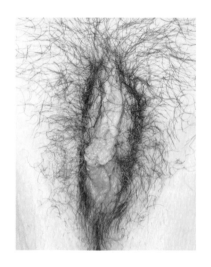

my labia and then rub my clitoris and it just depends on the pressure and the environment. If I'm in a warm room and there's a lot of sunshine and it's very relaxing, first thing in the morning, it's much easier because there's nothing going on in in my head. If I'm in the wrong mind space then it's very difficult. I usually start with a fantasy to get myself into the right headspace, but I am trying to focus more on the sensations these days.

The best orgasm that I ever had was quite spiritual actually. I was 23. It was a summer's day, the windows were open, there was a gentle breeze, my body was warm. I was comfortable and we felt very connected. We'd taken everything really slowly. He was giving me oral sex and using the edging technique, where you build up to the orgasm, then come back down, then build up again, and so on. Such a slow build gave me a very powerful orgasm. At the end of it I felt like I had electricity going through my whole body all the way to the ends of my limbs and it was just a complete state of bliss. All I could say was, 'Don't touch me,' because I didn't want anything to take me out of that feeling. It was phenomenal. In a way I've been seeking a sexual and spiritual experience like it ever since.

It's opened the doors to lots of other things that I would have scoffed at just as nonsense really. I've become more interested in spirituality and how that's connected to my body and sex. I think there's a massive amount to be explored and understood. I'm now exploring yoga, meditation and chakras. Yoga for me is about stretching and so that just releases tension, and meditation for me is about calming and so that releases tension, and tension doesn't lead to an orgasm. In general I am more attuned to sensual experience now.

Part of me is pissed off that I've had to figure all this out so late. It takes women so long to let go of embarrassment and shame that's ingrained in us. I'm pissed off that we're not having these kinds of conversations about the body and the possibilities, and that I've potentially missed out on years of great pleasure because it's been smothered by tension or embarrassment or shame. I was dead keen to be part of this because I see it as a means to change the conversation. I'm pissed off that people are still able to frame vaginas and vulvas as mechanical things, or things to have babies, or things for men, rather than us owning our vulvas and vagina, and all the pleasure that is possible.

Thirty-seven years old, no children

"Your vulva goes south too"

I love the word 'cunt'. Although I had two boys and inevitably I had to lecture them not to use it as a swear word. When I became a lesbian, the word cunt really came into its own for me. Women used it in a very sexual, exciting and comforting way.

Before I came here today, I was incredibly nervous about having a photograph taken. I'm old and my body has changed; my legs have changed, my face, my hands, I can see those changes, but I don't see the changes in my vagina all the time. It didn't look as bad as I thought it would. I wonder if anyone dyes their pubic hair or wears a wig as they get older?

I've never had a cunt crew cut, I've never had any style. I've always liked pubic hair. I don't understand why some men don't want to go down on women if they have a bunch of pubic hair, because it seems really obvious to me that you just part the hair with your fingers and get your head in there.

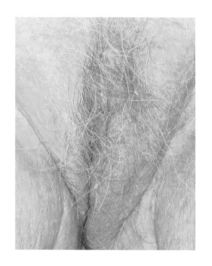

I wish that there was no mutilation of vulvas and vaginas, not just within other countries and cultures, but also here, because there are young women having surgery to somehow make their vagina perfect. I think that vaginal politics is really about women being freed in every way. Until that happens I fear that the vagina will suffer the consequences of discrimination, hatred: whatever exists that's very negative about women.

I think 100 vulvas together will be abstract art on one level, and form a pattern which will intrigue me visually and artistically. I think looking closely at each vulva will, I hope, amaze me. I think I'll then be a lot more generous and happy about all the vulvas that I see and maybe I'll be a little nicer about my own.

This little vulva is 77 years old now, so it's gone through rather a lot. The aging process is interesting because people talk about your body going south and they mean your breasts, face and tummy, but of course your vulva goes south too. I miss tight curly pubic hair. I'm not quite sure why, but it becomes wispier as you age. When I finished the menopause I didn't stop desiring sex, I didn't stop wanting orgasms.

I love to wank. I always have and hopefully I always will until my dying day – wouldn't that be a great way to go! When I discovered the possibilities of masturbation I never looked back. I wish I'd learned when I was a hell of a lot younger, but once I did find out it was great. There is something wonderful and magical about making love with someone else, but it's lovely to be secure in the knowledge that you can pleasure yourself. I'm afraid I'm quite orgasm orientated.

Boy do I love to come. I use a toy called a magic wand, it's a real lawnmower of a vibrator. It's electric and it never runs out of energy. I can have an orgasm in a short time, but I try and spin it out a bit and have two, three or four in about five minutes.

If I can cast my mind back to a very young age, I remember finding my clitoris on my own but I didn't know what it was. I manipulated it with a bobby pin. And I then completely forgot about it until I was a teenager.

A lot of women wish they'd waited longer, but I wish I'd had a sexual experience when I was much younger. All I did was make out with young boys who didn't know what the hell they were doing. So I was just filled

with this longing for something more to happen. And it never did. I was in New York after I graduated from high school with a couple of friends, and I was picked up by a handsome older man. I must have been like a little berry waiting to be plucked from the bush. I went home with him and he fucked me. I was completely into it, wet and extraordinarily lustful. Then it was the classic disappointment, I didn't even realise that it had happened. I said, 'Oh, is that it?' And it was.

I never minded fucking, but I never had an orgasm. I never had an orgasm until the person that I married. I think it was because I was in love with him and truly relaxed.

In the 1970s, I was part of the women's liberation movement. We had small groups all over the country. We talked about everything: childbirth, sex, men, kids, everything. We said the personal is political, and we tried to connect up our experiences in different ways.

One of the things we did was to meet in church halls and places like that, and hold a whole day's workshop about women's health. We learnt how to do self-examination. We'd take turns getting up on a table, with a mirror and torch, and use a plastic speculum, not a cold, horrible metal one, and we would look at our own cervix. The first time I saw my cervix I thought, 'Oh my god, this is me – this is inside me.'

It was a little bit scary at first, but once we'd done it we felt elated. It was absolutely amazing to take control of our bodies. We saw the variations in labia and inside vaginas, the ways in which we were incredibly different and yet had something in common too.

I decided to get sterilised when I was in my 30s after I'd had two kids. Much to my amazement I was told I needed my husband's permission. I told them they had to be joking, but they insisted. I knew enough about the law, because I was part of the women's health movement, and I told them I refused to get my husband's permission. I got my sterilisation.

There have been a lot of changes during my lifetime in regards to vaginas and how women feel about them. Some good changes and some of them unfortunately going backwards.

Since I was in the women's liberation movement, being a woman has meant being totally dedicated to and passionate about changing the way women are perceived. I want women to be free, I want women to be equal.

Seventy-seven years old, two children

"I'm unlikely to conceive naturally"

My vulva is happy and majestic. It's heart-shaped and it looks a little bit like a flower. It isn't one colour, there are different shades of brown, from light parts near the top to darker shades towards the middle. It's kind of tidy, but it's also an organised mess.

I think there's something really powerful about having the opportunity to look at yourself in more detail. It gives you a different appreciation for your body. I'm excited about seeing my vulva among 100 women's.

My family is very matriarchal. There aren't really any boys in the family. I think the relationships with my mum, aunt, cousin and nan structured a lot of what I felt being a woman involves. My early experiences of womanhood started with the women who raised me and I think there's something really special about that.

My nan was very much the life and soul of the party. She taught

me a lot about enjoying yourself, your body and who you are. She was responsible and conservative, but she could also be wild. We hosted an underwear sales party at our house and my nan put on this little negligee, went outside, did a little dance and went up and down the street on a scooter. It was like she had no shame. A lot of the time, when we say that a woman has no shame, we typically see that in a very negative way, but I think there's something really empowering about feeling free, so free that you're not bothered about what other people think. It's freeing to let go of people's expectations.

My mum is literally my best friend, there's nothing that I don't share with her. One day I decided I wanted to wax my vulva and I asked my mum to do it. She always did it for me up until my mid-20s. It might seem weird to other people, but my mum gave birth to me so there's nothing that I have that she hasn't seen. And I trust her. It's nice that we have an open relationship. When my mum was in hospital and she couldn't bathe herself, I had to wash her. Those kind of intimate moments, where somebody's very vulnerable, and you're the only person that's there for them to care for them, are things that will always stay with you.

I never wanted to have children until I developed reproductive health problems. After my first surgery I had to redefine my whole concept of being a woman and what womanhood meant. It had been intrinsically linked to my ability to conceive and have my own child.

When I was 19, I had a Mirena coil fitted and that caused me to get pelvic inflammatory disease, which was excruciatingly painful. I grew a cyst on my right ovary very rapidly. I put on over a stone within the first week that I had the coil fitted. After a couple of months I was in so much pain every single day. I was in and out of A&E and I had to suspend my studies at uni. In the end I had emergency surgery that resulted in the loss of my right ovary and fallopian tube and they drained five litres of fluid from the cyst. That's a massive amount of weight to be carrying on your ovary.

I was told that I might go into premature menopause, but there was no counselling or conversation about what this would mean for the rest of my life. I continued having pain, but I kept being told it was normal.

It took another three years for a doctor to agree to give me a laparoscopy to see if there was something else wrong. It turned out I have endometriosis, uterine polyps and fibroids, which was a bit of a blow, especially on top of a missing ovary.

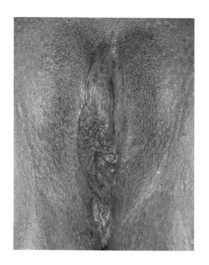

The really big deal was finding out that if I waited too long I would be unlikely to conceive naturally, if at all, and because of the fibroids and uterine polyps I've got a really high risk of recurrent miscarriage. I didn't feel ready to become a mum at that age and I didn't have the money to pay for egg freezing.

Having endometriosis means that my periods are irregular and can be excruciating. It's like a hot, burning sensation in my uterus that radiates throughout the lower half of my body, into my hips and down into my knees. Sometimes my knees even swell up and it's difficult to walk. People think I'm exaggerating, but sometimes I can't work. I also get a sudden sharp shooting pain in my vagina, which catches me off guard. I never know what type of pain I'm going to get on any given day. It's exhausting having to live with a level of pain every single day of your life that never really goes away. It's almost always there.

It got to the point where I was obsessive in my desire to have a child. My mum told me I needed some counselling. I started to re-evaluate what womanhood could look like for me, outside of my biological capabilities. I think we kind of take for granted that we're going to be able to have children. Not being able to conceive doesn't reduce your value as a woman, it doesn't make you less of a woman, but that's kind of what society tells us.

Twenty-six years old, no children

"My pubic hair looked like a codpiece"

When I was in my 20s, I thought no one would want to give me oral sex because I had so much pubic hair. I've learnt not to worry about it. My partner loves my pubic hair. I've had it all the time we've been together. I told him I was going to stop shaving my armpits, and he said, 'What are you bothering telling me for?' He loves my body. He has had partners who don't have any body hair, but he thinks it's more natural to have it.

I have genuinely enjoyed the ageing process, and I am less critical of my body now. I am more in love with my body than ever. Now I am happy to let my body hair grow. In a way, I've never felt more sexy. I don't have stubble or rashes, just perfectly natural hair. I think that age has built confidence. I still shave leg hair. It's the last frontier! I feel disappointed in myself that I can't let my leg hair grow, but it goes against the grain.

I wish younger girls had that confidence. It's a huge thing to have that shame about body hair. I certainly had it as a teenager, because I have

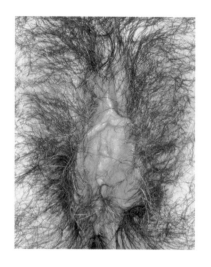

very dark hair. In swimming lessons you could see the obvious bulge of my pubic hair through my swimming costume, it looked a like a codpiece. I thought that was mortifying, but because porn wasn't such a big thing then, it wouldn't have occurred to me to do something about it. It's obvious on models now that they have no pubic hair at all.

Chemists have a huge aisle for body hair removal, from razors to bleaches to creams, and the products have names like 'Sea Breeze' and 'Fresh', to imply you will be clean if you use them, but if you don't use them you are dirty. It's a huge industry.

I didn't consciously set out not to have children. Equally, I never thought I wanted them. I really like children! I feel like if I don't say I like children I will sound like a witch. Women are expected to like and want them. Women, more than men, are very quick to ask about it.

I have endometriosis. I don't know if I would have been able to have children. I have suffered greatly with very heavy periods and pain. For years, before I was diagnosed, doctors would tell me I had heavy periods and just to get on with it. I had two surgeries and was put on hormone treatment, to balance things out, although all that did was make me bleed more. At one stage, for more than 18 months I bled day in, day out.

At its worst, it was passing chunks of liver. When I stood up from my chair at work I would have to check I hadn't left a stain on the chair. I've lain in pain on the landing floor, just trying to get to the bathroom, in agony, sweating. I was anaemic because I bled so much.

So for a long time I had a bad relationship with my vagina because it only felt like it was causing me misery and pain.

I'm peri-menopausal now and my periods are less intense and heavy, but I developed severe pre-menstrual depression. I'd get very tearful, I didn't care about anything. I had no energy and would feel unable to go out. I just stared into space. I couldn't answer questions. It was depression. It was my partner who noticed my emotions were connected to my periods. I tried to get on with it and I lived with being down. He noticed the timing. One weekend we went away and I spent the whole time in tears. I could have just walked into the sea.

I now take anti-depressants every day. I still get PMT, but they have helped. I'm not ashamed anymore of saying I might have to be on them forever. I have to get through the menopause. My mood noticeably lifts when my period starts. It's like a release as soon as it starts.

I don't function to the best of my ability before my period. I try to avoid putting things into my diary for the week before my period. Society is coded male. Instead of women trying to fit into that code, and women trying to fit the male stereotypes to get on, we should change society. A girl may have to sit an exam for an important A-level on the day that her period starts, with her stomach in bits. Or the week before, and emotionally she feels terrible. Points in girls' and women's lives can be so affected by such a natural thing – exams, going for an interview, performing in your sport. I don't know how we can change that.

People talk about vulvas as being vaginas. There is a lack of naming our bodies. It doesn't help empower girls and women. When I first masturbated I didn't know what I'd found, or the name for it, it just felt good. I'm not even sure when I learnt the word 'clitoris'. It certainly wasn't mentioned in biology lessons. We don't talk about our bodies enough.

Forty-six years old, no children

"I love exploring creative ways to have sex"

I am so grateful to be a woman with a vagina. I love it. We can have multiple orgasms and different types of orgasms. I have personal experience of different orgasms.

So there's the clitoral one. Then the vaginal one when it's closer to the entrance of the vagina. I get that when I am riding a cock from an almost milking action, the vaginal muscles tighten and contract. And then there is an orgasm which comes from closer to the cervix that comes, for me, from a fuller penetration and it feels really different. It's deeper and longer.

I've never had a G-spot orgasm. I feel vulnerable when someone is

going down on me or handling me with their hands or with their fingers. Maybe it's too much action around my pussy – I'm more of a full body person. I've read that the G-spot orgasm takes a long time and the woman has to be totally relaxed.

I started masturbating at a really early age. I think I was ten years old. I saw a video of a circle of women in a tribe masturbating together and I was like, 'You do it with your hands?!' and I was so shocked. 'You actually put your hands in the place where you pee?' Before I saw that I had been riding pillows and I would place the seams in the right place because it felt better.

Then I had a lot of explorations in school, like, 'Can I have an orgasm during class without anybody noticing?' And I just had loads of fun in boring classes. I'd press against the seam of my trousers and I'd start to feel some kind of buzz in my vulva and my clitoris, and gently shuffle and move to stimulate my clitoris.

I went through a phase when I was a teenager, like 13, 14, of masturbating to fall asleep. Sometimes I'd give myself eight or nine orgasms because I was a little bit bored. They weren't amazing, they were clitoral orgasms, but it was quite nice to do.

My boyfriend and I were both 16 and virgins and we wanted to have sex. It was an amazing experience and I think it shaped my view of sex. It was a beautiful day and we were in love. It was painful because of the hymen or because I was not super-wet or something. I'd never had period pains, so these were my first pains there. It was a horrible sharp pain, so we took it really gently. At some point I was like, 'Oh, I need to stop.' So he made me a really nice bath and we just hung out in the bath and cuddled. Then I wanted to try again. I knew it couldn't hurt forever.

I didn't orgasm that first time. We went on to have loads more sex and I would come, but only when I was riding my boyfriend because my clitoris would also rub against the pubic bone and the hair.

At 16, I was definitely thinking a lot about how a woman should look when she's having sex. I was not thinking just about my sexual pleasure; it was more if my boyfriend was satisfied. I used to shave everywhere. I guess I wasn't so relaxed and in my own body. I was always a very intellectual person so being totally in my body only happened way later.

We get our ideas about how we should look from magazines and films. I'm a very visual person, so in any film where there's a sex scene I would notice the woman's face was lit differently, because it's always about how the woman looks.

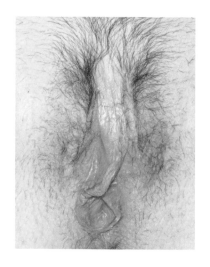

I love exploring new creative and fun ways to have sex with my current partner. Recently I wanted to try to have a cervical orgasm. I needed slow penetration and gentle pressing on the cervix. I wasn't trying to get there, we were just having a lot of fun. Maybe it took 15 minutes in the same position, let's say, not counting foreplay or anything.

I was coached to have anal sex by a very experienced man. In the beginning it was really weird because the anus is a place things come out of, so going in feels odd. I felt like I was going to poop myself. The girth of his penis was a little bit smaller than normal, which helped. I've had lovers with wider girths and I would never put that in my arse.

In the beginning we had lubrication and we would just play around and play with my clitoris at the same time, so there would be some pleasure. We took it really slowly, but for a bit longer each time. Eventually he could penetrate me, and then penetrate me at a 'normal' speed, always with clitoral stimulation. And at some point, we were having normal vaginal sex, and I was super lubricated and I just started feeling this kind of 'yes' from my bum and it was like, 'Oh, this never happens.' We had anal sex and it was almost like the circuits were connected, my vagina, clitoris and the anus were somehow connected, and I orgasmed.

There is something that happens when only women are together, a kind of nourishment that I can never get when I am with men. I don't know why. I think I have a kind of predefined behaviour towards men, the ones that I fancy and the ones that I don't. For me, being with men has a lot to do with making sure that I'm not giving mixed signals in my affection, being clear with my boundaries at all times.

With women I don't have any of that, I can just be me. But I do sometimes compare myself more with other women. Being a woman trying to survive and thrive in a very patriarchal society, navigating chauvinism and also feminism.

I feel like women have an advantage because they have to be very aware of their bodies every month at least. I am confronted with my own body and how it works. This visceral relationship with my body is part of

the answer. But I'm still asking myself what it means to be a woman; the bottom line is that I don't know.

Thirty-four years old, no children

"I gave birth in a car park"

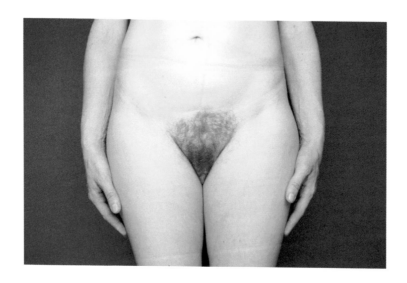

I first realised that girls were treated unfairly when I was at school.
I was about eight. We had sewing classes with the boys; they made pencil
cases and the girls made samplers. It was really obvious to me that the
boys were making something practical and useful, whereas we made
something that was purely decorative. So I asked if I could make a pencil
case and it was a really big deal and it had to go up to the headmaster
to get approval. It was my first little victory and the beginning of my
feminism.

 I'd say my relationship with my body and my vulva is quite
complicated. There's the part of me that's really proud of having my kids,
but there is a part of me that feels a kind of shame about the female body
and feels it's more unclean than the male body. I don't want to have these
feelings, but I do.

I use the words 'vagina' and 'vulva'. If I was talking in public I'd probably say something really embarrassingly euphemistic like 'my bits'. I don't like porno language, I would never say pussy. I'd be more likely to say my vulva, even though I'm sure it makes me sound really prudish.

I didn't know that I had a vagina until I was nine, although I knew I didn't have a willy – it's so Freudian, isn't it? I knew that my brother stood up to wee and I couldn't because I'd tried. I'd seen that he stood in front of the toilet whereas I sat on it, so I went and stood in front of it and my wee ran down my legs because I couldn't aim, and I found that really frustrating.

Girls have so little knowledge of their bodies. I asked my mum once at the swimming pool what the machines in the toilets were for, and she said something really vague like, 'When women have babies they bleed once a month,' so I just thought, 'Well, I'm not going to have a baby so I won't have to do that.'

I've had three vaginal births. My vagina is not in the state it used to be in, and I should do more pelvic floor exercises. I've had one miscarriage and three live vaginal births and they've not been difficult births at all. There's such a morality tale about whether you have a good birth and whether you've planned it and I think so much is down to luck. My children were born quite easily and quite quickly.

One of them was born in the car park. Labour came on quite quickly. We were having lunch and my waters broke and we drove to the hospital. I remember sitting in the car being in a lot of pain and thinking, 'God, this feels really far on,' but then also thinking, 'I've only had one baby before so what do I know about whether it's far on.' Then we got out the car, having struggled to find somewhere to park, and I felt a massive contraction. I put my hand down and felt my son's head, so I lay down on the tarmac, next to a Portacabin, and my partner caught the baby. It was magical. For a while we were quiet; it was like we were the only people in the world, then we felt a bit panicked because we couldn't remember what was supposed to happen. When the baby started crying, my husband was saying over and over, 'Thank you for crying.'

I felt tremendously powerful after giving birth to all my children. A woman in the car park gave me her fleece to cover my modesty as I was lying there, my skirt hitched up, my legs apart. I didn't care: I'd just had a baby, produced a human being. I didn't care who saw.

It's strange the way that women's bodies can do all these powerful things but they're shrouded in shame. There's not an issue with female

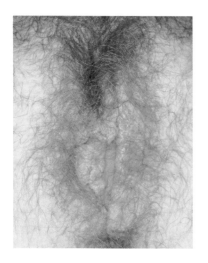

flashers, whereas men will expose themselves to women, and particularly young girls, as an expression of power. Women don't go around flashing their vulvas or their breasts at people to intimidate. Normally, when they are revealed, it's functional for breastfeeding and birth, unless it's objectification in porn.

I went through early puberty when I was 10. I got changed for PE and noticed there was blood all over my pants and I got in a panic and kind of kicked them underneath the benches where we were getting changed. Someone noticed and asked whose they were. I didn't have any pads and had to use toilet paper. I felt like I was really disgusting and that the other girls who hadn't developed yet were cleaner than me and less leaky.

I started starving myself because I really hated my body. I was very conscious about having hips and breasts. So I had three or four periods when I was 11 and then, because I was anorexic, they stopped until I was 21.

I was admitted to hospital and force-fed shortly after my 12th birthday and that was a very traumatic experience. This was the late 1980s, there was no sophisticated treatment for anorexia. It was almost like a punishment treatment. I was tube-fed and I wasn't allowed to see my parents or have books unless I ate.

When I see adolescent girls now going through puberty I totally get it. If I'd been my mum and dad I don't know what I'd have done, because obviously I was making myself very ill. But I think we need to look at the causes of why girls don't want to go through puberty. They used to say 'Do you want to have children later? You should be menstruating. Don't you want to be a woman?' I couldn't think in those terms. I didn't want to be a body, let alone one which menstruated, I wanted to be a mind. I felt like women were treated as nothing more than bodies in some ways and I wanted to be valued for my mind.

My mum was a stay-at-home mum who thought her whole life was about childcare and caring and having children, and I didn't want that kind of life at all. I also never felt I could compete with the girls who were the prettiest or the most attractive. I felt that I was going to lose at

womanhood anyway, so I wanted to opt out.

In a way, it made me feel almost superior to other girls, like they'd sold out and submitted, whereas I focussed on studies and didn't care about what men or boys thought of me. I didn't care about make-up or clothes.

I still make myself sick sometimes if I've eaten too much. I've been a normal weight for about 20 years now and my weight has barely changed apart from pregnancies, but I still make myself sick sometimes. I still have fantasies about being thin. I know it's not healthy.

I would never have said this years ago, but I think the best thing about being a woman is relationships with other women and knowing how strong women are. I am also proud of being a mother.

Being female shouldn't be shameful. I've accepted this rationally, but not fully on an emotional level. Celebrating wombs and vaginas is seen as a bit hippyish, a bit 1970s, like you're some weird second-waver drinking your own menstrual blood, but we should celebrate female reproductive biology because it's such a powerful thing.

Forty-two years old, three children

"I was recognised from 'Readers' Wives'"

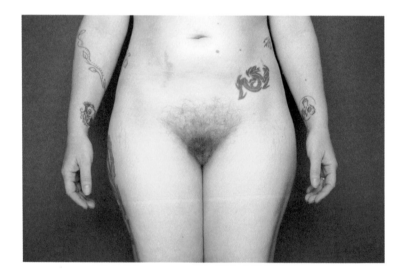

Despite my best effort to wipe it off, you can see blood in the photo today. I think the photo is quite fascinating. Magic. I want to say it's beautiful. It feels like quite a big adjective to use, but I certainly don't think it's ugly. I bleed from it, I've had babies from it, so yeah, I think it's quite special.

I was raised in the goddess tradition, the pagan tradition. Menstruation is seen as sacred in most paganism, so I knew well in advance of getting my first period that it was something really special and important. Once you start bleeding you can create life – it is an arrival into being a woman.

My first bleed was celebrated. The necklace that I'm wearing today was actually a gift from my parents to celebrate my 'menarche' as it's sometimes called. I remember wearing the necklace all the time and being really proud of it. My friends didn't understand it and they were quite weirded out by the idea that periods are something special.

About a month after I'd been given it, this boy came along and yanked it and broke it off my neck. I was always seen as a bit of an oddball at school, I didn't fit in. I was bullied. The whole experience made me feel closed down, but I also remember feeling sad that the other girls clearly didn't have the same connection with their period as I did.

I was quite a late bloomer, I didn't lose my virginity till I was 16. It was with this boy in the village where I grew up. One thing led to another I suppose. There wasn't any finesse, I don't think he even kissed me. It took about two minutes. And then he was done and we went our separate ways.

He was one of the cool crowd at school. I didn't tell anyone, but he must have done. A few days later at school people started calling me a slapper, a scrubber and a slut. I couldn't quite wrap my head around it because there were two of us in this, but I was the only one being called names. It's not an uncommon story for women. Men can have sex with as many women as they like and that's fine, but heaven forbid a woman should have more than one or two sexual partners.

When I was 18, the boyfriend I was living with suggested taking some photographs of me. They were only for us, and there was much chuckling about getting them developed. He took some photographs of me in underwear and then really close up, personal shots of my vagina.

In those dates there was a top-shelf magazine called Razzle, which had a section called 'Readers' Wives'. You sent in personal photographs and if they published them you got paid. I think it was £20 a photograph, which at the time seemed like quite a lot of money.

We were skint and my boyfriend thought the photos were really good... I wasn't totally OK with it, but it was just a laugh. I didn't really think through the consequences.

Sure enough, they used four of my photographs and we got 80 quid. I think in some way it was kind of cool to be in a magazine!

What wasn't so cool was about three or four months later, when I was sitting in a pub with some friends and this bloke came over to me and said, 'I know you, I've seen your photographs in a magazine, you're Angel, aren't you?' I tried to bluff it and pretend I didn't know what he was talking about. But inside I thought, 'Oh my God, I can't believe I've actually been

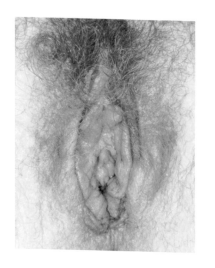

recognised!' I was really embarrassed. I thought I might be seen as a certain kind of woman, a bit easy and up for sex. He wasn't the only man either. I struggled for a long, long time about this. I only made my peace with how I felt about those photographs relatively recently.

Porn magazines seem to be like an investment, you pay your money and you put it away somewhere for a rainy day. I realised that there are probably men out there, possibly 20 years later, who still have the magazine and wank over it. That's quite a startling thing and it definitely didn't cross my mind at the time when I agreed to send my pictures in.

I'm sure I am not the only woman in the world who has been a reader's wife in a pornography magazine and then regretted it in later years.

It's hard to imagine what 100 vulvas are going to look like together, but I think it's going to be really powerful. Knowing that mine is going to be one of those 100 is really beautiful. It's the antithesis to having been a readers' wife. My vulva has been out in the world twice in completely different ways, and it feels like I have come full circle.

Thirty-eight years old, four children

"My vagina looks like an avocado without the stone"

I don't really call it anything. Mum always called it something cute like 'fairy', which feels weird when you're older. 'Cunt' is a very cutting, negative word and 'pussy' is used to mean weak and wimpy, so I don't like attaching those negative connotations to my vagina. Until I come up with a better word, I'm trying to use 'vagina', but that's not a very sexy word. My boyfriend calls it 'the chubby bit' because the top is quite chubby. I think that's quite funny and I'm OK with it.

 I looked at it with a hand mirror the other day and I thought it looked like an avocado without the stone, obviously not green. I don't think there's such a thing as a pretty vagina or a normal one because they all vary.

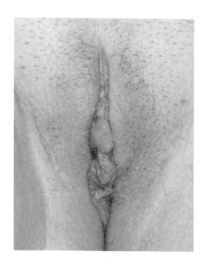

I don't think penises are pretty either. Why would we think genitals should be pretty, except if we get ideas from porn?

I saw porn for the first time when I was a teenager, with my friends. It was quite scary actually: girls screaming loud, fake orgasms, the man being in control, anal, gang sex, and things that women probably weren't comfortable with at all but acted like they were. Abuse really. As a 14-year-old it made me think that's what you have to do to please a man. It didn't feel like the women were properly involved. Their pleasure was nothing to do with it. It's really fucking weird if you think about it.

So I was very open to pleasing the man and not really into the idea of being involved and having pleasure myself. It was a man's world.

When we were 13, me and my friend both had a boyfriend. When she had sex I felt like I needed to do that as well, just because I'm from a really small town and I felt like that was the sort of the thing to do. I didn't really want to do it, and I don't think he did either, but we just did it anyway, almost like an 'I've done it now so you can't call me a virgin,' sort of thing.

I've come to understand more since being at university. I started sleeping with people for my gain, not for theirs, because I wanted to, without being worried about whether I'll be called a slut or a slag or horrible derogatory terms that I was scared of being called. I have found it really hard to put my pleasure first, when I've been putting men's pleasure in front of mine for so long. But I've got the hang of it now, I think.

Women's orgasms are very fake in porn, which puts me off it even more. Why is it pleasurable for men to see a woman fake an orgasm? I feel like it's been drilled into me to try and fake an orgasm because of porn, but I make sure I don't now during sex, just because I think it's really disingenuous to my partner to think that he's pleasuring me if he's not. I think honesty is more attractive.

I've been with this partner for two years and I'm more honest about what I like because I've discovered it with him. I'm more 'in the moment', and more comfortable with him.

My partner stopped using porn. He said he was watching it quite often and he realised how brain dead he was getting from it, that he wasn't sexually pleased by women anymore. He stopped watching it to enjoy actual sex more. It's quite amazing for a man to say that porn's bad.

Obviously I don't mind him masturbating, but I wouldn't be comfortable with him using porn. It's so awful for your head. I couldn't keep up with those expectations and I wouldn't want to either.

I can't have a vaginal orgasm. My friend and I were talking about it and we're not honestly sure it's possible.

All my friends remove all their pubic hair. They think they need to before a night out, in case they get with anyone. Pubic hair is seen as quite shameful and disgusting. You think men won't want to have oral sex with you if you don't shave. I've heard men talking about women being hairy and disgusting. It's called a Barbie trim. Mind you, you have to take note of the fact that the Barbie doesn't have a vagina, it's just a place that is fused out.

I don't like the association of looking like a young girl, but I think some men enjoy the submission and the vulnerability of a young girl look. That's quite scary.

I find shaving really awkward because my shower is tiny. I've always shaved my vagina, but recently I've realised that I hate it actually. So I've been experimenting with more hair. I have recently shaved again and I thought, 'Oh shit, I've shaved my vagina. It's going to be red and prickly and weird in the photo!' But this is being truthful, it is uncomfortable to be shaved.

I feel like I've had the privilege of having women in my life that I have been able to talk to really openly about menstruation and pleasure and keeping on top of your body hair and everything like this. I'm close to my mum and my sister. I didn't realise that other women couldn't talk to their mums, they had to go through menstruation on their own and didn't understand their own pleasure until they were older and they were disgusted by their vaginas completely. I hate the idea that there's so much shame around vaginas and I want to break that stigma. Male pleasure is put on a pedestal and celebrated, and female pleasure definitely isn't. I want other women to realise that there are completely different vaginas, that we are all individuals and to try and talk to other women openly.

Twenty-one years old, no children

"#MeToo made me speak out about a celebrity"

Fourteen was a really tricky year. I had an early sexual experience that I now see as gross and potentially causing a lot of harm to my healthy relationship with sex. In a way, I'm just processing it now. My boyfriend was 18 and seemed very experienced. In my head, coming from a Christian background, I thought that the 'no sex before marriage thing' was outdated, and that God probably meant just wait for the right person. I think I might have thought this boyfriend was the right person on some level, and also I was afraid that if I didn't have sex with him I would lose him. I kind of had an out-of-body experience – I just remember looking down and seeing a very flat, still me.

When I was 19, I randomly met a celebrity who came on to me. He was 34. I was in awe that some celebrity would find me attractive and want to sleep with me. Quite early into the evening I realised what an idiot he was and then, scarily, that his mate wasn't going to go away. But I went along with it because I'd put myself in a crazy, vulnerable position. We were in a small village by this point where his hotel was and there was no transport out. I doubt I'd have even been able to get a taxi away, and I was all alone. I'd said goodnight to my friend and she'd gone. So I knew at some point I was committed to stay there for the night. I didn't feel in danger, I just felt like this wasn't going to go quite as romantically as I'd hoped. I 'consented', but the night was just degrading – taking it in turns between the three of us.

I left in the morning and then completely rewrote everything. I saw my friend and said I'd had a lovely night. I continued to stay in contact with this celebrity because I got a little buzz out of him still wanting me, until I saw him one more time. This time was really horrible and outright degrading. We were in quite a public place, in a room, but with people coming and going. We were just sat next to each other, catching up after quite a few months of not seeing each other, just exchanging emails. He put his hand at the back of my head and forced me to give him a blow job. It was cut short as someone else entered the room. No one knew I'd gone there so I didn't have anyone to instantly report back to: 'Ha! I saw him again, it was lovely.' I never mentioned that incident to anyone.

Subsequently I had inklings from the media that this guy had gone on to have relationships with younger girls. I never felt like I could come forward with my story because I was so embarrassed that I had told any friend that would listen that I had had great sex with him.

The #MeToo movement on social media was hugely influential. I saw this guy's name come up. I thought, 'maybe I'm the only girl brave enough to speak up, maybe my story could help others.' So I went to the police just saying, 'It's a very small piece of a jigsaw puzzle, but if there are any other girls out there that might need to hear it, this is what happened.'

It was embarrassing, but the first thing I had to do was out myself as a liar, first to my husband and then to a few key friends that I just wanted to set it right with. They all forgave me and reassured me that it wasn't a lie, it was a process.

The police have been great. As far as I know they may never contact me again. The only potential allegation is the forced blow job. I gave the whole background story about the night, but said I'd stayed of my own volition and that I wasn't making an allegation that anything had been forced.

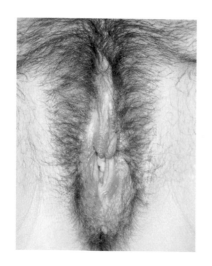

It was telling this story that helped me realise that the experiences at 14 and 19 were intertwined. My husband hadn't known the full details of either so I told him everything. I'm finally going to counselling and am hoping to unpick it all more and how it's affected me.

I think it has taken me umpteen safeguarding courses as a teacher, becoming a mother to a daughter, becoming happy and secure in my marriage and having influential, amazing female friends and the age of 33 to fully understand how predatory that celebrity was. What I'd really like to crack next is what I can give to my daughter so that she doesn't make the same choices.

I've got an amazing mum and dad. I don't conform to quite a few of the stereotypes of why someone might go off the rails. I grew up knowing I couldn't take sex lightly. Yet I had a lot of sex quickly or, one might argue, got into relationships quickly where I had sex. It was, 'Is this the one? Let's see, because we've got to connect sexually, we've got to connect emotionally. I need to throw everything at this. Are you the one?' I could count just one or two times when I kissed a man and wasn't half-thinking, 'Are you the one?'

Yet despite all that sex, there's been so much performance. I wonder if at 14 the deal was done, with me going, 'Right, this guy only wants experienced girls who know what they're doing. I shall be that girl.' Maybe I never got out of the role from then on, because what concluded with that guy was then reinforced by watching porn, where girls buck and arch their backs and look like they know what they're doing.

I've always liked sex with the lights on, eyes open, because for ages after those bad experiences I had flashbacks. If I close my eyes during sex someone else's face crops up.

Everything has come to a head this year. I admitted to my husband six months ago, after telling him these stories, that I don't think I've ever had an orgasm. He's been very understanding. I've got close several times. It feels like I reach the crest of a wave sometimes and then it quickly goes away. I do get great pleasure through sex, and enjoy the intimacy.

I'm also trying to balance embracing femininity more as well as being strong and independent. I'm still struggling with pleasure, but right now my 'foof' and I are friends, we're happy, and things are getting better.

Thirty-three years old, two children

"As a black woman, porn makes me feel uncomfortable"

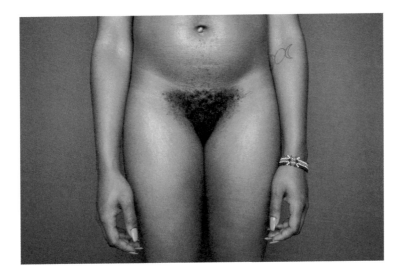

My vagina is not completely uniform. I wouldn't like to say it's mashed up, that's not a particularly great way of describing it.

Before today I wondered if I should shave, the same way that you'd get your make-up done: groom a little bit, make it look a little bit more presentable, but then I thought if this is supposed to be about my experience and vulva on a daily basis, then shouldn't I just leave it and be as I am? So that's what I decided to do.

When I think about being a woman, the first thing that comes into my mind is hardship, but then also strength – it's kind of like a double-edged sword. Women are still quite oppressed in some parts of the world

and don't really have a voice. If I was to go out dressed like I am today I could be attacked. At the same time, it's definitely the best time to be alive as a woman in other parts of the world because of how many rights we have in comparison to the past.

I'm a very young woman so I guess I'm learning, and just accepting me for who I am rather than what society tells me or what I get from the media and the internet.

I've grown up in an age where social media is really relevant. Beautiful women on social media are depicted as very tall, skinny, with really straight, blonde hair and lovely amazing eyes. I'm very short, I was a lot more 'robust' and I wore a headscarf because I was Muslim and had acne as well. I didn't feel beautiful, do you know what I mean? I felt very disconnected from the beauty standard. There shouldn't be a standard.

When I was 11, I heard my older brothers and their friends joking around mentioning porn, so I decided to google it. At first I was very weirded out – a child seeing adults having sex is really disturbing. I didn't watch it again for a while, but I was curious and I wanted to know what an orgasm was. I saw the orgasms that the women were having and thought it looked great, so I decided to imitate what they were doing. It didn't work for a long time. I was like, 'What is this, this is terrible!'

When it comes to porn, women are shaven, their vagina is very straight, there are no folds or anything, it's very uniform. They look little-girlish, and 'clean'. Porn kind of made me feel like my vagina wasn't normal in its shape and the pubic hairs I grew. I don't think porn is a healthy way for young girls to be exposed to the vulva for the first time. It made me afraid to have sex because I'm a dark-skinned woman and the darker pigmentation we have in our vulva is not depicted in porn. It made me feel undesirable.

The depiction of black women in internet porn is actually quite vulgar and degrading. As a black woman, porn makes me feel uncomfortable. I guess some people have these sexual fetishes of degradation, but the positions you see black women in and the way that they're spoken to comes across a bit racist. What kind of effect does that have on a young girls' mind watching it? But in a way it made me more empowered,

because seeing black women being depicted as animals in a degrading and racist way made me determined to take my sexuality back.

I grew up in a very matriarchal family, there are a lot of strong women in my family. My mum inspires me. She taught me to hold my own and never allow a man to say 'you got this because of me'. A lot of girls are quite babied and sheltered; my mum said I need to fly on my own. We talk to each other every day.

I decided to stop wearing the hijab at the age of 14, after wearing it full-time from five. I didn't want to disappoint mum, because I knew how much she wanted me to believe in her religion and follow her way of life. Of course it hurts if your child says no to your way of life, but at the same time I felt like it wasn't me. You wear the hijab to cover up your beauty, your preciousness, but I felt like I was hiding myself. Some women take a lot of pride in wearing the hijab, which I completely respect, but for me it mostly felt like I was just concealing who I was.

When I was 14, I'd leave the house with my headscarf on, pants, everything, and as soon as I got behind the dumpsters, or whatever, I would take off my headscarf, put a school skirt on and go to school with my legs out. I did that for two months, then I thought, 'What am I doing?' I didn't want to go to my grave regretting the choices I made just to keep society happy.

For two years after this decision, me and my mother had a very difficult relationship, although we're best friends again now. It took time for her to understand that I didn't completely disregard religion, I still follow a lot of teachings, but it would be hypocritical to say I'm a Muslim now.

The first time I looked my mum in the face and said I'm not Muslim is probably one of the defining moments of becoming a woman. I realised that I was embracing myself and my sexuality.

My Islamic community didn't take it well. We're tight-knit, like family, everyone knows everyone, like extended aunties and uncles. People told me I would go to hell. Well, you can only go to hell if it exists. Some people wanted me to have an arranged marriage, because apparently a marriage would help my secular situation. I knew my rights and I would have run away. I was born here, I know 999, we've got the internet, you can't just basically force a lifestyle on somebody and expect them to completely comply. Don't get me wrong, it happens to some women and they don't say anything. I thought to myself, what did the Suffragettes fight for if I can't use my voice and say this is not what I want as a woman?

Twenty years old, no children

"My daughter is 18 and is spreading her wings"

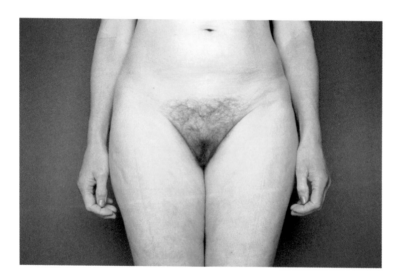

This is my finger, this is my wrist, this is my... oh, what shall I call it? It's strange. I brought up my daughter to know it as a 'vagina'. 'Yoni' doesn't feel like it's me – it feels like it's from somewhere else. I've been wondering about 'lady garden' recently – I like the garden aspect of it and it's more playful. But I don't really know, I haven't found a name that really sits well with me. It feels a bit strange, this far on in my life, not having a name.

I felt sad when I saw the prolapse evident on my photograph. I'm ashamed of it. I noticed it a couple of weeks after I'd birthed my daughter. The doctor told me there wasn't much they could do then, but I could have a kind of tuck in the future.

I try to improve it by doing pelvic floor and core strength exercises, which do help it. I've done quite a bit of walking today and that's when the prolapse tends to drop. I can't run or jump, it makes the muscle fall out which feels like a tampon falling out.

I went on a workshop recently and learned about pelvic floor exercises. There are three sets of muscles in the vagina and you can tense them and contract them separately. I've learned how to do it. It takes a lot of concentration. I'm sure that I could get so fluent in it that I could just make it undulate.

Since the workshop I've been feeling more curious about my lady garden. I haven't been in a relationship for a few years, so the attention I give it is up to me. There's lots of other stuff going on in the world and in my life and I don't give it as much attention as I could. So my relationship with it is intermittent.

Sometimes touch is really, really pleasurable and very occasionally it's orgasm-focussed and purely functional. It's maybe like a wave that starts really small. I've started to be curious rather than more driven. The curiosity of touch and of the muscle contractions leads to greater pleasure. I often used to feel really frustrated in my relationships and in self-pleasuring because it would be orgasm-focussed and I'd feel like I'd abused myself or I'd let myself be abused. I don't just want sex, because I know what it's like to make love. I had one relationship in my life where we made love and that's what I want. That's why I'm single, because I yearn to make love rather than to have sex. It's a high bar.

Making love is emotional, it's an energetic flow between two people, there's a listening and a responding and a being in the moment. Whereas sex is more practical and physical and the reason for it is orgasm. I need to be in a relationship and feel safe in order to really open up. A recurring mistake in my life is that I have involved myself in sex before I have really felt ready. That hasn't brought me happiness and it hasn't made me the best self I can be with another person. I feel really grief-stricken that I've been through so many years of saying yes to sex with men because I want to feel valuable, rather than valuing myself first.

The journey through menopause was challenging. I felt infertile and therefore not attractive, not desirable, not interesting anymore. I had to reshape how I thought of myself. I don't quite know how I got my head round it, but I had to realise I am valuable as I am. I'm emotionally intelligent and I'm interested in a strong bond and true connection of heart and body and soul.

I have been afraid of my sexuality. I've kept it hidden, it can bring me trouble. There is a bigger version of me, or a more confident version of me. My daughter is 18 and she's moving outwards. I have grief about that, but sometimes I also get glimpses of how I can be in the next phase of my life. The future me might get out a really long leather coat and big chunky boots and she might have a whip in her pocket – figuratively!

There was a moment of challenge when my daughter was starting her periods and blossoming into this peachy-skinned, fresh young maiden and becoming fertile at about the same time as I was becoming ragged and infertile. It wasn't quite like that, but it felt poignant that both of us were slipping into the next phase.

My daughter is 18 and spreading her wings. It feels like a really precious part of my life is changing. I'll really miss her, her physical presence. I love her so much. In some ways it will be a real relief because of all the picking up and the focussing. She's been my main focus for all these years as a single parent, which I would never change because I knew that it was for a finite amount of time. As well as grief there is joy, because it's exciting to have her life opening up before her. I'm excited and sad.

When my daughter was little I used to pray that she would know her heart and be strong in her sense of self. That she wouldn't stand for bullshit, she'd somehow forge her way from her own sense of strength and self. My prayer has been answered. I wouldn't change my prayer at all, but she's very wilful and sometimes she won't negotiate.

When she was born my mother became a grandmother and my grandmother became a great-grandmother and I became a mother. The generations move up a step on the rung of the ladder, further from where we started and closer to where we're headed. In that way it's sometimes a little bit daunting.

I think it's a privilege to be a woman, especially at this time. It feels like there is a rising of the feminine. It's like there's a whisper of the strength of the feminine revealing itself. I've never felt stronger in my femininity or in my womanhood. Men are taught to not be in touch with their feelings, whereas women say how we feel. I like that about being a woman. I like that I don't have to hide behind some kind of macho behaviour.

Fifty-four years old, one child

"I don't define myself as a woman anymore"

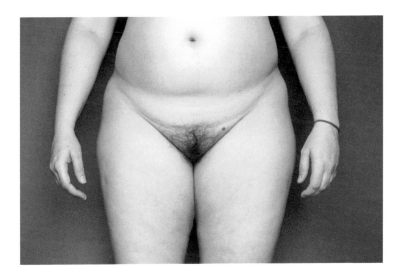

I have seen, touched, indeed worshipped many vulvas in my life. I appreciated each one. And yet I have never had the courage to look at my own. There is an edge to this which I find incredibly powerful and perfect. I know that I am meant to do this.

I have identified as a lesbian most of my life. I desperately wanted to be a boy as a child. I was molested by my father as a teenager. I hated my body, my gender, my sex for many years. Since then I have come full circle to a place of love and honouring and reverence for who I am and what I am made of.

I've named my boobs and I've had girlfriends name my boobs. But I realised I don't have a name for... I have a very distinct memory, it must be one of my earliest memories. I was four or five, sitting in the bath with my best friend. We must have been having one of those

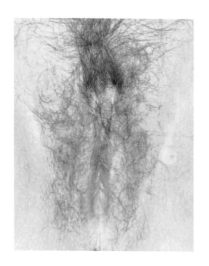

'What have you got down there?' conversations. I remember knowing – I must have been told – that mine was called a turtle. She said she had a butterfly. I thought, 'Why does she get to have a beautiful butterfly and I have a turtle?' I remember carrying the idea that mine was ugly, slow, boring and weird, and hers had a much better, more beautiful name.

I was afraid of penises my whole life. First I wanted to have one; I was extremely jealous of everybody who did and I wanted to be a boy when I was younger. Then I entered puberty and my breasts grew and I knew there was no way I was going to be a boy. Then there were things that happened in my life where I was hurt by penises. I was molested by my father and I had teenage interactions with boys who put pressure on me. So I guess my penis envy went away.

I didn't grow up with my father, I was born out of wedlock. My parents had a one-night stand, she fell pregnant and I was born. But he lived in another country. I met him when I was about seven. From the minute I met him I worshipped him. I thought he was just incredible, as many children do when they have separated parents. We had an instant close bond.

Then, when I was a teenager, he bought a house near us. He used to show up at school sometimes and I'd go and spend the weekend with him. He had a big house but he only had one big bed so I used to sleep in the bed with him.

I was already struggling with my body and having a female body. I remember being really unhappy with having a turtle. As a teenager I would be hunched over, hiding my body. Around this time I'd started menstruating and found that very difficult. I had terrible cramping, and bled a lot, and all the embarrassing things that happen when you're a teenager. So it was a very difficult time.

One night when he got into bed with me he started touching me. I was aroused and very confused and just kind of lay still. He touched my breasts and played with my clitoris and started fingering me. He didn't penetrate me. And then he took my hand and put it on his erect penis and that was when I reacted. I rolled over into a ball and curled up and he left me alone.

The next day I confronted him about it and we unpacked it a bit. His reasoning was that he wanted me to realise that I was a beautiful woman and I had a beautiful body and that sex was a wonderful thing. I was like, 'That's fine, but you're not the right person to be teaching me any of this because you're my father and you're much older than me.' There were a few other incidents that happened in the space of a year or two. He gave me a full body massage with oil, which was extremely uncomfortable for me. He got in the shower with me once and washed me.

I challenged him about it once. He apologised and said he didn't want this to fuck me up for the rest of my life. He also said, 'If you tell anyone, they'll lock me up and you'll never be allowed to see me again.' I really loved him and I tried to understand it and forgive him. But it did fuck me up. I became much more closed off. Even in the middle of summer I always had long johns under my jeans and long shirts that I would pull down.

I needed someone to talk to, so I told a teacher and I made her promise not to tell anyone. I was terrified that he would be taken away from me and that I wouldn't be able to see him and I still really, really loved him.

Four or five years later, when I kissed a woman for the first time and I was very confused, I went to the same teacher and again asked to speak with her in confidence. This time though, she told the whole faculty. Parents told my mum I wasn't allowed to play with their children anymore. I've done child protection training now and I know unequivocally that the teacher handled this wrong.

I am sexually oriented towards women. I defined myself as a lesbian at 16 and was part of an activist movement around that. A lot of healing and acceptance of my own body has come about through having very many beautiful, pleasurable, gentle experiences at the hands of other women.

In the last couple of years, I have discovered that there are so many more labels and identities and the world is really opening up. I've been rethinking my sexual orientation as well.

I don't define myself as a woman anymore. I tried for 20 years to force myself to accept my body and being a woman. But what does it mean to me to be a woman? A man can have a vulva and a woman can have a penis. Part of why I am taking part is so that is represented.

I now identify as non-binary or genderqueer. I prefer they/them pronouns, though I live with being called she/her, and to have Mx in front of my name rather than Mr or Ms. I don't really feel comfortable

being defined as male or female and I don't really subscribe to a reality where there are only two options. Sex may be the genitalia we are born with, but gender is a social construct and there are so many better ways now that we can do this.

I don't want to transition into being a man; I'm not taking testosterone and all of those things. I don't think I ever want to have top surgery, because I have done a lot of healing work and I love my breasts now. I love what they do for me and I love how they feel.

Ultimately I want to live in a world where we are people and not defined by what's between our legs. My sexual preference is polysexual, which means that I am attracted to different genders, though not necessarily all.

We wrap qualities up in this umbrella of masculine or feminine, like being nurturing is seen as feminine, but those are stereotypes: we all have the capacity for those things within us. Why should I say whether I am male or female on life insurance or driving insurance? It doesn't matter unless you are having surgery or something. Why should we get different Christmas presents based on whether we're boys or girls? I definitely got the crappy girl Christmas presents. My life journey has been about finding balance within myself and that's where I'm finding my healing.

Forty-one years old, no children

"I gave birth under a beautiful tree"

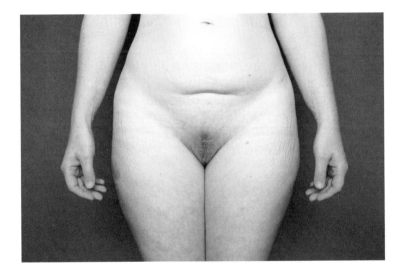

I was sexually abused as a child, by my adoptive father. I can't remember what age it started – I think it was at around 10 or 11. I have very few memories. One memory is particularly clear, but it's a fragment of a memory. My bedroom is pitch dark, I'm lying on my bedroom floor, I don't know why. My stepfather has his hand up my top and is touching nipples that are only just starting to develop. He gets up without a word and leaves my room and shuts the door and I'm left still lying there in the dark. But I don't know how I came to be in my room lying in the dark on the floor.

My mother had me very young, in her late teens, and my biological father had not wanted the responsibility. She got married again when I was two and her husband adopted me. Then she left. He was a single parent and I lived with him until I was 18. I never lived with my mother again.

It's really hard to explain to people. I have very few specific memories, but I have an awareness that there was a low level of it going

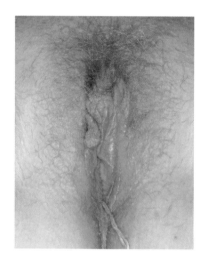

on all the time. I have no memory of being raped. I don't think he ever did that. It was all very insidious. When he hugged me he'd linger too long on inappropriate parts of my body. It was very confusing and I blocked it out. It wasn't until I left home that it hit me. I think that while I was living with him I couldn't look at it.

I tried telling my mum. I couldn't say, 'I'm being sexually abused,' because I didn't believe that was happening. I do remember saying to her, 'Sometimes dad touches me in ways that I don't like,' and she said, 'Oh, just try and stay away from him.' That was impossible, it was a ridiculous thing to say – I was living on my own with him. I've had a conversation with her about this since and she says she didn't know what I meant, that I wasn't clear. But I think if my 14-year-old daughter said to me that a man touched her in ways she didn't like, I would know. I would know what she meant and I would take action. So, for my mum, I think it was the same thing – she just didn't want to look at it. She couldn't look at it, it was too painful.

So I was a wild teenager, self-harming, running away from home and just being a complete pain in the arse.

I'm a recovering alcoholic, I've been sober five years. I had severe problems with alcohol. My mum likes a drink as well, so when I went to see her we'd be drinking partners and we'd stay up all night getting absolutely blotto. Then it would all come out and we'd talk and talk and talk. But I don't think it was productive, because we were just drunk and living out our trauma. Since I got sober our relationship has been much less close. It's interesting. I get a sense that she resents me becoming more stable. I think she preferred me when I was all over the place and desperately needed her as a rock.

My role as a mother is to keep my children as safe as I can. I can't protect them from everything, and independence and freedom are important, but I've always been very clear that I was never going to abandon my kids and I was always going to protect them. Then I want to teach them decent values: kindness, respect for themselves and other people. I want my children to do well academically, my daughter particularly. I really would like it very much if she could be financially

independent before she thought about settling down or having children or anything like that. I'd really like her to have the means to always know that she can just pack her bag and go if she needs to.

I spent a lot of time as an environmental activist living in various traveller sites and squatter villages. One hot, hot summer, I was pregnant, living in a yurt, waiting for my baby to come. I'd always planned to have the baby at home in the yurt, but it was as hot as a blinking oven. So me, my partner and a few women ended up under a beautiful tree. Two midwives came. They were great. Somebody from across the field made us elderflower cordial. Somebody else brought some fruit. I ate cherries, to try and keep my energy up. When our son was born, my partner caught him. Everybody said that they could hear me over the other side of the hill. It was one of the peak experiences of my life actually. Beautiful.

The women made up my bed for me with new brushed cotton bedding, and I got in there with my new baby and he had his first little feed. Everyone brought me cake and nice things to eat. It was lovely.

Today is the first day of my cycle. I feel euphoric when I get my period – it's the new start of a new cycle. In the week leading up to my period I can feel pretty damn dreadful, but I still love the whole process. I love to bleed. On the first day of my period I want to hunker down, eat nice things, watch telly and put a blanket over my feet. It feels cosy. Then the period finishes and I move into the fertile phase of my cycle. I'm almost 43 but it's still definitely there; I still have a good few fertile days where there is lots of clear discharge. I like that and I feel sexy, especially when it's sunny. After I ovulate I can feel pretty dark, not great, and I wish for bleeding again. And then the process starts all over again. But it's the structure – you're always somewhere in your cycle. I'm a woman and it's part of that and I just like it.

Being in my 40s is a strange phase of life. I feel psychologically and emotionally better than I've ever been. But I feel like I don't want to go near menopausal women just in case it's catching. The symptoms of menopause sound horrific and frightening. If I'm going to be absolutely honest, I fear losing my sexual attractiveness as well. I know that doesn't sound a particularly feminist thing to say, but it's true. I don't feel ready to be invisible. Every time I get a little admiring glance I'm like, 'Treasure that, because that's going soon.'

Forty-two years old, three children

"As a fat woman I'm allowed to be one of three things"

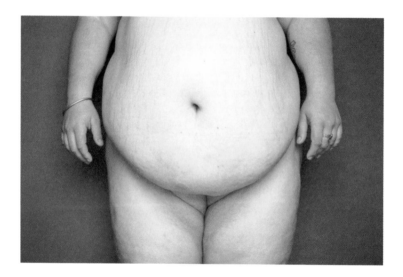

I'm from a long line of fat women. I found a letter from my great-grandmother talking about how much she hated her body. She was a short, fat woman and I'm a tall, fat woman. It's almost as if I have inherited grief, shame and guilt around bodies.

As a fat woman I'm allowed to be one of three things – funny, a mother or a sexual fetish. I'm not allowed to be anything else. To find out who I am, the whole of who I am, I've had to shake off the shackles of those three things. I am also a sexual creature.

The last time I had a lover was in the summer, a young man who was seven or eight years younger than me. It was the height of the summer and

we went swimming in the river together. I went round the corner and took my clothes off and went in. We ended up talking for hours, him sat on the riverbank and me in the water. And then he came back and sat at my hearth, kissed me and it was beautiful. It was delicious for three or four days.

I'm often the first fat woman a lover has slept with. I'm so tired of initiating people in that way. Fat bodies work differently. There are the logistics of having sex with a body that looks like mine. I have to get my belly out of the way, but also not forget about it, it's still part of me. I'd love to sit on someone's face but I never would because I'm worried about smothering them.

I had a very positive experience with someone who fancied me because I was fat. I was feeling sexy and we were getting down to it, he was taking my clothes off and I suddenly felt crippled by self-consciousness. He could tell and he asked me what was wrong. And I said, 'I just suddenly feel really inhibited and a bit scared. Why do you fancy me?' He said when he was young, just when his sexuality was starting to develop, he saw a documentary on goddess figures. He got really turned on by these big, fat goddess figures, and that's where it started for him. That doesn't mean to say that he is never with other women, but that's his particular thing.

I'm 35 and I don't have kids. I don't have a partner and I don't know if it's going to happen for me. There's a cruel irony in the fertility goddesses being really fat and no-one fancying them. Putting it crudely, fertility goddesses need to be fucked in some way to have a baby, but no one's going to fuck you if you're fat.

In some ways I'm far more free than more conventionally beautiful women because I'm not sexualised. My fat allows me a certain freedom, because I can walk down the street and people don't sexualise me. People don't look at me or my tits or my arse and go 'Phwoar.' I don't get cat-called.

I lost my virginity when I was 14 on a Girl Guide camp in Sherwood Forest to a tree surgeon. He was 18. I lied and told him that I was 18 too.

There was a little disco, he was doing the snack bar and he gave me a free can of coke. I'm quite tall and I like to be towered over when I'm with men, and he was really tall. He asked me to dance the Time Warp from *The Rocky Horror Picture Show*. Okay, not a classically sexy dance, just quite silly. And then he said, 'Do you want to go for a walk?'

We walked through the forest to a clearing by a little brook, and he laid me down and kissed me. He was the first person I'd ever kissed. I remember it felt like a film. Everything he did – take my top off, touch

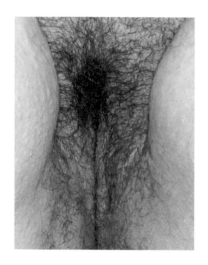

my chest, his hand slipping down my trousers – everything was for the first time and it was beautiful and ridiculously romantic.

I'm queer. I fancy men, women and everyone in between. There's no endgame with a woman lover. However much I try and shake it off, when I'm with a man it's leading to this moment where I really want him inside me. I want his cock in me, filling me up. With a woman, sex can look like so much more. I'm not saying I don't enjoy sex with men, I really do. Sex with men can look like lots of different things but even within myself there's always this endgame. I know physiologically that often they're knackered once they've ejaculated as well, so you might have about ten minutes before they're done. With a woman there's so much more variety and freedom. Take away the phallus, and there's no rulebook, there's no pressure to come.

When I masturbate I like to penetrate myself. It's like I put my fingers really deep inside myself and I feel like I'm touching my heart. At the moment I long to have someone else inside me, so it hurts – I end up crying if I penetrate myself. Because I don't have a lover right now, it's like an itch I've got to scratch. I just want to get down with myself really quick, get it over with. It helps me sleep. I feel ashamed that masturbation for me right now is about disconnection or avoidance.

I get turned on all the time. Rivers turn me on like nobody's business. Because I'm so big I feel completely held when I have no clothes on in a wild river. The river sneaks into my hidden places and it's very easy to rock up against a rock and I can come quite easily. I have one special rock in my local river that's like a saddle.

I'm big, I fill spaces. I want to occupy the whole of who I am. I don't believe in occupying other people's territory and I don't make myself too small. I find that space in between being really safe and small and being really out there and too big. I can't do anything but be whole-hearted – that is in my nature. So I may as well fucking do it.

Thirty-five years old, no children

"My first husband aborted our child"

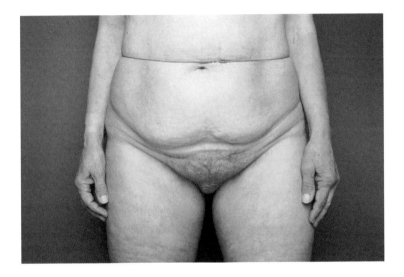

I've always called it a cunt and I wouldn't think of calling it anything else. I'm very proud that it's a cunt.

I'm quite amused by people talking about men's brains being in their penises, because I feel that a lot of me lies in my cunt. I think through my cunt and it's very integral to my being.

My family background is Nordic and Viking women were always quite strong. There was quite a decent parity between the Scandinavian gods and the goddesses. The goddesses didn't run around doing the gods' bidding – they were a powerful lot in their own right. And in Scandinavia today, women are well represented in parliament; they've got good parental leave and society is more equal in general. I see us as powerful warrior women.

I feel very visceral about most things. My rage and my feelings come

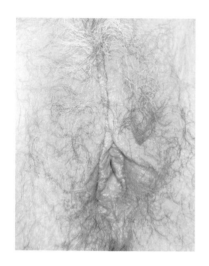

from my cunt more than my heart or head.

My rage informs so much of what I do. I work to improve the lives of the poor, the vulnerable, the unrepresented. In almost any sector of society it's always going to be a woman who is worse off. We live in a first world society, yet look how unequal society still is.

My first husband aborted our child. I scarcely dare to talk about it. I kept it secret for so many years. It undoubtedly caused me to feel a great fire and an anger about women's vulnerability.

When I fell pregnant he decided he didn't want it. He did like to get his own way dreadfully, at all costs. He was an obstetrician and knew what he was doing. He literally held me down and used some kind of sharp instrument on me. All I can remember is shouting and shouting and shouting, 'You're hurting me, you're hurting me. Don't, don't, don't, don't.' He caused enough damage that I had to go to hospital. I can't talk more about it than that, because it was horrible and violent.

Years later I told my mother and she asked why I didn't scream. I did scream, but we were alone and no one came.

For a time it made me very, very vulnerable and then it made me very, very tough. First of all I thought, 'How could this have happened?' and I questioned whether it was my fault, a similar process to the aftermath of rape. Then after a time I began to get really angry. You can look backward, facing the anger, or look forward and do what you can to make sure that other women have a better chance.

I didn't trust him after that, ever again. He played the victim, there was a pattern of abuse. We didn't have much sex, I'll tell you that, although I went on to get pregnant again. I told people early on that I was pregnant so that I would be safe, he couldn't do it again. I have never told our children about what happened. How can I?

The interesting and surprising thing is that after our relationship ended, I could go on to meet a really lovely man and have an absolutely fabulous sex life. Sex with my ex-husband was... not good. I didn't realise quite how not good it was until I was with someone else.

I had young children and after my marriage ended I wanted a long-

distance relationship so it wouldn't disturb them. I put an ad in *Private Eye*. He was about 80 miles away, but it was distance enough. We had the longest one-night stand in the history of the world – it's been 19 years now.

My second husband is absolutely gorgeous. We're a perfect fit, and we come together, just like that, every single time. It's amazing. We fit properly, specifically our penis and vagina fit properly. I can orgasm from vaginal sex with him but we have to do it for a very long time, maybe 40 minutes or so. I prefer to have my clitoris stimulated too.

I've got this theory that you can actually tell what a man's penis is shaped like by the way the man looks. I reckon that if a man's got quite a big head so has his penis. And if he's very long and thin he might have a very long and thin penis. I don't wish to badmouth a penis, but it's quite a simple piece of equipment – it's a rod with a knob on top, whereas the cunt has got lots of bits to it with various kinds of requirements. I think, certainly for me, a penis needn't be too long, but a good, solid head on it is what I'm looking for.

As far as I'm concerned, I wasn't even touched by the menopause because I had to have a Mirena coil fitted. They thought I wouldn't need another one when I was 50, but I did. They tested my hormones and I was still fertile. The only difference for me is lubrication now. I tend to use a bit of baby oil.

My cunt is warm and wonderful. I'm sure my cunt would like to go back in time to tell me that my own enjoyment is essential to the process. I wouldn't have even married my first husband if I'd known that. I realised I am a very sexy person. I'm 60 and my sex life is glorious and blossoming.

Sixty years old, three children

"I shaved with washing up liquid in the sink"

Taking part has been surprisingly freeing. Liberating. It didn't feel odd in any way being naked in front of someone who's not a sexual partner or a medic.

I'd never heard the word 'vulva' till about a year ago – now I say vulva or vagina, depending. I think mine is hairy, average and moley. I mean average as in normal. I love the mole next to my vulva so much. My vulva is slightly flappier than I thought it was. I'm not that bothered about how my vulva looks, it's much more about how it feels and how I interact with it. If it broke that would be a lot worse than if I had an ugly one.

I became sexually active quite late. I didn't really think of myself as a woman until very recently. I feel like my relationship with my vagina only developed from the age of 24. Before 24 it bled, and it was something that enabled my partner to have sex with me. Only recently have I realised that actually it's more than that and that's a good thing.

I lost my virginity the week before my 19th birthday. Most people I knew started being sexually active when they were 14 or 15. By the time they were living away from home at university they were more confident in themselves, talking about sex very openly, the type of sex they liked to have. I'm a bit behind on the timeline.

I've always been quite embarrassed about sex and my vulva being there. I was brought up in quite a conservative household. If I needed to go and buy tampons or sanitary towels I'd make an excuse because my dad would have to drive me to the shop and I wouldn't want him to know that's what I was buying. It was all very secret and nobody ever spoke about sex ever, ever, ever. It would be a bit strange and my dad wouldn't enjoy it, I wouldn't enjoy it and it wouldn't actually do us any good. He wouldn't have been a better dad, I wouldn't have been a better daughter so there was no need.

I'd had boyfriends at school who I'd kissed and then been in bed with and then made up excuses why we couldn't have sex, why they couldn't finger me. Obviously I sucked a dick because I didn't want them to have sex with me, so that then they would be done. I gave my first blow job at 16. That wasn't young compared to most people I knew.

When I got to university everyone was having lots of sex and I felt very, very strange for not having had it. I was terrified that a guy would know that I was a virgin and wouldn't want to date me, and wouldn't want the awkwardness of taking my virginity.

I lied all the time, especially during drinking games. There was a game at uni called 'Never Have I Ever', where you say something you haven't done and everyone who has done it has to drink. So someone would be like 'Never have I ever had sex in the shower,' and I'd drink because I didn't want anyone to think... because if I never drank then it would be, 'Well, have you even had sex?' No one would even say, 'Never have I ever had sex,' because it was so basic it wasn't even questioned.

I really fancied a guy on my course. I asked him if he wanted to go to this club night at the university. My 19th birthday was coming up and I really didn't want to be 19 and a virgin. He said that he'd go and he was looking forward to seeing me and I was like, 'This is the night!'

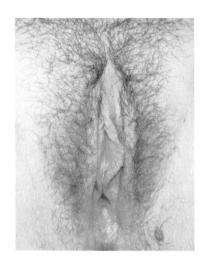

I prepared myself as I was told that I should by the one person who knew that I was a virgin. I shaved my vulva, but I did it so terribly. I lived with six girls so the showers were all taken for hours before we went out on a night out. So I did it in the sink in our uni kitchen, using washing-up liquid. I thought it looked amazing, because I'd never done it before, but I did it really badly. I took everything off, of course – it would have been unthinkable to keep anything on.

He stood me up and didn't come to the club night. I was really devastated. He didn't know that I'd had all these plans, obviously, and he didn't know that I was a virgin so he had no clue how big a deal this was for me. But my friends got me absolutely hammered and I went up to a guy who looked slightly nice, asked him if he wanted to dance. We were in a taxi within five minutes and I lost my virginity on a one-night stand.

The guy who stood me up went on to become my boyfriend for two years. He still doesn't know about the plans I had for that night and what happened, which is so funny. He thinks that I was having sex like a normal person.

I'm not ashamed anymore of losing my virginity late and I'm not ashamed of losing it on a one-night stand. I think my vagina and I have made the right decisions together and empowered each other. I think that I'd do everything the same, to be honest.

Twenty-seven years old, no children

"Miscarriage knocked me on my arse"

When I was younger, I didn't think a lot about what being a woman was. I was too busy enjoying myself, having fun, building a career, getting married. When you're younger you spend a lot of time trying not to get pregnant. I did anyway. From the age of 30 it flipped and I wanted to get pregnant. Then it was about staying pregnant, having a baby, then breastfeeding. And all of that really made me understand what it was to be a woman compared to being a man. Because it's all on you. Your partner can support you, but other than the initial sex, all the rest of it is up to you and your body. Pregnancy, birth and breastfeeding take a toll on you and your health, not your partner. My husband's body didn't change at all, but overnight my young woman's body became a mature woman's body with stretch marks and saggy bits.

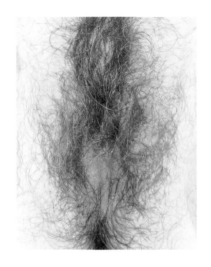

We tried to get pregnant for our first baby for eight months. I remember thinking, 'Oh, when is this going to happen?' Then it happened and I remember reading the positive test and bursting into tears and saying, 'I'm not ready! I don't know if I want to do this.' It seems so silly, but I was shocked by the impact, that I was actually going to grow a baby. My whole life changed in that moment. It wasn't till my first baby was four months that it really dawned on me that this was forever.

My entire thirties were centred around having kids, breastfeeding them and losing them. In between my son and my daughter I had two miscarriages. I'd already had one baby so I felt confident that I could do it again. But they were hard. The first miscarriage knocked me on my arse, to be honest. Before it happened something didn't feel right. I didn't feel positive about the pregnancy, and then when I was 12 weeks I started bleeding.

I should have gone to A&E earlier than I did, because the bleeding was very heavy. I started to get dizzy. I ended up having to have a blood transfusion. The foetus was large and had to be manually removed. It was really, really rough. I had intravenous painkillers, but it was painful. I felt like the pain wasn't necessarily a bad thing. In a way it was closure – a horrible, painful experience and then I came home and I quite quickly got back on with things.

I had a few weeks off work, and then it was all about getting pregnant again, to be honest. It took us a year to get pregnant again, which was definitely a rough year emotionally. I had another miscarriage at 10 weeks and I did that one completely on my own at home. It wasn't as bloody. I felt like I knew what was what now, and once I'd passed it, I could tell it was over. I'd known this pregnancy wouldn't work too. There were obvious signs like my boobs stopped being tender. But other subtle feelings it's hard to put my finger on.

During that year of trying to get pregnant, I was taking my temperature, we were both on vitamins, we were doing everything that you can to try and maximise your chances. It was a horrible year. It just takes the fun out of sex completely. It was not romantic at all. So we decided that we couldn't carry on doing that – it was awful. After

the second miscarriage we decided to just accept we were supposed to have one kid, and to not use contraception but otherwise stop trying. Of course, I got pregnant immediately, same month.

Both of my births were vaginal and pretty good. I think I've been quite lucky. I had a kidney infection while pregnant and it was the most horrendous pain of my life, it eclipsed the pain of childbirth. I needed morphine for it.

It's a lot, isn't it, a baby coming out of you? It's amazing to think how much the vagina stretches. Having sex after you've had stitches is scary. It took me a good few months to feel like it again. I was scared the first time. The fear probably made me tense up, and it was sore, but fine after the first time.

I noticed after having my son that the labia are less even and I have one dangly down bit, like a skin tag, which might have been caused by the tear. But it doesn't bother me.

If I do star jumps in an exercise class the labia slap together. I'm looser than I was before children. It played on my mind a bit, but according to my husband it's not an issue. My vagina might be looser, but I would say that sex is better since having children.

I'm a lot more comfortable with my body. Before babies I was slimmer and firmer, less love handles. Now I have stretch marks and saggy bits and my relationship with my body is the best it's been. I let my children wobble my belly sometimes in the mirror. I kind of like it.

I know what my body is capable of, so I don't care about how it's changed. If I'm on a beach in a bikini I feel OK, because I've got the body of a woman who has had two kids. Whereas perhaps pre-children if my body was a bit wobbly I felt like I had no excuse. This is actually not a bad body for a forty-year-old woman who has had two kids. It's a shame I wasted so much time feeling like my body wasn't as good as it could be when I was younger. I would tell my younger self to stop worrying and be kinder to myself.

Forty years old, two children

"It's not a porn-perfect fanny"

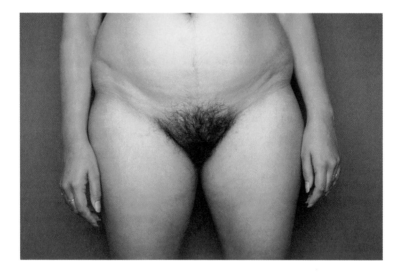

I've never looked at a photograph of my vulva and, weirdly enough, I've never even looked with a mirror.

I'm a bit nervous that I might be grossed out by it. Maybe I'm worried about what my partner sees. Logically, when I think about it, he's got a naked bird in the room, hasn't he, so he's not going to complain. I know he likes it!

I really wanted to do this. I've been proudly telling people that I'm going to be doing this. Yet in that moment when I considered looking at my photo, I thought, 'It's definitely not going to look like a porn star's fanny.' I'm a feminist and an activist and my first thought is that I won't have the kind of pristine fanny that everybody is used to. I don't beat myself up, I've not had shame in the bedroom when I'm having sex or anything like that, but it's interesting that I still have that split-

second thought that it's not a porn-perfect fanny. Not that I even want one.

I've never had any complaints. I also know when a chap is in the bedroom and he's about to get his end away, he's not going to be thinking, 'Oh, it could have done with a bit of work.' He's just thinking, 'Fab, I've got a shag.'

I've actively campaigned against FGM for the last ten years in various capacities. One of the things I do is talk about how women don't look at their fannies; we don't even talk about our fannies. I've talked about some really, really personal things with close friends, but not fannies.

I was born into a Muslim Pakistani family. I am no longer a Muslim and I kind of don't tell people that I am Pakistani, but I am. For me, one of the turning points for not remaining religious was the violent passages of the Quran and the Hadith, the sayings of Muhammad. In the Quran there's section 4:34 that says that you can beat your wife. There are certain escalations if she is disobedient, a consideration that women are unable to make any decisions themselves. If a woman is disobedient first you stop talking to her, then you stop having sex with her and then you kindly beat the shit out of her until she is obedient again and then you can carry on having sex with her. I have to elaborate a little bit. There's a lot of debate around passage 4:34 – the facts are that it tells you you can beat your wife. Some people say that it says you can beat your wife lightly, even with a feather or with a toothbrush. Regardless, I don't think violence is ever the answer. I don't think it can be justified.

The other part of it was the sexual violence stuff. So your husband can have sex with you if he wants to. If you refuse your husband sex when he wants it, they say that the angels will curse you all night. As a devout Muslim, when I was first reading that, it was quite a scary idea that God would be displeased and the angels would be cursing me. So even though they're not saying the words, essentially your husband can rape you.

Those are the main two reasons that I first decided to leave Islam, although there were other reasons.

My relationship with my family is based entirely on my terms, which is the only way to keep it manageable. I keep them at a distance. When I want to see them, I see them, but I don't visit too often. I do the bare minimum. I have no interaction with the community that I'm from. The last time I saw the whole community was three years ago and I had to

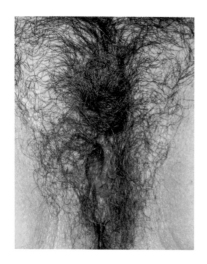

extract myself pretty quickly after that.

I can take part because this is anonymous. There are two things that my family don't know about me that would push them over the edge. One, that I've had sex and two, that I eat pork. Of course, they're completely deluded if they think that I haven't had sex.

My family have regular gatherings and meetings about the new things that I've been doing. I'm sure there will be a meeting about this if they find out I've been involved in *Womanhood*. Fortunately, I'm in a very, very privileged position. It's taken me ten years to get myself into a safe situation where I can do and say whatever I want. Honour killings still happen, even here in Britain. Acid attacks and honour killings have been happening in Britain for a long time.

I marched at Pride and I was decorated with body paint and had my tits out quite openly. There were objections. There were men in Borat-style mankinis, men in fetish animal costumes, men with their nipples out. It was a sausage fest. None of that was a problem, but the odd female nipple here and there... Maybe it's why there are a lot fewer women at Pride than men. The threshold for nudity is supposed to be what you would wear on the beach. I feel like it's just men telling women what to do again with their fucking bodies. Women's bodies should not be seen as more offensive than men's. That's why, even if it's freezing cold, I wear the tiniest of skirts. I'm not satisfied unless I go out and everyone can see my breakfast when I bend over.

Thirty-one years old, no children

"Menopause was a natural transition"

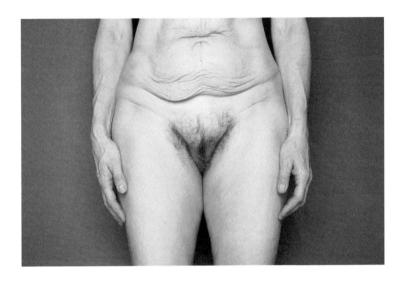

I like my sexuality, but it has never felt like a natural function like eating, drinking, sleeping, that I would perform without any second thoughts or conflict or anything else involved. Sexuality has always happened in this inter-relational space which is so different from eating, drinking, sleeping. So it has never been mine, it has always been something shared.

I don't have any inhibitions around masturbating, but it's just not so much fun. Sometimes I do it every day and then there could be a month when I don't do it at all. I don't feel my body needs it as much. My orgasmic urges have to be triggered by something, by a movie or by a book I'm reading. I've always liked to masturbate with books rather than with movies. For a while I tried looking for nice female porn, but I couldn't find anything I liked on the internet and I'm not going to pay for it. It might sound very kitschy, but I like the sexuality in the *Outlander*

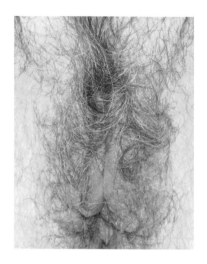

books. They are hot because they are sensual, they describe scenarios that I think everybody is dreaming of. I'm not sure that men in that age, in that century, would have been able to perform that, but it's a lovely idea.

I love my sexuality, but I've never been able to keep it in long-term relationships. I've always become disinterested after a while. I love physical contact, I love sensuality, I love being very alive in sexuality, but knowing I will lose my interest with a partner long term feels limiting.

I've never been able to have one-night stands just for the pleasure of it because I always get involved emotionally. I tried when I was younger. I normally get emotionally engaged with a man before I want to be sexual with him.

I lost my husband about ten years ago. There was also a grief that love and sexuality might not happen again. Right now it feels okay, it's not the most important thing in my life. If it comes my way again I'll welcome it. If I have a sexual urge I can be with myself but the desire is not so prominent anymore. That might be a question of age or hormones.

I don't feel 58. I've realised that I've started to find younger men in their 40s very attractive. But I'm very aware that they don't find women my age as attractive as women in their 20s and 30s.

I don't feel like I'm on the shelf; I feel very much in the middle of life. I feel younger and more alive and more satisfied with my life than ever, but I don't think there are a lot of men around that are mature enough to want that. I feel I have fewer problems with ageing than men have. I think for men, having younger women is a way to defy their ageing. I see so many attractive and vibrant women my age, but they are not with men.

I'm resentful about men sleeping with women young enough to be their daughters. Then they'll say those women have a father complex. I think the men have a daughter complex! I sometimes wonder what they would say if their own daughters made that choice. Very simply, I think men like that don't know what they miss out on with women their own age.

Although I am attracted to younger men, I don't go there. I keep that kind of desire closed down. It would feel too vulnerable to be rejected.

I sort of assume rejection. It's not that I don't want men my age, or I'm not interested, but I find fewer men my age that are interesting for me, because they are a generation of men that have not experienced what our generation of women has experienced. For me, all that had to do with women's struggle for equal rights, women's liberation, the feminist movement.

I entered the menopause in my early 50s. It felt like a natural transition. It happened around and after the death of my husband, which was quite interesting. I have had really tough menstrual cramps and migraines all my life. All of that was gone. I didn't miss the mood swings either. I had hot flushes but they are normal in my family.

My ob-gyn prescribes me hormones, which help me nicely. They aren't oral, I put one into my vagina every week, to keep it moist and in a good shape. Once he told me my vagina was a bit atrophic from loss of usage! I had a bit of incontinence so I'd asked him for those little cones that you put in your vagina to train the muscles. I struggled to get them in though, my vagina felt too tight, and that was because of the atrophy.

In the few sexual encounters I've had in recent years I haven't had any problems with lubrication or penetration. I haven't had much sexual experience since being in the menopause though. I can still have multiple orgasms when I masturbate. I can have five, six or eight in an hour. The first ones are always easier.

I've never managed to find the G-spot, but I have different orgasms. My orgasms feel different when they are just merely clitoral or when they have to do with intercourse. They are usually better when they are from intercourse and when my vagina feels filled. But I think it's still the clitoris which makes me orgasm during sex. With intercourse it feels like my whole body is more involved, whereas a clitoral orgasm feels like a small, picky thing. I once talked to a man I had sex with about male orgasms and I think clitoral orgasms are probably a bit more like male orgasms, just like blip and that's it. Not always but they feel too spikey, they feel too limited. For me, a good orgasm feels like a whole body experience. It also feels longer.

Fifty-eight years old, no children

"Every time she poked my cervix it bled"

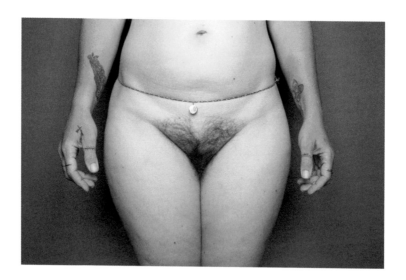

Cervical cancer has been a massive wake-up call.

I was getting flooding in my moon-time and pain after intercourse. I thought the flooding was perimenopause – my mother had had flooding during that time, she had fibroids and ended up having a hysterectomy. So, I'm 46 and I thought the flooding was normal. The pain was the big message, because I don't get pain down there.

When I started spotting as well I went to the doctor's and asked for a scan because I wanted to see if it was fibroids. I'd been back and forth to the doctor's about three times over three months and they'd been hassling me to have a smear. She said, 'I want to do some swabs,' and when she opened me up to do the swabs she said, 'Your cervix looks like it's a bit eroded,' and I'd never heard that term before. 'I'd like to do a smear.' So I went, 'Okay, there's something wrong. Do the smear.'

The smear came back fine. In the meantime, I was waiting to see a gynaecologist about the fibroids, which it turns out I don't have.

I went to see the gynaecologist to do the whole stirrups, speculum and camera. I could see my cervix on the screen. I couldn't understand what I was seeing, because I know what a healthy cervix is supposed to look like, and it didn't look like that. Every time she poked it, it bled. It was covered in lumps and bumps. I could tell from looking at the faces of the nurses in the room that I had cervical cancer. I just knew and I felt completely calm about it. I was just like, 'Okay, if this is what it is, this is what I'm dealing with.'

I had an anaesthetic before she took the biopsies. I could feel poking, but no pain. I remember my mum saying when she had her polyps removed she wasn't given any anaesthetic and that it was incredibly painful. She shouted at the doctor, 'Would you just chop the end of your knob off?' He told her, 'You shouldn't feel anything, there's no nerve endings down there.' Men wrote the medical books that are then used to teach more men doctors. No nerve endings down in the cervix? Anyway, I had a woman doing it and she was great; she talked me through it, and she was very gentle.

But then there's the waiting. Waiting for the result of the biopsies is the worst part. I was told it would take weeks to get the results, but I got a phone call four days later asking me to go in. You know if there's something wrong – they phone you and want to see you.

I took a friend with me and the cervical cancer nurse is sitting there with all her leaflets and the doctor was sitting there. They said it didn't make sense that my smear came back normal. I had an MRI to see if it had spread. The MRI test showed it was only in my cervix. The next stage is full hysterectomy, with lymph removal as a precaution.

It's stage 1B, so it's early. I've decided that I'm not having a hysterectomy, not yet. The hysterectomy would remove my womb, ovaries, cervix, tubes. I want to try and heal this myself. I at least want to have a go. So what I've said to the doctor is I'm not going to meet up with the surgeons, which is the next step, for a couple more months. I've got an amazing support team of a herbalist, a nutritionist and I'm working with a shamanic sound healer and I'm doing a lot of work on myself.

My husband wants to know more about the cancer and what kind it is, whether it's fast-growing and all that kind of thing. I don't actually want to know any of that. He wants the statistics and I know from the medical books that I've read that statistics are very skewed. If you're

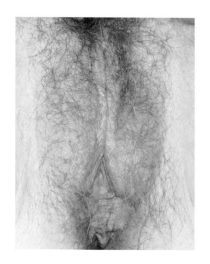

alive for five years after having treatment you're one of the ones in that box where you've survived, but actually you could die five and a half years after having chemotherapy.

I've watched friends with cancer get sicker and sicker. They went down the medical route and I believe they've died from the poisoning of the chemotherapy and the radiotherapy. It just completely fucks your body. I've seen people try and do both and not survive. And I know a few people who are doing the alternative and are living with it. I know someone who has been living with cancer for 15 years and it's not growing, but it's not shrinking. It's just like that. She's got it in places where they couldn't operate or do anything anyway, so they're just like, 'There's nothing we can do.' But you don't hear those stories, they're not the ones that make the headlines. I have no idea if I can do it, but I can give it a couple of months. I'm going to ask for regular scans during this time to keep an eye on it.

I think everything in our body comes from any things that are going wrong. It's dis-ease; it's not a disease, it's dis-ease in our body. There's something that's not quite right, something that we need to address. I need to work on the root causes.

I feel like my womb has done an amazing job – it's produced four children. I'm getting to the end of my fertility. If I need to let it go, I'll let it go, but I at least want to try.

I think my cervix thinks we're doing the right thing. She'd tell me we are a good team and we're going to be alright, now that I'm listening. We're talking to each other every day. I see myself as a grandmother. I see myself as an old woman. Whether I have surgery, or whether I do this the alternative way, it doesn't matter. I'm going to be fine.

Forty-six years old, four children

"I accidentally found myself at a sex party"

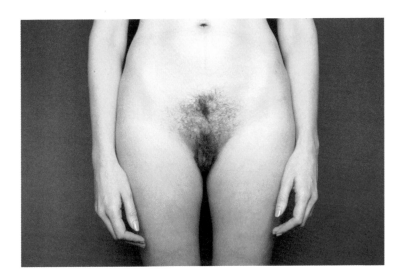

It's really easy for me to have pleasure. When I decide I want to engage with someone sexually I don't hold back. I go deep, in a literal and metaphorical sense. It wasn't always that way for me. What changed me was accidentally finding myself at a sex party.

I was invited to a party and didn't realise what it was about. It was an amazing event, with different types of people who had different types of bodies. There was an open-hearted way of considering bodies and sexuality that I had never been exposed to before. It was a special community of people and I wanted to know more.

I went with my husband and we had an amazing experience together. We became vulnerable in a way with each other that we hadn't before. More things have become accessible to me since then. I feel more 'in the moment', and more exploratory about being with other people

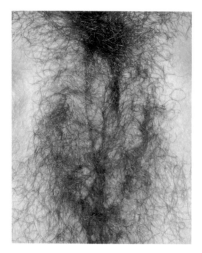

and less embarrassed about my own body. I think, as women, we worry about our bodies so much that it affects our pleasure.

I try and have loving thoughts about my vulva and vagina because I think the world is so anti-women and women's bodies. Childbirth helped me perceive my body in a completely different and positive way. I love my body.

I like to use the correct words, vulva and vagina, and normalise them. I think vulva is quite a pretty word. The 'V' and the 'U' reflect the shape of that part of the body too. I avoid using a word in a sexual context. I don't like the word 'pussy' at all. It makes me think of old men watching pornography.

If I have sex with a new man, sometimes I feel guilt towards my vagina and vulva. I feel like I've put them through something with a strange man without consulting them. There is more shame for women when they have sex. If you have sex with more than one man you might be seen as having loose morals. I want to push back against the narrative of women who have a lot of sex behaving improperly.

I don't believe it's possible for me to orgasm without clitoral stimulation. Sometimes, if I've been having a long, slow sexual experience, I get a feeling, a heat moving up through my body, and I think I might have an orgasm without my clitoris, but it hasn't happened yet. Maybe it will take something very specific and special for it to happen.

I am quite happy with the way my body works. I know I can have fun and have earth-shattering pleasure. It must be nice for people to have vaginal orgasms, but I love *my* orgasms.

I didn't want to look at the photo of my vulva on the camera today. When I got a glimpse from the side and I was about to look at it, I recognised myself instantly. I wasn't expecting that. I thought when I saw it, it could be anyone, but I knew it was me. You don't see yourself from that perspective ever, unless you use a mirror. I felt like I was intruding on myself! I want to look in a different way, when my photograph is in a book, with other woman, like it is meant to be. This hasn't been about showing myself to others, but showing myself to me.

I haven't really thought about the look of my vulva before. I used to

have a Brazilian wax once a month. I don't do it anymore, I can't believe I ever went along with the pressure of having to look a certain way. Now I think of it as violence against my vulva! The first time you have one done you get a horrifically painful rash. It feels like your vulva is swollen, sore and crying.

The women doing it make you feel fantastically at ease and like it's not a big deal. One woman once looked down and said, 'Oh, I've not done you before, have I?' And afterwards I wondered what she meant – is there something really distinctive about my vulva? Are they that different? I suppose we'll know when this book comes out.

I found the process of having my photograph taken made me feel quite vulnerable. It reminded me of when I've not been able to control my environment or my boundaries. I have felt vulnerable in medical settings, both abortion and birth.

I have had two abortions, both times with male doctors. They examined me and handled me with little care. Both times I left feeling traumatised.

You have to wait for all the material to come out of you. The second time I had an abortion it didn't come out. I had to stay for hours, waiting. I was examined by a doctor and he was a big man with big hands. I don't think he understood how that felt for me as a smaller woman. He said there was a bit left and he was going to get it out. He yanked it out and it felt like my insides coming out. He walked away and the nurse was very caring and asked if I was okay – she said it must have been painful. He hadn't put a towel or anything under me. There was all this blood and material on my dressing-gown, and my gown was stuck to me. I remember a thud when a piece landed on the floor.

Having a termination has a lot associated with it anyway, but when it's approached like that it feels even more barbaric and frightening. I don't think a female doctor would have been the same way.

Thirty-three years old, two children

"I had an orgasm typing an email"

I had an orgasm once when I sent an email to a lover. I wasn't touching myself, I was just typing. I wouldn't have believed it was possible until it happened. The orgasm was only in my womb. It made me realise that orgasm is about more than nerve endings. I was writing of desires, and the orgasm also made me realise how powerful my desire is. Since then it's almost like my womb talks to me, she flutters and moves when she wants to say 'yes', like a compass pointing the way to the true north of my deepest desire.

I love my cunt. I love the word 'cunt' too. It's interesting that the most negative, insulting word in the English language is the word for female genitalia, yet it's where life comes from and where exquisite pleasure can be found. It's a powerful body part and therefore a powerful word. There is no point trying to strip the power from the word – I wouldn't want to –

but we can reclaim it for ourselves. I never use cunt as an insult, but it is the word I use for my own cunt with myself, lover and friends.

I didn't always love my cunt. It's been a journey.

In films and TV programmes, men and women start having penetrative sex quickly and the woman orgasms through vaginal sex. You don't see much oral sex given to women, or awkward angling of hands to make sure the clitoris is being stimulated. So when I grew up I thought that's how it all worked. When I didn't have orgasms when I started having sex, I thought my vagina was broken, defective.

I distinctly remember being disappointed in sex and disappointed in myself. I thought there was something wrong with me, because it felt so different to how it looked in films. I remember faking an orgasm the eighth time I had sex. I don't think that boyfriend ever suspected. Most of my friends have also admitted to faking orgasms. It must be the most stupid and counter-productive thing that women do. How to ruin your own sex life. It's insane when you think about it.

As I got older, I touched my clitoris myself to achieve orgasm during penetration. Also, as I got older, men were more clued up about oral sex and touching me, and I became more confident about asking for what I wanted. I stopped faking orgasms and, funnily enough, sex got better! The first man I had an orgasm with, I married. That was obviously not the only reason, but I wonder: would I have married him otherwise?

I think it's really hard for women to express their needs. Films, porn, advertising, literally everything creates an atmosphere in which women are expected to be pleasing to men and prioritise them. Women are sold a pretty disappointing vision of sex. I find porn very tricky, for lots of reasons, but mainly I cannot relate well to a scene where a woman fakes her pleasure and her orgasm, and that is what nearly always happens. If I put myself in her position, she's who I empathise with in porn, and when I see her faking it or looking uncomfortable then I feel sad and shut down. The 'money shot' is a man's actual orgasm and ejaculation. Imagine how different the world would be if the money shot was a woman's actual orgasm, not a faked one? If the film showed everything she genuinely desired and needed to have a real orgasm, that would be pretty fucking sexy.

Talking to women friends in my 20s helped me realise not all women can have vaginal orgasms. I think the clitoris is very undervalued. But if it wasn't so potently pleasurable it wouldn't be cut off in FGM, would it? We should be proud of our clitorises. Freud has a lot to answer for. He's

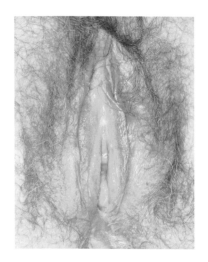

made a lot of women feel inadequate.

I can have vaginal orgasms now. I had one with my husband when we were together. I got close other times. Then I started having them on my own using my fingers or a sex toy. Now I am having them all the time with a man I am seeing. I've been sexually evolving, but I think our fit must be good – I joked that he has a 'magic cock'.

I know what I need now. A deep connection, either with my lover or, and it might sound strange, with myself. I need to be in the right mood. It has to be a slow rhythmic movement and takes quite a long time. The way my vagina sinks into that sort of pleasure involves connection and surrender, and it's a very different feeling to touching my clitoris to orgasm.

I think that every time I had sex when I didn't really want to or when I faked my pleasure, I slightly killed off a bit of my vagina's ability to feel and enjoy. Somehow these negative experiences built armour inside my vagina. Having better sex and masturbating with self-love has dismantled the armour.

I had difficult births and the first one was especially traumatic. Thinking about it and talking about it now can still make me feel very emotional. It had a huge impact on how I feel about my body and my vagina. I've realised that a lot of what went wrong was not my fault, not my body's fault, and I have forgiven my vagina for the birth.

The fact is, my cunt is incredible. She has given me children. She has given me, and my lovers, pleasure. It isn't me who needed to forgive my vagina, it's my vagina who needed to forgive me, because I didn't know how incredible she is. I wish all women knew how incredible their cunts are.

I think my cunt is beautiful. I've looked at her in a mirror. She brings me more and more pleasure. I have a feeling that my deepest instincts, my creativity and my power reside in my cunt and my womb.

Forty-five years old, two children

"My labia felt like big elephant ears"

When I masturbated when I was younger I used to hate it when my clitoris got bigger – I thought it looked like a penis. I felt very self-conscious about it. It didn't put me off masturbating, but afterwards I felt really bad about myself. I thought my labia were too big as well. I even questioned if I had half male and half female parts.

I didn't talk to anyone about these fears. I used to just give boys blow jobs because I didn't want them to see or touch me in case they felt it and said that it was really big. I had to be drunk to have sex.

I was drunk my first time. I didn't even know that I'd done it until the next morning when he said I had to get the morning-after pill. From that time on, I always just let partners do what they wanted, but I never let anybody pleasure me. I would never let anybody do oral because they'd see it, they'd be right there. I was sure a man would think it felt

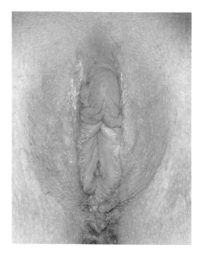

like I had a penis or really saggy lips. Sex was all about pleasuring the man; sex wouldn't be enjoyable for myself. I would just sleep with someone and get the feel-good factor for them.

I thought the area of the vagina should look like the ones that I'd seen in porn on the internet, and they looked the exact polar opposite to mine. Some ladies obviously did have lips, but they were ten times smaller than mine. Porn made me feel like shit in all sorts of ways – it would be my weight, my boobs, my vagina. I've cried so much about everything in the past. I think I wasted 12 years of my life suffering because of what I thought my vagina looked like.

I watch a lot of porn. It's a funny one because I don't know myself at all, I don't know what I enjoy. I watch porn to get ideas from it, but it gives me body issues because everybody looks so different to me. I think it turns me on, but I usually end up watching quite degrading stuff. I end up re-enacting that and letting men do whatever they want to me and I don't get anything out of it. It's not sexual pleasure for me – I get pleasure from knowing that the man has been pleased. It's a bit sad, really, isn't it?

Men have liked strangling me, spitting on me, hitting me, speaking down to me. I had one ex-boyfriend who was really horrible. He used to break into the bathroom and wee on me if I was having a bath. Another partner was mentally abusive. He would tell me that my labia were really big and say, 'I don't understand why you're really wet.' It wasn't in an excitable way, it would be to make me embarrassed. The only way that he could come was if I was passed out, unconscious, then he could come inside me. It spiralled and he did more and more degrading things to me.

I watched a documentary that talked about porn stars who were having operations to make their labia smaller. I realised it was something you could have done and I went to my GP and I had a bit of a breakdown. I think it was a really low day. I'd watched porn and my body dysmorphia was bad.

The consultant I saw said that labiaplasty would definitely help me, but it wouldn't be done on the NHS. He referred me to a private doctor. So that convinced me that I needed it.

Before the procedure they gave me some numbing cream. I was awake throughout the procedure. He injected anaesthetic into the labia and up into my bottom and then just sliced away. I lay there thinking how much better my life would be afterwards. In reality, my labia were probably quite small pieces of skin, but to me they felt like big elephant ears.

My recovery was horrific. I thought I'd have a week off work and I ended up having to have two. It was so swollen I couldn't walk. Obviously that worried me to start with because I'd gone to have everything smaller. I knew there was going to be swelling but it looked like a huge hamburger in between my legs and I couldn't even put my legs together. It was very painful.

My partner didn't want me to have the procedure done. He would make jokes that he thought I was going to end up running off with somebody else once I had it done, which obviously isn't the case. I think he was possibly worried that I would be more confident.

I feel a lot more comfortable day to day, sitting down, crossing my legs in jeans, the type of underwear that I can wear. My labia also used to get caught in tampon applicators, so now I can use tampons.

My labia used to be saggy, wrinkly, brown, hanging bits of skin. Now there's nothing there and I feel cleaner. I feel happier.

I had barely had oral sex before. I have tried it more, but I still haven't orgasmed from it. It does feel good, but it gets to a point where I'm worried it's taking me too long and he's bored. So then I can't let go, and feel negative and definitely won't orgasm.

I don't really have any confidence. I wish I could be more confident and powerful. I'm trying to stop worrying about what other people think of me all the time. I want to find out who the real me is, because I still don't know at 30.

I would hate for my daughter to grow up and feel like me, because it's just sad. I try to make my daughter feel confident. I've been practising mindfulness exercises and teaching them to her.

I want women to see that we all come in different shapes and sizes. If I can just help one person feel confident and happy, that would be great for me.

Thirty years old, one child

"Women are taught to fear their bodies"

I'm a doula. I support women through pregnancy, childbirth and postnatally. I've spent a lot of time looking at vulvas and watching them open as babies come out.

During an undisturbed birth a woman opens slowly and closes back. When I see a disturbed birth and a woman being told how she should and shouldn't push, sometimes it's controlled – for want of a better word – pushing where the perineum stretches nicely and everything opens. Sometimes I see a cut and a tear. Sometimes that happens because the baby's got a hand up against its head and nothing would have stopped that happening.

I think society tries to frighten women by talking about our vaginas and our vulvas as though terrible traumas happen to them. I'm not just talking about abuse, but also birth – we talk about it with such

frightening language. If you scare a woman about the way her vulva won't open then how will she trust it to open? It becomes a self-fulfilling prophecy. It becomes that thing that she fears. I don't understand why women are continually taught to fear their bodies by people who don't understand their bodies.

I find birth incredible after all these years. Every time is an awe-inspiring moment, watching a woman's inner goddess come out, however she births, whatever the situation.

I discovered my vulva after I got into birth work. I came to understand the workings of a woman's body so that I could support my clients well and know my stuff, and that was when I started to look at myself. I think my vagina is magical and powerful now. I think it would like to tell me to relax and enjoy when I was younger, seriously babe!

I'm matter-of-fact about myself and my body. I don't buy into other people's ideas as to how I should view my body. I'm 51, I'm a black woman and I live in a world that denigrates everything about my own personal beauty, except for when it's trendy to like it. If a white woman were to wear and do the things that I do then it would be edgy and urban and exciting, but with me it's synonymous with fetishism and eroticism. I don't like it.

I know that I'm fabulous and no one can tell me that I'm not. I have to talk about my vulva in the context of being a black woman because black female bodies have been politicised, eroticised and fetishised. It's difficult for us to own and love our bodies because our bodies haven't belonged to us for the longest time.

There are two pleasure spots. My mind is a fertile field. I love erotica, but I find it gets boring because there aren't many black women in it.

There's a song with the line, 'Oh I love your brown skin, I don't know where mine ends, I don't know where yours begins.' I had a white boyfriend who really liked the differences in our skin tones. He liked the difference in tone, and seeing my brown skin against his white skin. That brought me no peace or joy. It made me really want a black lover. Of course, you know what will happen now – I'm going to meet the most amazing incredible white guy and then have to apologise for this story. But the older I become, the more I am aware of who I am and what I want.

I hope there's good sex after the menopause. I think there will be more freedom in sex after menopause. We live in a time when women live much longer and menopause is coming up more in the conversation.

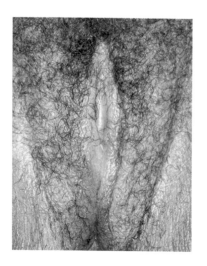

I love being 51. When I turned 50 I realised I wanted to walk into every room and spin around in celebration at being 50. If good sex comes my way then I'm gonna enjoy every moment of it, whether I'm 51 or 91.

I'm teaching my daughters not to be ashamed. They are not handmaidens, they are queens. They should take pleasure in their bodies. But it's not just my daughters, I tell my sons it is a privilege to have someone else's body in your hands, so why wouldn't they want to honour that?

Fifty-one years old, five children

"My period is my salvation"

I love my natural hair and I love my body. I don't shave my body hair.
I have nice thick, bushy armpits. I used to shave my pubes but I'd always
get horrible little bumps and spots. I realised I wasn't doing it for myself,
I hated it. I was doing it for partners and also I thought that's how it should
look because of porn.

I've had some difficult times, so I set out on a body positive journey a
couple of years ago. But I realised I was missing my bits out. These days
I try and say vulva and vagina, but usually it's 'bits'. I looked in a mirror
and thought it was lovely, really nice. I love my bits.

I didn't know about the clitoris until I was 18. I would touch myself
and have orgasms, but I had no idea what was happening. I didn't
know that orgasms were supposed to happen during sex. I knew from
playground banter that guys were supposed to have some sort of 'finish',

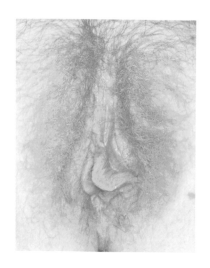

but I didn't know that I was! To get to 18 and still not know about the clitoris is a bit of a travesty really.

I discovered what a clitoris was when I started seeing a girl. She was concentrating on that area and it felt good, obviously. I told her it was the first time I'd had these feelings during sex. 'Oh, that's typical of men, they don't know or they don't care, one of the two.' She was really lovely and she helped me explore my body and pleasure.

When I was 14, my friends and I used to hang out in the town centre. There were older people hanging around with us. It didn't strike me as weird at the time. When one older guy started paying me attention all my friends bigged that up because it was seen as cool. When you're that age you definitely believe yourself to be older than your years.

One of the guys actually knew me from when I was eight or nine. When I was 14, he took an interest in me and started inviting me round to his house. Now that I think about it, that makes it even creepier. Things just grew from there and we started having sex. We were never seen together in public, which says a lot to me now, but then I was a naïve child.

A couple of months after we broke up he messaged me out of the blue and invited me over to watch a film. That's all I wanted, I didn't want to get back with him because he'd hurt my feelings. After the film he said he wanted to show me something. Nothing bad had ever really happened to me before, so I was quite trusting. I went up to his room and there were these... oh this is awful, this is such an awful story... there were under the bed restraints where handcuffs come up. Before I knew it he'd put my hand in one of them and I was like, 'Right, that's very funny but now let me go.' But he didn't let me go. He sexually assaulted me. He was kissing me, rubbing himself on me, had his hands down my pants. The only thing that stopped him from raping me was the fact that his dad came home from work early.

I was completely shocked that someone I considered a friend had done something so scary. He told me he enjoyed the way I struggled. Remembering that still creates feelings of fear.

I didn't report it to anyone. I only told one friend. She put it into context, she told me he was trying to rape me. I was confused. I thought

rape only happened to girls who walked home late at night.

I had another abusive boyfriend when I was 17. He had a massive drinking problem and he was quite physical with me. If I said 'no'to having sex with him he'd pull my hair or he'd force me down and things like that. I have a scar on my back because one time when I didn't want sex he held me down and cut my back. This went on for such a long time. I look back and I just want to shake myself. I should have stuck up for myself a bit more, but I didn't and it is what it is.

After those men I became scared of penetration.

I think I might have been vulnerable as a teenager because my dad was quite abusive when I was growing up. I have PMDD (Premenstrual dysphoric disorder), which made me behave terribly as a teenager. My dad didn't know how to handle me, he'd get into a temper and hit me and throw me against walls. I think I might have normalised violence because I grew up with it.

PMDD means I'm massively sensitive to hormonal fluctuations. My hormone levels are normal, it's just that my body has something like an allergic reaction to them. When I ovulate the hormone fluctuations can send me into depression, psychosis and I have ideas about suicide. It can be so overwhelming that I self-harm. It's half of the month, every month and it only stops when I bleed. I started my periods at 12 and it will continue until the menopause.

I worry that I'm going to hurt someone else, but I never have. The worst symptom is an intense rage that I don't feel I can control, and it can happen in the street, in front of other people, or it can happen privately at home. The first line of treatment is antidepressants and the pill. I had the implant but that made me worse, so I've refused to go on the pill. I tried the antidepressants – they sort of subdued it. After that you're looking at hormone replacement therapies, and the end of the line is a hysterectomy and oophorectomy, which is a big thing to have to go through. I've had behaviour therapy to tackle the anger, and managed to come off the antidepressants. I take CBD – cannabis oil – which helps mellow me.

My period is my salvation, I love it. It means I'm alive, I've made it. For yet another month I haven't killed myself.

Twenty-six years old, no children

"I have an incompetent cervix"

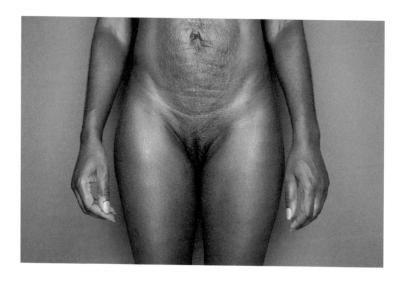

I thought the debate about pink pussy hats, from the women's marches, was quite funny. I got where people were coming from, but we're all pink on the inside. I didn't think the hats were exclusionary of women of any other race. You don't necessarily know what colour somebody's vulva lips are. They might be really fair but actually have quite brown lips.

I try to check in with my womb and my yoni. I know that might sound strange to some people but I feel a connection with her. I might place my hand on my tummy, have a meditation or an internal dialogue, just asking how we feel today. An answer might feel almost like butterflies. I can experience a feeling of 'no', or dread, coming from the womb space. A 'yes' is excited, it feels almost effervescent, like when I first started feeling my baby kicking in the womb. That effervescence feels like the beginning of orgasm for me. Once I'd had a baby I was more aware of sensation in my womb.

Sometimes I break out in fits of laughter when I orgasm. It's something that starts down there and it bubbles up, and I feel like it literally comes out of my throat.

I think I learnt how to love myself and what my body is capable of, through being pregnant. The birth wasn't exactly as I would have wanted, but it was a beautiful experience because I wanted him so badly and it was a bumpy road to get there. I had two miscarriages before I had him.

No one expected the first miscarriage, because I had the scan at 12 weeks and everything was fine. When I was 15½ weeks, I got out of my seat at work and felt this sensation as my waters released. I was in shock – I didn't know what was going on. I went to the hospital and had to wait until the next day for a scan, because by the time I got there that part of the clinic was closed. I stayed overnight and the obstetrician tried to reassure me. The next day they scanned me and said, 'There's no water.' So that was that.

An abrupt loss during a first pregnancy is seen as bad luck, even though a mid-trimester loss is uncommon. But they scanned me and kept an eye on me during my second pregnancy. At 13 weeks they told me that my cervix was funnelling. It turns out I have what is called an 'incompetent cervix.' I was grateful to know. I was given a suture, a stitch, to keep the cervix closed while pregnant, to help prevent another miscarriage.

A week later the same thing happened again, through the suture. It was like a horrible déjà vu because I was at work again. I remember feeling confused, because the miscarriages were so close together. The first one was July and the second one was December, and the December one was so close to the due date of the first baby that there were moments when I was confused about whether or not it was the same baby. Sometimes I'd have dreams that I was still pregnant with the same baby. I probably should have had counselling at the time.

I was really, really happy to be pregnant for the third time, but at the same time really scared. I had the suture again. I just wanted it to be okay. Once I got past 24 weeks I breathed a sigh of relief, but even then I still didn't relax because I didn't want him to be born early. He came at 37 weeks and 4 days so he was officially term, but I feel quite sure that he would have come sooner had I not had the suture.

My womb does its thing and then there's the cervix, and all it's supposed to do is stay closed until the baby is ready. My cervix was

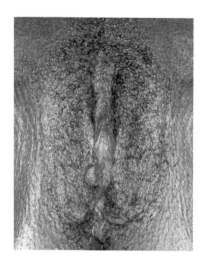

incompetent, I was incompetent. It's a horrible title. We hypnotise ourselves every day with the things that we tell ourselves. I've done so much work on just getting rid of this label... I know I'm not 'incompetent'. I have a beautiful boy who is proof that I'm not, but I still think about his brothers. I look at him and I'm so happy that he's here and stayed with me.

Thirty-seven years old, one child

"My vagina really likes a man to be strong"

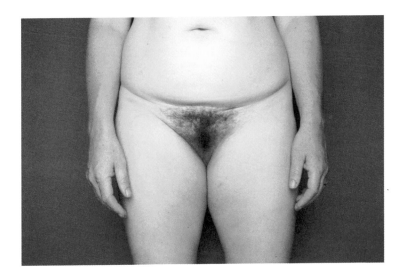

There's lots of confusion around gender now. People don't feel like they fit into the stereotype of what being a woman or a man means.

I want my son to feel like he could wear a dress if he wanted to. It seems totally bizarre to me that girls can wear absolutely any clothes they want – and that wasn't always the case, women weren't allowed to wear trousers – but it's seen as odd if a man should want to wear women's clothes. It's just a bit of clothing. It would be great if we could all just be human and wear and do whatever we want. I don't really know what it means to be a woman anymore.

Actually, it means that you get paid less. It means that in the career that I'm in as a street performer, I'm in a minority because most street performers are male.

One of the unique things I can do as a woman is that I can grow a

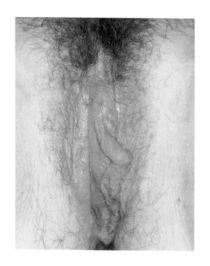

human in my belly and then feed that human with my body. That feels very womanly.

I love being with other women. When you hang out with a group of women it's a very different feeling to hanging out with men or mixed company. It's special and unique, something to do with sisterhood and connection.

I think the most powerful thing you can do as a woman is to love your body and support other women in loving their body too. You go about it by accepting that your body is *your* body, and it's how you move from A to B – it's a tool. We spend so much time abusing it and being negative about it, which is fuelled by the media and fashion and beauty industries and by other people as well. We can feel judged all the time by others so we need to 'put on our best face'.

At some point I realised that when I met other women I would form an immediate snap judgement based on their weight, make-up and what they were wearing. Once I realised that, I knew I didn't want to disempower other women or myself anymore. I decided to be more accepting of my own body, I stopped shaving as strictly, I let my hair go natural. I wanted to be happy and I wanted to be healthy, and actually I lost weight, because I wanted to put good things in my body. I ended up losing four stone. It's about educating yourself. I think you get to a certain age where you're like, 'Oh, fuck it.'

Out of that, I now run a skinny dip every year called 'This Is Me' at a beach in Wales for a mixture of nervous and confident women. We do an introductory talk, a bit of yoga and stretching, trying to get out of our heads and into our bodies. We do all this clothed – this is Wales, it's chilly! – then there's lots of giggling, nervous energy and excitement and everybody gets changed into their robes or towel. We leave it all at the top of the beach and we walk down to the sea. Then once we're all down on the beach and all in the same place we have somebody count us in, then everybody drops their robes and just runs for it into the ocean.

I've held this for six years now. It is relaxing and empowering seeing women of all ages and shapes and sizes, all totally unique and different and you go, 'Oh wow, they're all beautiful.' Everybody is beautiful. It's a celebration of you and your body.

Some women are fearful and anxious: for some it's their living nightmare to strip off and be naked and be seen, but they feel powerful and exhilarated afterwards. There's such a difference between the panicky run into the sea and the confident striding back to the robes afterwards. It's a transformative experience that can really shift how you see your body.

In my public performing I do a clown show, so I'm really physical, very stupid. A glorious idiot is how I would describe myself. I do ridiculous things with my body. I'm not sexual or feminine in my performance and I exaggerate the grotesque. I see the teenage girls watching me going, 'What is she doing and why is she doing it and why do these people clap and cheer and laugh at her? I don't understand it.' It's so subversive to see a woman be ugly and playful and make people laugh. It brings me a lot of pleasure.

I love my vagina. It brings me a tremendous amount of pleasure and it always has. Mostly my clitoris, but the older and more sophisticated I've got, the more my vagina has brought me pleasure. I've been with my husband for 15 years and with that comes a better understanding of your body.

We have an open relationship, so I haven't exclusively had sex with the same person for 15 years. We go through our wedding vows every year on our anniversary, to make sure we're still doing the things that we said we would, because otherwise you can lose yourself.

After having a baby my sex life disappeared completely for about a year. We had to be more creative and inventive. There have been times when we just haven't been attracted to each other and it's okay to say and not think it means the end of the relationship. Being stuck in domesticity is not attractive; you have to go on dates and excite each other and challenge each other.

I find orgasming very easy. I can orgasm in maybe a minute. My clitoris is really, really sensitive. If I'm not in the mood for it I just won't have an orgasm. The mind and body have to be connected, otherwise your head is somewhere else thinking about your shopping or what you're having for dinner.

My vagina really likes a man to be strong, to take the lead and be really passionately in that moment, like nothing else in the world matters apart from that. I like the man to initiate. It could look like coming up behind, kissing the neck and being very gentle, passionate and caring, kissing and stroking. And then being like 'I've got to have this now.'

Forty years old, one child

"My mother did not love me"

Doing this is a like a big middle finger. It's a big middle finger to taking our bodies back. To patriarchy. A big middle finger to men's ownership of women. Doing this is about self-love, self-acceptance, freedom.

When I watch porn I imagine I am that woman and the man is doing x, y, z to me. If it's a man I cannot imagine having sex with, then that completely doesn't work for me and it either turns me off or it creeps me out. I have to be able to imagine being there with them. I don't like it to be too staged, like, 'Oh, here's a pizza!' I like it to have realness and some passion.

When I am with someone my libido is very, very high. But as soon as there's no person to share it with it, just drops down to low or non-existant. However there are periods – I'm not sure if it's weather-related or mood-related, probably everything – where I can get aroused very quickly. So, often the thing I do is watch porn and use my Rampant

Rabbit. The one I have simulates a penis and has two rabbit ears on top which stimulate the clit.

If I haven't had sex for a long time, it can take just seconds to come. That's great, but at the same time it's frustrating. I also like using the shower head, which needs a lot longer because it has to be the right temperature and the right force.

I feel quite neutral about my vagina. I know what it looks like, I know it well. It's my vulva, so it's nobody's business to give their opinion on it. I'm not going to modify it with plastic surgery because it doesn't look like a porn vagina. It is what it is.

I've got a scar on the outside of my left outer lip. I used to shave my vulva because I like it neat, but I had an ingrowing hair which became infected. It got bigger and bigger and it was so painful that I could barely sit or walk. I had to have minor surgery at the GP to remove it, which left me with a scar.

I don't shave there anymore because I'm not having that again, it's too painful, it's not worth it. I haven't had sex or a partner for a while. But when I have a partner, sometimes I do something more fancy – a nice heart shape or a diamond shape. I make a stencil out of paper, then lay it down with a pen, draw it and shave around it. I like to be arty with it.

I was neglected and abused. I ran away when I was 18. There was a lot of shouting and fighting in my house. My dad was very aggressive and dominant; he was probably an alcoholic. I would lock myself up in my room and, when they went out, I would come downstairs to see if there was anything to eat.

I grew up without a good female role model. My mother did not love me. I was always told I wasn't good enough and that I was doing everything wrong. She wouldn't pay the fees at school. When the new school year started, I would come home with no books because she hadn't paid for them. I couldn't go on school trips. Puberty was hell. No one, not even my mother, talked to me about my body, or sexual education, or any of the shit that goes on in your mind as a girl. I cannot understand why a mother would not love their children. She must have had a fucked up past, a family that mistreated her, for her to become that way.

I learned throughout growing up that at the end of the day you can only trust yourself. Everybody else upsets you or harms you and you're in it alone. I've only had two romantic relationships that were really toxic and unhealthy. I have done a lot of work on this though, and I am getting better.

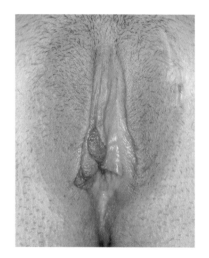

I find I get on better with men than women. I think I have trust issues with women. I feel insecure and jealous, and I want to push them away. I haven't figured it out yet, but I know it's not healthy. I'm aware of it, and I want to let people get closer. I think it's hard for me to look up to women, because the woman who brought me up was weak and she hurt me. I was ashamed to be her daughter.

Being a woman, or rather just being human, is to be kind to others and being the best version of yourself. My childhood pushed me to want to better myself and get away; I tried so hard to get good grades when I was young. I don't want my past to determine my future.

The main difference between men and women is that women can bear children – we can give life. Hopefully, within the next ten years, I would like to be a mother. I think that once I have given birth to a child my eyes will be more open to what it means to be a woman. Although I think not having children does not make a woman less of a woman.

I would like to be the mother I never had. Maybe it's therapy for my past. Maybe it's a primal instinct to be a mother. I have a very clear vision on how we, as human beings, should treat our children. Being a mother will be a wonderful way to let a human being come into life, and create something worthwhile, to leave my footprint and theirs in this world.

Twenty-eight years old, no children

"My mum called periods 'the curse'"

When I was a student, it felt like I was passed round the rugby team. I had lots of very unsatisfactory sexual experiences while really drunk and didn't have the empowerment or the confidence to say 'This is no good for me, how about doing it like this?' I never felt confident about communicating what I liked. I threw myself into having sex, but I didn't have the knowledge or language.

I think if my vagina could have a word with the student me, she'd tell me not to open her up for that many men. To keep her for myself, honour her, get my own pleasure. To have the confidence to really express what I need and want.

I think opening her up would have been better if it was just more on my terms. There was another woman at university who also had many sexual encounters with the men but it was on her terms, and she was more empowered. I feel that I was doing it for a different reason,

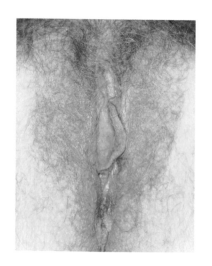

to measure my worth and attractiveness to the opposite sex. Chasing sex in that way ultimately wasn't good for my self-worth.

The men I know who have been really good at sex have been taught by a woman. To put it bluntly, some just put it in and out and then they come and that's it. I think a lot of men don't know how to do foreplay.

When I was young, nearly 30 years ago, I had one boyfriend who was magnificent. I was like, 'Oh my God!' and it was as if the heavens opened. I could have sung. The light and everything is just like you step into this kind of other place.

We were on his bedroom floor between the bed and the cupboard, lying on the floor, lots of kissing, lots of stroking, lots of boob action, lots of stroking my whole body and making sure I was ready. He used his fingers a lot to stimulate me, made sure I was really wet before we actually had the sex. So I was actually properly ready to accept him. So then it was just like, 'Oh my God!' I think you have to be ready otherwise if someone goes in when you're not wet enough or you're not aroused enough then it doesn't really ever work. I orgasmed from vaginal sex with him and it was amazing.

Another lover would just take exquisite time to take me to a place of heightened pleasure. He would get me really high and then slow everything down, then take me up to a high point again and then slow everything down. The point wasn't orgasm, the point was to have an amazing sensual experience.

My most intense, amazing experiences were when we've held eye contact.

I think there is immense power in a woman who is in a heightened place of sexual pleasure. Ecstasy takes us to our power place. And the fact that we are holders of life. The masculine force of patriarchy is absolutely petrified of the woman having her power in society, and it's why women have been held down, abased and sexually controlled. I think if men really understood the deeper experience that is possible, they'd be like, 'Ah, I want more of that, thank you.' Men are just as wowed by women when it's that kind of experience.

My yoni doesn't get as much attention as it used to. Life is busy,

and my libido has definitely got less since I had my son. My husband and I used to be more intimate. I feel more sexual around ovulation.

My husband found it really challenging that I only really wanted sex when I was ovulating. He just didn't really understand – 'Where's it gone? What's happened?' He felt it as an affront to him, that I didn't want him. It caused a lot of difficulty, actually, between us. My body didn't just want it out of the blue. If he had approached me and started the process then I probably would have responded. Also it felt like my boobs became milk machines. Before our son came along I was all about the boobs – I needed the boobs stroked and nipples played with. After breastfeeding I didn't want them touched and sex became more about my yoni.

These days, I want the whole body being involved in sex, I don't want to be rushed in the boobs, I want it to take a lot longer. My husband knows when I'm ovulating now, he senses it, and his body responds to mine.

My mum called periods 'the curse'. As I grew up it didn't make sense to me. The flip side of this bleeding is that we can grow children, which is not a curse. You can be in pain with your period, but otherwise it's positive if you see it as about creating life. I'm angry about bleeding being referred to as 'the curse', but I'm angry that pain in childbirth is blamed on Eve's wrongdoing in the Bible.

When I have my period my brain is different, I'm much more foggy, much more clumsy, I can't really communicate. I go into a whole different zone. But if I spend that first day on my own, the difference in me the rest of that month is amazing. It's almost like I need to go into a cave and have no other influence. I might sit and paint or meditate, or sleep or I'll just go into the woods on my own. Having time on my own, even for one day, means that the rest of my cycle is so much more smooth – I don't get PMT, even the pain in my body is less.

I feel like each part of my cycle is split into four seasons. When I bleed I consider that my winter, like trees lose all their leaves in autumn and they restore their energy in winter. In spring they start unfurling and bringing their leaves out – I feel like I'm doing that as well. And in summer it's like when the trees are in full bloom, that's when I'm ovulating. I'm in full bloom and I'm much more loving and more engaged in the outside world, and I really get things done. But if I haven't given myself that first day of my bleed, it would be like the tree has had a really bad drought and it's limping through the season.

Forty-six years old, one child

"Anorexia was almost like a power game"

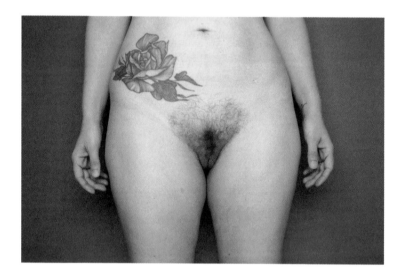

I call mine vagina and vulva generally. I think it's important to use the right words. When we were young my mother called it 'tail', which I find really distasteful. But it was the 1970s.

Someone in the pub once told me off for saying 'cunt', and I said, 'I've got one, I'm perfectly entitled to.' Cunt is more acceptable than it used to be, it gets used on Mumsnet. Pussy is a word that I find absolutely vile – it's so naff, you'd find it in a 'Readers' Wives' story circa 1989 or something. All the bad sex I've had with people – and I've had a lot! – was with the kind of man that said 'pussy'.

I had an adult female body by the age of 12. I started my periods when I was ten. I knew it was going to come. My family is very open about bodies and bodily functions, so periods were never a secret. But my changing body, being the largest girl in the class for a while, was very difficult for me – embarrassing.

In primary school, who had started their periods, and who was wearing a bra, was a really big deal. The boys thought it was weird and fascinating. I remember a story about the other girl who started her periods in the same year as me. We were playing rounders and she fell over and her gym skirt flew up a bit and the boys were like, 'Er, Princess has shit herself,' and of course she'd just leaked.

In Maths we were plotting statistics and we had to decide between recording height or weight. All the girls wanted it to be height because at 12 years old we already knew that weight was shameful. The teacher decided weight and we all came in on Monday with our weight. We entered them in columns. I was an outlier. She said, 'Which girl is in this box? Which girl?' and she wouldn't stop until I said it was me and I felt utterly shamed by the fact that I was effectively highlighted as the fat girl in the class. I was 5ft 4in and wearing size 12 clothes, but I had developed early and was ahead of the other girls. It's a particular moment when I look back and remember feeling shame about my body.

My parents are quite stiff upper lip – we're British, it's what we do. I learned very early on not to deal with emotions, not to make a fuss, not to express feelings. Factual thoughts were more important. In the last few years, after some very intensive therapy, I've started accepting my feelings.

Here's a top tip: don't be anorexic, it's really shit. Food has always been a problem for me and I'm very much the opposite of the comfort-eater. If I am distressed or upset I can't cope with food at all. In my early 30s I developed quite bad anxiety and then in my mid-30s it morphed into anorexia.

When you are in a state of starvation, your brain can't function properly. Panic and awkwardness go away because your brain can't process them. Your brain is fixated on the food that you will or won't let yourself eat. Anorexia was almost like a power game: feeling hungry and being able to beat it was powerful.

I'd go to the cinema or theatre and pay absolutely no attention because I'd be so focussed on what I was allowed to eat later and how I would manage to do it. If we were in company I would be concentrating on how to appear normal even though I was clearly very ill.

I was very small. I was a size 4. I'm now 'normal' me again and I am size 10 to 12. I knew I was thin, but I felt fat. It was almost that fat became an expression for anxious, upset, bewildered, angry, all of these things. 'Fat' encompassed all the negative emotions I was feeling. A lot

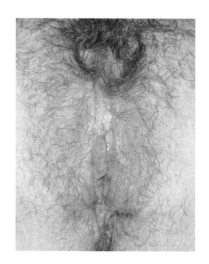

of anorexics do talk about a target weight – 'I have a target weight. When I get to this target weight I will be fine' – but it's bollocks. Your target weight is n−1, it's always one less, one less, one less. It's like an addiction. It's about disappearing rather than being thin.

I don't want to say that anorexia and gender dysphoria are linked, but I think the mechanism seems similar. I have a huge amount of empathy for gender dysphoric girls, because I know what it's like to not want your body. I had a disconnect and disgust with my bodily physical self. Being anorexic I have done permanent damage to myself, but most of what happens during an eating disorder is undone when you recover. What really scares me is that the medicalised pathway that these girls are put on can't be undone, and they'll have permanent changes to their bodies which could have been avoided if they were taught to accept who they are.

I don't really buy the idea that anyone is born in the wrong body. Anorexics are taught they have to accept their body, to accept reality, but young people with gender dysphoria are affirmed and taught they can change reality, even though biologically, truly, they can't.

My husband is a very kind and sensitive man. I could see that I was doing him a lot of harm, which would then cause me distress, which would then worsen the eating disorder. It was very counterproductive, I suppose. My husband talks about the eating disorder as if it's a separate entity, the biggest bully he's ever met. I was so angry about food and exercise and everything, completely irrational and unkind.

Our sex life dropped off a cliff and it's been really hard work getting it back. It must have been very difficult for him because obviously he loves me, but I was not attractive. I was his wife but I was also this very frail, ill woman. I can't imagine that he would have wanted me sexually.

Between a long-married couple there can be an unromantic scheduling of sex, of saying, 'Let's do it. We are doing it. We are having sex.' Sex becomes habitual. Then, of course, we go to bed and we kiss and touch and it goes from there. It's still awkward for me, because I'm not completely okay with my body yet.

I have had a general disconnect with my body, as well as my cunt.

I didn't masturbate until my late 20s. In some ways adolescence has happened to me late. Understanding one's body and getting pleasure from one's body is something that most people do in their teens.

This is an awful word, but 'functional' is where I'm at now. There's a huge comfort in my acceptance. My vulva is just a body part, it's the same as a foot or an arm.

Thirty-nine years old, no children

"My vulva reminds me of a pink cupcake"

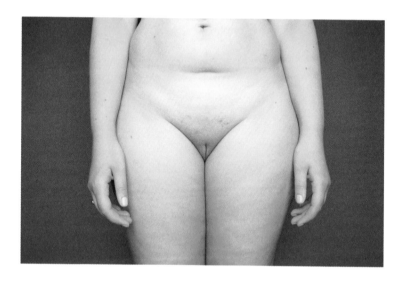

My vulva reminds me of a pink cupcake. The labia and clitoris look like layers of piped pink icing. Obviously the flavour would be rose. The little mole to the left of my labia reminds me of a chocolate chip that's just been popped on the top of the cupcake. When we're having sex, I enjoy the imagery of the penis being a knife that is cutting into the layers of the rose velvet – and I call it velvet because it looks smooth and luxurious. Once the knife goes in, which is when we're having sex, it slices through the cake, which is almost disintegrating, which plays on my wanting to be 'ruined' in a way and sort of fucked up. It ends up being this messy mixture at the end, which is when I'm at my most shaky and vulnerable, in a good way. Then I'm completely done and I'm just a mess of rose velvet. I think I'll have Rose Velvet as a stage name at some point.

I know not everybody's overly comfortable and excited to show the world their genitals, but God, looking at her now, she is pretty. She looks

delicate, symmetrical and neat. I love my beauty spot, which isn't quite on the vulva. I think I could pick it out of a line-up. *(laughs)* It's just a nice reminder of what's in my knickers.

I like that she's moist. A lot of people hate that word. There's a really big taboo around the word 'discharge'; people think it's disgusting or claim not to get any. You do, we all do, it's nothing to be embarrassed about. We need to be moist when we're having sex, because it helps the penis slide in more easily. I think there's something quite exciting about getting wet, just like when a man gets an erection.

Before I notice feeling wet I definitely feel my clitoris swell a little bit, you kind of feel the pulse of it. Then, if you've got clothes on you can feel your knickers becoming moist and sticky and that's exciting.

My pussy likes warm breath around it, so it's kind of a tease, anticipation of what's to come – maybe it's a tongue, maybe it's a finger, maybe it's a toy, maybe it's a penis. It likes a very gentle start in sexual situations. I like quite rough sex and I'm quite submissive generally, but when starting I like to be eased in gently. I'm quite tight, and even when really aroused and wet, I can't take a massive dick straight away. If it's opened up carefully, like a little rose that's being peeled apart, then it enjoys being dominated. I like to be treated with respect, but not with much care, if that makes sense.

Over a few weeks, I bled a lot between periods, and also after sex with my boyfriend at the time. He asked if it was because his dick was too big. Yeah, good for him. So, I googled bleeding and it came up with lots of different things that it could be: an STI, hormonal imbalance, cervical cancer.

I went to the doctor, she had a look at me, and although I was too young for a smear test she did one anyway. She could see something was wrong, she didn't even need to wait for the results. I was sent to the hospital for a colposcopy, which involves a camera going into the vagina. After that lady looking for a couple of minutes, she went to get somebody more senior. I knew by now it must be quite serious.

A consultant came in and he barely spent any time looking at me compared to his colleague. I asked him straight out, 'Is it cancer?' He said he'd taken a biopsy and the results would take two weeks, but I pushed him, and he said, 'I've been doing this for 30 years and I'd be surprised if it wasn't cancer.' Two weeks later it was confirmed it was cancer.

It's really difficult to put those feelings into words. It was almost like I was watching a film of my own life. I was there, and hearing

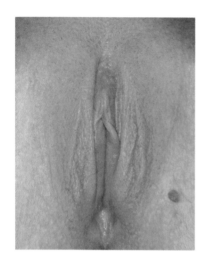

what he was saying, but not present at all, and I felt hot, sweaty, shaky. It felt like paving stones falling off the back of a lorry into the windscreen of the car behind it – slam – right on my chest. It also made me feel really weirdly alive – there was an adrenaline rush. 'Cancer' means dying, that's what we all think it means. I was just 24, I couldn't understand how this could be happening. I hadn't even started smear tests yet.

I was so glad that I went to the doctor with those symptoms, because I wasn't in pain, it was just blood. I could have ignored it.

I had a stage 1B grade 3, which is small, but nasty. Thankfully it was caught early. I had my cervix removed, the surrounding kind of tissue area and the top third of my vagina and, thank God, didn't need any further treatment, like chemotherapy.

It was a painful recovery, and it took a long time for me to like my body again, because it did change. You can't really do much activity for a while, and you put on weight. I wasn't allowed to have sex for ages. Well, I say ages: it was about six to eight weeks, but when you're not allowed something, you want it even more. I was scared to have sex the first time after my surgery because I didn't know how it would feel.

I can get pregnant, but because there's no cervix there's a high chance of miscarriage or early birth. If I do choose to have children, I'll have to have a caesarean at about 36 weeks.

There's a lot of stigma around having a gynaecological disease. Somebody at my old job asked what kind of cancer I had, and when I said cervical, she said, 'Oh, how do you get that?' You wouldn't ask the same if I'd said breast, bowel, or brain. People don't ask those questions because they're common places to have cancer, but when it's something in between your legs, there's an assumption that you've done something wrong as a woman, that you've slept with a lot of people. It is a cancer that's associated with sex, as in most cases you get it from the HPV virus, which is transmitted through sexual contact. I did feel conscious about people judging my sexual activity.

I feel a bit broken as a woman, because we're supposed to carry babies. And I'm also broken in the pleasure way, because I have a shorter

vagina now so I can't even get the same pleasure I used to. I felt angry that the part of my body which defines a lot of women, and is central to women's identity, had done a number on me at 24. It took a long time for me to forgive my body. I don't know if I have, to be honest.

I have a new boyfriend, and I'm lucky that I am very turned on by him. He's got a very nice penis too – he'll be happy I've said that. Sex does hurt a bit more than if I'd met him five years ago, because I've just got a shorter, tighter vagina. Not in a 'Wow, you have a gorgeous, tight pussy' way, but we need a very slow start, and he has to ease himself in. It might be that I tense up because of everything I've been through, because it did take me a long time to see myself as a sexual being, rather than a medical specimen.

Over a quarter of women in the UK are not attending their cervical smear appointments. Sometimes there are very serious reasons, but often women are embarrassed to show their genitals, or they feel embarrassed they might smell. It makes me feel sick that shame, and stigma around gynae health, means that some women won't be as lucky as I was.

Twenty-eight years old, no children

"The stitches were like torture"

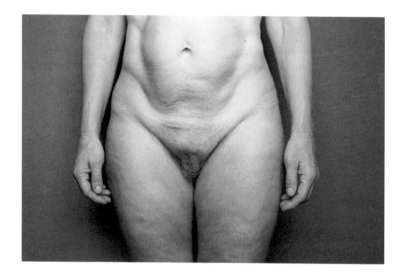

I got pregnant by accident. I never wanted children and I feel guilty saying that, because I know a lot of women do want them and can't. I ended up having four children, which I don't regret for a minute, but I was very frightened and I did not enjoy pregnancy one bit. I felt a complete loss of control, that my body was doing something against my will. I felt nauseous for the first three months continually. I also felt big and lumpen and sweaty. There are parts of it that I did enjoy – it was exciting and magical to feel bumps and kicks, but I wouldn't say that I blossomed, or felt that glow that you're supposed to feel when you're pregnant.

I had my first child in another country and my first experience of birth was in some ways quite traumatic. We visited a maternity unit in the hospital and there were rows and rows of babies in cots, all screaming, and I asked the nurse why they weren't with their mothers and the nurse said, 'Oh, we only take them to their mothers twice a

day.' And I said, 'What if I'm in your hospital and I want to have my baby with me all the time?' And the nurse said, 'No, only twice a day.' I was heartbroken seeing babies crying without their mothers. I also learned that women wore face masks when they were given their babies to feed them so as not to pass on germs. Of course, the baby needs to be passed germs from the mother for the immune system – this was a crazy system.

We decided on a home birth and my partner and I found an elderly midwife who would agree to come to a home birth, which we weren't supposed to have. I kept pretending at the antenatal checks that I was planning on a hospital birth.

When contractions started I was absolutely blown away by how painful it was. The pain is inexplicable because your whole body is doing something against your will. I was thinking, 'I want to stop now. I want this to stop.' And I couldn't stop. And actually that was very helpful, knowing that it had to continue to the end and then there would be relief.

The midwife was really nervous, because we weren't supposed to be doing this, and at one point she pushed me backwards onto my back to check whether I was dilated. That was just the worst agony. But then the birth happened. I squatted, and had to push hard, as I never felt an urge to push with this birth. When he was born, oh my God, it was the most magical miracle. I could not believe that this full human being had been inside my body. I don't know what I was expecting, some lump or something, but he was this exquisitely perfect human being. I could not get over it. Then I did become a real earth mother – all my babies have slept with me in the bed, with me and my husband. I absolutely loved it. I loved the smell, the noises, even the poo – I just love it all. There's nothing like it.

Because I had been straining to push, I ripped quite badly. I had to have a seat with a hole in it to sit down. I couldn't wee or poo, it was agony. My vagina was very sore and it felt like I'd been ripped apart. A few days after the birth I went to see the doctor because I needed stitches. We had to pretend that we were sorry we didn't get to the hospital and said it had happened so quickly we couldn't make it. It was so against the rules to do that.

The doctor put me on a table on my back with my legs up in stirrups and sewed me up with no anaesthetic. I remember at one point the needle went through my anus. I was screaming and the young female nurse standing next to me was clearly embarrassed, because you're

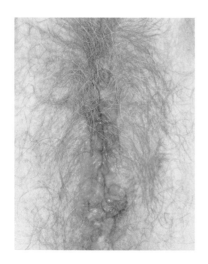

not supposed to scream. I couldn't move, I was strapped down, feet in stirrups. I still believe to this day that the doctor was getting his own back on me. He was so angry that I hadn't come to his hospital to give birth. It was like experiencing torture. To this day I would describe that experience as a form of revenge and sexual torture.

A woman is a full human being who is not treated as a full human being globally throughout society. A woman is a full human being in a way that is different to a man and that's very bound up, I think, with women's reproductive capacity, that women can gestate a foetus and birth a baby. I think women are magical for that reason and it both brings us closer to animals and also elevates us to a kind of spiritual level. We have the capacity for giving life; it's both a burden to bear and used against us, but it's also the most amazing, magic, powerful and potent thing that any human being could possess. And I don't mean to say that that means that women who can't have children are any less of a woman. Being born into the class that has the potential for giving new life qualifies you to share in the ability to perform miracles.

Feminism means the liberation of women, it means looking out for women. I like to see women as the underdog rather than oppressed, because it's a more hopeful word.

Fifty-nine years old, four children

"I'm excited about the birth"

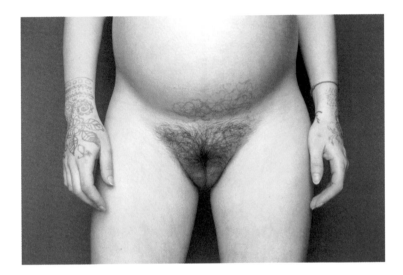

I've been reading a lot about birth and it's taken me back to what a vagina is anatomically able to do.

Since I got pregnant I've been dreaming a lot about sex. I seem to be connected to my vagina when I am asleep. I wake up close to orgasm a lot. In my awake life I don't feel so connected to my vagina or sexuality at the moment. I was quite horny in the beginning of my pregnancy, but physically I find it harder to have sex now.

My breasts have become really, really sensitive. If my partner touches my nipples it's like, 'Oh wow,' my heart just explodes, it's wonderful. My vagina feels a bit more sensitive, but not in an easy way. I feel like I need much more time and I feel a bit closed. Maybe I need more tenderness at the moment. I don't feel like I'm tender towards myself, and my partner and I aren't really in that place at the moment.

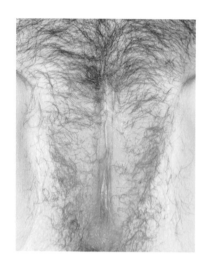

I was very surprised by my first strong orgasm when I was pregnant. I felt it very strongly in my womb and the baby really reacted to it, which was a really strange sensation. My womb expanded and contracted when I orgasmed, then really relaxed and it felt like the baby flipped around. It felt like it was really good for the baby. It was like my belly grew after the orgasm.

I really like being pregnant. It's been such a cool experience. I felt amazed by how quickly the body changes and adapts. Even if it's slightly uncomfortable I always feel like my body is one step ahead. Sometimes it can feel quite like the skin is not enough to hold the bump, but then the next week I'm bigger, so clearly my skin has grown. I have one and a half months left. That's when I'm going to start to feel really heavy. I've been feeling quite balanced the whole pregnancy; my bump has been quite compact so far.

I'm excited about the birth. This is such a blessing. I've read a lot of hippy books, but I'm aware that birth can be really difficult and really painful. Not everyone gets to experience the birth they hope for. I don't want lots of interventions, but if it happens, it happens. I don't feel massively worried about the birth.

I will give birth in a midwife-led hospital unit. They have birthing pools and stuff. I'm going to go and visit soon. I was actually born at the same hospital. My mum gave birth to all four of her children there and she just loved that place – all her experiences were beautiful.

Right before I got pregnant, me and my partner happened to meet a woman who is a doula, and she made a real impression and we connected really well. Then one month later I got pregnant and we wondered about contacting her. At first I was a bit hesitant because she's really, really beautiful and young. To be honest, I saw her almost like a threat a little bit, like, 'Wow, she's really gorgeous; it would be hard to have such a beautiful woman in the same room as me while giving birth. Maybe my partner would think she's much more beautiful.' We decided to go ahead and meet her and we actually brought that up. She took it really well. It needed to be said and she was great about it. After that I felt okay. It feels good that we're going to have her there.

I like the idea of having a guide, another perspective. It's not so much about the birth itself – I've always felt confident about my ability to give birth – but about the whole pregnancy. Having a doula is helping me to feel more prepared and it's good to talk to someone about all the changes that I'm going through. I don't have my family around much so it's good to have support.

The thing with pregnancy is that after a while you can't see yourself easily any more. I'm hairier. Also, I made a conscious decision I'm not going to trim or shave or anything, because actually removing hair is an infection risk. There's a reason that we have hair there, and during this time it feels important that I have hair. Normally I wouldn't be this hairy!

I want to be in a really accepting relationship with my own cunt. I feel like I'm not quite there yet, it's still that it needs to look good or it needs to be perfect somehow. Yes, there is a beauty in having sex, and it is incredible to give birth, yes. It has functions, but its main function is not to please or do. It just is.

Twenty-seven years old, 34 weeks pregnant

"An extraordinary meeting with a little human"

Birth is such a timeless space to be in, I didn't notice the time. But it took nine hours, which was quite all right.

My waters broke after I went to bed. To start with it was just a little water, so I wasn't sure. Within an hour I was having really strong surges, three every ten minutes. We had thought we would stay at home as long as possible and cuddle, smooch and get in the bath tub, but it was full on so quickly that we had to go, as we are an hour's drive from the hospital.

On the way, my waters broke more. There was water everywhere, like a really warm tap running. I don't know how much it was but it felt

like loads. My partner was super focussed on driving. I was holding the roof handle in the ceiling. There was a really beautiful moon. It was quite intense during the journey. By the time we got to the hospital, my trousers were so wet and so heavy they nearly fell off. The car seat was completely soaked.

I think I had romanticised birth a little bit. People say, 'Just ride the waves and go with it.' But it feels like more than waves, the sensation is very strong and takes over the body completely. It was quite painful and it took all my attention. We had a TENS machine. In the beginning the little electrical pulse gave me some relief, but after a while it was like an annoying mosquito biting me. I think it helped me that we had brought nice lights with us though, rather than the cold blue hospital light.

I got into the bath at the hospital which was nice. I really liked the support from the water. Then our doula came. The midwife asked to examine me – she wanted to check how open I was and my birth plan had said to ask me. I just didn't want it. I didn't want her to go inside me. And I felt good in the bath. I think I was very clear on what I wanted. It was important to me that I felt empowered. I felt like I was in a no bullshit zone, a little bit like when you're premenstrual or in the menopause. She asked a few times if I wanted her to check me. After about four or five hours I was fine with it. Then she started and it was painful and I was like, 'No way, I'm not going to do that.'

My partner had brought roast potatoes with us, because our doula said it's good to eat, but I couldn't eat them. The whole birth I was throwing up, pooing, throwing up, pooing. In the end, that's really tiring for the muscles. I couldn't control it. There's actually a beautiful photograph of my partner and I looking into each other's eyes, and the candlelight is beautiful, but literally all I saw at the time was sick, blood and poo.

Birth didn't feel dramatic, like you see on TV. It felt quite long and slow and steady. But there was a lot of fluid. There was a lot of sitting on a potty, because we didn't have a toilet in my room.

The first time I felt okay about being checked – it turned out I was 9 cm. I really recommend that! I felt it was great for me to not know how open I was. When I found out, I knew I was going to give birth soon. Then my doula showed me a specific position where you're on your side and let your knee drop over the other knee because that's supposed to spin the baby and help it out. I could feel when I did that position everything got really intense suddenly. At this stage it stepped up and felt really hard,

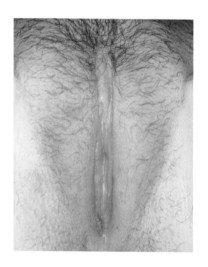

you know when you get to, 'Oh shit, this is really fucking hard and it's going to get more intense.'

I remember feeling like my bones and muscles couldn't expand and work any harder to push the baby out. I felt like the baby would get stuck. I realised I was feeling weak, so I just kept on saying the opposite: 'I can be really big, I can get really huge. I'm really strong. I can do this.'

I lost confidence in myself in the pushing stage, because I was worried about tearing. I started to ask the midwives a lot of questions about how I should push. When he came I delivered him myself and the midwife took the cord off his neck and I just lifted him up from the water. It's like everyone says, at that point all the pain is gone, it didn't really matter anymore.

I felt awe. When I was giving birth, everyone told me I was doing well, and I would see my baby soon, but I didn't care. It was so overwhelming I couldn't even think about seeing him. When I did see him, it was, 'Woah, there you are.' It was really beautiful, an extraordinary meeting with a little human. I remember saying, 'Oh my God, this is our baby.' My partner started to cry, he'd been holding it in for so long. He had been looking after me 100% and then he just let go – it was over.

I had a first grade tear which was nothing. I think I was a bit insecure in the end, and pushed a bit too hard. My husband took a picture of my vulva right after the birth with his camera. I asked him to because I wanted to see the stitches. But oh fuck, that was intense.

I was shocked about how run down my body was afterwards. Everything ached. I could barely go to the toilet. I had more of a romantic image of what afterwards might feel like. Then straight away you are up all night, feeding and looking after a baby, and your hormones are crazy.

I was completely feral. I just wore the hospital gown and some synthetic panties and a huge nappy, for days. The funny thing was that I had imagined I was going to be some beautiful goddess when I gave birth. Other mums got up and brushed their hair and brushed their teeth, they looked normal in the sitting room, whereas I pretty much had dreads – I looked completely mad.

We had sex about eight weeks after the birth. My body said 'No!'

the first time. He didn't push me to try. I wanted it to work out, but I just wasn't ready. When we've had sex it's been a bit painful. I'm quite sore and tender still. I think he needs to be softer and I need to be softer with myself. I find I compromise a lot with sex. I need it much softer, much more gentle and much more tender than I've said. In a way, giving birth has allowed me to say what I need, more than before. I'm very tired so I feel like my sexuality is not a priority.

Birth was magical in a way I didn't expect. It was very earthy and physical. My body really felt it. I have so much respect for every woman who has gone before. And then they do it again!

I'm the same as before the birth, I still want to have an accepting relationship with my vagina. I can definitely appreciate its potential more now. I think vaginas are powerful and beautiful.

Twenty-seven years old, one child

"My clitoris piercing set off a metal detector"

When I was younger, people around me had 'Marys' and 'fairies' and 'fou-fou's and 'front bottoms', but mine didn't have a name.

If I was to start at the beginning, I guess I noticed when I was in my early teens that I have a really puffy 'mons pubis', mound of Venus. I felt that was wrong, that it should be a thin slit. I don't know where I got that from. I used to wonder what was wrong with my body. I even thought, 'Am I a hermaphrodite? Is there stuff stuck in there?'

My pubic hair is quite spaced out, and I also thought that you were supposed to have tight curls, that you could then wax and shape and things. I thought tight curls looked beautiful.

So I guess I didn't have a good relationship with my vulva, or any part of my body actually, from the top of my thighs to the top of my boobs, for years and years.

When I was 26, I started a 'friends with benefits' relationship with somebody who was very good for me. There were no expectations, no pressure, he didn't look down on me, we had crazy fun sex, full of laughter, full of spontaneity, and I finally engaged with my body. It was with this man, for the first time, that I parted my puffy outer lips and was like, 'Oh wow, look at this. This is a beautiful space.' It was a revelation.

I decided to get my clitoral hood pierced. I had other piercings, and thought it would be awesome, beautiful and actually quite cheeky. I thought it would be a lovely surprise for my friend with benefits. I did a lot of research beforehand, about the type I wanted. I wanted it to bring me pleasure and adorn me, not to hurt me, so I chose one that goes through the hood.

The woman who did it sprayed me with something first. I literally lay with my legs open, sat on a bed. The needle was 3–4 cm, tiny, thin, like a fishing hook. As she put the hook through it was like a hot searing pain for a second and if I had been able to, I'd have backed up the bed. But then it was done. She expertly threaded a little bar through and then she tied the little ball on. Then she put a mirror in front of my vulva, in between my legs, and said, 'Have a look.' So I'm sat there with this woman who has never met me before, with my legs splayed open, just looking at this little diamond in this beautiful... It looked perfect, like the most beautiful inner labia minora and everything. How hadn't I noticed before how beautiful my vulva was? I felt like royalty. The piercing was a tiara in my pants. It was the shining light of my yoni.

It felt like a throbbing bruise for a few weeks; if I sat on myself funny I could feel it. For weeks I would look at it in a mirror before bed. I was fascinated and I really got to know what I look like. It took me till I was 26 to look at my own body and appreciate what's in between my legs.

I experimented with lots of different piercings. I had some crazy ones with cherries, one with a diamanté, hoops. The one I've got now is a 'glow in the dark' plastic one. The reason that I'm wearing a plastic 'glow in the dark' ball is not for its 'glow in the dark party in your pants kind of fun' way, but because it was the only plastic one I could find.

Years ago, I went to the O2 stadium and I set off the metal detector

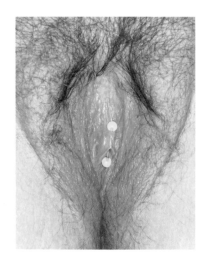

that you walk through. I knew that the only thing metal on me was my clitoral hood piercing. I was with my mum and dad, who didn't know about it. It was so embarrassing, I thought I was going to die. We're not the kind of family who would share such intimate details – not looking at my body comes from being in a family where we didn't really talk about anything to do with bodies. If you fast-forward to now, I'm a very different person. So I leaned close into the man and I said, 'I've got a genital piercing,' and he went, 'Oh okay. Off you go love,' and he just let me through. Then I had to think on my feet because my parents said, 'What was it? What happened?' and I said something ridiculous like, 'Oh, it must be the fork in my bag for lunch.'

I love my vulva. I love my whole body now.

Thirty-seven years old, no children

"An STD made me disgusted with my vagina"

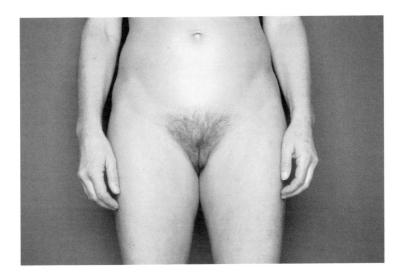

Before I saw my pussy, I felt her. When I was 13, my best friend and I would lie in a bed and masturbate together. That used to be the norm at the weekends – we'd just lie in bed and masturbate. So I was quite comfortable with my pussy, and masturbating and really enjoying her from quite early.

I like my pussy, and the playfulness in the word. I know how to enjoy her. I love cats so the relationship with fur and hair, and the purring pussy, go together.

Just seeing my pussy on the screen I was like, 'Oh wow!' Because I have a relationship with her through touch, through the physicality.

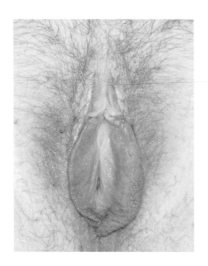

I feel very embodied but not visually connected. I think seeing her more would put me in a new level of relationship with her.

A man's cock is so clear and so prominent. I think that's why I love cock, because it is so 'there'. I can cradle it, I can do these things with it. It's this malleable functioning thing, whereas a vagina is just so hidden. There's more to be discovered. It's hard to see one's own pussy. We see our pussies through our partner's eyes.

We live in such a fucked-up world. The lack of naturalness around our bodies is just insane. There's a starvation in walking around fully clothed all the time and not even being able to see each other's bodies. I think it would be good for us to have more mindful nudity. In India they have the sex temples with thousands of incredible hand-carved figures, every single Tantric position. They are exquisite and it puts you in a zone of immense appreciation for the beauty of eroticism, of making love, of bodies.

I've had really negative experiences with gynaecologists and now being on a table in that clinical, stark context, especially with a male, would feel traumatic. It feels like someone's getting mediaeval on me, on my vagina, and yes I relate to it as a vagina then. Examinations are often painful too. The few times I've had women nurses they have been more caring and talked me through the procedure. But when a man has examined me I've sensed a disregard there, and my pussy has just been an object.

There was one episode when I had to have an STD test and the male doctor who examined me was absolutely abominable. I knew that his intention was not to investigate the STD – he saw a body in front of him and he wanted to exploit the situation. He was trying to touch me as much as possible, unnecessarily, around my labia, the folds... I complained about that doctor.

I had to push and push and push for an STD to be diagnosed. It's not normally tested for, but it's really dangerous for women and can cause infertility. Eventually I was given the right tests and they diagnosed genitalia mycoplasma. It disappeared after taking the correct antibiotics.

The difficult symptom is that you get really smelly discharge. It's disgusting. Over an eight-year period of my life, while this STD wasn't correctly diagnosed, I had to live with a disgust with my vagina. And it really was a vagina – it was a thing I didn't like – not a pussy. I felt really dirty and disempowered, unclean and contaminated. I also became infertile, hence I have no children.

The dissociation with my vagina became mirrored by self-loathing, it almost became like dysmorphia as well. I began to have a lot of body shame, and I felt unattractive. I responded by trying to make myself worthy of men's approval. I was really focussed on the exterior parts of myself and wanting to be attractive enough to be loved. It was constantly like, 'How can I make myself good enough to seduce the man so that he really wants me?' I compensated for feeling inadequate by trying to be very good in bed. I was focussed on the man having the best pleasure. I had three partners in the space of those eight years and I never once told them about the STD and how I felt. Now I have a very different interest in self-care. It's still a journey, but I'm much more about connection rather than just the attributes of physical attraction and desire.

The way the STD would affect me was very sporadic. Some days I was okay and other days I would suddenly detect a smell that was, for me, really strong and I would need to go and wash. I think I became very attuned to the smell. I would be so paranoid and I'd confer with my girlfriends, saying 'Can you smell it?' They couldn't, but I could even smell it on my clothes. Not a nice experience and it was eight years until it got sorted out.

I tried for seven years and never got pregnant. I grieved over that, but I've now made peace with it. I've let go of being a mother. I don't know if my body would be up for even a pregnancy, who knows? A miracle could still happen, but I doubt it.

I feel grief because I couldn't feel proud of her. I went from feeling my vagina is beautiful, loving her and bring proud of her, to feeling dirty and contaminated. I never even knew who gave it to me, and that's one of the worst things about it.

Forty-five years old, no children

"I'm still a virgin"

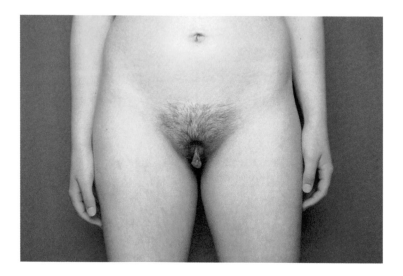

I've never seen it close up before. I have no words. It's a bit... It's weird. I'm not disgusted or repulsed, I just think it's not a nice thing to look at. I call it vagina, fanny, 'dead dog' and 'front door of happiness'. I used to think it was something no one would ever want to look at, like a dead dog, and it just seemed like a funny name.

To me, it's just another body part. It's functional: I wee out of it, I have my period out of it. I haven't had sex, I haven't done anything. It's nothing special, it's just there. I don't feel like I have a relationship with it.

I don't like the label 'virgin' at all. I think it's just a stage in your life: you've had it or you haven't had it. I don't think there needs to be a label. Labels separate you as something 'other'. I told a friend that I'm still a virgin and they turned round and said, 'Oh that's like a unicorn, isn't it, there's not many of you about.' They didn't mean it in a rude way, and as

a person I'm quite independent anyway, quite headstrong, so I was OK.

Everything's my choice. If I want to have sex, then I'll have sex, but at the minute I'm just not that bothered. I don't want to just go out and have sex – that's not my bag – I want them to love me. Having sex is not a right, it's a privilege.

I don't know how many girls my age are virgins. My friends are quite mixed, some are virgins and some aren't. I think it depends who you associate yourself with really, it depends on your friend group. If all your friends weren't virgins then you might feel more under pressure. Some of my friends lost it a bit younger and they've said they'd rather be in my position.

I think having sex is an intimate thing and I feel like you've got to have a connection with the person to have sex, you've got to really know them. It's not just about being naked, but actually naked-naked, I think you've got to bare your soul and heart and be accepted for who you are, including your flaws that make you 'you'.

I have snogged people, but I don't really think it's all it's cracked up to be. I had a kiss on stage with one of my amateur theatre groups and, yeah, I didn't enjoy it. That's not my only kiss. I was saying to my mum and sister that the difference, in my experience, between the stage snog and a proper snog is whether you put a bit of tongue in. My mum and my sister went, 'Urgh that's disgusting, why would you tell us that!'

I think we should make vulvas more normal because when I was doing sex ed we never even saw one. We saw a computerised image in block colour, but that wasn't very good. I think it would be good to know what to expect. I started puberty quite young, and I had no idea.

I remember being on the toilet and my fanny must have changed or grown, and I thought I had an infection and asked my mum what it was, and she went, 'It's your vagina.' *(laughs)* I started to get spots when I was nine, and my period started when I was 11. We were coming home from my holiday and I had tummy ache all the way on the plane. I said to my mum, 'What's this in my pants?' and she said, 'Oh, you'll be starting your period,' but nothing really came until the first week of secondary school. Great, I had to deal with it at school. I remember being so embarrassed to think that somebody would hear me unwrap a pad in the school loos, it feels like the loudest thing. When you're younger you feel that everybody knows you're on it.

Losing my virginity will happen when it happens. I'm not putting a time limit on it, because that ruins it. I presume it would be better to be

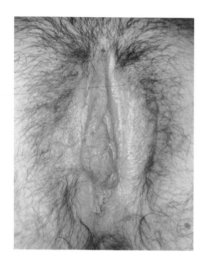

spontaneous, than set a day with someone.

You know, it's quite funny, sometimes when I get out of the shower and I'm drying my hair, no make-up on, nothing, for me, that's when I feel sexy. Totally un-dolled-up. Wearing a sexy dress doesn't make me feel sexy. The personal connection with someone is what I want.

Being a woman means being bold. Someone once told me that the most powerful word you can say as a woman is 'no' and that's always stuck. It's important to do what's comfortable for you, and if you don't want to do something, you turn around and say 'no'.

Nineteen years old, no children

"Burning the afterbirth was mad"

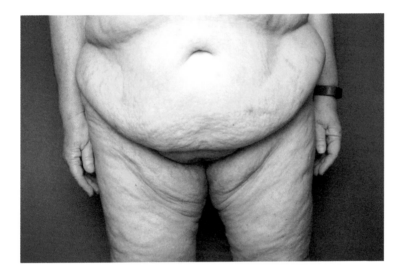

I call it my fanny. I use 'frou-frou' with my granddaughter instead of fanny, although I don't know why since she's 18 now. I don't use the c-word, I absolutely loathe it. I can say fuck, that's not a problem – I say it in the car quite often when I'm driving, but I will not say the c-word. It's a horrible, aggressive word for a lady part.

When you're a kid, it's just a wee hole, you don't think of anything else. Funnily enough, I felt down there but I never masturbated to orgasm. It was a very steep learning curve when I got married because my mum didn't talk to me about sex and I had no idea about orgasms.

I can remember my first orgasm, it was with my husband. He had a feel around and I liked it, it was nice and then it felt explosive. We met when I was 17, and I was probably 18, I think, when we started playing around a bit. It was lovely.

I was a virgin on our wedding night. We were a different generation!

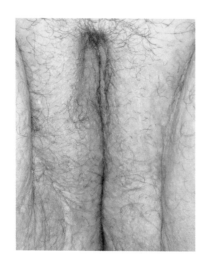

We had a bit of difficulty the first night.
I tensed up and there was too much pain.
It took us a couple of months before we were
both comfortable. Yet we were quite natural
with one another because we'd had a holiday
together, and bathing and walking around
naked was no problem.

He'd had relationships before so he wasn't
new to it, but I was new to penetrative and oral
sex. I knew it was a natural thing to do, but it
was difficult for the first couple of months, I
don't know why. We just sort of carried on and
got through it. I didn't think to go to the doctor,
but if I had, he would have said, 'Keep trying,'
wouldn't he? He wouldn't have done anything in
those days. My husband was nervous of hurting
me. In those days it was really good to be a virgin on your wedding night.
I wonder if I wanted my husband to know I was a virgin – to really know
– and if I tensed up to show him. Maybe I thought it should be painful.

We got married in September, had a drunken night on New Year's
Eve, and I was pregnant by January. So it was a short honeymoon, but
good fun. We carried on having sex when I was pregnant until it got
uncomfortable. I was quite big because I put on about three stone
when I had my first.

I had a routine episiotomy with my first baby in hospital, and was
shaved and had an enema. They are right bastards, aren't they? You did
as the hospital told you to do in those days. It was like school, they had all
the authority. They shaved me with a Gillette blade. The funny thing is,
I think they just took the front off. I mean, what was the point in that?

The midwives were lovely, but they took the baby away straight away.
That was horrible, it felt strange and wrong. The babies were in a crèche,
they weren't beside your bed. Husbands weren't allowed in when you gave
birth in those days. When I had my first baby he just dropped me at the
hospital and went. It was quite a lonely experience in many ways, so with
the second baby I thought, 'I'm not having this.' I had my second baby at
home. My husband was fucking useless. He was holding my hand and he
said, 'Go on, push.' And I said, 'Oh fuck off. What the fuck would you know
about it?' The midwife was wonderful, very relaxed. She sat on the edge of
the bed and would tell me I was coming along nicely.

Afterwards, I asked my husband what he thought about it, and he said, 'Ah yeah, you were really good.' Not very expressive, my husband. He said, 'You shit yourself.' You try pushing down there and not shit yourself!

Dealing with the afterbirth at home was a bit of a struggle. The midwife said to my husband, 'You'd better go and burn that.' He's not very practical, but how mad is that, to burn the afterbirth? Burying it would have been better, not cooking it up.

It's quite sad now. I'm six years younger than my husband and he's not a well man, and the sex sort of died off. As you get older, you know… I didn't realise until he got older and we stopped having sex, but he's not a cuddly man. He's not touchy-feely. I don't miss the sex, I think that's done and dusted, but I do miss the cuddles. It's a shame, isn't it? But he is what he is. I've tried to tell him and it goes over his head, he doesn't understand. He's a selfish bastard in that respect, but we've lived together for over 50 years and the foundations are strong and safe.

I told my husband I was doing this and he said, 'I haven't got a problem with it.' He thought it was great. He's never stopped me doing anything at all. He told me to enjoy it and he laughed. I asked what he was doing today and he said he was going to get the paper. I said, 'And? Okay, the garage needs sweeping and you need to put the hoover round.' Otherwise he wouldn't do anything, he'd just sit and read the paper and do the codewords and crossword and that's not very good for him.

I did laugh about taking part in *Womanhood*, I did laugh. This book will end up in the library and my fanny's there for posterity. It's brilliant.

Seventy years old, two children

"My mum took me to Weight Watchers meetings"

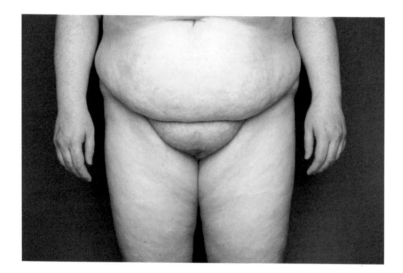

From a small child, I've been told in the bluntest way possible that being overweight invalidated me as a woman. I've always been tall, I've always been large, I've always been bigger than everybody else in the room. I've been judged. The ideal woman is petite and doesn't take up much space.

Being large has even affected how I feel about my vulva. Overall, I think it's alright, it does the job. I menstruate, I have sex. But I've always felt like the bulge in the front, the pudendum, is too much because I'm overweight. But it's part of me and I don't have any major issues with it.

I've always been shy and found it hard to make friends at school. I was bullied from the age of seven, because of my weight. Looking back,

the language was harsh and it was gendered – fat bitch, fat cow, that sort of thing.

It was hard when I was growing up to get shoes and clothes in my size. Luckily, it's an awful lot better nowadays. I am so pleased for girls growing up now that they have more options than I did. The thing is, it's quite darkly amusing how many messages I get from health professionals and the media that I should exercise, as an overweight woman, but how hard it is to buy sports clothes, especially sports bras. I have to cover myself somehow and support the bits that need supporting. A decent sports bra is essential and yet they're quite hard to come across in my size. I'm a 38I at the moment. I spend a lot of money on bras. I have got the right to be healthy and to make myself stronger, but it's not easy.

I've always had an ambiguous relationship with femininity. I want to wear feminine clothes to a certain degree, but I don't have any real interest in wearing heels. I wear a little make-up, but not necessarily every day. Now I'm older I have got to the point where I'm more interested in dressing for comfort, especially if I'm on a night shift. I want to look feminine, but do it more on my terms than any particular chart I've got in my head.

Funnily enough, my introduction to feminism was probably through my father rather than my mum. My mum had a difficult upbringing. She was given the impression by a lot of people that if she kept quiet, and shut up, that life would be easier for her. This carried through into her parenting. She didn't tell me to shut up exactly, but it was very much, 'Don't say too much. Don't be too loud. Don't do that.' She was genuinely afraid for me. Whereas my father was quite a rebellious character and encouraged me to express myself. That helped quite a lot, although it only takes you so far.

My mum had weight issues and passed her insecurity on to me. I accompanied her to many Weight Watchers meetings, but luckily I think I looked at it in a far more balanced way and didn't internalise too much. The book *Diet Busters*, and thinking about our relationship with food, was the germ of me developing feminism. The book covers the ground that as a woman you've got a right to exist and take up the space that you take up.

I struggle with what being a woman means. I am me, and if there was nothing else going on in my life I probably wouldn't spend a lot of time thinking about me as a woman.

One of the major issues for women is that men are really interested

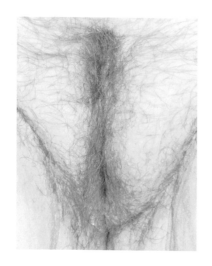

in defining womanhood for us and without us. A lot of the time I don't think we have an awful lot of input into the definition of womanhood, yet we're judged against it. Life is a bit heavy on women in a way that it isn't for men. Periods aren't fun. I had the coil to stop the inevitable consequence of having sex with a man, which is a baby, and it has given me heavier periods than I think I've ever had in my life, and they've been painful and made me tired. It's been quite tough actually. I feel that there isn't enough research into how we can get to a point where we control our own fertility and destiny – it's always up for grabs. In America at the moment, it seems to be particularly up for grabs and very difficult for women to control their own destiny. I find that quite depressing in a society that thinks of itself as civilised.

There isn't enough research or support in childbirth, postnatal care, periods or anything to do with biologically female genitalia and reproductive organs. It's almost taken for granted that womanhood involves a certain amount of suffering. There is a shared understanding, especially among natal women, if you've grown up as a woman, that you are often put in a lot of difficult positions and made to make choices that men are never made to make.

Forty years old, no children

"Anal sex is complicated"

It's an unnameable thing, a shameful part of the body. Socially, you're not supposed to talk about it. You can say willy for a boy, but the word 'fanny' is just embarrassing. You can tell how much secrecy and social unacceptability there is around the vulva, around women's bodies, from the fact that there's such variation in the way that we talk about it. There isn't a commonly accepted and agreed upon term that we'd use. The curse words for male genitals are mid-range curses and the scientific words for male genitals don't feel off-putting or forbidding or technical at all. They're all words in general usage, whereas talking about the female body is put out of reach.

I used to call it 'front bottom' when I was a child, which is a terrible term. In medical environments I would talk about vulva and vagina. When I'm having sex I'd say cunt. I feel like there's this big gulf where me and my genitals should be on some kind of friendly first-name

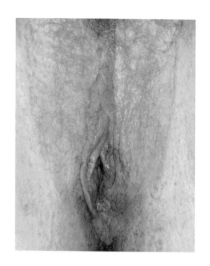

terms, 'Sorry, I can only call you by your Latin name or a name that is actually shameful to say in public.'

As a kid I was a fiddler for definite. I've always been quite curious about it. When I started to become more sexually aware I knew that me and this part of my body definitely had things to do. I remember a new boy started at primary school and I thought, 'Oh my God, I fancy him.' I had a whole roving sensitive sensation around my whole body, and I knew which bits were interested.

I'm really bad at masturbating. I feel like it's a thing that I've never really learnt to do. I got a vibrator when I was really young and I've always been really lazy about it. I'm good at making myself come though. I use a bullet vibrator on my clitoris, just really hard. There's no technique or skill required.

I like wanking in my own bed and not having any distractions. I don't masturbate that much, maybe once a week, maybe less, it depends on how much sex I'm having really. However much sex we're having, my husband would do the same amount of masturbating. We've been together 20 years now and your sex life changes. We got together when we were insanely randy teenagers and, along with all the things that made us compatible, that was quite a big part of the compatibility. I've had two children and been on hormonal contraception for a long time, both of which affect your sex drive.

I think the way we have sex has changed. We've tried lots of stuff. My husband quite likes slapping me on the arse and a couple of years ago I said, 'You know, I don't really like this. It doesn't really work for me.'

As a woman, it takes a really long time to get over all the cultural messages that tell you don't have self-possession of your own body and your sexuality. I could not wait to get in the world and be having sex, and then I started having sex and I didn't have a vocabulary for what sex was, apart from a thing men do to you. That's really unsatisfying. One of the bonds that I really have with my husband is that he's really great at sex. He really likes making me come, which is very welcome.

When we first got together I felt incredibly self-conscious about him giving me oral sex. I was much happier giving than receiving because

I found attention to that part of my body mortifying. Not even so much my genitals, but more anxious about my thighs and stomach and just the idea of having someone nosing around down there.

We have anal sex about once a month. I have always really liked it. It was always part of masturbation. I like to penetrate myself with a finger. I remember the first time my husband put an exploratory tongue in the area and I thought, 'This is good. This is going to work.' An ex-boyfriend said to me he thought you'd have to be gay to be into anal sex and I knew we wouldn't work out.

I think it is to do with what your internal clitoris is like, because it reaches around your vagina and can reach to your anus. I have to be stimulating my clitoris as well, otherwise it just doesn't really work, but it is definitely pleasurable in its own right and it is a part of incredibly intense orgasms.

In porn, sex is generally a show of male bravado and absolute dominance. Anal sex is considered better if the woman looks like she's in pain. As a feminist I think anal sex is complicated because it's great done in the right way with the right person, but anal sex is one of the most destructive and horrible tropes in porn. If you're looking for classic humiliation in porn, it would be a tiny white woman anally destroyed by a big black dick.

I really like having a female body. It's wonderful how many different sites of sexual pleasure you have as a woman. We don't talk enough about how different women's bodies are and how specifically we are all calibrated for different kinds of pleasure. The distance between your vulva and your clitoris is really important for what kinds of sex are going to be good for you. The extent of your internal clitoris and the relationship that has to your other organs affects whether penetrative sex is good, fun or a bore. It can be the difference between whether anal sex is horrible or nice. All of that is really interesting.

Having children has been wonderful. I love the incredible closeness of having children. Both times I gave birth I thought I was going to die and it was awful and frightening. Being a woman means feeling vulnerable about reproduction, the anxiety of getting pregnant. I had an unplanned pregnancy and it was very frightening to see my future take to a whole different track that I wasn't prepared for at all. Having had two children quite young, I definitely don't want to have any more children and I wouldn't want to give that up. I find the idea of not being able to make that decision for myself really frightening.

I was a bit worried about today because my period has started, but you won't be able to see. Because I've got an implant I only have really light, infrequent periods.

My vulva looks much more neat and vulnerable than I imagined. I don't really think about what it looks like very much, I think about how it feels and what's nice to do with it. I have a lot of physical anxiety about the rest of my body, but I've never had physical anxiety about how my vulva looks. It looks vulnerable.

Thirty-six years old, two children

"I've been ostracised for talking about women's health"

I actually really like the picture of my vulva. It looks dead cute, doesn't it? It's brown, like me, and pink, fleshy and delicate. I want to touch it because it looks really soft. Why do men go in so hard when it looks that soft and delicate? I feel like I should be coming out of a big cloud and just shouting 'Vagina!' at people now.

I've got a very good relationship with my vulva – I actually know where it is! That's come about through me actually wanting to know about my body, and that's because of my reproductive health issues.

When I was 18, I was diagnosed with PCOS (Polycystic ovary syndrome). I also have endometriosis, which means I have very painful periods.

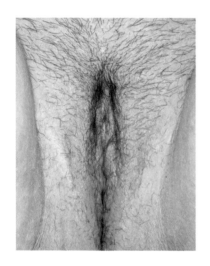

I've recently been diagnosed with PMDD, which is Premenstrual dysphoric disorder. In the build up to my cycle I'm quite crazy. I know a lot of people with mental health problems don't like being associated with the word 'crazy', but I'm quite comfortable with that. I become really agitated, I struggle with self-harm and I feel suicidal. Because I have PCOS I don't have a regular cycle, so I don't know when it will come and it can span weeks – it's almost like I have a manic phase, which is quite difficult when you're holding down a full-time job. I'm a lawyer by day, and you don't really want a manic lawyer.

A couple of years ago I set up Cysters, which is a charity about reproductive health, predominantly aimed at the BAME community. Reproductive health issues are not well received in our community and they are heavily sexualised and linked to women's honour. So women weren't coming forward and saying that they'd got certain issues because they were afraid that they would be judged or seen as sexually promiscuous.

When I started Cysters and openly said the word 'vagina' I was described with a Punjabi term that basically means I'm a sexually promiscuous woman. It's quite a derogatory term in Punjabi. That's what people would say about me.

I've been really ostracised from the community for openly talking about women's health. I've been made fun of, especially by males who hold positions of power. Recently, I was asked to speak at a prestigious networking event about how women's health can impact the economy. Four prominent men all took that opportunity to have a real laugh about it, like 'Oh yeah, you're gonna talk about pussies on stage.' I felt like I was 10 years old again, being told that I can't talk about my vagina, I can't show anyone, I can't touch myself or anything. I left that networking event in tears. But the next day it fuelled the fire. The exact reason I do what I do, is because that attitude stops women coming forward.

I gave a talk in a refuge for women, about general reproductive health. Within ten minutes of talking and saying the words 'vagina' and 'vulva' I was actually pulled out of the room and asked to leave. They thought the word 'vulva' in particular was really sexually promiscuous and I was

advocating everyone to look at and talk about their vulva. Although there shouldn't be anything wrong with that anyway, that's when I decided to be more culturally sensitive, because the only way to break these barriers is to explain more, because a lot of women don't know what their vulva is. There are no Punjabi words for certain body parts; it's just spoken about as a whole and spoken about in terms of childbirth.

People also weren't keen on my coming into places of worship because they felt that I brought an aura of promiscuity. They felt that I was misleading women into having more sex, when the charity is not actually anything to do with sex. It's about health issues like endometriosis and PCOS, and biology and medical care.

It's only recently that the community has come round to me talking as openly as I do. It's ironic because the Indian community invented Kama Sutra, yet we're the same community that won't openly talk about sex.

I was seen as a sexually promiscuous woman for a long time, although no one said it to my face. It was said behind the scenes. Elders spoke to my family, to my father as the male head of the household. They said he shouldn't be allowing me to speak about these issues and I shouldn't have been permitted to leave home. He's had to have broad shoulders. He's amazing and he's actually the first person who pushed me with Cysters because he recognises this is important work.

There should be no shame in talking about vaginas and vulvas and no shame in being a woman. I've come to a place of unlearning everything that I've been taught about womanhood. I now see that Asian women don't have to be subservient to men. I don't need to wait until the age of 26 to marry and have children. The resistance and the problems have been a really eye-opening journey for me.

The breakthrough really started when women came to me with their personal stories: women with gynae health problems, and also women who had suffered sexual abuse that led to problems with them conceiving. The charity became a safe haven for hundreds of women to talk about their problems. I feel that the only way to create change is to openly talk about these issues.

A woman in the Asian community has something attached to her called 'Izzat'. That is your honour and it is usually taken at the time when your virginity is lost. It can be attached to other things as well. Essentially, Izzat is located in your vagina and taken at the point when you're married. I've been told that woman is like a rose – once you pluck it nobody wants it anymore, because it dies. Asian women are brought

up on the same principle, to protect their honour above everything.

When I was younger, I really felt like everybody's honour was riding on my vagina, up until the point I would get married in what the family would feel is a suitable relationship. Then I would lose my honour, but in a suitable way. My friends from the white community didn't have that pressure and were leading really fulfilled lives doing what they wanted to do. It was really difficult because I didn't fit into either world.

My mum's definitely my role model. She probably doesn't even realise that she is. Years ago, she taught sex education as part of the schools programme. She was the only Asian woman to have done it, so most of my friends have learnt sex education through my mum. I believe it's why I'm here now, why I do what I do, because I had such a positive influence at home. A lot of families have to hide, and I can be open, and that has come from my mum. Being a woman means to me that I can and will be anything that I want to be. As simple as that.

Twenty-nine years old, no children

"I don't want to be tied down to one man"

I call it 'lady garden' personally, and pussy to everyone else. It gives me the freedom to live a life that I love and gives me a lot of excitement.

I work in the sex business so a lot of people get to see it. I get great feedback about it, which in turn makes me a lot more proud of it. One of the first gentlemen that I saw told me how pretty it is. Lots of clients love the way I smell and taste and it's nice for me to know. In general my body confidence and body positivity has been boosted.

I've got clients that enjoy the smell so much, they will be like, 'Make sure you've worn your knickers all day,' and sometimes they want me to take them off and put them in their mouth. Or sometimes they want to put them in my mouth. I'm not that keen on my own taste or smell to be honest; it doesn't bother me, but I'm not into pussies.

My first sexual experience wasn't the best. I was 15. I think I'd skipped school to spend the day at his. It wasn't just unpleasant, it was

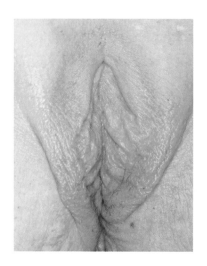

painful. I thought if that's what sex is about then why is everyone all hoo-ha over it.

I waited two years to do it again. I was in a relationship and it was quite fun – not as good as what it is today, because you live and you learn – but certainly it wasn't as horrific as losing my virginity.

My best sexual experience was at 26 when I met a beautiful big skinhead. He absolutely ruined me. I had to go home the day after we had sex and google what had happened, because he was the one that first discovered that I could squirt. That's what I like to chase now, is a good squirt. I didn't know sex like that was possible. I've always been quite playful, quite sexual, but that was a real turning point.

It feels really intense like you are going to go to the toilet. I had to learn to harness it. Squirting is different to normal orgasms. A clitoral orgasm is different from a penetrative orgasm is different from a squirt. They all work really well together, so usually it's nice to have the clit, then the pen, then the squirt.

I thought about it for nine months before I got into sex work. I'm not a smaller girl, I'm not a petite size 8, I had body confidence issues, and didn't know if I would make any money. Would there be a market for a woman like me? Would it taint me? Would it make me dirty? They were psychological barriers that I had to push through.

Friends and family supported me. Most people who know me think it's perfect for me – it suits my dating style. I don't want to be tied down to one man. I don't want to wash, cook, clean, live with someone, have them under my feet 365 days a year.

I get a wage, I get a lot of varied sexual experiences, and I've had my mind blown with different orgasms. Sex with clients is very varied. I met a gentleman who made me come just through kissing alone, no touching at all. I didn't even know that you could have an orgasm just through kissing, but you can. It was intense because he sort of wouldn't let me go.

In my last long relationship I was cheated on. It caused me turmoil at that time, but I wouldn't be who I am today if that hadn't have happened and I love who I am today and what I'm about. So, thank you very much. You know who you are.

I saw my mum go through experiences in her life that I learnt from, so I haven't had to go through them myself. I learnt a lot from her by watching her make mistakes, and what I will and will not accept as behaviour from other people. She went through some difficult times, and I don't want to go through them.

My relationship with my real father was pretty much non-existent. I knew where he lived; I could have knocked on his door at any time. He chose to have nothing to do with me. I don't really think that's bothered me too much, to be honest. It's his loss, not mine. I think it's probably stood me in better stead to grow up without somebody like that around.

We're brought up like little Disney princesses to believe in happy-ever-afters. We dress up as princesses, we role-play getting married and from a very young age we're socialised to dream of that. Nothing lasts forever anywhere on Earth.

I run my own life, I make my own choices. My life might be financed by men, but I enjoy it. I manipulate them. Men only generally want one thing anyway, so they may as well pay me for it.

Thirty-two years old, no children

"I found a sex book when I was nine"

I'm quite friendly with my fanny and we have a good sex life.

My brother had a winkle and I had a willy. For some reason, 'willy' was the family name for a clitoris. It was that era of not referring to any female parts of the body. I told my mum once that if I touched my willy it tickled and felt nice and she said, 'Don't do that, it's disgusting.' No further discussion.

I suppose you don't like to think about your children becoming interested in masturbation too early because you don't want them to get into trouble with boys. I used to play doctors and nurses and kiss chase with boys. When I was about nine, I remember going to a friend's house and he had all his mates round and they made me stand on the bath tub so they could all have a look at me. I think I offered actually. I was proud to show them what girls looked like. Then they had a little play with me, to see if they could put their finger in. It was all playful experimentation.

My sister used to play a little game where she'd rub herself up and down the edge of the bed and she called it 'cuccacoona'. It's a good word for it! She encouraged me to try it, but it didn't do anything for me.

When I was nine, I found a sex book of my parents' – one of those great big, embossed old-fashioned books, given to them as a wedding present, about what you do after you are married, how to pleasure each other and what a wife should be expected to do. I was an avid reader, I wanted to read everything in the library. I was gobsmacked when I read that a man inserts his penis into the woman's vagina. I was stunned and also a bit excited. There was a bit of a tingle going on when I thought about it.

I didn't do anything with that information until the night that I got confirmed at the age of 14 and I was at boarding school. The confirmation was a formal thing, all the parents had come and there were gifts. For some reason, in the evening when the lights were out and I was in bed in the dormitory, I just got down with myself and had my first orgasm. Another confirmation. Something opened up. I had a little rebellion and was sinful.

At school, I'd wait until people were asleep or it was quiet and I'd quietly rub myself. To be honest, if I masturbate on my own I'm not particularly noisy, not like I would be with a partner. When you're with a partner you want to share your pleasure and show them where you're at, how much you're enjoying it and when the pace is picking up. So you're sharing that and a lot of men get turned on by it.

We wouldn't have talked about that kind of thing at school. It could be quite bitchy and you didn't know who was going to be your friend one month and not the next.

I wanted to talk a little bit about childbirth and how that really changed my body. I tore with my second baby. My vulva didn't look the same again. It was battered and torn. I felt really bad about that for a while. I had a bit of prolapse.

I got some Kegel balls but I couldn't keep them in. There were a couple of embarrassing slips and the last thing I wanted was for it to pop out and down my trouser leg! A tampon slipped out once. I think it was too small for me. It actually came out of my trousers. It was such a mortifying experience that I have put it to the back of my mind and can't remember too much about it.

I have had a boyfriend who absolutely loved my vulva. He said it was really beautiful, well-formed and symmetrical. I thought that was really

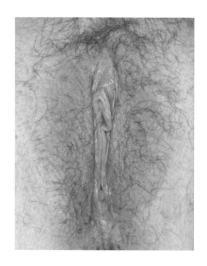

funny because nobody had really talked to me about it before. Him saying that gave me some confidence.

I'm fascinated by what fannies look like. My first friend and I had a bath together when we were about four and we looked at each other's. I've never looked at another friend's. Wow, isn't that strange? Isn't that really odd that women only see vaginas when they're looking at porn and those are maybe nipped and tucked and all shaved anyway. It's something that's kind of hidden. I'm absolutely curious to be introduced to the world of real women's vaginas. Will they be as unique as faces?

I think that if we actually saw each other's genitalia there'd be a lot less jealousy. I think as women we get jealous around other women when we wonder what they've got. We may see their breasts, but we never see their cunts. We never see what the man has access to — that's so private. I think seeing each other might make our relationships more basic and earthy and real.

Fifty-one years old, three children

"I don't really have much pleasure inside my vagina"

My vagina and vulva are soft and inviting. I like the word 'cunt'. I think it's a very strong word and I like where the word comes from. Cunt, kunta, queen. It's an old and wonderful word. This is my cunt and it's regal and majestic.

My relationship with my cunt is ever-changing. I used to disassociate from it quite a lot. It was just a sexual thing and I thought it was more for other people. It was a tool for sexual gratification, but also it was for someone to insert something into, like a vessel.

My relationship with sex wasn't good for many, many years. My first sexual experience was actually rape. I don't really remember the act.

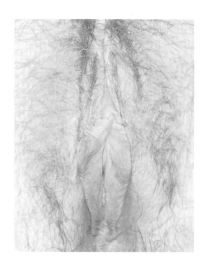

I was 13, at a party and very drunk. The guy, who was 16, is a genuinely nice person and I don't think he had an understanding of what he was doing as rape. But it's clear now I couldn't have consented, as I was too young, and I was drunk to the point of passing out.

So my relationship with my vagina and my vulva and sex in general was really cut off. The other thing that happened after that experience, was that my relationships with my friends changed. We were 'caught' having sex at the party. My friends really liked this chap, and I ended up being ostracised from my friendship group for quite some time. It was presumed that I was 'guilty' and I had created this environment that led to it happening, rather than actually being a young, vulnerable girl who was drunk.

When I was 16 I lost my virginity for the second time to a caring partner who was very gentle and took his time with me.

I think this history is why I have felt a lot more comfortable without penetrative sex. I much prefer my clitoris being stimulated or having slow sex. It's taken a long time to really enjoy penetrative sex. I have to be very specifically in the mood for it to enjoy it.

I don't really have much pleasure inside my vagina – clitoral stimulation is what I really enjoy. I wouldn't choose penetration over anything else. It's not hold on to the side of the bed and be like, 'Woah, this is the best thing I've ever felt.'

I explored my sexuality with women when I was at university. I don't think I generalise about women and men. I find both sensual and sexy. I've had very penetrative sex with women and I've had some very slow and sensual relationships with men for whom penetration isn't the endgame. Sex is always better for me when I'm emotionally attached to someone. I've been lucky to be in some really exciting situations, but I still think the best sex is very connected sex.

I did some wonderful therapy with a woman recently who encouraged me to spend some time just very slowly stimulating myself. On my own, for my own pleasure, without toys, porn or any stimulus, to find out what I enjoy and really focus on how much pressure it takes for me to go, 'Ooh.' It took me a long time to do the exercise, I felt like I

couldn't do it. So when I did there was a huge sense of relief and actually it wasn't really scary.

I've had some fear in asking for what I want: touching myself, and learning what I want. When I have sex I'm not very directive, I go with the flow. To sit there and go, 'What turns me on?' then links me into, 'Well, what do I want? What do I want from my sexual relationship with my partner? Am I fulfilled with what I'm getting at the moment?' It's changed my sexual relationship with my partner for the better because now I'm more direct. I'm less afraid of expressing what I want and don't want.

There's a wonderful cartoon about sex ed. There's one part in it where this young girl takes a mirror to her vulva and it has a conversation with her. It's fun, happy and gregarious and it says, 'We're going to have a lot of fun together. Don't you worry, we're going to get to know each other.' That's how I think of my vulva and vagina now: flamboyant, exciting and sensual, and it's a nice relationship to have.

As a woman I can create life with my partner, but I would have to carry that life and I'm not ready to do that. As a woman I have to take responsibility to stop that from happening. I might want to have a child in future, but not right now. I'm very bad with tablets, so I had a coil inserted. It's such a sensual and private area, to have someone examine me with my legs spread felt like a violation. It's so medicalised and there was a deep griping pain of my insides feeling tugged around, even if it didn't last for long. Now I'm happy that I have this contraceptive and it works for me, but it felt very violent. I also felt anger and bitterness at my partner at the time because I was like, 'Why do I have to be the one that goes through this? Why is it my responsibility?' I felt a sense of responsibility for what being a woman could involve.

I hope that in the future women have more of a place at the table, then smash the table up and realise that we don't need the table and we can all just have a conversation together, men and woman as equal humans.

Twenty-seven years old, no children

"I sound like I've got a family of frogs living up my fanny"

I remember when I was little being told, 'Take your hands away. Your hands will be smelly. Go and wash your hands.' I felt ashamed and I stopped touching myself. I didn't masturbate throughout my teenage years. As a child, before I had pubes, I put a back scrubber with a long handle inside my yoni and it didn't feel nice. It wasn't sexual exploration, I wanted to discover how deep the hole went.

When I went through puberty I was horrified that I had long lips. I hated them. I remember being sure that they were different and I had fantasies about cutting them off with a pair of scissors.

I never self-pleasured and I went straight into sex. When I was 15,

a boy stuck his finger inside me and it didn't feel good. And all those old stories of, 'Oh, you're smelly, you've got to wash your hands,' came up in that moment. I was worried about being smelly. I can still feel that shame.

Once I was in a communal shower with a group of female friends, and I remember saying to a woman, 'I've always felt like my lips are really big, what are yours like?' And in that moment all 12 of us were like, 'What do you look like then?' We stood there and parted our yonis so we could see the internal lips. It was so amazing to experience the yoni not being sexual, to see each other and compare. It was sweet and innocent and 'in the moment', like being children.

I discovered that we all had different insecurities. Some women had big lips like me, but they were all so different and beautiful, like all our noses are so different. We all felt acceptance and celebration. I think that was the time that I really fell in love with my yoni.

Later that night I was with a lover and I said, 'I just want you to look at me.' He said, 'Wow, look at you. You're so beautiful,' and he wept. That was his first invitation to just simply look, and it was the first time I had created an opportunity to be seen. It was like gold, it was such a moment of deep acceptance.

A huge reason that I felt compelled to be in *Womanhood* was to share the incredibly beautiful positive experience of my birth.

In leading up to the birth my big thing was I wished to remain intact. I wished my yoni to remain intact and instead of saying, 'I don't want to tear,' my mantra was, 'My beautiful yoni is elastic, fantastic and super-stretchy.' I imagined my body simply opening. I was absolutely determined that my baby would be born at home and we managed to achieve that. I had a doula so I felt like I had a big sister with me.

My whole birthing process started with me saying to my husband, 'Shall we invite our baby to be born tomorrow?' We made love for hours until about midnight and then we went to sleep, feeling blissful. We hadn't had much sex during pregnancy, as throughout pregnancy I didn't feel very sexual. At four o'clock in the morning I literally heard a pop in my body and with that my waters burst and out dribbled about a teaspoon of liquid. We were both really excited, it was like, 'Wow, wow, it's happening, it's happening!'

Over the next six hours I proceeded to get more and more high on joy and excitement. My heart was exploding, riding the waves of birth, at times I had tears rolling down my face. I was 41 when I gave birth and I'd been wanting to be a mumma for 20 years – a long, long time.

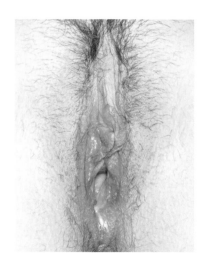

It went on for quite a while. My doula arrived at a similar time to the midwife. I felt like a wolf in her own cave as I was labouring. I needed to be on my own each time I felt a surge. I'd have times when the surges were strong, and times that I got a bit frightened. And I would just say 'yes, yes, yes', and coach myself through the fear.

It wasn't pain. It was a strong, full body sensation. It was the ultimate feeling of being in love with myself. I felt very orgasmic – not a genital orgasm, my whole body.

When the baby came I was squatting. There was a point when I felt like all this pushing had just been going on for so long, I was failing. I was using gas and air like billy-o and by that time things were really strong. The pressure coming down through my bum felt bruising and hot.

Then he crowned and, my God, that was the pain. That was the pain, that was the fire, the shock of all shocks. I pushed really hard and with that he came out all in one, no head and shoulders, he came out in one straight onto the floor.

The birth was euphoric, but I completely shredded my yoni and ripped all the way through my perineum to my arsehole. Afterwards, the excruciating pain of my arsehole was terrible. I was on ice pack alert. For the next four weeks, everything was about my arsehole. Pooing was really scary. The pain in my arse would wake me up through the night. I had a posterior prolapse. Even now, nearly a year on, there are times when it sounds like I've got a family of frogs living up my fanny. I can be walking down the street and my vagina is literally making a noise. I have to laugh about it, but actually that's the really tough bit.

I was very fearful about having sex, but actually the few times that we have had sex it's not affected pleasure. Sex is very soft. I feel like more healing is needed over time. We didn't even have sex for about eight months. I have a very tender, loving husband.

Life begins again after birth. You have a new body. Breasts fill up with milk and become tender and sore. They are for the baby; they're not particularly sexy, scrummy playthings anymore. And my body is a very different shape. I can't get back my pre-pregnancy body because that doesn't exist anymore.

Forty-two years old, one child

"I can happily go years without sex"

My period started when I was nine. Because I didn't know about periods I didn't realise I'd started them. My mum noticed some dark patches in my pants when she was doing the washing and she went to her doctor concerned. It was then my mum had to take me aside and explain what was happening.

I've always had heavy periods. When I was at school mum would crush up ibuprofen for me, and I had to take days off. If I ever went to the doctor about it, there wasn't much sympathy, unless it was a female doctor. It was very much you just put up with it and, yes, there's going to be pain and that's the end of it. Some periods would last two weeks. Even on the pill I would bleed randomly. I couldn't predict when my periods were going to be and I knew it wasn't right.

Eventually, after a scan, it turned out I had fibroids. I had them removed by open surgery because one of them was 7 cm and there were

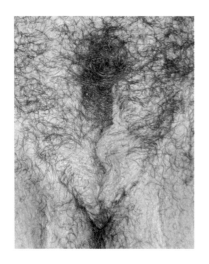

a few others. I had eight weeks off work because it was seen as such intrusive, major surgery. That was nice over the summer! I was a bit tired but managed to do some lovely walking. I was in a bit of pain initially after the surgery, but actually, I immediately felt the benefits.

I have been on hormonal contraception from about 13, and I think it has really affected my sexuality. I don't really masturbate very much, I don't have those kinds of urges. Because of that I don't really think about this body part. I am in a sexual relationship with someone, but that's not the key part of sex for me – it's more about the emotional connection. I'm not completely asexual, but I can quite happily go years without it, and that is no reflection on my partner. I am just indifferent to sex itself. I'm lucky I'm with someone who has a very similar sex drive to me and he's very understanding, but it does seem a bit like actually I don't need to live like this.

I've tried the combined pill, but the oestrogen makes my fibroids grow bigger. Now I'm taking the Depo injection. I've made the decision that when this one finishes I'm going to try and have normal cycles and we can use condoms. The point of removing my fibroids was to make my periods okay, so I need to see how they are. For six weeks after the operation, while I wasn't taking contraceptives, I wanted to have sex with my partner and I was really annoyed that I couldn't because I'd just had this major surgery.

The contraception has changed my body in other ways. I feel like I'm not attractive enough to have sex, because of the weight gain and other feelings. Also, the progesterone makes me dry, which I didn't get with the combined pill. I need a lot of lubrication, but I'm only 30 – that can't be right. I feel like saying 'Screw the system and screw contraceptives.' Until they make contraceptives better, I'm out, but they won't because it's women and they don't care.

I enjoy cuddling and kissing my partner. I don't think I have enjoyed sex in the way that other people speak of it. I don't think I've ever had an orgasm. I feel like I've come close with him, but I'm not actually sure I'd recognise it. My partner and I don't really discuss it. It takes me a long time to feel aroused, like an hour or more, whereas my partner

is a lot quicker so I feel like I have to keep up with him and just go, 'Do you know what? We'll just use some lube.' I always feel really bad using lube because it feels like I'm saying, 'Actually I'm not aroused, I'm not enjoying this,' which is not the case.

I think my body has betrayed me. My womb has been the centre of my body and life. I don't feel like I'm fixed. I hope a few years down the line I can say, 'Actually, it was worth all that pain, all that waiting because now my body feels like it belongs to me and I've got control over it.'

If I was a man I wouldn't have these problems, but I don't like to think that being a woman is just about having a womb and periods, because I feel like there's more to me than that. But I'd be probably quite a different person if I was male.

Having children isn't my ultimate goal, but I feel the idea that I might become a mother is somehow holding me back. I just think this is ridiculous. I've just seen a situation at work where a male employee took some parental leave and he came back to a promotion, whereas I doubt if anyone came back after a year of maternity leave they'd say, 'Here's a better job for you to go straight into.' It just wouldn't happen, they'd go, 'How dare you leave us for a year. You're going back to your job and, by the way, we've changed it since you've been away.' That's the environment people have and it is really hard to be a woman, not because you're a woman but because of how other people treat women. So that would be my argument.

As a mixed-race woman you can be perceived as angry if you confront something. If a man was in a meeting and said, 'I'm not happy about that,' they'd probably go, 'Oh, he's a bit of an arse,' but they wouldn't associate it with being a man. Whereas as a woman if you show authority or if you say, 'Actually, do you know what, I'm not happy about this and this is why,' you're seen as angry, confrontational, bossy. I've seen this happen: women of a certain age are not given a promotion or considered for the promotion because there's still this idea that you're only going for it because you want to run off and have children and get the maternity leave. I come from it as a BME woman on top of it, as well, which is another type of maligned group.

Thirty years old, no children

"I'm engaged to a transwoman"

I got my period very early, when I was nine. I found it terrifying, I thought I was dying. I went to my mum who gave me a sanitary towel. She didn't tell me how to use it, just 'Put it there.' Society is very conservative where I am from. We had an unspoken rule in the house that periods, genitals and sex were not to be talked about.

I wasn't close to my mum. She lives back home. I spoke to my dad more about relationships and dating. I started discovering sex when I was 14, when I got my first boyfriend, but it was more through trial and error and the internet.

I spent many years not particularly looking at it. I didn't pick up a mirror and look at my genitals until I was about 16 or 17. I was quite pleased that it looked quite symmetrical, but I didn't think it was particularly pretty or ugly either way. A few years ago a male partner told me I have 'textbook genitals' and that they are very pretty.

I identify as pansexual. I'm interested in men, women, everyone in between and beyond. I'm engaged to a transwoman. I have had long-term relationships with men and I have had shorter relationships with women.

When I was growing up, I was more interested in finding out more about other people's vaginas and vulvas, rather than penises, but it wasn't acceptable culturally where I'm from – it's quite a homophobic society. When I moved to London I started dating women and I dated a transwoman, not my current partner.

I find that penises are more straightforward in how they show arousal and in how they can be operated. It's more difficult to discover what vaginas like, without clear verbal communication. I found experimenting with vulvas and vaginas quite fascinating and there is a massive variety in the way they look. The distance between the vaginal opening and the clitoris varies a lot – with some women you just keep going!

I'm attracted to femininity regardless of whether that comes in a male-identifying person or a female-identifying person, but I feel more animal attraction to penises, regardless of the person's gender. A person presenting female with male genitals is the ideal partner sexually for me.

I'm a big fan of masturbation. It's the easiest way to make yourself happy and let other people know what makes you happy as well, being aware of what gives you an orgasm and what you really don't like. I also like watching porn. If I see something I like, then I try it with myself or with a partner.

I very rarely orgasm just by penetration. It's happened when I've been really into the person that I was having penetrative sex with and also felt really horny. But usually I need clitoral stimulation and penetration, or just clitoral. Clitoral orgasm can be just a physical reaction for me, it doesn't necessarily have to be connected to feelings. It's literally just about pushing the right buttons.

I've been polyamorous for six years and I have two partners. I'm engaged at the moment, and see no reason why I would become monogamous when I get married. It's a lifestyle, it doesn't change when the formal status of a relationship changes. Marriage will be a cohabiting relationship, and imply more of a time commitment.

My partner and I live together and spend about 70–80% of our time together. We intend to have children in the future. My other partner is male and in a similar relationship. We see each other maybe once

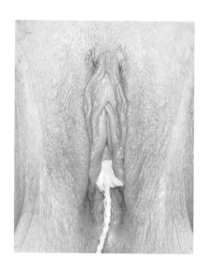

a week or once a fortnight if our lives are too busy. It is a romantic relationship, it's not just sexual. It is, for want of a better word, a 'proper' relationship. I talk to both of my partners on a daily basis.

It's interesting, getting different things from different people. Having sex with two or more people over the same period of time means you get different things. I'd say my pussy is pretty spoilt at the moment.

Twenty-four years old, no children

"My mother abused me"

My mother abused me greatly when I was quite young. I'm very good at disassociating. It's only in the last 15 years I've come to terms with it.

When I was young, perhaps till the age of nine, she sexually abused me. Because I was so young, some of it is hazy, but she would lie on me, fondle me, masturbate me and rub cream on me. I think she put objects in me. She was always there at night. I can piece it back to about the age of four, because I can remember being about that age. If I awoke with a nightmare, she was already there.

After about the age of nine it changed, and she would keep me at home. She had me at the doctor's all the time, I think she was living vicariously through me. I was given fairly heavy sedation; sleeping drugs were often administered to me. She often used to sleep with me even when I was 13 or 14. It was quite a weird upbringing.

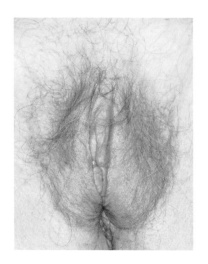

I had Catholicism going on as well. I was taught by my father to sleep with my hands crossed over my body, so that if I died, I would die pure. Of course, I mustn't touch myself.

I always knew from an early age that I would go to hell, because my parents believed I was such a bad child and I was constantly disappointing them. I used to immerse myself in scalding hot baths so that I was ready for hell, because I knew I was going there.

I had two younger sisters, one younger sister was two years younger and then one was eight years younger and I was very much the family social worker. I had to look after the baby.

Would you believe, this summer I'm going to go to my sister's 70th birthday weekend, and I'm going to ask her and my youngest sister for the first time what they remember. I don't think that they were abused by my mother in the same way. My mother always said, 'You're mine, she's Daddy's girl,' about the middle sister. And the youngest was theirs, she belonged to both of them.

I didn't have sex before marriage. My husband was a philanderer. Even when we were going to get married he was a serial womaniser. So he had sex before marriage – that wasn't an issue for him. On the wedding night we didn't have sex – he wanted to party. That was ultimately why the marriage finished – he found someone else. Well, he always had someone else. But he loved sex, demanded sex and wanted sex and I was pregnant within a few weeks of being married.

I've got two daughters and a son. My youngest daughter had terrible nappy rash and so she had to lie down and have egg white put on her bottom and some stuff put all around her vulva area. I was aware that I would do it gently, lightly, speedily and with a great sense of respect. The same when my son was circumcised when he was about two and a half because of difficulty urinating, I remember when I was dressing him that I was very respectful, careful and, yes, probably a little detached. I know my touch was light and I didn't dwell on it. I didn't fully remember my own childhood abuse at that time of my life, but I can see how I responded to my own children with a careful and respectful touch.

I didn't have an orgasm with my husband and I didn't masturbate

till my 30s. My first orgasm was after my divorce, with a younger man. The relationship was never going to go anywhere, but the wonderful thing was that I realised I could do it. After that I felt able to masturbate. The orgasm made sense; bodily it made sense. I wanted the earth to move and bells to chime and all of those sorts of things, and I wouldn't say any of that happened, but I knew that physically I'd had an orgasm.

I am post-menopause. Vaginal atrophy is real – dryness, soreness. I have lichen sclerosus on my vulva, which is painful. I'm twice-divorced. I don't have a partner at the moment, and thought recently about using a dating agency. I have not given up on sex. I'm looking forward to meeting someone and I want sexual relations. The older I get, the more I enjoy that closeness and intimacy. An orgasm now feels deeper and more meaningful. It feels more pleasurable – fact. I think my emotional availability has influenced my receptivity physically.

It's very important for women to speak up. We need the acknowledgement of our bodies and our experiences.

Seventy-two years old, three children

"I've had some divine orgasms"

Pussy is the word I use most at the moment, but cunt feels more powerful. I will transition to using cunt. Cunt is shorter, stronger, guttural. Pussy is a softer and frillier word.

I'm in a community of people who practise 'Orgasmic Meditation'. That is a 15 minute practice where a man or a woman strokes a woman's clitoris for 15 minutes. Both of you are there to focus the brain, it is not about achieving orgasm, although that can happen. I practise regularly, I have a lot of friends who practise it and I am part of a very sex-positive culture.

When I did my first orgasmic meditation course, I watched a woman getting her clit stroked – holy fuck, it was like being a spectator at a concert.

It's a practice where you learn to hold high sensation in the most delicate, sensitive part of your body. I have general anxiety disorder, I'm an alcoholic, I have been someone who gets stressed easily and would

easily go into hating myself at the slightest provocation. Orgasmic meditation has taught me to hold more sensation, be a lot more conscious and intervene in those thoughts.

Wherever you do it, whoever you do it with, you always set it up in the same way. You always have a blanket, you have two cushions under your feet, a cushion under your head. We call it a nest. There are ways to ask people if they want to 'OM' and ways to respond. You use a timer so the practice lasts exactly 15 minutes. Everything is built to help the woman's vigilant centre relax. Women are programmed to be more on alert for threats, like sexual threat, so it's harder for us to drop into our body and sex. By using a set of steps you can learn to relax and it's only going to be 15 minutes. He sets a timer, you're not in control. He's there handling all that stuff.

My first OM was lovely. I met this guy on the course. As soon as I talked to him I blushed bright red and I was like, 'Oh my God, I could actually go OM with him.' He asked me and I was terrified, but said yes. He was such a gentleman, a really kind guy. He was more nervous than I was because I just had to lie there. He actually had to stroke and men have all this performance anxiety in general.

One thing I've gotten out of it, is it's a lot easier for me to drop into my body in sex. I can feel a lot more sensation and it's easier for me to stay present and to climax. I express myself more, because in an OM you ask for the adjustments you need, like, 'Can you go to the left please? Can you go to the right?' Harder, faster, slower, whatever and the man says 'thank you' and does it. That assertiveness translates over to life and to sex. So when I'm having sex, when somebody is giving me head I'll be like, 'Oh, can you go slower please,' or 'Can you just go lower.'

Orgasms used to be more effort. Sometimes I felt guilty if I was taking too long – 'My pussy is shit compared to other pussies.' Now, because I've climaxed so much through OM, a climax doesn't actually feel like a goal. It does happen, but my hunger to climax is gone. I much prefer to hold out and just go with the sensation and to feel it in the moment than to climax, because when you climax you break the energy and you're building it up again.

In the past couple of years I've had some divine orgasms, where it feels like I'm touching God. And I've had crazy trippy sex where time has dissolved, the rooms are vibrating and the lights are flickering and it's like I'm on psychedelics. That's the kind of experience I'm hungry for now.

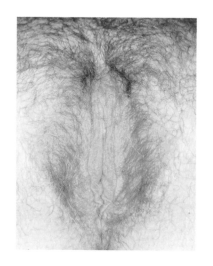

One of the OM steps is that the man or woman will visually describe your pussy. Not, 'You've got a hot pussy,' none of that – a literal physical description. Because I've got pubes, and there is a patch of grey pubes on one side, I'd hear, 'You've got some silver pubes on the right side of your pussy and there's a fold of flesh that is pink in colour.' I used to feel some shame about how I looked, and worried about having pubes, but my pussy has been described to me so many times that I feel great about it now. It's an experience that deeply relaxes you.

Being a woman is about power. Power, power, power. Witchy fucking power. We are having a conversation up here, but there's another one happening down here where our pussies are talking.

There's obviously so much shame around what cunts look like and a lot of women hear all this crazy bullshit – labiaplasty and all that mad shit. I'm doing this because I want women to see a happy cunt. 100 cunts. Power.

Thirty-one years old, no children

"I used to feed my tomatoes with my blood"

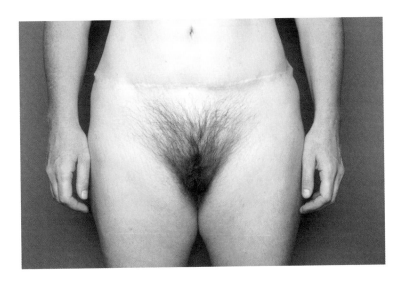

I still remember the first orgasm that I ever had with a man. The feeling of euphoria was beautiful. I also knew I'd conceived; I felt something magical had happened. Sure enough, I was pregnant. I knew at the other times of conception in my life too.

The key to orgasming during sex is that I've got to be on top. Then I can control it and rub the right bits. I have had lots of good sex.

I'm a doula and I love working with women. Just being there at the birth is important, but also all the postnatal care and experience. I do reiki with pregnant women as well and I love being able to give women's bodies love and care. I usually introduce myself to the baby by saying,

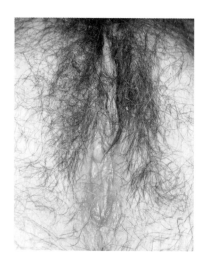

'Hello, I'm your doula, I'll be there at your birth. Your mum's a beautiful woman, she's excited to be seeing you.' I don't give the baby reiki because it isn't able to say if it wants it. I just want to say hello to the baby, really.

The power of women is amazing. Honestly, I know it sounds silly as a doula, because this is what I do, but to see a yoni open and the baby come out... but I just believe we're made of magic, we're made of stars. When I think of the inside of myself, or the inside of any woman, I think of beautiful space. It's physical when women give birth – there's blood and there's poo, but I still believe it's magic.

People say, 'It's like a flower,' and it sounds like a cliché, but watching a yoni opening is a bit like a flower opening. It feels like a very private moment. I have a sense of it being private and beautiful and I look away, I don't stare at it.

First-time mums don't know what it's going to be like. They get to a point and think, 'This is it, it must be soon,' and really as a doula you're like, 'It's not soon. You've still got a bit to go.' But you don't want to tell them that, because they'll think it's going to get worse. Worse isn't a good word, better to think of it as intensity. As doulas, we try and be positive.

I was 21 when I became pregnant, so I've been a mother for most of my life. Being a woman means everything to me. Every cell in my body is woman. I think I became a feminist at a very young age.

Among other things, it is about bleeding. I've always loved bleeding. I used to feed my plants with my blood – it was great for the tomatoes! I've never used tampons or even bought pads. Before I had my first son, I just used moss. I would put moss in my knickers. I've always been a bit of a hippy, earthy girl. When I had my first son I used terry towelling nappies with him, and afterwards I cut them up into rags. I used those for 26 years till my bleeding stopped.

It's been almost a year since my last period. I knew I was going to have my last period. I kept some of my blood in a little jar. I did a little letting go – I gave my blood to the river every time I had a period and really said goodbye to it. I think that was really important for me because I loved bleeding.

I've been getting a bit caught up in all the trans stuff. I think I'm

confused by it. Just yesterday, a friend posted an article on Facebook, there was a positive, respectful discussion, and then this morning she was like, 'Oh, I was reported and the whole thing was taken down.' Women can't even talk about it; we literally cannot talk about what being a woman is, because it's seen as offensive to trans people. I feel like I've gone from being open to what it all means to being a furious feminist. I don't understand why we can't talk about it.

My big worry is about women's spaces. As somebody who has been raped and been verbally and sexually abused by men in the past, I would not feel comfortable going into a toilet with four men in the toilet and me, then putting myself in a cubicle on my own. Even though I love men and I have grown to trust men again, I still feel uncomfortable if I'm with a lot of men.

Being a woman is about relationships as well. I've always been good at being friends with men as well, but I have a lot of women friends. It's important to me to have a tribe of sisters around me. We support each other in the way that men can't.

Forty-eight years old, two children

"Stripping gave me amazing sales skills"

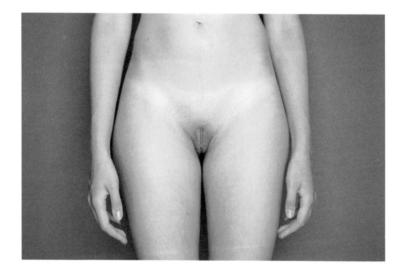

My relationship with my vagina is very straightforward and also incredibly complex. I grew up in quite a strong female household and my mother never shaved any of her body hair off at all. I never used to shave all my pubic hair off, and then I did once and my ex-boyfriend loved it. Funnily enough, that was upsetting. I think that most men love it when you take everything off. It's nice to look at – tidy. It makes me feel cleaner. But I think it upsets me because it's like you're reverting back to childhood. Do men want a vulva to look like it belongs to a nine-year-old?

I am very honest about all of my reproductive anatomy. It doesn't feel like the discharge we produce is socially acceptable. I really want to write something called *A Month in the Life of Mucus* about this. Not enough people know that it's totally normal.

In my fertile time I produce a lot of clear mucus, and I can be very, very wet, it's like I've wet myself. Only for two days a month, but it's

annoying, and can even go through leggings. If I take my knickers off before we have sex there's going to be remnants of discharge there.

I know a lot of women who've had guys who won't go down on them. But if someone wouldn't go down on me then I would just walk out the door. I'm very happy to go down and penises are not as clean as they think they are. Nobody jumps in the shower before sex every single time, do they? I've had bits of toilet paper and hairs in my mouth and that's what happens because you're putting your face in an intimate area.

When I was 22, I was very drunk one night and I lost all my friends. I'd been dancing with a guy for two songs. I hadn't kissed him, there'd been no sexual contact, when he asked if I wanted to go home with him. I decided in my fuddled brain that it would be safer to go with him than be alone in a city at 5.30 am.

I went back to his and I asked for something to wear in bed. I borrowed a T-shirt and some boxers, got into bed, went to sleep. I woke up, the clothes were gone, he was going down on me and I was saying, 'Stop. Stop. No, please. I've got a boyfriend.' And then he had sex with me. The reason I said that I wasn't raped for many years was because I said, 'If you're going to do it, put a condom on,' and that made me feel like I was culpable. I didn't know this guy at all. I didn't want to have sex at all. I woke up two hours later, threw up in the sink, put my clothes on and walked out.

I wasn't stopped in an alleyway at knifepoint. But I said 'no' over and over. It's taken a long time, and therapy, to trace all the points at which I said, 'Don't. No. Stop. I've got a boyfriend. No. Don't,' and all the times I pushed him away, to realise that he should have stopped. For a long time I blamed myself.

Therapy also helped me realise that I was trying to re-enact the situation with other men. Apparently a lot of people do this. I would let people have very rough sex with me that I didn't want. And I would encourage people to have sex with me when I was asleep. I would pretend to be comatose.

Sometimes now I get a kind of muscle memory panic. If sex hurts a little bit and I don't stop in that second, maybe because I think it will stop hurting, or my partner's enjoying it, I'll have a panic attack. I'll start crying and can't breathe and feel very, very panicked. But I've been working on that and it's abated a lot.

I still have some problems and I feel like they're a little bit dismissed. I like rough sex as an occasional thing. Maybe grabbing, a little bit of spanking, giving a very deep blow job, maybe having my head

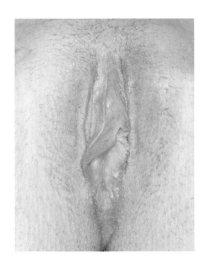

held: I don't mind any of that when it's totally consensual. But I find that my partner wants it a lot more than me and doesn't appreciate that when I'm not in that mood it's very distressing for me. Then that's dismissed as me having 'those problems'. Of course I can stop at any point and that is one of my problems, that I don't stop.

I don't know if I would ever have been a stripper if I hadn't been raped. I always wanted to try because I love performing and I thought that it would be a good means to an end. I don't want it to feel like every stripper is a victim, because I fully believe it's a great way of making money if you can do it healthily. But I think I might have been subconsciously devaluing myself. I don't know. I definitely devalued my body and my desires.

I decorated my house, bought a car and paid for university fees with stripping. It's given me a huge breadth of experience. It's given me amazing sales skills, which is funny, because I can't really talk about it in job interviews. Lap-dancing is one of the harshest sales environments you'll ever experience in your life. It's a shark pit.

I did lap-dancing, which is very intimate. Essentially it's dry humping: sex with one person's clothes on. Lap-dancers get assaulted all the time, all of the time. The men know that they're not allowed to touch; they've got to have their hands by their side. In fact, the touching was rough. Boundaries were crossed all the time. I've been licked, pinched, I've been bitten on my nipple – I had tooth marks round it.

That led me to webcam work, which I did for about four or five months. You get asked to do all sorts. Loads of guys want a girl with a strap-on. People want to see your face, your vulva, fingers inside you, if you've got toys use those. Some guys actually just want a fantasy. I used to have a guy who just used to tell this story between us and it was hardly sexual at all.

I've stopped because I really want my life to move away from sex work. I'm a bit sick of it and I'm enjoying a generally healthier – not totally healthy, but generally healthier – sex life. I know I am a capable woman, and I should give myself more credit.

Thirty years old, no children

"I was over-protective of my daughter"

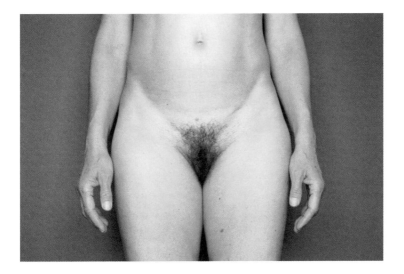

When I was a child. it was not named; it was 'down there', something shameful and not talked about.

I experienced sexual abuse for years. I felt dirty and ugly and I didn't want to be seen by anybody. I would spend a long time in the showers. I felt so much shame and disgust towards myself. I've had therapy and, while I have healed, I am not completely free from it.

I can only see a woman when I go to a gynaecologist or get a mammogram. I almost can't stand it, I almost pass out. Even if it's a woman, when she uses her hands it's very challenging for me. The abuse is still in my body.

My father left my mother when she was pregnant with me and she brought me up on her own. She worked full time by the time I was six weeks old. My uncle persuaded my mother that we should move from West to East Germany. He was a communist, although he never moved to

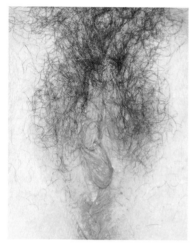

the East himself. After the war she had survived everything you can imagine, everything, so she went East with the hope of a better life.

My uncle would visit us about once a month. The sexual abuse would happen after school in our apartment. My mother was working and had no idea what was happening.

Somehow growing up in a communist dictatorship means you never learn to think for yourself and to value yourself. I just I became silent, I didn't say a word. I knew it was terrible, beyond disgust, but never thought I could do anything about it. Somehow from the very beginning, from kindergarten, they trained us not to think.

I didn't tell my mother while it was happening because I sensed she was highly traumatised herself. She did her best and she gave me all the love she had. She was a single mum and had a full-time job and did her best. I was the treasure of her life. If I had told her what was happening, it would have broken her.

Later, when I was in my 30s, I told my mother about it. It is a harsh story, and it broke her heart. She was enraged, she wanted to kill him. She didn't kill him, because at this point I had my daughter already and she didn't want my daughter, her grandchild, having a grandma sitting in prison. So she didn't kill him. She developed cancer and I think it was because of the emotional trauma. My mother's sister and the rest of the family refused to believe us at the time, although later they admitted they knew it was true. He had viciously beaten up his daughter, my cousin, even though there was no sexual violence. My mother and I were excluded from the family though.

The abuse basically destroyed my relationship with my mother. I went into withdrawal completely, my heart was closed. She would try and be loving with me, but I was closed to her and to everyone. The only companion I had was my big tom cat.

The first normal sexual contact with a man my age was when I was 16. I was not in love, but he really loved me and wanted to be with me and this was very nice. But the sexual experiences we had were not pleasurable for me at all. Of course I didn't tell him anything. I faked everything; I faked orgasms for a long time, for years I did this, just to look... to fulfil the role.

I became pregnant with this man. I knew in theory I could become pregnant, but I was so unconscious of my sexuality. I was just 17 and I never wanted children. I had an abortion in a dark room in an old, dark hospital and it was awful. It was a little bit like a horror movie. They treated me like a whore. I had the most incredibly painful cramps. When I went to the toilet the baby, not yet a baby, came out. I felt disconnected, I couldn't understand what was happening. Another layer of me closed down.

The next man I met was the father of my daughter. He was from the West and he drove a Porsche and I was so amazed that this man felt attracted by me because I felt so ugly and undesirable and so ashamed about everything. He really wanted me and he came visiting me in Berlin and I became pregnant again.

I was a single mother too, from the beginning. Her father really wanted to have a family and marry me and have a house and I said 'No, no, no, this child is not a reason for me to be with you. I was never good in relationships and I'm still not good at it.'

I was very over-protective of my daughter, telling her what to do and what is right for her. I wanted to be strong, but I think I dominated her. There was no father or other person to add space or make it more relative. My daughter is a wonderful person. She's 33 now and she lives her own life, which is very different to mine.

When she was 18 she moved out and started to live her own life, which was such a good thing for her to do. There is still some tension when we are together. I would so love to have a free and open relationship with her and maybe one day we will get there. We write and call, and things are fine between us for a couple of days when we visit, but then tensions will build up. My mother was a single mother and her mother was a single mother of four girls in war time, and I am a single mother – patterns of behaviour run through the generations.

I didn't experience truly joyful, passionate sexuality till I was 52. In this relationship, sex was the only thing which actually worked between us. I was not ashamed of anything there. He adored me and I was happy. I felt strong and beautiful.

I'm really grateful that I'm not a man. I'm not fully comfortable in my womanhood yet and I don't really know how it would feel. There is more to set free. I'm happy and I'm getting happier and freer every year and this is a beautiful journey.

Fifty-five years old, one child

"I can't claim womanhood"

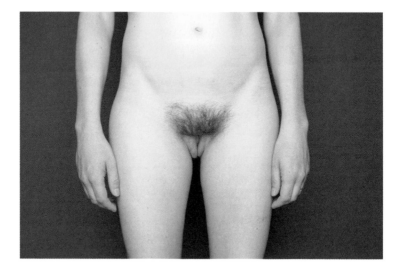

When I was eight, I came to the realisation that I should have been born a girl.

I grew up in a town in west central Scotland – quite a macho town. I also went to a Catholic school. In the 1980s, just being gay or lesbian would have been a big problem. There were very regimented, strict ideas about what it was to be a man and a woman. It was not a great environment for a boy to realise he should be a girl. I couldn't tell anybody.

I was always really uncomfortable with my body, from a very, very young age. When I was three, maybe four, I felt strange and wondered if I fitted in. My penis felt like a foreign object. I felt no connection with it; it didn't make sense to me. When you're young that's not much of an issue, it's just something to pee out of. I sat to pee. I suppose that was one coping mechanism.

Puberty was a problem. My penis wouldn't leave me alone, it needed constant attention. It needed to be relieved, so yeah, I kind of had to masturbate. It wouldn't let me not.

My teens were drug-fuelled. I don't really remember a great deal about those years. I came out as bisexual, sort of testing the ground to see how people responded. I lost some friends then. I was asked to leave the house and I stayed with a friend for a while. The relationship with my father became quite difficult.

When I was 22, I started cross-dressing and I contacted the doctor to make a referral to the gender clinic. There was a lot else going on in my life at the time, so I went back to the gender clinic when I was 28. They remembered me from the last visits, and I had the psych evaluations and a diagnosis. Then I went ahead with the operation when I was 31.

I was excited before the big day! I had a penile conversion. They take skin off the penis, and they use the nerves that run along the shaft to make the clitoris. The whole thing gets sewn up, inverted and they make a space, between the prostate and the anus, so it's in there. So if I go for a prostate exam now, they don't go up my backside any more, they have to go up the vagina. I've not had it done yet and I'm not looking forward to it, but I suppose it's necessary. The testicles go, and they use the scrotum skin to make the labia.

Recovery is tough. You have five days' mandatory bed rest. I lost a lot of blood; they kept on having to change the mat underneath me. I was out of my head on morphine and various other painkillers.

I remember five days after the operation they took off the bandage, took out the packing and I saw it for the first time. Not that there was a whole lot to see. So, I'm lying in the bed and there's a mirror at the end of the bed and the surgeon's asking what I think. I don't think I gave him answers he liked – maybe I didn't come across well when I was out of my face. But I couldn't see much except a black/blue void, with a glint of stitches or something.

When the stitches started to heal and knit together, that's when it got really mental. Everything was compacted and squeezed together, right on the clitoris. I could be sitting there talking to someone, and I'd be like, 'Oh yeah... ahhh...' It was so funny. It would happen at random times. If I was talking to somebody and it happened, they'd ask, 'Are you okay?' and I'd be like, 'Fine.' Really, really, fine.

Even the first time I had sex after the surgery was surprisingly good. I enjoyed it. Sex as a man could be fun, but ultimately it was

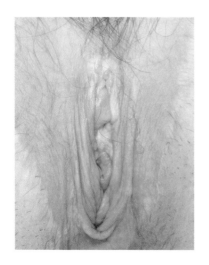

confusing. Sex as a woman just makes so much more sense. My vagina is just as sensitive as the penis before it. Masturbation also makes more sense now. I feel relief after an orgasm, rather than confusion. Somehow, orgasm registers differently in my mind now.

I think my vulva looks good. It's not perfect, but it doesn't need to be. I like it. As far as I'm concerned it's better than what was there before. They've done a sterling job. Let's be straight up front and honest about this: I don't have a vagina. I would describe mine as a neo-vagina.

I'm not a real woman. I canna be. I'd have loved to have been one, but that didn't happen for me and I have to make do. I can't claim womanhood. I have a different body to women, I have different biology, different needs, I grew up differently. I don't think it should be something to feel embarrassed or shamed about. I'm a transsexual woman and that's fine by me.

I didn't have a girlhood, I wasn't socialised as a girl. I have some similar experiences to other women. I deal with everyday, casual sexism now. The world can be a challenging place for a woman, but I'm certainly far more comfortable in it now as a transwoman, and I can contribute more in the world than I could as a man. The world's a far better place for me and I'm happier within it.

I'd like to see a very bright future for women. We need to resolve this whole debate about sex and gender, that's for sure, before we can make sure the future is bright. Women need to make sure that they do not lose their language. If you lose your language, you lose your power – what little of it you have. The power to name things must not be stolen from women.

Thirty-eight years old

"My mother used to call me 'gorilla'"

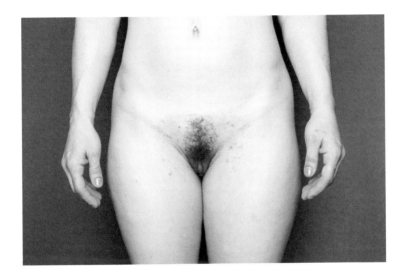

I don't like the words 'vagina' and 'vulva' at all actually – they sound medical. I don't see it as scientific or medical, I see it as powerful and a bit more mysterious. I prefer cunt, punani and pussy. If I went to the doctor I probably wouldn't use a word, I'd probably just say, 'down there', or, 'my thing.'

I like my pussy. I'm quite happy with it, and I think it's quite happy with me. Generally we get along. Sometimes it calls out to you to look after it, other times it doesn't. Sometimes it wants a party, other times it wants more quiet time – like anyone.

As a woman, you have power in society because it generates desire in others, and that can have a very strong positive or negative effect on your social life, on your work life, on many areas of your life. For example, I am totally at ease with me and my sexuality, but I do find that sometimes as a woman in society I can be objectified or sexualised or abused in some way.

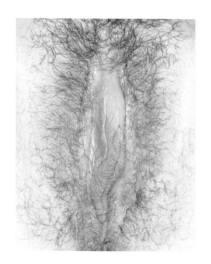

I have experienced liking someone, having a sexual interaction with them, and then developing a lover relationship, only for their friends to start to approach me, like, 'Oh, we want some too.' Like I've become a sexual object instead of getting to know me and liking me and seeing how we interact. It's like I'm an available hole for anyone. That's quite disappointing.

I am generally heterosexual but I do like having sex with women as well. I've had less experience with women than with men, and I've never had a relationship with a woman. But I find them very attractive and interesting, and they're in my fantasies as much as, or more, than men. I often fantasise about both together. I've done my fair bit of everything.

Women are supposed to be the weaker sex, but I've always been strong. I've always been stronger than a lot of males my age. At school, all the boys were scared of me because I was stronger than them. So it always makes me laugh when people say women are weaker and that's that, it's biology. They haven't had my experience of life. I grew up being the strongest and guys being scared of me.

I am small in size, but my muscles are big and very defined. It makes me feel less feminine, but it also makes me feel very powerful. When I was younger I hated my muscles and I was always trying to hide them. My mother used to call me 'gorilla', lorry driver, Bruce Springsteen – what nicknames. Fashion has changed and now it's more acceptable for women to be muscly. Madonna started it, maybe 15–20 years ago or so. Nowadays men like more athletic women. So because I've grown up and I feel better about my body, and because attitudes to women's bodies have changed, I do like my muscles now and I show them off instead of hiding them.

I'm not this dainty little girl. It frustrates me sometimes that my mother wants me to be a certain way. All mothers want their daughters to be something they haven't been, or be more pretty and more beautiful. She used to try and convince me to stop training. In the end I did stop training. Then I started going out, getting drunk and shagging boys. There you go. I don't know what was best. She didn't call me gorilla then, I suppose.

My mother is not traditional in so many ways. She had me when she was 18 and I don't know who my father is biologically. My mum and I were always very good friends, very close because she's young. Because she didn't really have a normal life when she was a teenager, because she had kids when she was really young, she used to go out with me and my friends. That's when she actually had her teenagehood and started drinking and all that kind of thing. It was quite fun.

Forty-two years old, no children

"Becoming a woman was to be harassed by men"

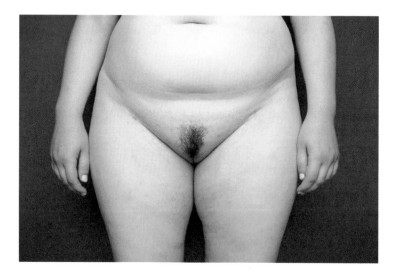

When I was younger, I was repulsed by my vagina. I remember being in the bath when I was about 12 and noticing a few hairs. I asked my mum what they were, and felt horrified. And they kept on growing and growing. I got used to it the more I saw it, but we're only really exposed to pictures of hairless women.

Around the time I started my periods, men started beeping their horns at me. It felt like becoming a woman was to be harassed by men, unfortunately, and to wear make-up and do your hair, wear heels, have your boobs on show. I wouldn't say puberty was a positive experience.

I know I felt almost flattered, as well as confused, that going outside,

showing any flesh, even just up to my knee, meant that the whole world wanted to beep at me. When I was 14, I was out with a friend, and some men were like, 'Get in the back of my truck. I'll give you a good seeing to.' I didn't know what that actually meant at that age. They would have been in their 30s or 40s. We laughed it off, but it felt really weird, so we had to get a milkshake from McDonald's to cheer ourselves up.

My period tracking app refers to me as a 'they', presumably because they don't want to say 'she' in case I could be a transman. I find being given a gender-neutral pronoun a bit insulting. I've had experience as a woman, I've felt repulsed by my vagina; I had to grow into the idea of having it and having hair down there. I think I was scared of growing up, because once you start growing hair and having periods you become sexualised in the eyes of the world. So not being able to say, 'I'm a woman,' removes that experience for me, it becomes a neutral experience. It's hard to explain.

My sex life is very good now, but for a long time it was a bit iffy. I found it boring and wondered if I was a lesbian. I realise now I was with the wrong man. I'd just want it over, it was so boring. Also, he could get erections, but they wouldn't last long. He'd been watching porn since he was a teenager, and could only come by watching porn. Men get this thing called 'the death grip' because they're masturbating so hard, and the problem is that the vagina cannot recreate that sensation.

I've never really liked the idea of porn because I could never tell if the woman was consenting or not. I also don't like the way it's ruined sex for a lot of people, men and women. If men aren't able to have sex, or enjoy sex, with a woman, even though they're straight, how do you fix that? Maybe a sex counsellor? I don't know.

My current boyfriend watches porn, but not regularly. He likes what he calls 'feminist porn', and he likes girl-on-girl stuff. There's no problem with him, he's able to get an erection as soon as I walk in the room. He has a perfect-sized penis, not too long, not too short, just a nice mid-range one, which is good as I have a reasonably small vagina. The sensation, the way he hits me inside is perfect. He cares about my pleasure as well as his pleasure. The sex doesn't end when he orgasms and it doesn't begin with me with just sex – there's lots of foreplay. If he comes he will continue with me with his finger, or we've got a little toy that sometimes we use. Or sometimes we lie side by side and I'll just do it myself.

He says my vagina is pretty, which I think is really sweet. No one's complimented it before. It makes me feel better about myself. If you're

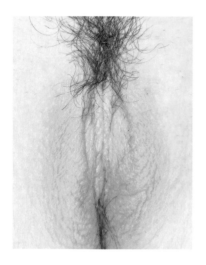

not concentrating on how you look, then you can concentrate more on how you're feeling. My last boyfriend said he wouldn't give me oral sex because he didn't like how vaginas smell, which made me scared that I smell. We're constantly worrying, 'Does it look a bit wonky? What's going on? Does it smell?' Everyone looks different, everyone has a different smell. Once you let that go, you're able to just lie back and enjoy it.

I have a little clitoral stimulator with a moving head. Have you seen the movie WALL-E? You know Eve? It kind of looks like that. It's got a moving top that moves around so you can get all different angles and different speeds. I thought it was adorable but it's also really powerful.

I've been on an anti-depressant to help me with panic attacks. Unfortunately it can affect sexual function. I've been off it for four days now, and in those days I've noticed my sensation has increased. While I was on the normal dose I found it very hard to orgasm, even on my own. Maybe I am just beginning my sexual journey. I think I will be able to orgasm more easily now.

I think my vagina is very happy that I'm finally enjoying her.

Twenty-five years old, no children

"We would create elaborate fantasies online"

It took five years to conceive my daughter. My marriage was not in a good place, but I was a woman in my thirties with hormonal urges and I wanted kids. Sex was just about conception.

At the same time as wanting to conceive, I was working therapeutically with sexually abused children and I was in a really bad place around sex. Sex to me was abusive, dirty, horrific. I was working with a young woman who had been in a paedophile ring from being a baby. As soon as my daughter was born I'd look at her and feel some kind of PTSD horror. So as soon as my daughter was conceived, my husband and I stopped having any intimacy. We didn't cuddle or anything, we

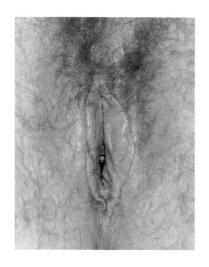

became distant. We only had sex again when I wanted to conceive another child.

My husband withdrew, he had his own room. It was hell. What kept me going was my children. When we separated and he had relationships with other women it was actually a relief.

When my son was about three, I got into dance again. I got fit, and I started thinking, 'Do you know what? I really would like to have some sex.' I'd been having therapy and my therapist really helped me get out of this hole of how abusive sex can be. As well as the work I'd done with sexually abused children, I don't feel I had fully consenting sex with most of the people I had sex with. She reminded me that sex can also be this amazing, wonderful connecting experience.

By the time I met a man over Facebook, I was in a different place. I was 41, feeling really great physically, I was fit, slim, I looked gorgeous. I think women in their 40s can be in an incredibly powerful place. When we met we had an amazing connection. We had an astonishing sexual relationship. We were very experimental. We went down some fantasy routes that I realised I wasn't comfortable with, and we came back from those, because we could communicate about it.

He was into S&M stuff. We would create elaborate fantasies online. He played this character, a German strict office manager, and I was his sexy secretary. He'd tell me he was going to turn up at a certain time and I'd be in trouble for not having taken the notes down, or whatever. He wanted to smack me and use a riding crop and take photographs of this. The build-up was very exciting, but I realised really quickly that I wasn't into being hurt. Then I wondered why he was so into it, why did he want to hurt me? I wanted to sustain a non-judgemental space around it because he's a very loving person, but there was a part of him that was excited by degrading women.

A favourite fantasy was him playing the tribal elder having to initiate me, the virgin. I liked that one – he'd 'show me the ropes' – it was very exciting. There's part of me that enjoys the service and the exploration of power.

It's not part of our sex life now. But interestingly, he finds it hard to

ask for what he needs if we're just having ordinary sex. He can act out an elaborate role-play, but not tell me how he wants me to suck him. On the other hand, I am more empowered than at any time of my life. I say 'no' if I don't like something and I won't fake orgasms any more, which I did at the beginning because I was playing into this whole sexy goddess thing.

I haven't told him I faked orgasms. Women do it to please men, or they want it to be over, or to play along with the idea that they are an incredible sexual woman.

I have much deeper orgasms with him. His cock fits me well – it's the right length, not too long, not too small. It curves up slightly, which suits me because I have a retrograde uterus; my cervix pokes back at an awkward angle. Sometimes when I've been with guys, their cock has hit the neck of the cervix and been really painful.

I recently looked at online dating. I live in the country so I had a look at Muddy Matches, which is for people who love the outdoors. Where I live there's a lot of fat farmers who make no effort whatsoever with their selfies. You can imagine, Daveth in his overalls with his pigs. I was astonished by the lack of care some of the guys took over their profile pictures, but it was hilarious.

My fanny has given me a lot of pleasure. I think she'd like to keep having sex! It's a wonderful joyous act. I need to do it with full knowledge, love and care.

Forty-six years old, two children

"We should be proud of our cunts"

We've been a good team, my cunt and I. It has been kind to me, served me well and I look forward to it continuing to do so for the rest of my life. I love my beautiful cunt, it's a gorgeous pinky red colour. It's been appreciated by partners too. The word 'cunt' means good things to me. The worst thing you can ever call a person is a cunt; I think we should re-appropriate the word in a really positive way.

I didn't have sex until I was 25. I was married for three years in the 1970s and actually got a divorce on the basis of non-consummation. I wanted to have children, and that was never going to happen with my husband.

We spent our honeymoon at a bed and breakfast overlooking the sea in Weymouth. On our wedding night my husband said he had a headache, which is supposedly what women say when they don't want sex. I thought it was fair enough, but it went on for three years.

I went to see a marriage guidance counsellor and she said some quite unhelpful things like, 'Perhaps you ought to wear a sexy black nightdress.' I knew it wasn't about me, it was about him. I was resigned to it, but I did want children. If my cunt could have had a word with him, it would have said, 'Come on now, you're missing out, we've got something really beautiful we could share and you're missing all these lovely opportunities to have sex with me.' But it was a different time. People didn't talk about these things. He was a very nice, gentle man and I'm still good friends with him.

I met somebody else and that changed everything. We had brilliant sex. And then we had children.

It was through my involvement with the women's movement in the 1970s that l found my voice and the strength to confront patriarchy. I began to express my sexuality on my terms. In our patriarchal system women are divided off from each other when they start living with their sexual partner in a couple, each in their own little box, with very little outside help from family and friends. I think there is such a thing as the biological imperative, where we want to have children, but the reality is when we have them, it is a lonely, isolating furrow to plough.

Since I split up with the father of my children back in 1981, I have not lived with a sexual partner, because if you can maintain your own roof over your own head you're much more empowered when you have sexual relationships with men.

My attitude is what's good for the goose is good for the gander. If a relationship isn't working you can back off, if you have your own space. I didn't want to be dependent on anyone else's space. If a woman controls the roof above her head, she has control of what goes on underneath the roof.

I think pornography is degrading. It finished one of my relationships. He had a fetish for breasts. About two years into a relationship I found out my partner was using porn. l felt demeaned and undermined knowing he used it. As a feminist l objected to women's bodies being exploited in this way. He said he would have counselling about it, so l stuck with him for too many years after. But a leopard can't always change his spots.

I'm 70 and I still enjoy sex. I see my current partner for extended weekends. For half the week I do my own thing: I look after my grandchildren, I belong to a women's drama group, I see my friends. Most people don't have sex seven nights a week, so just seeing him for four nights a week doesn't affect our sex life. Every time we see each

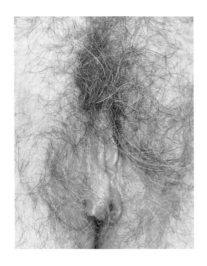

other it's a positive step we're taking, a choice to be together. It's wonderful to have somebody I can share my bed with.

I was ready for the menopause to happen. I think we have to come to terms with life's changes in the most positive way we can. You lose some of your lubrication, but a little bit of spit solves that problem. Your sex life can still continue post-menopause!

I became a midwife because I'm a feminist. I wanted to empower women. Very often women aren't empowered in the process of giving birth and I wanted to try and encourage them, give them more self-confidence.

It's wonderful to see the baby come through the birth canal. It happens with a great deal of effort from the woman and it's a wonderful, beautiful moment. At best it is a gentle slow process, the baby just slithers out. It's amazing how a woman's body goes back to its original shape – it's miraculous, beautiful.

Having children can change your relationship with your cunt. I had a slight tear when my daughter was born, but I had to wait to be stitched up by a doctor. That was the worst bit of all, and it coloured the whole birth experience, because after he stitched me up I didn't feel the same as before – one labia felt smaller. One lip felt tucked in a bit, that's the best way I can describe it.

As a midwife I've probably seen more vaginas than most people, and they're as different as our faces or our hands. Whatever you've got is wonderful. I think an artwork of 100 vulvas is a brilliant idea. We should be proud of our cunts.

I'd like to see cunts being the focus for women's sexual solidarity. Women are often divided off from each other. Women all have cunts, and that should be the basis of our sexual solidarity. Cunts are us.

Seventy years old, three children

"My pussy guides me"

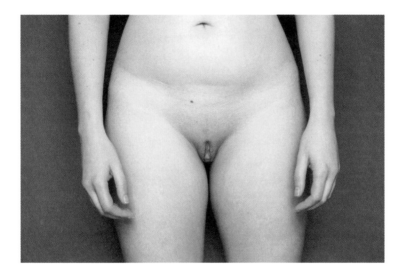

If I'm feeling playful or in a sexual setting with my partner, then I will refer to my vagina as my pussy. If I'm talking with my friends or I'm on my period or something like that, then I will refer to it as my vagina.

I go through phases with pubic hair. At the moment it's gone. Typically, when the sun starts to come out and it gets hotter, I find it a bit more hygienic. It also depends what's going on in my life. If I'm meeting somebody then I might remove it. My pussy can be more sensitive when it's not guarded by the hair, so I like that too. And I do like being able to see it. Sometimes I want to feel a bit hidden, so I'll let the hair grow out a little bit and hide me away.

I've always had a really great connection with my pussy. From talking to my friends, I realised I discovered it at a very young age. From the age of three or four, I enjoyed touching myself, knowing that my clitoris was there and that it felt good. I remember being caught.

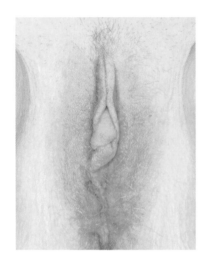

I was very young, I was in the front room and I was having a little tickle. *(laughs)* My Nan came in and saw me and she told me to 'Stop that right now!' I went from enjoying myself in a free and expansive way, to feeling very self-conscious all of a sudden. Even today, that's quite a poignant memory. I was caught a few more times and so I started masturbating in secret.

Society isn't positive about masturbation, or it wasn't then. My gran was from that era when sexuality wasn't exactly liberated. She wouldn't have been able to say, 'Well, don't do it in public but in your own free time just masturbate away.'

My mum fell pregnant with me when she was very young. She had me at 17 and then my sister when she was 18. So to prevent us from being teenage mothers she didn't allow us to have boyfriends until we were 16. But that created a lot of secrecy and curiosity around the opposite sex. Once I turned 17, I felt suddenly free and I really wanted to explore my sexuality. I knew that I was a sexual being and that I loved interacting with fantasy and desire. My pussy had the most fun when I hit my mid-20s. By then I felt really free to explore my sexuality and fantasies.

I feel very positive about the experiences that I've had. I feel honoured that my pussy has guided me towards exploring my desire, and to an understanding of how the brain and the pussy are very connected.

Sometimes I can be exploring something sexually and my mind may be saying, 'Oh, no way. I could never explore something like that,' but my pussy is saying, 'Yes, you could!' I have been quite playful in the realms of the kink world. There's a wide spectrum within that world. I would be considered quite tame, but everybody has their likes, their dislikes, their limits.

When I am engaged in an act which is about surrendering sexually, surrendering to the masculine, however that looks, I can come up against internal barriers that I feel like I could never go past, I could never step out into that much liberation. But my pussy guides me by saying, 'Yes, something is happening down there.' When I feel aroused, there are signals; my pussy is communicating to the mind somehow, and I can surrender.

I like to say 'yes' again and again to new experiences. I like to explore what I already like and the new. I like to be free and unencumbered in my sexual explorations.

I have orgasms from my clitoris and G-spot. The two work in unison to create fireworks. I've had partners that really get off on the idea of my pleasure and they want to ensure that I am pleasured before they are pleasured and that's wonderful. It's important to me that my partner has a connection with my vagina.

The kink world is almost like a subculture. There are workshops, meet-up groups, parties, clubs. There are special parties put on by companies in different types of venues. It might be a standard club or a kink club. You couldn't tell it from a different bar, people are having a chat and a drink, but there are other rooms. There's normally a room with a large bed for orgies and then you'll have other rooms that are more catered towards specific types of fantasies, like you might have a classroom or a doctor's surgery. There will be toys within the rooms to make it more authentic, like desks and chairs and a chalkboard in the classroom, for example.

I feel like I've been on a journey of liberating myself sexually. I would love to be able to ignite and encourage women to explore their sexuality. There's a lot of shaming of masculine sexuality. I wonder if there would be so much shaming of men's sexuality if women would just allow themselves to get out there and explore.

Thirty-two years old, no children

"I have no vagina"

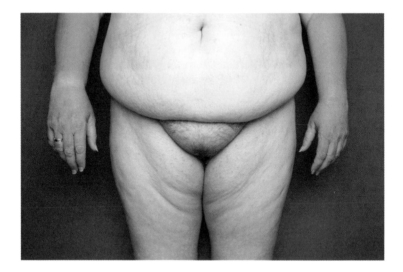

My fanny has served me very well throughout my life. I wish I'd had her a bit longer.

I haven't got many hang-ups and I've been really lucky with my sex life. I have probably slept with more men than I 'should have', or is socially acceptable. I don't know what the average number is, but I'm sure I've had more. I had two big brothers and so I've maybe absorbed a more male way of looking at sex. Men seem to be much freer in the way that they take pleasure and have sex.

My first sexual experience was awful. I decided to lose my virginity because all my friends had, and I was drunk, at a party – it was a one-night stand. But sex was fantastic from the second time, with a boyfriend I absolutely loved. I had an orgasm from oral sex the first time we were together, on my mum's lounge floor. I've never been able to have orgasms from vaginal penetration.

My son was 10 days late and I was induced. To cut a very long story short, I was in labour for about 17 hours and I almost gave birth to him, but they decided he was stuck and I needed an emergency caesarean. The midwife was between my legs basically thumping my son's head back into me while the consultant was kneeling on the trolley with the forceps in my stomach yanking this baby out. It was quite a traumatic birth, to be fair. Then I had a major infection on my c-section scar.

It felt like my vagina was wrecked. I vowed at the hospital I would never, ever have another baby, and I would never, ever have sex again. I felt like no one would ever touch me below my waist again. Of course, they did.

Very rarely have I looked at a guy and gone, 'Oh my God, I really fancy you. I want to rip your clothes off.' The one guy I fancied the most with was the one that I had the best sex with. We didn't have a relationship, but we had incredible chemistry, and we had lots and lots of sex.

I think it was so good because it was just purely sex. Literally, it was walk through the door, have sex. I didn't want someone to have a conversation with, I didn't want to sit and have a cup of tea, I just wanted to get laid. I think if I had loved him it would have got really messy and really complicated. He had a very big dick which is always nice. I like a big dick, you can't say fairer than that. Some women prefer certain types of cock – I'd choose girth over length any day – and any man will have preferences about vaginas.

Anyway, I hadn't seen him for ages, years, and I saw him out of the blue and, of course, we had sex the very next day. And thank God we did, because afterwards he said, 'You're bleeding like a stab victim.' They were his exact words. He was clearly worried. I was concerned. I went to the doctor the same day.

The GP examined me and the mood in the room completely dropped. She asked me when I'd last had a smear test, and I hadn't had one for years. I put two and two together. She wouldn't tell me if it was cancer or not, but she said, 'I'm going to refer you on to the hospital.' I said, 'What will they do?' and she said, 'They'll stage you.' So that was kind of telling me. She took one look and she absolutely knew.

The stage of cancer that I had was a 2A, which means it was growing down into the vagina, so she would have seen it clearly. I was diagnosed the week before Christmas. I don't think there's ever a good time to get cancer, but the week before Christmas is particularly shit because everyone is, 'Happy Christmas!' and you're dealing with just being told

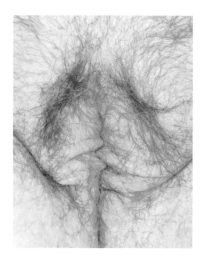

that you've got cancer, going backwards and forwards to the hospital for scans and blood tests, with all the lights and the Christmas songs on the radio. It was a really, really hard time.

It made me very angry. I remember my Macmillan nurse saying to me, 'Have you been angry yet?' and I said, 'No, not yet.' Then about two days later I absolutely lost it in Curry's because I hadn't bought my son any Christmas presents yet. The manager wouldn't ring up to see if there was a PlayStation at the next branch. I called him a cunt and I got barred from the shop.

Really, a lot of this anger was because I was angry with myself, because I'd not gone for a regular smear test. I only had myself to blame, didn't I? There was a lot of that sort of talk in my head: 'You've only got yourself to blame. You've slept with too many men. You've not looked after yourself. You've not gone for your smear test, so what did you expect?'

I had a radical hysterectomy that involved taking the uterus, cervix and top few centimetres of my vagina away. I kept my ovaries – I was only 42 at the time, and didn't want to go into surgical menopause as well. I felt like less of a woman after the hysterectomy. Although I didn't want more children, it took the option away.

It was major surgery, not to be compared with a normal hysterectomy. After the op, I had to wear a catheter for a long time because the tumour was growing all round the nerves that led to my bladder. So they had to cut through all the nerves that connected to my bladder to get the tumour out and then join them back up. It took quite a while for my bladder to work properly. Having a piss bag strapped to your thigh is really nasty. I had a rough old ride.

Death can make you feel quite horny, which is a bit bizarre because you'd think it would be the opposite. There's a part of you that wants to make sure it all still works and functions. 'Lovely sex man' knew that I had cancer, and after I'd recovered he used to pop round. The first time was scary, but I was relieved that everything still worked.

When you haven't got a uterus, your orgasms feel completely different, because you don't have those contractions. It's one more shitty thing. Yes, I can still come, but it's not the same as it used to be. If you

think of an orgasm, it starts at your clit and it takes you right up to your bellybutton. But mine doesn't anymore.

Later that year I was diagnosed with vaginal pre-cancer. Not the cervical cancer returning, but vaginal pre-cancer. I had it removed with a small incision and then it came back again. We watched and waited – it got worse. I had another big chunk of my vagina taken away.

Ultimately, I needed all my vagina removed, because they couldn't be sure about my risk and if they could catch it before it spread. I have no vagina anymore. I look normal from the outside, but there's nothing inside. They basically take the skin off the inside of your vagina and it heals closed.

It's quite odd to have your vagina taken away, because that's where the dick goes. I loved vaginal penetration but it never gave me an orgasm. Still, I had to think about whether I could live without my vagina. I was very low after that operation. I was 46, I loved sex, I'd had the most amazing sex, and that was over.

How do you bring up not having a vagina in conversation? How can I date again? Why would I put myself through that? That's big shit. I've not been with a man since I've had my vaginectomy in any way, shape or form. Perhaps I need to find a fat, impotent man.

They offered me a reconstruction. To reconstruct a vagina, they would have needed some skin to graft back onto the muscle of the vagina. They'd have taken the skin from my thigh.

There were many, many things that put me off reconstruction. By this time, I'd just had enough of surgeries. It would have involved meeting another consultant, a plastic surgeon, and more procedures, more recovery. The vagina also wouldn't have had any lubrication. Thigh skin does not self-lubricate. It wouldn't have had any sensation. If I had penetrative sex it would feel like someone was rubbing my thigh. And because they take the skin off the inside of your thigh, if that's hairy, then the inside of my vagina would be hairy, which I think is just really weird. So the idea didn't appeal. If it sounds like it was an easy decision to make, it really wasn't.

The really big downside for me, was the risk of ruining the nerves to my clit. I could potentially go through that entire procedure to have a fake, hairy tube, which would be for someone else's pleasure, not mine, and I could risk losing my own pleasure if I lost sensation in my clit. I've always loved my clit, my clit has done some amazing things. You've got to define whose vagina it is, what it's there for and what you want to do

with it. It was my vagina.

I've not looked at my vulva since I've had my vaginectomy. I nearly backed out of being in *Womanhood*. And I don't like how it looks. It looks like a worn out old balloon or something.

People say you are brave when you have cancer. Actually, when you have cancer, there's no choice – it's not bravery. I think having my photograph taken today was braver. But I believe it's important that women feel more comfortable with their vulvas and vaginas, for lots of reasons, but also because they need to go for their smear tests.

No woman alive wants to go for their smear test. I've always been overweight. I was embarrassed about my body. I've always been quite hairy, so I was embarrassed about that too. I was more insecure about my belly than my fanny. A lot of women are embarrassed about their bodies and their fannies. We're taught from a young age that its private. Sometimes we get reactions from doctors and nurses that don't help. I went for the morning after pill when I was about 19 or 20, and as I was leaving the doctor said, 'Don't be such a slag next time.'

I think I only had one or two smear tests in my whole life up until the last five years, when I've had more bloody things stuck up my fanny than I can count. If you don't want to lose your vagina, go and have your smear test.

Forty-seven years old, one child

"I get very, very wet"

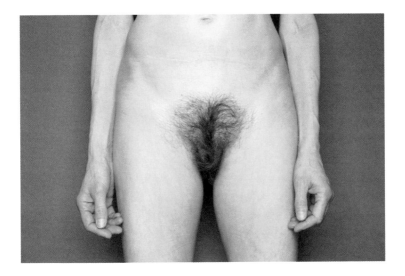

When I was breastfeeding, I first made the connection between my breasts and my womb. For the first six weeks when you breastfeed your baby, the pain is excruciating as the womb shrinks back down. I was so aware of the connection between the flow of the milk and a direct line down into the womb causing contractions.

The moment of my milk letting down was almost like a mini-orgasm. It's difficult to explain, but a feeling of tension and release. The oxytocin made me feel very relaxed and calm, whereas it's not really my nature to be sitting doing nothing. My babies and I were both nourished in different ways. And the great thing was no periods.

I have never really called it anything. I know some people call it a yoni or the vulva or the vagina. I've only referred to it at all in the last few years, and I've had four children. I think I was in denial and not

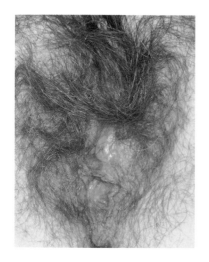

connected to it. I wanted children, but for many years I didn't actually take that much sexual pleasure.

I was with my husband for 30 years, but we've been separated for three years. Maybe I didn't choose wisely. My husband was a good provider, but there was a certain something missing in the relationship. We didn't have sex much, my drive was much higher than his, and we never talked about sex. I think the time that I was most aware of my sexuality and the absence of sex was during my pregnancies, because you have this tremendous amount of blood going down to that area and I was very horny, and he wasn't. It was a great frustration for me.

I got to 50 and I thought, is this what I want for my life? Am I happy with this? The answer was 'no', I wasn't living a fulfilling life and I had no sex life with my husband.

I have a new partner now and a much healthier sex life. It has given me a lot of joy and pleasure in the last couple of years, more than I could ever have imagined.

I'm in menopause and it's a rollercoaster of a ride. I have these hot flushes that are like mini-orgasms. When I fight the hot flushes it's not positive, but when I actually ride them, it's like riding a wave of energy and heat. My current partner and I sometimes ride that wave together, cuddling and close, and it's really quite powerful. My whole body breaks out in one big sweat. I am completely wet all over.

I have read somewhere that menopausal hot flushes are a release of sexual energy that's been pushed down. So if you've not been able to express your sexual energy in a healthy way through your fertile and younger years, you get worse flushes. I know when one is coming on. And some thoughts bring it on too; I think there's a psychological aspect to them. I've got no body thermostat, I'm either sweltering or freezing, there doesn't seem to be a happy medium at this point.

Another thing I have discovered since being in the menopause and since being more active sexually is that I get very, very wet. I experience female ejaculation. Another word for it is 'amrita', which means nectar.

In the past, it was an annoyance with my husband – he didn't like

it when the bed was wet and it was, 'Who's going to sleep in the wet patch?'. But my current partner really loves it. For him it's a real bonus. If I'm really relaxed and 'in the moment', it's like a dam welling up and it just bursts. Because my partner really likes it, I don't feel inhibited and it can be like a fountain. For him, the wetter the better.

I always hated my body and it's taken me a very long time to accept it. I was teased at school for being the tallest and skinniest. I was 5ft 9in when I was 12, very thin, with no breasts. I was just skin and bone and teased relentlessly – thread legs, stick insect, you name it. I used to do everything I could to hide it. When I was 50, my friend told me about boudoir shoots, and I found it very empowering to see that actually my body wasn't that bad. Taking part in *Womanhood* is a very affirming thing to do. Having spent the last couple of years discovering the pleasure of my vagina and vulva with my new partner, this process is part of my body acceptance. My vulva and vagina are an important part of me and they bring me pleasure.

Fifty-four years old, four children

"I'm not really sure if I have orgasms"

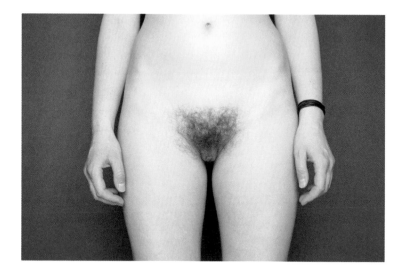

I like her, I really like her. Her, of course, because in German we have male and female articles so she is *die Vagina*, female. I don't like the words we use in German, but we also say vagina and vulva. I barely talk about her though.

It's so interesting to see what she looks like. I'm proud and a bit surprised how she really looks. She's so beautiful. When you look on the internet at advertisements for porn sites, or workers, phone sex ads, the penises and vulvas don't look so nice, quite aggressive, even disgusting. I think *Womanhood* will show how different and beautiful we all are. There is too much shame about our bodies.

I'm proud to be part of a book about vulvas. I think it really could help women, and people in general, to accept themselves and see the diversity in human beings and find themselves beautiful.

Before I ever saw her, I felt her. I remember I discovered her when

I got my period. I wanted to stop using sanitary napkins, and start using tampons. Exploring my vagina felt quite technical in the beginning.

I tried to look at myself in mirrors, but I gave up quite quickly. I was a little bit embarrassed. I was always afraid that someone was going to come and knock on my door while I was trying to look.

It was the same when I started to masturbate, which was weird, because I grew up with very open sexual parents. I often saw my parents naked. I knew they did Tantra. There was a very open atmosphere in our house, so I'm not sure why I was so embarrassed. Despite my family, I think I got the message from society that I shouldn't touch myself. Touching is very natural for children. Boys always touch their penis and it's okay. I have seen little girls told, 'No, no, don't touch it.' The shame applied to women runs very deep in our cultural and societal genes, because oppression has happened over many centuries.

After getting used to touching myself, I realised there could be some pleasure. Then later, with the first sexual partners, I was comfortable with touching and exploring her. I was about 14 when I had my first sexual partner. I didn't really like it, it was more for him. I felt some pleasure, but I had more pleasure when I explored myself on my own. With my second partner something really clicked, then it was better with the next one and even better with my current partner! I felt like a knot was released or something with my new partner, something just felt better. Now I also have a vibrator.

I'm not really sure if I have had orgasms. If I compare it with what people write about and talk about, I'm not sure if I'm quite there. The best sensation has come from touching and oral sex. Penetration isn't enough on its own, I need some help to get there. You read about all these different mystical kinds of orgasms and I haven't had that!

I'm trying to understand my cycle more. It makes me feel more feminine, and more like a woman. I never felt like I was in the wrong body before, but I never particularly felt like a woman. I feel more connected with my body now.

Just a few weeks ago, I found the opening of my cervix. I couldn't find it before, but then last month I felt the change in it a few days before my period. I want to understand natural fertility and contraception better.

People talk about male energy and female energy. I wrote my Master's thesis on gender studies and literature. But I'm really struggling with male and female energy – does it exist? Is it a social construct? A spiritual

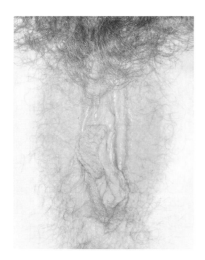

idea? I don't think I have a working system to explain male and female 'energy'.

I see myself as a soft, gentle, caring, loving person, but also as very smart and confident. I want to be seen and live as a human being to my full potential. This is what I'm fighting for in different ways.

Twenty-eight years old, no children

"I tore from my vagina to my anus"

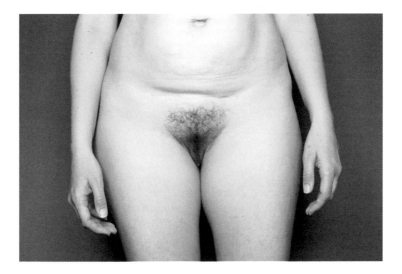

I'm glad there are two photos in this project. They show both ways I had my babies. I have perineal scars and caesarean scars.

I tore from my vagina to my anus when I had my first baby. I had an episiotomy, ventouse and forceps and then I tore as well, so there was quite a lot of damage. It was clearly not the birth experience that I wanted, but I've made my peace with it now.

I had physio for nine months afterwards to try to restore normal function. My physiotherapist didn't have a sense of humour, which was really hard when she was putting things up my bum. (laughs) I tore through the muscle tissue around my anus so I don't have the control that I should have. If I need to poo, I need to poo straight away. I could have had surgery, but that wasn't recommended if I was going to have more children. It's manageable now. I'm only really affected first thing in the morning. I don't always make it to the toilet in the morning. I have

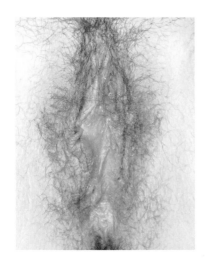

to wear disposable pants if we go camping so that I can get across the field.

After she was born I was offered 'birth reflections' by the hospital, but it was rubbish and in a way made me feel worse. I think they were making sure that I couldn't have a case to take any kind of action against them. Basically, someone looked through my notes and said they did what they needed to do, which is fine, and I was not disputing that, and I am very grateful that she and I both came out in one piece, but the trauma and the emotional aspects weren't addressed.

At home with the girls, we tend to say 'foof', and 'fanny', although I do say vagina with them. My eldest who is 10 hates that, but it's important to use the right words. She's on the cusp of going into adolescence and she really hates talking about periods. We've always been very open and clear about bodies and sex and reproduction. She was five when I was pregnant with my second and she was very inquisitive and would ask me how did that get there and what do you do. There was no brushing under the carpet, she wanted to know everything and I very openly told her. So she's been okay with all of that. When I have a period they see me on the toilet, they see me changing. My eldest really doesn't like seeing me in the bathroom if I'm having a period now. She'll be like, 'Ugh,' and turn away.

I started my periods when I was 11 and I wanted to make sure that she was prepared. I made a little pack for her; I bought her a Zoella make-up case to hold sanitary towels, wipes, some hand gel and a spare pair of knickers. I've stocked the toilet that's next to her bedroom with stuff. I've asked her to think about what she'll do if her period starts at school, because she's very private and she would be mortified if she had to go and tell a teacher. She'll probably want to deal with it herself.

I remember feeling quite proud of being grown up when I had my period. Mine started at home, so I told my mum. I remember that she gave me some sanitary towels, the big old-school type, not like what we have now, and they were crinkly when I walked.

My mum was a very strong presence and she was amazing. She worked full time, but we knew that she was always there for us, that she

loved and protected us. It's been hugely important for me to have my mum involved in my children's lives.

My children don't know that my mum has terminal cancer. We haven't shied away from the word 'cancer'. She was originally a bit nervous about using the word in front of them. They know it's an illness, but they don't know what that means. We don't talk about it too openly in front of them, because I don't want to frighten them and I want them to treat her in the way that they would every day without a shadow over that.

When she was first diagnosed three years ago, one of my overwhelming thoughts was that she's like a third parent to my children. She does things for them as a loving grandparent that nobody would be able to replace. I think her grandchildren are a large part of why she continues to be well and healthy and positive about the future – she's got that relationship with them.

She came to live here for a while after her latest diagnosis. Originally she had breast cancer, then secondary bone cancers, now liver cancer. She arrived with us on Christmas Eve. Even though she didn't look well and she couldn't play with them, she mostly just sat in a chair and read them stories on her lap. They loved having her here.

I love being a woman. I have always been thankful that I'm a woman because I knew I always wanted to have children. Pregnancy, birth and the ability to feed a baby were mind-blowing. I loved being pregnant.

Genuinely, I think women are amazing – we're very strong. I love how emotionally literate, articulate and sensitive women are. I think the downside for women is that women who do not conform to a maternal, emotionally-connected stereotype can get a really hard time and be seen as less of a woman, which I hate. Women are often treated very poorly in leadership; the same qualities that are celebrated in male leaders somehow become a negative thing in women.

I want my daughters to know they have the right to govern their own bodies and their own choices. That they can say 'yes', they can say 'no'. People make little children kiss people, relatives, because socially that's the acceptable thing to do. I have massive issues with that, because as an adult you would not make somebody kiss somebody that they felt uncomfortable with.

I want my daughters to know they can do anything. I want them to be successful in whatever success means for them.

Forty-two years old, three children

"The ideal scenario is clit, vagina and arsehole all in one"

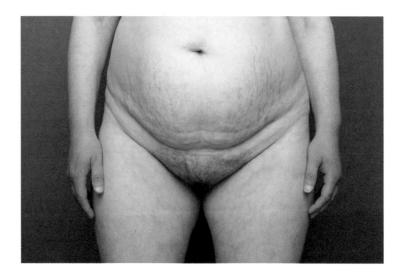

I was only an adult human for a couple of years before having my daughter so, for me, being a woman is very much being a mother. I'm only now starting to consider more about who I am as a woman in my own right.

Me being a mother made me feel a lot of anger and a lot of genuine despair about my mother. She's not a woman that I would be friends with or have anything to do with if she wasn't my mum. But she is my mum.

I left home when I was 16. I didn't have a very nice stepdad. We never got on and he never liked me. I was a fucking arsehole of a teenager, but there were reasons and I wasn't happy. My mum had to write a letter saying that they were kicking me out of the house so that I could get

income support and housing benefit. She did that because, frankly, they didn't want me there.

Later on I was quite sad about it. I've been rejected and not looked after, and it has stayed with me in some ways. I think it's difficult being a mother, it's difficult trying to do the best that you can, but I don't believe that she did the best that she could. I'm okay with that now.

My daughter is 16 and I can't imagine her living on her own and getting by on a day-to-day level without having parents around. I must have been alright, mustn't I, because I looked after myself. Actually, it's quite incredible.

My mother is very judgemental about women's bodies and always has been. She'll say things like, 'Oh so-and-so had their legs out. I wouldn't have my legs out if they looked like that.' She's quite judgemental and bitchy. For a long time she would tell me I needed to lose weight. She doesn't say that anymore, instead she'll say, 'I'll tell you what I do. I eat half a grapefruit for breakfast and it just helps with this bit here,' and she'll pat her tummy. For breakfast – half a grapefruit. It's basically her way of 'gently' suggesting that if I did that maybe I would lose some weight on this bit here. My partner and daughter and I can't talk about grapefruit without laughing. If I write a comedy show it's going to be called *This Bit Here* and it's going to be me talking about my relationship with my mum and then my relationship with my daughter and about bodies. Obviously it's going to be funny but tragic.

Until today I hadn't seen a photograph of my vagina. It was quite interesting. I quite like it. It takes a lot of effort to look with mirrors.

My partner loves going down on me, he's not grossed out about it, but it makes me feel incredibly vulnerable, I can't get past that. You're so open when you're receiving oral sex that I don't find it powerful.

The problem is I was raped when I was younger and that person forcefully did some oral sex on me. He had his elbows on my knees and held me down. He physically forced it, and ignored me shouting at him to get off me.

Even though my partner would never do that, I feel really on edge during oral sex and I'm not able to relax. It's been better if I am on top and in the position of power, and I could run away if I needed to, even though obviously I wouldn't need to with my partner.

After that incident I went to the police. They interviewed me and tested me. So I had to have another fucking intrusion after already being intruded on, you know what I mean? But they have to do it. I couldn't

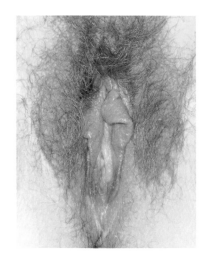

even wash till it was over. I felt really dirty, dirty in all the ways. I felt unclean, I wanted to wash, and I felt ashamed.

I was under 18 so they called my mum, even though I lived on my own. My mum was like, 'Oh no, you didn't have a couple of drinks?' and I had had a couple of drinks. I'd been out with friends – it was around Christmas time.

The police were the same, 'Oh, you'd had some drinks. Oh, how short was your skirt?' I was still wearing it, and they could see it wasn't short. Anyway, even if I was wearing a skirt up to my arse, there was no invitation ever. I don't care if you're wearing a string around your vagina and around your nipples, you're not asking to be raped. It's not an invitation.

I dropped the charges just before my 18th birthday because I did not want that to be the first chapter of what I considered was going to be my adult life. Part of me wishes I could have been stronger and seen it through. But actually, also I respect that part of me that went, 'I don't want to carry this.'

It's in my past, although clearly it's affected my sex life in some ways. I love my partner, I love sex with my partner. I just wish that I could allow myself to get completely carried away. I want to completely go for it and have that sense of abandon.

I love a clitoral orgasm, but I also love the deeper, amazing orgasm through penetrative sex that builds to the point of I don't know what to do with myself. The ideal scenario is clit, vagina and arsehole, all three at once. Just one man though! The clitoris being stimulated, vaginal penetrative sex, and if you are doggy-style you can have a little bit of a finger up the arse. It's a great scenario. It's really intense so I have to be very much in the mood for it. We have neighbours and a daughter, and we have to do it at a time or place with no one around – it's noisy. I said to my partner the other day, 'We need to go to a hotel that has soundproofed walls, so that we can fuck all weekend and have a really nice time.'

Thirty-seven years old, one child

"I lost a daughter at 28 weeks"

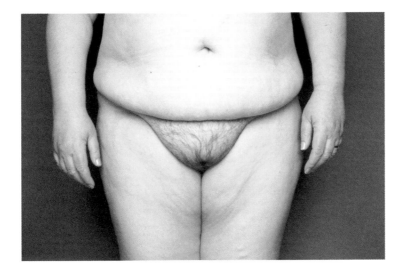

I definitely wouldn't want a penis. I wouldn't want something that could make itself known in quite that way, without me necessarily having any say in it. They're unwieldy, what would you do with them? I've got this nice little area that I can just put my pants on, I don't have to worry about a side on my trousers, for example. They seem like an awful lot of trouble.

I think of it as my front bottom. When I was little, no one mentioned it at all. I might refer to it as my lady garden, but with tongue firmly in my cheek. My lady garden, yes, it needs a little replanting. That's probably what I'd refer to it as. We called genitals a 'tiddler' for our children, for vagina and penis.

Once I had children, it changed everything. Being a woman is completely tied up with motherhood now and, in a way, mothering anybody in my circle who I want to look after.

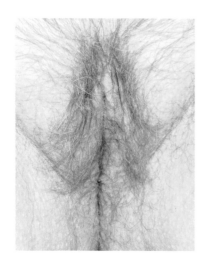

I lost a daughter at 28 weeks. When we knew that she'd died I thought they would do a caesarean section, but they said it would have implications for any further pregnancies and that I should deliver her vaginally. I was horrified. Having said that, I'm so glad that's how it went, because it meant that she arrived with some dignity. She was not removed from me. It didn't take much, she was only a pound and ten ounces, bless her. In the end, she is the only one of my children that I delivered naturally.

She was due in May. We got to March and I stopped feeling any movement. I lay there in bed at night, thinking, 'Any second…' Nothing, just nothing at all. I pushed and prodded and nothing. I told my husband I was really worried. So he called the hospital and they said they could give me a scan and put my mind at rest.

I went to the hospital and they did the scan and the woman said, 'I'm really sorry but I can't find a heartbeat.' So then I heard this woman screaming, and it turned out that was me. We fell to bits really. 28 years on it still affects me.

She is buried in a little graveyard just up the road, overlooking a field of sheep. It's got two big apple trees at the gateway. When they are in blossom it is absolutely beautiful. There are two small children buried near her; we found it kind of comforting in a way that she's not on her own surrounded by old people.

We always took the children there, right from when they were born. We'd go up on her birthday or on Mother's Day, or we'd take up a little Christmas tree at Christmas, that kind of thing. They always knew that they had a big little sister and they knew her name.

When I became pregnant with my next daughter I had a very obstructive midwife; she attached a monitor to her scalp and put a belt around me to monitor this, that and the other thing and laid me down on a bed. Because of my stillborn I just did what I was told. I feel like had I been able to get up and move around things might have been different, but I ended up with an emergency section.

I wanted to have a vaginal delivery with my next baby, my son, and my initial consultant was willing to give it a go. I'd read up a lot about

vaginal birth after caesarean. Of course, this was pre-internet so it was a case of going to the library and getting what books there were available. As the baby was two weeks late they decided to induce me. When I was in hospital the midwife, and then the consultant, questioned me, and frightened me into having another section. I think that was horrible.

It took me about 15 years to get over having caesarean sections. I felt like a complete failure, that my body didn't work the way it was meant to work. It didn't feel like birth, and I didn't feel like a proper mother when I couldn't even manage to give birth to my children.

If people ask me how many children I have I'll say three, but I feel like I've got four. You hear a lot about miscarriage, but you don't hear very much about stillbirth.

Fifty-six years old, four children

"I've never had an orgasm"

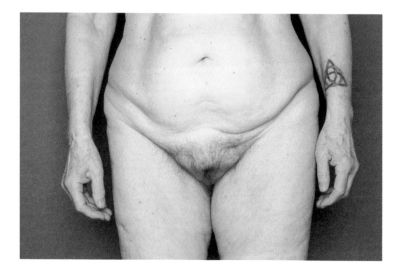

I like my fanny. It was easy to say 'yes' to this project.

I heard about women's consciousness-raising groups in the mid-1970s. I had no idea what they were and I didn't know my consciousness needed to be raised. Something we did in these groups was to examine our own cervixes. We bought speculums, mirrors and lights and we helped each other to look at our own cervix. It's terribly easy to do. Now, here's the funny thing, your cervix looks exactly like the end of a penis. So when the two of them meet, it's like the same two things meeting.

I've never had an orgasm. It's been a sadness in my life. It's one of the main reasons why my husband had an affair and then left me. He said to me, 'Well, at least she has orgasms.' I think he felt less than a man because he wasn't able to give me an orgasm, if you like.

Women friends have made suggestions. I've tried everything. I've been to sex therapy. I've tried masturbating till I'm sore. I've been to a

doctor who examined me and said I've got a very small clitoris, but that's no reason not to have orgasms.

I might know one of the reasons I don't have orgasms. When I was 15, I was having very heavy petting with my boyfriend who was 21 and I got sperm on my thigh but we didn't have intercourse. I didn't like all that sex stuff, I thought it was a bit bleurgh, messy, so I broke up with him. By the time I'd missed two periods and I went to the doctor and the doctor did a pregnancy test he said to me, 'You're pregnant. Bring your mum in,' because I was still only 15. My parents were very good, they talked to me about it and we went to see a gynaecologist. The gynaecologist examined me and spoke to my mum and said, 'This is very puzzling, this child is intact and pregnant.' It was a shocking experience and I wonder if it affected my ability to enjoy sex to orgasm. Anyway, I was telling that story in a women's group and a woman burst into tears and said, 'The same happened to me and nobody would ever believe me that I hadn't had sex.'

When I was in my 40s, I met a new partner. Before we started to be sexual, I told him, 'I just want you to know that so far in my life I haven't experienced orgasm.' He didn't mind, he just thanked me for telling him.

After we'd been sexual for some time he told me I was the most abandoned, relaxed woman he'd ever had sex with. He said, 'A lot of women are chasing their orgasm, they're end-gaming, and that's all they want to get to. Whereas with you, when you lie back and put your arms back behind your head and you just let me make love to you, I can feel you really appreciating and loving what's happening and it's not like we're trying to get to this thing at the end.' He started to practise that type of sex where he wouldn't ejaculate. So this relationship was deeply healing and loving and it was the best sexual time in my life.

One weekend I felt so horny I asked him to have sex with me about four times. After that I never, ever felt sexual again. My menopause came quite quickly when I was 40. My periods just stopped and I never felt sexual again. We both read up on it and thought my sex drive would come back. Every now and then we'd get into bed and kiss and I would just laugh, because if you're not aroused it's hilarious trying to be sexual. After two years he said to me, 'I really need sex.' I said, 'I know you do, you're great with sex, you need sex.' I was okay with that. I have never felt sexual since then.

Recently, I met a woman and I thought, 'Woah, who is that?' I was so attracted to her. I got very nervous and I couldn't make myself go and

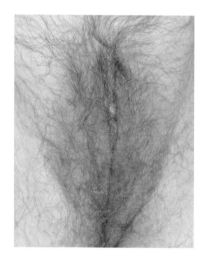

talk to her. She came striding over to me! She said she really liked me and wanted to get to know me.

Over a few days I started to feel that I was falling in love with her. I took her for a walk in the woods, where we've got one of those kissing gates. I was going to lean in and kiss her and she said, 'Hold on. Do you really want to do that?' I said, 'Yes.' She said, 'Because that's going to be our first kiss.' And she kissed me so sweetly and gently and my knees just gave way and I thought, 'Oh God, I've fallen in love.' But she didn't fall in love with me and she didn't want a relationship; she's not long come out of a marriage to another woman.

The kiss was an awakening, rather than arousal. My entire body softened. I wanted another kiss, and at first I found it a little bit arousing, but I felt profoundly disappointed that I wasn't more aroused. You know in movies when you see people who can't keep their hands off each other and they get in, close the door and they rip their clothes off? I kind of thought when we had our first proper kiss that I would feel all that arousal.

In theory, I feel open to meeting another woman. When I told my daughter, she said, 'Oh Mum, that's so great. I always thought you were a bit of a lesbian.' She's so sweet, my daughter. I hope I am a lesbian.

Sometimes I think I'm not as wounded as I think I am. That it doesn't matter that much whether I've had orgasms or not. I have used my body in extraordinary ways in my life. I trust my body. My body has been strong and fit and taken me to the most incredible places. So I love my body and my fanny is part of my body.

Sixty-seven years old, one child

"My fangita can take over completely"

I call my vagina my 'fangita'. It sounds kind of powerful, yet very feminine and fun. I know she's part of me, but I still feel she is her own entity. She has a life of her own, doesn't she?

I've always had a pretty good relationship with my fangita. I've always known what she likes. I think there were times when I didn't consider her enough, when I've had sex when I didn't really want to, and made her sore.

I've become much more in tune with her as I get older. You can meet certain men, and there's a feeling down there, of whether they are bad or good people, or whether they'd be good for me anyway... But she can also be very misleading because there are times when she has taken over completely, 'Yes, I want that and I'm going to have it,' and the sex might be great, but other aspects aren't. If I've starved her for too long she goes, 'Fuck your brain. I want this.'

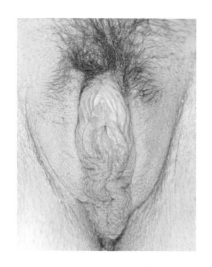

When I was about 21, I got really bad pains which I thought was a kidney infection. The doctors assumed it was a UTI and never tested me for STDs. It was only many years later that I realised I couldn't get pregnant because I'd had an infection, probably chlamydia. I could only have caught this from my first relationship. He wasn't faithful to me, and he was mentally abusive and eventually physically abusive. He was a very troubled individual. I was so pissed off that this was the result.

My current partner and I tried for about two or three years to get pregnant, before having tests and finding out that my fallopian tubes were blocked. Toxic fluid had basically been killing any babies that I had maybe tried to have before that. I'm pregnant with twins through IVF. I don't think I feel the same as I would if I'd done it naturally. So I don't feel like my vagina had much involvement in it. I just have to accept that. So there's a little bit of a separation between the vagina and the pregnancy, a connection that is not complete.

She looks different because she's got all this pressure from above and she's swollen and bulgy. I feel like my insides are coming out, which isn't the nicest feeling. At times I feel completely unsexual, but then there's other moments where I'm really, really horny.

Sex is great during pregnancy, very animalistic. I need to have sex right now, I need to feel that letting go and that pleasure that comes with it. There are moments when I do wonder if it's weird because I've got babies inside of me. There are also times when I just feel like a big fat whale and very uncomfortable. But then there are other moments where I really want it. You just learn to listen to your body and your vagina and give her what she wants.

My partner worries that he'll hurt them when we have sex. The babies generally just go very quiet during sex, there's no movement at all. Nothing. I imagine that they're lying there going, 'What the hell is going on?' But I feel that they know that this is a good thing, a fun thing. After we've finished they start moving around again. During it, it's almost like they're experiencing it in a way – that's kind of weird.

I'm more sensitive while I'm pregnant and it's a lot easier to come.

Orgasms are very intense – much more in my face – they hit me like I've got a lot less control. I can come quite easily, which is nice, so I've had to learn to control it so that it lasts longer. I've always felt quite lucky about how easily I can come, in general.

I feel scared about becoming a mother at the moment. It took so long to get here that I'd kind of got to the point where I was like, 'Do I really want kids?' I hope that my maternal instinct will kick in when I have the kids.

Being pregnant is not as much fun as one would think it would be. I felt sick the entire first three months. The second trimester was probably the nicest bit because I wasn't too big, but I was starting to show and associate myself with being a mother. Now I'm in the third trimester it's a bit like, 'Oh shit, it's actually happening.' Natural instincts to 'nest' and clean every nook and cranny around the house have kicked in.

My fangita is probably a little bit scared at the moment. I think she's in preparation – she doesn't know I am having a caesarean.

I've decided to have a caesarean partly because of my age, because I'm 45 and I feel like my body hasn't ever had to go through that much stress, and because I am having twins. I don't know why, but I have had an instinct that natural birth would be too stressful for my body. I'm not averse to having a natural birth and there's definitely a bit of sadness in me thinking that I'm going to miss out.

I've enjoyed finding out how amazing the female body is. I had no idea. I respect my body so much more now that I've become pregnant. Wow, what women have to go through is quite incredible. Being pregnant has made me realise how powerful women are.

Forty-five years old, pregnant with twins

"My vagina smells of strawberries and cream"

I've never met a vagina I didn't like. I wouldn't put mine on that list.
I'm not enthralled by mine. It's just there. We're not that close.

Vulvas and vaginas are my favourite place to be in the whole wide
world. My partner is the specific focus of that attention and that makes
me very, very lucky indeed. I love the taste, the smell, the feel, everything
about vaginas. Mine smells of strawberries and cream. My girlfriend's
very lucky. *(laughs)*

There's a purity and sensuality, an exceptionally raw and deeply
personal experience when you are with somebody else's vagina. It's
a privilege, which is way beyond the physicality of sex. The intimacy

of being allowed there is a huge thing, because you are going inside somebody. It's utterly on the terms of the person whose vagina I'm exploring. It's a very precious connection, a passport to a very special place. We live in a society that treats women entirely like a cock pocket. Like a useable object, like a hole, and that shit's got to end. I would like reverence for vaginas. Yes, I'd like a better understanding of how they function, but really what they need is huge respect.

An orgasm is the moment of least control I've ever experienced. Colours and lights, then a massive blankness. It's like a bit like being drugged, like you've slipped into a parallel universe.

I was 13 when I had my first period, on a camping holiday. It was a heart-breaking moment. It didn't feel like the beginning of something, it was the end of something. It was like there was no hope. I don't know why I felt that – it was a guttural response – it was like I felt my heart just plummet. I honestly thought I would grow up to be a boy. I thought some people changed, maybe I thought I already was a boy. It just seemed to fit way better than anything I'd been presented before. A part of me that was still a little child that had a dream, kind of gave up the day my period started. I was sad. I got over it.

I hate my periods, I absolutely dread them. They are painful as hell... It's a horrible, evil, nasty thing that I have to put up with every three weeks. I mean for goodness sake, it's like some sort of joke. From my knees to my ribcage aches. It feels like someone has taken a splintery broom handle and forcibly pushed it through the small of my back and out my front and then just left it there. I can't wait for menopause, I want my period to be over with. I want it gone.

I'm non-binary, which means that I don't really see myself as male or female. I understand that my physical body is female, that I was born female, but my inner self is much more neutral and I have elements of masculine and feminine. I think everybody does really, but I feel that mine are very balanced and I sit somewhere cleanly in the middle, though it fluctuates a fair bit. The moment that I understood what non-binary meant, it was like I was flooded with light. I just went click. I felt so calm and centred, and it was just like finally I make sense.

When I was five or six, I wanted to wear trousers to school. At my primary school we had a uniform and the girls either had to wear a tabard dress or a summer dress that was like a picnic blanket. This was the 1980s and they were proper hideous dresses with little puffy sleeves. I really wanted to wear trousers, so I convinced my mum to let me wear

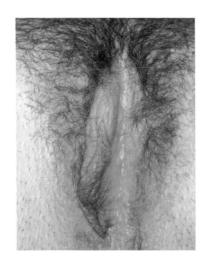

trousers to school. I wore them one day, just one day. At break time it felt like the whole school stopped and questioned me about the trousers. At one point I was backed up against a wall with a big crowd of people asking, 'Why are you wearing trousers? Do you think you're a boy? Do you want to be a boy?' I remember it vividly. The pressure was intense and it was horrifying. I felt isolated and cornered. I never wore trousers again.

I don't know why we have stupid rules about the bits of cloth we hang off our body. Why our genitals dictate how we outwardly express ourselves. I don't really get it. When I go to buy milk, I'm not buying milk with my vagina. I'm buying milk with my money, do you know what I mean? Everybody should have the option to wear whatever they want.

I think the idea that if you look masculine then you can't be a woman is rubbish. I also think that being feminine or effeminate doesn't make you any less of a man.

Thirty-four years old, no children

"Sex is the best bloody thing in the world"

Sister Philomena used to say, 'Never look at yourself in the bath, just don't look.' In my Catholic school's sex education leaflet it said that we may prefer to wear a swimming costume in the bath. I was caught reading *From Russia With Love* by Ian Fleming in library class and I was slapped for it and told it was a disgusting book.

I was going round Europe in a one-man tent with this man when I was 19, and my mum realised I would lose my virginity, and she said, 'I just don't want you to give yourself away too easily.' And I said, 'Mum, has it ever crossed your mind I might enjoy it?' and she just had a look of incredulity and she said, 'I was never much good in the downstairs department.' That was her line. I think that is so tragic, so sad.

I looked at myself in the mirror when I was young. I looked at the clitoris and pulled the hood back. I used tampons very early. I knew

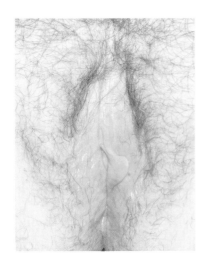

one girl at school who tried to put a tampon up her anus because she didn't know what to do. I'm quite rebellious and was always interested in how things work.

I don't think I'm attractive down there but I think that might be partly the Catholic thing. I think it's ugly, but I think they all are! Vulvas look a bit like a clam shell and some kind of sea creature inside. I think penises are more attractive than vaginas.

When I was a teenager, I ended up with a boy in the toilet at a party. He came in his pants and I missed the next two periods. I was convinced I was pregnant. It was the Catholic guilt.

When I finally lost my virginity, it was to a man I was very much in love with, who was in love with me. I bled and that was my loss of virginity. I absolutely fucking adored having sex with him. I just felt so known. I felt acknowledged. I felt loved and I was mad about him and he was mad about me. It was great. He was inside me and I was so wet for him. I remember walking across the college green area thinking, 'How can everybody not know that everything's different now? Everything's changed.' It was so wonderful. My vagina has given me a lot of pleasure.

I didn't orgasm from vaginal intercourse for many years. My lack of orgasm during intercourse had been a major issue with a previous partner, even ending our relationship because he thought I wasn't enjoying it. I did enjoy it, I just couldn't orgasm that way.

When I was in my 40s, I met a man who was a lot younger than me and he was determined to try. So he researched it all very diligently and looked into the G-spot. He asked if I had one and I said I didn't know. He put his finger in, in exactly the way that it said on the Catholic Marriage Guidance website – because they really care about you having a good sex life so that you don't stray – and I had the most outrageously enormous, huge female ejaculation. Whoosh, absolute whoosh, huge. It was fantastic, it felt amazing. We did things I hadn't done before. I wasn't in love with him and maybe that meant I was able to relax more.

The love of my life now lives abroad. I swear the happiest I have ever been in my whole life is when that man's cock is inside me. He gives me a feeling of being filled, my vagina being filled by him and him looking me

in the eye is the most transcendent experience, the most connected to the universe, the most wonderful flush of dopamine I have ever, ever had in my life. I adore his cock, I adore what he does, I adore the way he touches me, I adore the way he smells.

We have seen each other again after a break. I'm now ten years past menopause and I've got vaginal atrophy. I'm taking oestrogen suppositories but they aren't really working. I'm not on HRT because both my mother and my grandmother died of breast cancer. I was shoving everything up there. He can't maintain his erection the way he used to. So we only had penetrative sex twice in a fortnight. But I gave him numerous blow jobs, which he adored and I adored doing them. I didn't want him to give me oral sex, I don't feel as relaxed about my vagina anymore. I'm very sad to think that this means the end of vaginal intercourse. I don't want it to end, it's too soon, I'm not ready.

Vaginal atrophy is not talked about at all. It can be so raw that the flesh at the top of the vagina can stick together. I can insert a dildo three-quarters, but the very top near the cervix feels a bit raw all the time.

Of course, my vagina hasn't done the thing it was meant to do, it has not had children. That is the great tragedy of my life. I don't know if I would have been a great mother, because I'm a bit of a perfectionist and I would have been very disappointed if they weren't bright, which is a terrible thing to say, but anyway.

I was in a relationship where we thought we would have children but I found out I was riddled with endometriosis. I've never had a painful period in my life, they aren't heavy, but it affected my fertility. I had two cycles of IVF. The first time there were only two eggs fertilised and they put them in and I didn't get pregnant. The second time they couldn't get a single egg. By 40, I was peri-menopausal. Normally talking about this will still make me burst into tears.

I have not had anywhere near as much sex as I should have done. I would say to any youngster, 'Get laid more.' Sex is the thing you should have more of. It's the best bloody thing in the world.

Fifty-eight years old, no children

"I want to see my grandchildren grow up"

As the years have gone on, I haven't really thought much about my fanny at all.

I remember a really horrible time when my brother wanted to look at my fanny and made me lie on the bed with my legs up. I was 10 and he was 15. He didn't touch me or anything, he just wanted to have a good look. I've never forgotten it. It was a horrible invasion of my privacy and my body, but I didn't have the courage to say no to him. I shut it out of my mind afterwards, I tried not to think about it, although I am sure it affected me subconsciously and affected my later relationships with men. The more you hear about this sort of thing, the

more you think that's the way it's always been. Let's hope it's not the way it always will be.

The first time I had sex was my wedding night, although we'd got near to it before. There were no religious reasons or anything, I just thought it would be the wrong thing to do. And yet when you think how near we got to it, there would have been hardly any difference. It was quite common among my friends to wait till marriage.

Our first time was very exciting. We stayed in a hotel and it was a lovely experience and felt really nice. I orgasmed the first time, but I had orgasmed with him before.

Sex was good but it was never the same after I'd had the children. Especially after my third child. Back in those days it was the woman who looked after the children and did everything around the house, so I was very tired and I lost my sex drive. I didn't feel that he was as understanding and tender as he could have been. Of course, he looked elsewhere. He just came home one day and said he was having an affair and leaving. My boys were three and five and my daughter was one at the time. They were still so small, and my mum had died just six months before. It was a horrible time.

I didn't go out and socialise or meet a man again for a long time after. The children were small and I didn't have anyone to babysit or anything. And, to be honest, I wouldn't have known where to go. When my youngest was about 10, I went out with a guy for a while. And that wasn't particularly good sex. And then there were a couple after that which were good, but nobody that I wanted to settle down with or anything. Those relationships ran their course. I think it's probably 15 or 20 years since I've had sex. I could go long periods without sex and not miss it, but then when I had sex again, I thought how could I go without it. I did masturbate, but I've also lost the impulse or need to do that.

I'd only just started the menopause when I got breast cancer. I had surgery and tamoxifen. I have secondary breast cancer now. I was told the average life expectancy was two years, which I was shocked at. I knew it wasn't curable, but I did think you had a lot longer than that. But he said some people do well and have longer, some people don't make two years.

That was over three years ago. So I've been very lucky, but I'm not ready to go yet, there's too many things I want to see. I want to see how things turn out for my children and see my grandchildren grow up. My daughter's eldest girl will go to secondary school in September

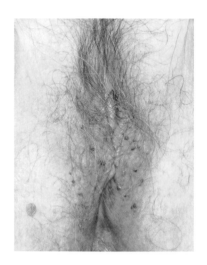

and I want to know how she gets on there. The thought of not being there for them upsets me more than anything.

I firmly believe that once you're gone, you're gone. I'm not religious, so I don't believe in anything after death. I think it will be like going to sleep and that's it. I'm not frightened of being dead, it's the process of getting to that, when you get to the stage where you're ill. At the moment I'm not ill, I can still walk to the shops, walk to the school to pick the children up. I'm not as physically fit as I was, but then I might not be anyway.

It is strange. We all know we're going to go, but we don't know when and we don't tend to think about it.

I just wish I could see my grandchildren grow up. There's nowhere in the world that I think, 'Ooh, I really must see that,' and I wouldn't get insurance anyway. *(laughs)* I just want to know that my children and grandchildren are happy.

Seventy-three years old, three children

"All young women should masturbate in front of a mirror"

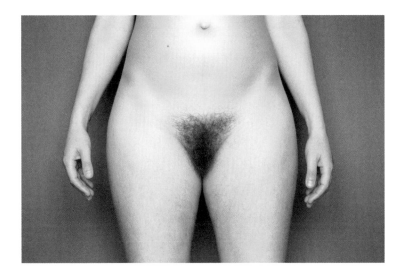

I'd see my dad and brother walking around at home, and I remember being very fascinated by penises, particularly by this idea of peeing through your penis. So I would fish my parents' used contact lens solution bottles out of the bin, fill them with water, and pretend to 'pee' using the bottle around the patio.

I think I was a bit jealous of penises. I didn't want one forever, but I wanted to know what it would be like to pee with one and play with it. They are powerful organs!

I remember having a shower with a little boy when I was about five and he peed on me in the shower. I was very cross. That's my only ever

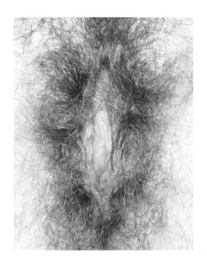

experience of any type of 'sexual assault', and it doesn't count as that. He was four! He was a year younger than me. I'm sure he was a lovely boy but it was a very unpleasant experience and I was very cross.

Sometimes I call her my vagina, sometimes fanny. Vulva sounds pretentious to me because it's not a word that's commonly used or known. I often call her my 'fannoir' which is sort of humorous, but also sort of respectful.

When I was around seven or eight, I don't know if things were starting to change, but I became aware of the smell of her and I really liked it. I used to pull my nightie down over my feet and make a little tent and stick my head in so that I could smell her.

It really bothers me how self-conscious I am about smell. There is shame around vaginas smelling. When you are growing up there's an idea that vaginas are a bit dirty, a bit smelly, something we don't really talk about or touch.

My view of my vagina has been altered by men's veneration of my vagina. I've come to see her as more beautiful and accept her, because lovers have. I have struggled with the idea of oral sex if I haven't just washed, but men have adored it. One partner enjoyed looking at my vagina with such a sense of reverence. Once after oral sex he referred to it as worshipping my vagina.

One of the reasons I jumped at this project was that I wanted to see my vagina. I hadn't looked at it since I was pubescent. Then I thought, 'This is ridiculous, I don't need a stranger to come and photograph my vagina and put it in a book for me to see my own vagina.' So at that point I got the mirror out and had a proper look. I did it with the particular intention of wanting to see this beauty that lovers have seen. I wanted to see the beauty of the vagina for myself.

I was a bit underwhelmed. It didn't look horrible, I just didn't see some shining beauty. And then I started to get a bit curious about the aroused versus unaroused. So I masturbated in front of the mirror. I want to explore this more because I didn't really get a clear sense of how different she looked aroused, maybe it was the way that I masturbated. But the visual image I was left with was beautiful. I feel quite evangelical

about it now. I think all young women should masturbate in front of a mirror. I want to get a separate mirror for it, something appropriately decorated and ornate. But then everyone would know that it was my fanny mirror!

I actually had some regret when I saw the photo because a while back I decided to laser remove my bikini line, just because I was so fed up of the moral dilemma every time I went swimming of 'do I show hair or do I not?'. I still have a lot of hair though.

I don't remove my pubic hair, or shave my armpits or legs. I want to be unashamedly in my natural state and yet a lot of the time it just feels too edgy. Like I don't feel brave enough to be out and proud. I feel emotional talking about it.

There's a part of me that wants to look like a Barbie doll. The feminine ideal in music videos and stuff like that turns me on a bit, and it turns me on to think of myself looking like that. And then I get upset because I'm not going to look like that because I refuse to shave my legs. It pisses me off that I have that attitude. I want to fully believe that being natural is sexy.

After a very intense and powerful therapeutic process, I felt a huge energy within me, located in my vagina. You know the expression, 'Grow a pair of balls'? I had the sense of my vulva being suddenly, radically enlarged, like 10 times. Like a cartoon, it was going 'Kerchunk!' In horrible man-speak I'd 'grown a pair', but I'd suddenly grown a vagina and was a woman and felt in my power. I think I became a woman right then.

That really powerful energy stayed with me for a few days and was quite overwhelming – it felt like I had a huge fireball down there. Then it faded, but afterwards I knew where my power was and if I wanted to access it I knew where I had to put my attention. I think I had a 'Satori', a flash of enlightenment. Taking it further, it felt like accessing divine power. When I saw Sheela-na-gigs I felt some validation: there's this tradition depicting a goddess holding her massive, oversized vulva open.

Vaginas are mainly ignored as we grow up. Barbie dolls don't even have them. In fact, my vagina is the most powerful, important, divine part of my body.

Thirty-eight years old, no children

"I orgasmed when I gave birth"

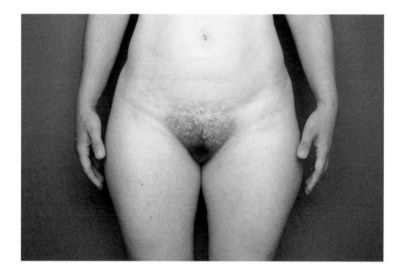

I was a bit worried about having the photograph taken. What if there was discharge and toilet paper on me? I thought there would be a gaping crevice, but it's tidier than I imagined it would be. I don't know why I have never looked at my vulva before today. I suppose I don't really think about it. Actually that photo is fine. It's less hairy than I thought it would be too. I don't like my little middle-aged tummy, which never used to be there. I've always had a washboard tight stomach and now there's a paunch on top which I don't seem to be able to get rid of anymore.

More than the photographs, I think what's interesting is having conversations about things which are normally private and hidden away.

My vulva has served me well and I don't have any bad emotion around it. My vagina has given me three children. Luckily I've never had any bad experiences.

I tried to have a home birth with my second child. Unfortunately, I had to be in hospital in the end because I had an infection they wanted to treat. When I got to the hospital the contractions stopped – they thought I wasn't even in labour. They examined me and said I wasn't even dilated.

As soon as they left the room I felt it start again and come on really strong. I hit the floor on all fours and I was mooing, like a big cow. An hour later they stuck their head round the door and I remember them saying, 'Oh, maybe she is in labour.' Then they said, 'After the next contraction, if you jump up on the bed we'll examine you,' and I remember saying, 'Don't touch me,' like this crazed woman... I was making noises I've never heard myself make before. After every contraction I'd turn to my husband and apologise in case I was scaring him with the noises.

I did let them examine me – I'd gone from nothing to 8 cm in an hour. I wanted to be at home, but I couldn't leave at that point. I wasn't really aware of anything because I went into a whole birth frame of mind. They were lovely and they kept saying, 'Can you lie down?' and I was like, 'No, I'm not lying down.' I was in a 'zone'. I wanted all the lights off. The funny thing is, I stripped my clothes off. I wanted to be totally naked, which is not like me.

My son's birth was amazing, but something unusual happened, that I felt really weird about at the time. I orgasmed when I gave birth to him. I actually orgasmed. I've never really told anybody about that, not my husband, and no one at the time.

There is a point when the head is crowning and it's the hardest bit, like a ring of fire. At the point where the head released into my vagina, an orgasm started building. As the head passed through, it happened. Obviously this wasn't an orgasm that went on and on for ages, but it definitely happened. I distinctly remember thinking at the time, 'That's weird.' I was making lots of noises anyway, so I don't think anyone realised.

I don't really feel worried about people's judgement of me anymore. I've grown up and matured, but at the time I probably felt a bit weird about it. I'll tell my husband now it's in a book!

I worry about how my son might perceive it. I feel a little bit anxious about him identifying me and the story of his birth and then feeling strange about it. I don't know why.

After he was born, he was delivered straight up onto my tummy.

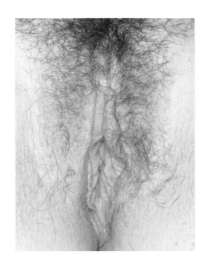

Again, like the orgasm, if I hadn't experienced this, I would never have believed it possible, but he crawled up my stomach. It was the most primal thing, he literally moved up my body completely on his own. He latched straight on to my breast and breastfed immediately. It was amazing.

I was like a rampant sex maniac while I was pregnant. When we had sex again, a couple of months after the birth, I cried because it wasn't the same heightened experience that I'd had all the way through the pregnancy. Of course, sex was wonderful again in time.

When I first started having sex as a teenager, I didn't even realise that clitoral orgasms were a thing. I always had orgasms from vaginal penetration and didn't pay much attention to my clitoris, which I now realise makes me unusual. With my husband I have orgasms from clitoral stimulation then other times from vaginal sex, when everything's really, really slow. If I have an orgasm from penetration, usually it would be me on top and him not doing anything else and just me guiding the pace. It has to be slow.

I don't carry a lot of hang-ups in my head and I've been very lucky with my vulva experiences! We're all just little human beings bumbling along on this rock trying to make sense of it all. I think stripping us back to raw nakedness helps people with their hang-ups. I'm hearing a lot at the moment about how being a woman isn't about biology. I think that's quite disturbing actually. The human body is what it is and a woman's body is what it is.

Forty-two years old, three children

"My vulva is an unexplored landscape"

Looking at the photograph of my vulva today, the first thing that came to mind was a memory from when I was 13, just after my mother died. I fell over and I cut myself really badly on one of my labia. There was so much blood. My father was a doctor and so I went to him to ask if I needed stitches. It was that really awkward time, I hadn't started my periods yet, I couldn't ask my mum because she wasn't there anymore, and it was so awful to have to let my father look.

When I was a child, I remember swimming with a friend when we were 10. We put our goggles on then swam on our backs, with our legs open, and looked at each other's genitals. I remember looking at each

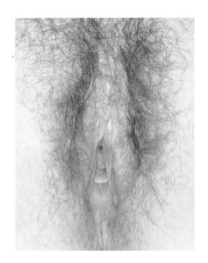

other being quite a profound experience.

I don't look at my vulva often. I think of it as an unexplored landscape. It's weird looking at it today. It's soft, curvy and pink, protected by hairy lips and crowned by the clitoris. It's like a peach, with hairy skin to protect itself, yet when you open it up it's all fleshy and sweet.

As a young woman my monthly bleed was extremely painful a lot of the time, but I really mourned my last period because it meant the end of a whole cycle in my life. It was bittersweet. The menopause was tied up with a miscarriage just before.

I fell pregnant one May. Everything was blossoming and the sap was rising. I felt an absolute feeling of bliss in this state of motherhood. One day I started to feel very tired and had some bleeding. I remember ringing the midwife and she said, 'Don't worry, it's normal,' but I wasn't so sure. Something didn't feel right. I went to the hospital when I realised I was having a miscarriage.

The consultant kept asking for a pee sample. I went to the toilet to pee and then the whole miscarriage just came out. I remember looking in the loo and thinking, 'That's my baby in the loo.' I put my hand down to pick her up and just held her in my hand. *(cries)* A little voice in my head was saying, 'You don't put your hands down the toilet,' but I had to because that was my child. It was like a massive piece of liver: dark, warm, bloody and in there somewhere, I knew that the heart had been beating, but was no longer beating. I wanted to keep it, and I wished I had, but I remember flushing it away anyway, wondering how I could flush it away like a goldfish.

I pulled the button for some help; I said I need a sanitary towel or something and the nurse brought me a nappy. Bloody great. I'd just lost my fucking child and they gave me a nappy. So I walked down the A&E corridor with a giant nappy on.

When I spoke to the doctor he said they need material from miscarriages to try and identify why miscarriages happen. I was glad he didn't have mine, and wished I could have buried her to honour her.

I create art now to honour the life of this child; my very short experience of being a mother and the physical changes that happen.

It's about the loss of dreams and desires, but somehow I'm also connecting with beauty and helping myself to understand. I hope I enable other people who have lost a pregnancy to access those emotions. People don't really talk about miscarriage.

I create paper bodies on the remote coast. One of the sites is a beautiful cave that looks like a huge vulva, which is a very intimate and special place to work in. I wanted to give a body to my child, a body for my grief, to let it go in the sea, to say goodbye. I work with the tide coming in, so in a sense I have no control. The paper bodies wash up with the waves so air is left only in the hands, the hair, the toes. They look like bodies drowning or gasping for air. They move underwater like a foetus moving as if it were in the womb.

Not having children has been a huge battle for me for many years. It's now possible for me to look at motherhood in different ways, in terms of birthing creations, pieces of artwork or performances, and also looking after young family members and also nature, taking care of my environment.

At this age, post-menopausal, I am now more able to be a wild and free person. Somehow I allow myself to experience the depths more. I don't give myself as freely as when I was younger, when I had a need for love that I could never get from another person. I think I should have kept my hand on my ha'penny, as they used to say! *(laughs)* I've learnt how to mother myself to a degree, which has affected my relationship with my sexuality, sensuality and my vulva.

Women are great as they age. I feel I'm more sexy and I'm not ashamed about it. Women should be celebrated at they get older. This, in a sense, is the unexplored landscape – as women become more at home in their bodies and happier in their skin, there is more to explore.

My favourite place to masturbate is in the woods, with the feel of the breeze, and the smell of flowers and trees around me. I feel more connected to the energy of nature, which adds to the orgasm and the ecstatic experience. I love that sense of cells suddenly on fire when I orgasm, and the tingling sensation that runs through the body and right into the toes, and you just have to let go, you can't control anything. It's like the excitement and terror of running down a steep grassy hill.

I like the physicality of being a woman. People may look at me and think I'm calm and peaceful, but they don't know what's underneath. There is power and strength underneath, and I love to surprise people with that.

Fifty-two years old, no children

"Becoming a woman feels dangerous"

In high school I was friends with popular girls but I was quite nervous about having sex with anyone. When I was growing up, my mum would tell me all these horror stories. She'd tuck me into bed at night and tell me, 'Boys are only after one thing,' or, 'Watch out for boys, they're only going to hurt you.' And then talk about sexual diseases. I felt like sex could only be a negative thing; I didn't know that it could be something really positive and wonderful between two people that is part of a healthy relationship. My parents were quite embarrassed about talking about sex. My mum called a vagina a 'front bottom'.

Sex has been really good with my last three boyfriends, but my first boyfriend and I were inexperienced and didn't have an understanding of what good sex is. In the beginning I had all these bruises on my inner thighs. I think I didn't recognise the pain and discomfort as something negative. We were both happy and into it, but it was probably a bit

forceful and I didn't see it as relevant to voice my discomfort.

I get the feeling from porn, especially the Pornhub type of porn, that the girls don't look comfortable to say the least. Things that were once quite niche have become quite commonplace. There was a phase when sex was quite unrealistic and boys had quite high demands, I think that came from porn. Boys that I spent time with would have an expectation that you would be shaved and that they would control the situation, putting their hands on top of girlfriends' heads and pushing them down to their penis to suck them off. Yeah, it was all about servicing their needs and women being expected to do it. I had quite a few occasions when I was like, 'This has not gone how I would have wanted it to go in an ideal world.' It all felt so rushed.

My relationship with my vagina has become more neutral as I've gotten older. I try to think about it as little as possible. I was devastated when I got my period at 13. It's a time when you realise your body has changed and you are stuck with this change until menopause.

I wouldn't say I have the most attractive vagina. Obviously in porn you see all these very neat vaginas, although I don't subscribe to that idea. I don't think I compare my own vagina to porn. I don't dislike it, I would say I'm neutral about it. It's like saying, 'What do you think of your elbow?'

At school I had a terror that it would be found out that I had pubic hair down there. I went to an all-girls school and I remember the gossip. 'Have you seen that girl's bush? It's like the Amazon,' or, 'That boy put his hand down her pants and it's so furry.' That kind of thing would be talked about all the time.

With a partner that you love and trust you can just get creative and maybe for a month you grow it out and see what happens and then maybe the next month you try a pattern. I tried to do the landing strip; it's really hard to do unless you get it done professionally – you take a little bit off and then you have to take more off etcetera. For a new lover I'd go for under control, tamed, trimmed – but not like I've thought about it too much. But it's also nice to let it grow out completely.

I didn't feel girlie when I was growing up. I was a bit scruffy and clumsy, I wore hand-me-downs, I never had my hair all nicely done. I played football with the boys at school and ran about in the playground. Then all of a sudden, I was the first girl at school to get breasts and wear a bra and get my period. I was embarrassed about all the changes that my body was going through.

In my first year at university I was sexually assaulted in halls. I was

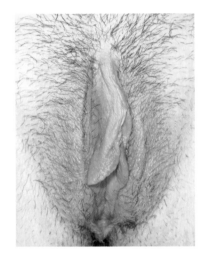

sleeping and then this person came into my room and started groping me and touching me. I had known him for a year. The next day he pretended like nothing had happened. I had to live with him in halls for another four months till the end of term.

I told a female friend about it and we made jokes, and thought he was weird, but we didn't even think to report it. He'd been creepy around other girls too, and it wasn't an isolated incident. In the end I did report it to the police, but I decided not to pursue it as the police told me it was unlikely there would be a conviction. I also felt very nervous and anxious that his friends might come and hurt me.

I disassociated from my body after the experience. I felt like I wasn't in control. If people didn't respect my body, then why should I? I started binge-eating and became quite depressed. I was put on antidepressants and I went to counselling and slowly got better.

It's made me more aware of what I'm doing with my body and I find I move towards things that give me that freedom with my body. I do a lot of ice skating, I love dancing and go to yoga because it gives me a chance to have a completely peaceful moment and just be with myself and be in my body.

When boys become men it feels like it's an irreversible state – you become a man and that's you, you're there. As women age they go into different stages. I feel like I have quite a complex relationship with being a woman. I think being a woman is about being sexually available and fertile. But when you become a mother you then become less visible.

Each year that goes by, I feel myself becoming more of a woman, and for me that means being more in control and more self-assured. But it also feels dangerous and vulnerable and changeable. You have to perform this thing called femininity. If I could have been born a man, I would probably say 'yes' because women have a lot more hurdles. I want to feel more positive about being a woman and feel more ownership over my body.

Twenty-four years old, no children

"My vagina wants more, more, more"

I love the word 'vulva', its beautiful to say, it's like velvet. Vulvas are fantastic, versatile, brilliant, amazing.

My vagina wants more, more, more, more of whatever it is: more babies, more sex, more anything, just more, because it's the beginning and the end, isn't it? It's the entrance to a woman's reproductive system: her vagina, uterus, fallopian tubes and ovaries. It's a gateway to sex and pleasure, another beginning. Then with birth, it's also the end because it's the endpoint where the baby comes out. The vagina is beginning and end – full circle.

The vulva is such a pleasure-giving zone as well. It houses the clitoris, which is much more than just a little button. The sole purpose of the clitoris is pleasure. It's an amazing, all-consuming thing, which cradles the vulva and the vagina. If you actually look at the shape of

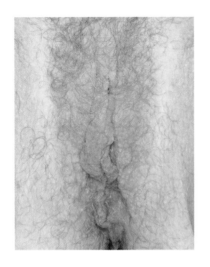

the clitoris as we now understand it, and it's only recently been understood, then how we experience pleasure and orgasm makes such sense. You've got the tip of the clitoris which is where everyone, if you're lucky, zones in on and then you've got the two big fronds and then there's the other ones as well. I think they must go up either side of the vagina. A lot more work needs to be done finding out.

To minimise it to just one little button – 'press for orgasm!' – sells the clitoris and women short. It's a very beautiful thing. It could almost be a metaphor for misunderstanding women. That's what I find so interesting about the vaginal orgasm myth; men think that if they do it right or in a special way you have a vaginal orgasm because it's all down to the penis. It's just so crap. It's the same as losing your virginity – men think their penises are so powerful they can change a woman from a virgin, literally as dynamically and magically as that, as though a penis defines a woman.

That's the other thing: when you meet a new partner the question always comes up, doesn't it, of how many people you've slept with. You add up all the men that you've had sex with, but you never include the women, do you? Well I didn't.

I've always been a big fan of masturbation. I remember a friend of mine telling me about it and she was saying, 'Well you have to masturbate, it's fantastic.' And I said, 'Okay, so how do you do it?' We were quite young – I think I was 11 or 12 or something. And she said, 'What you have to do is get a pillow and you have to rub yourself on it.' We were both brought up in very religious households and everything about sex was totally repressed, which just goes to show – repressing sexual urges never really works out.

Our family was religious, patriarchal and very sexist. I remember being on holiday in France and my dad and my older brother photographing a topless sunbather on the beach, having a big joke about it. They actually took photos of her on their camera so they would have the photos another time. As a 12-year-old, what do you do with that message?

I'd look around me in church, and in life in general, and be amazed by the sheer inequality. In church we had male priests and male altar

boys, but the girls weren't allowed to do anything. And how weird is dressing up as mini-brides for First Holy Communion?

I was angry and rebellious for a very long time. I did very badly at school because I was just busy raging against all these injustices that I couldn't quite understand. The repression and the inequality wasted a lot of my life.

I'm still very angry with my mother. She let me down very, very badly. I was in an abusive relationship. The abuse started once I was pregnant, which I've since learnt is common in domestic abuse. It's about loss of control and jealousy. He was emotionally, physically and sexually abusive. He had lots of affairs and gave me a sexually transmitted disease. I told my mother about him shoving me around and the affair and she just said, 'Well men do that sort of thing, you just have to put up with it.' She placed the sanctity of marriage higher than my welfare and that was really difficult for me to deal with. She's prepared to kowtow to the ultimate patriarchal institution, Catholicism, and put that before anything. I felt so betrayed.

At the moment the future looks pretty dire for women and girls. I think we have to be alive to the fact that human rights are hard won. Women's rights are hard won and you can lose them easily if you are complacent. We have to be so alert to that because there's loads of fuckers out there that want to put us right back down there.

I have got two teenage daughters, and I am aware that they are bombarded with images and porn culture. Boys are learning about sex and physical intimacy through porn – we're screwed, basically! That's one of the reasons I wanted to do this project, to counter porn culture and all the unattainable, weird, unrealistic images of women.

Forty-eight years old, three children

"Womb cancer didn't affect how I think of myself"

Fanny, minge, foo-foo – it is what it is. I don't really think about it. I've noticed it more since I had the cancer.

I was diagnosed in February 2015 with a cancer that I had very little knowledge of. In fact, I had no knowledge of it at all. I hadn't bled for two years, then out of the blue I had a bleed, so I went to the doctor. I'm glad that I didn't have a doctor that turned around and said, 'It's your age,' because on the support group I'm on, regardless of what age the women go, it's always, 'Well, you've got to put up with it. It's being a woman.' Or if you're over a certain age it's, 'Well, it's the menopause, you've got to expect that.' I was lucky, my doctor sent me straight off.

They put a tube in my vagina, and blew it up with gas. I've had three children, but that was the most painful procedure of my life. People are campaigning to get it done with anaesthetic. As they should. It was so painful. I was going to get the bus home, but I had to call my daughter to come and get me.

They said they found polyps and I thought, 'Thank fuck for that,' because I'd been warned it could be cancer. But 10 days later I got a phone call asking if I could come in for the results. Obviously when you get a phone call you know it's bad news. She told me I had uterine cancer. It hadn't spread, it was confined to the uterus, but it was a grade 3, which is one of the higher grades. I was diagnosed on 10 February and had an operation on 17 March, so it went very quickly.

When you are first diagnosed with cancer everything's going on around you, but you feel like you're watching from the outside. I wanted to scream, 'For God's sake, will you stop what you're doing. I've just been diagnosed with cancer!' But you get over it. I told a few friends, because the more I spoke about it, the more real it became. I had a week of sleepless nights waiting for the results – I imagined the worst-case scenario and planned my own funeral.

I had a radical hysterectomy, which means I had ovaries, tubes, cervix, womb and the top third of my vagina removed. I also had 19 lymph nodes removed. They stitch up the top of the vagina and it's called the vaginal cuff. They didn't give me a lot of information, I had to find this out by watching things on YouTube. It's a funny feeling when you stand up after you've had it done – everything feels empty, you feel your bladder and bowel rattling around.

I had radiotherapy inside my vagina, which leaves scar tissue, so I was given these things called dilators which are horrible. They're plastic, the shape of a vibrator, and if you don't use them regularly in your vagina then it can stick together and close up.

When I went for my check-up the oncologist made me bleed when he did an internal. This is quite normal for me because they're pissing about disturbing scar tissue – I'm more fragile inside. He told me I'm not using the dilators enough. But he was worried I could have a possible reoccurrence, because it tends to happen at the vaginal cuff. So I had a scan.

I was very stressed about the results. When I was first diagnosed with the cancer that was bad enough, but everything moved quickly. I've now been waiting eight weeks for these results, to see whether it's a reoccurrence or whether I'm just a 'fragile vessel'. It actually used those

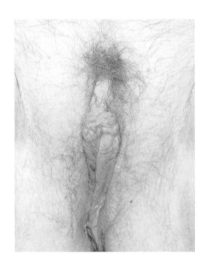

words in the letter – 'fragile vessel'. I find this terminology very strange.

People don't like to talk about cancer. One male friend was surprised when he found out I had uterine cancer. He assumed because it was cancer it must be breast cancer. I was totally ignorant of this cancer too. The more people that know the symptoms the better.

I was really pissed off because I don't fit the criteria – I'm not overweight, I've had children, I exercise. The only thing that was against me was my age. My consultant just shrugged her shoulders and said, 'You were unlucky.'

Womb cancer didn't affect how I think of myself as a woman, because I was 58, I've had my children. I have a partner. Our relationship has changed, although we still see each other. The fact is that they've taken a third of my vagina away and it's shorter. We don't have intercourse at the moment and I always say to him, 'Be careful! Be careful!'

I never masturbate, I never have. I'm not comfortable with it, for starters. I've probably tried it but it's not something that I would indulge in.

I have three daughters, five grandchildren and a sixth on the way. As a woman you tend to shoulder the responsibility of caregiving more. It's a very unequal society being female, although things have improved. I wish I could retire, but that's another issue. I can't retire until I'm 66. They changed the goalposts, and I'm pissed off about it. If I take my pension early I have to take a 25% loss. But I haven't gone down without a fight. I've written to Theresa May, Esther McVey, anybody I can think of. My last relationship left me homeless because he smashed the house up. It took me ten years to build up a house after that.

These days I just like being me. I'm settled now. I think I've got to the stage where I'm quite content within my own skin. I grew up with four brothers and wished I was a boy because my mum liked boys better than girls. I wished I was a boy because I could see that boys don't wash dishes, and all the rest of it. But I don't wish for that anymore. No, I'm me and I like being me. I'm content with what I've got, my children and my grandchildren.

Sixty-one years old, three children

"She's feeling excited like a puppy"

I call it 'pussy' in a sexual situation, 'yoni' if I'm talking to people I know or to myself, 'vagina' with people I don't know as well, and 'cunt' in a very emphatic, probably slightly humorous conversation with someone I feel really open with.

There is a real edginess to being naked and totally vulnerable. It's exciting that women will be able to see each other and break down taboos.

I feel quite familiar with how my vagina looks. I've taken pictures, more than I've looked in a hand mirror. Sometimes it's a sexy thing and sometimes just so I could really look. Because I know what I look like and there's no mystery, I feel less at the mercy of what someone else might think, looking at their eyes, working out if I pass a test. I've had lots of good experiences, lots of, 'Oh my God! It's so beautiful,' lovers loving the taste, the smell, how I look. A lot of adoration.

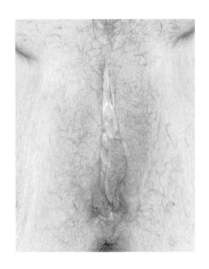

These days I worry less about needing to be super-clean and bleeding. As guys get older I've found they are less intimidated by me bleeding. There seem to be guys who are really open to explore that. I do still get a vulnerable feeling, 'Do you really like the taste? How do I compare to other women?'

I've found it really helpful being with other women, because I've loved how they look, and taste and smell, and they are all different from me and each other.

I don't know if I'm bisexual. I mean, I really like women, I love having sex with women, but I haven't ever had a long-term relationship with a woman. I feel like a straight woman who likes women. I love women's bodies and being sensual with women, but I think it's much more likely that I'll be in relationships with men. But you can be surprised.

I probably get that instant attraction across a room more with women than with men, but I feel like it's less likely that I'm going to be able to have sex with a woman because they might not be into women. I more often take the lead sexually with women, especially if they're not super-confident. I love that feeling of 'I know what this would feel like if this was me.'

I'd say I came into my sexual life not knowing how to say 'no', a bit over-sexualised and not having boundaries. I got into a lot of situations with older men and predatory men where either I said 'no' and that was overridden, or I was too drunk to be able to do anything. There was a series of events from 14 to 25. I got pregnant when I was 21, which was also a semi-consensual experience. I was totally on my own with the abortion experience.

I knew straight away that I was pregnant, so it was a really weird experience – I would wake up feeling this glow. I always thought I would never have an abortion because I am a maternal person, but I knew as soon as I was pregnant that I had to have one. I was eight weeks pregnant. I had a lot of grief.

I don't know where the lines for rape start and end really. I've gone through blaming myself, feeling like something that happened was my fault or it was nothing. I'd minimise what happened. I felt ashamed of myself.

One time which I can clearly process now as rape, was when I was 16, he was 33, and I was completely blacked out. I'm 35 now and I can look back and understand he shouldn't have done it. I've gone through layers of horror and rage. It's not okay for an older man to do that to such a young woman when she's not conscious.

I thought I'd be loved if I was sexual. I'd only be lovable if I gave someone everything and that I didn't really matter that much anyway. I got kind of sassy with myself about it in the later stages, in my early to mid-20s. 'Oh fuck it, it doesn't matter. If no one else knows what happened, it doesn't matter.' I was really cold and devaluing towards myself. The bare minimum, really, in terms of having a voice should be being able to say, 'No, I don't want this, I don't like you.'

A lot of self-hatred came from feeling like I could never get my dad's attention. I adored him and he didn't want to be there and he couldn't be there. I also saw the abusive dynamics between my parents and felt, 'Oh, okay, so I'm a woman, that's what I take. I need to take this shit. I need to put up with everything.'

I believe that the wounds we experience have some sort of wisdom in life. For me the wounds have been repeatedly sexual, the most horrible stuff that's happened to me has been to do with sex. It's probably the area where I have felt most frightened and broken.

My yoni has experienced rape, abortion, horrible smear tests and having the coil put in. I think those experiences are responsible for me holding on to trauma deep inside my vagina and sometimes it can be quite painful. I've had some therapeutic work. I had a yoni massage. I do work on myself on pressure points inside. Doing this work has been very emotional and takes time.

It's a challenge, but I need to rewire my body and relearn sex. Having sex has to be about me feeling what I want to feel, rather than thinking about what someone else wants or whether I'm doing it right. I have to feel what my body wants.

My vagina is not a separate entity, but I feel like I can almost have a little conversation with her. She has a voice of her own. Surprisingly, it's a slightly different voice to mine, as if she has knowledge and ideas that I'm not aware of. I know this means putting cynicism aside and being imaginative, but I think my vagina is more self-aware and insightful and wise than I am.

If she was to have a word with me right now she'd say, 'I'm super-alive, super-energised, really attention-seeking right now, like I want

some fucking attention. Can we do something now?' She's feeling excited like a puppy, very alive and positive and she wants some sexual attention, either with myself or with someone else. I think she's pissed off with me for just working recently and not giving her what she wants. I'm ovulating right now, totally on it, fertile fanny, ready for anything. I'm seeing my partner tonight. It's a very passionate relationship and it's good timing that I'm going to see him tonight.

Thirty-five years old, no children

"I didn't want to be 'that girl'"

Everyone has an opinion on how to manage your pubic hair, which is a very odd thing to have an opinion on. When I was in my teens, and we would have sleepovers, we would ask about each other's pubic hair and what we would want a partner's pubic hair to be like. I didn't really care! I started trimming it and obviously once you've started you've got to keep going because the hair gets thicker and it starts mattering.

I used to completely shave the front and then I realised how badly it itched when you do that. I looked up ways you can improve the process and read you can exfoliate and moisturise, but I wasn't prepared to do all that, so I stuck to neatening it up so it didn't poke out of bikinis.

I call mine a vagina, anything else feels odd. I don't think I had much of an opinion of my vagina, and never thought about its appearance until I left home at 18 and started being sexually active.

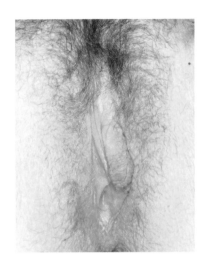

When I was around 15, I started going to house parties. You see people getting off with each other while drunk. I got a boyfriend at that time. I was very hung up on virginity then, I definitely had an idea from other people, other sources, that if you had sex before you were 18 you were a slut and that was a bad thing to be. There was also a superiority in not having sex and being someone who read books all the time.

I remember saying to my boyfriend at the time, when we were making out, that I didn't want to be 'that girl'. He was incredibly respectful, he eased up completely, we just chilled. My decision should have been based on how I felt and not because I didn't want to be a 'slut'. There shouldn't be shame around having sex.

Virgin is such a nasty word, it really needs to be thrown out of the vocabulary. The idea that if you have sex and lose your virginity you are now impure and sullied is so archaic and judgemental.

I am bisexual with a leaning towards women; I like to say I like men in theory. I find women more attractive, I find sexuality with women easier. I've had sex with women, so would consider I've lost my virginity, but losing your virginity is really seen as a penis penetrating your vagina.

One of my issues with men is because the ultimate act is penetrative. I don't like that. My vagina is very tight and I have never found any sort of penetration pleasurable, in fact it's uncomfortable. There is no burst of pleasure that writings say you have. So the question is, if I were to have sex with a man, how would I handle that, how would I make that work?

Penetration is a choice and if you don't want to, then it shouldn't really matter. Women don't gain that much pleasure from penetration in general. If a woman likes it, then I can do that for her – it's a choice.

I have been with fewer men than women. There's a thing about men finding it difficult to locate the clit. It's true. Women can find it by feel because we just know. Women are generally no effort.

However, when I've been with men it's usually not completely sober. It's been safe, just not sober. Alcohol has put me in a position where I'm like, 'Yeah sure, I wouldn't mind. Let's do it.'

I'm quite proud to be a woman, because of the history of feminism and politics, and also because of the way we're raised. Women are

more empathetic because we're taught to be. Men aren't taught that in the same way, which is a shame, but I like having that connection. I like the relationships women can have with other women. I like the solidarity and feeling like I am part of a network. It might be the same for men but I couldn't say because I'm not a man. I like being part of the woman gender.

Feminism has become a really loaded term. It's difficult to say, 'I am a feminist' without someone questioning and trying to put you down and make you ashamed. 'Equalist' has become a popular term. I'm not being ashamed of being a feminist.

If someone identifies as a woman my role is to respect that. In general, day-to-day, I'm trying to remember to ask people their pronouns. It can be difficult, but it's no more difficult than putting the effort into any kind of relationship in conversation.

Transwomen face a whole other set of issues. They might experience the gender pay gap, especially if they pass as a woman completely. But there are lots of issues with hate crime, with being able to even get a job. Transgender issues and non-binary issues are another set piled on top of the issues of gender that are already there.

I try to avoid terms like biological gender and biological sex. The idea that your genitals define who you are isn't something I subscribe to. I think that tying sex, your genitals and gender together is reductive and limiting.

Twenty years old, no children

"I feel like a dog on heat"

When I was a child, my mum called it a 'tail'. I've never heard anyone else say that. She'd say, 'Wash your tail,' which sounds a bit weird now. I would either go for cunt or vagina now, but usually said in a silly voice, or 'bits'. I like 'quim' – it's friendly and entertaining.

When I was small, I was self-conscious about it because it was different to other children's. Other girls had a little line at the front and I had protruding lips. In general, as a family we were not self-conscious about nudity, but I did notice and feel uncomfortable about my inner labia. Also, because I'm dark skinned, I've got brown labia and nipples and other women's seem to be pink.

I remember reading an article in a women's magazine about penises and thinking, 'I wish they'd done this for women because I've got no idea whether mine are normal or not.' When I was 16, I stole one of my brother's

porn mags, precisely because I wanted to see whether I was in the range of normality. My fears were slightly assuaged because porn was different then to how it is now – the vulvas were all quite different and everyone had loads of hair. I found some ancient porn mags from the 1980s when an old boyfriend moved out. He must have had them since he was a teenager, and it was just bizarre because their bits were like small animals – it would never be considered acceptable and sexy in porn today.

I need clitoral stimulation to come. I touch my clitoris myself during sex. Sometimes I've felt self-conscious about it, because wouldn't it be great if I didn't have to do that and I could just come. I am quite greedy because I can come two or three times and I'll be like, 'I want another one now.' *(laughs)* I have had boyfriends who have been quite shit around that, and don't want to give me another orgasm after sex if I have sperm inside me, even though it's theirs.

I feel terrible because it makes me look like a terrible feminist but, weirdly, I find it easier to come through anal sex. I still need a bit of clitoral stimulation going on, but I come really quickly. Once I orgasm I'm not interested in it anymore and I need to stop. I used to be scared of anal, then I had a boyfriend who was quite small and he persuaded me into it. I will say 'no' to guys if they are too big.

When I'm ovulating I feel like a dog on heat. I'm like a woman possessed, I can't get enough. I become really angry, like a ridiculous small child who's been denied sweets. I've had boyfriends who've hated when I'm ovulating; they find me unattractive because I'm so desperate. My best ever sex relationship was with a man who absolutely loved it when I was ovulating. He had a really high sex drive too and I was just like, 'Thank fucking God, this is amazing.'

I've lost count of how many people I've had sex with, more than 20 anyway. I'll tell you the worst and best.

I went out for dinner and drinks with a guy from a hostel I was staying in in Sri Lanka. He was very entertaining and witty. We had a pleasant evening. I hadn't really considered that sex was on the cards. When we got back he went for the lunge. I was a bit taken aback but thought, 'Oh, well, why not? It's my last night on holiday.'

He came within about 50 seconds. I was quite understanding about that because I don't want to make someone feel bad in that situation. He ran to go into the shower straight away – it was a blisteringly hot night – and when he came back I asked if he would be able to help me come. He said, 'No, it's just bad timing.' I said, 'What do you mean, bad timing?

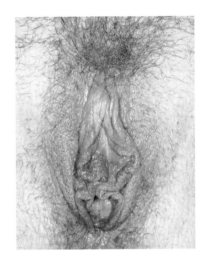

It's not going to take you very long.' He carried on telling me it was bad timing. Then I realised, 'Oh, you mean that now you've come you've lost interest.' He admitted it. I started laughing, which confused him. I told him, 'You're so rude. I cannot believe it.' I was utterly shocked and he was mortified because I just kept laughing at him.

I was so incensed that I couldn't sleep and wrote him a letter in which I absolutely ripped him to pieces. I told him he'd treated me like a fucking object and it had ruined my last night on holiday. He'd told me during the evening that his mother is a feminist – well, I wrote that she would be ashamed of him.

As soon as his desire was spent I was superfluous, he didn't feel like he needed to bother to make any effort towards me. Every other one-night stand I've had, if I've had to say that to someone, they've done it. Then we would both lie there in the afterglow of orgasmic bliss. Then a hug.

My best one-night stand was another last night on holiday, this time in Havana. I was flirting with this Irish guy – I have a bit of a thing for Irish men – and ended up snogging him. Then he told me he was in the club with his ex-girlfriend. He'd come on holiday with her to Cuba and just split up with her. She came over, found me snogging him, started attacking him physically and told him he was a 'fucking disrespectful bastard.' I felt at that point that I should have walked off and been in solidarity with her, like, 'Yeah, you bastard,' but my cunt spoke otherwise, because I did really fancy him.

We ended up getting a taxi, one of those really old Cuban 1950s cars. He was fingering me in the back seat of this taxi. His eyes were full of desire. The very hot chemistry on the back seat of the taxi continued to a hotel, an old colonial building with this neon light outside, clearly designed for exactly this kind of encounter. There was a slightly sleazy old man who chuckled and took us up to a shabby room, which had a condom on the bed. I kind of liked the fact that it was dirty and sleazy. We had really good sex. I knew we would from the kissing and looks between us. There is something so attractive about someone literally overcome with desire and on heat for you.

Forty-one years old, no children

"I'm literally done in three humps"

I think my vulva would probably like a break from itself to be honest.
I have the female equivalent of premature ejaculation. If a penis goes
inside my vagina, I'm literally done in three humps.

My vagina is like a pot that's waiting to boil over. It's very fortunate
in a lot of ways but also, give me a break. I can't even sit over the wheel
of a bumpy bus without having an orgasm. I feel like such a shit when
someone says they can't orgasm. I tend to stay quiet because I feel like
I'm a jammy arsehole.

An orgasm feels like you're on the edge of a pier and about to jump
into the sea. There's an anticipation, and then you feel free, and energy
and emotion wash through your body. Then you are relaxed and calm,
there's a feeling of complete peace. It can last for a few seconds to ten
seconds or longer.

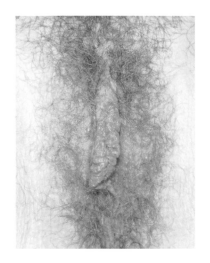

My best orgasms have been with my current partner, which is great! I think sexual pleasure is different when you have a connection with someone. I have bigger ones and sometimes multiple times in one session. I tend to have two orgasms in a row in the classic missionary position. But, this is really embarrassing – every time I have a second orgasm I fart. Maybe I'm relaxed, maybe my body needs to release more. Luckily we just laugh, but it is really embarrassing.

I've also had a few fanny farts or queefs. It's always happened when I'm in a position which is dull for me, like having sex from behind. I've already had an orgasm and I'm just a bit bored. That's when the fanny farts tend to happen most, which is great because then we both want to get it finished soon.

I hit puberty like a train. I was a really thin, little girl and then suddenly my thighs were covered in stretch marks, I had boobs and I didn't know what was going on. I think that because of how I looked when I went through puberty, I was quite sexually open and expressive. I felt so much like a woman but I was still a little girl in my brain. A lot of my early experiences with sex were because I wanted someone to find me attractive. Now, I think, 'Oh no, poor mini-you!'

I was probably 13 or 14 when I first gave a handjob at a party. My nickname had 'handjob' in it – it was not the best. Because I've always been able to orgasm very easily and quickly, I could give them a handjob, dry hump them and be like, 'Sweet, bye, see you later!'

I was very lucky losing my virginity because it was to my best friend, and he's still one of my best friends. We'd been going out for a few months. It was great, very consensual and calm and good. I lay there afterwards feeling like, this is what books are written about. It was a big thing. I wouldn't have lost it another way.

When I lost my virginity, I came home and my mum said, 'You've had sex,' and I was like, 'Excuse me?' and denying it. It was a weird witchiness.

Recent partners have been fine about my vulva, and it does the job. When I was younger, I had a couple of boyfriends who had shitty reactions. They'd watched a lot of porn, so they'd seen one type of vagina

basically, super-tucked, neat and no labia at all. That affected how I felt about myself for quite a long time.

Apparently my vagina smells different before I'm about to get my period. Periods smell different at different times. Sometimes it will smell like metal. And then sometimes, in the middle of the period, when it's really heavy and awful, it just smells fucking bad, it smells like wet dog. Vaginas smell kind of strange anyway. Usually, it smells slightly spicy, like a normal vagina, I suppose.

I thought my vulva looked like some sort of sea animal, maybe like a slug – in a nice way! I'm not like horrified, like I thought I would be. I'm pleasantly surprised. I last looked at it when I was 12. I think I tried to erase it from my memory, and I haven't looked at it since. Seeing my vulva among 100 others is actually really exciting. I think it fits with the whole concept of togetherness and sisterhood. I'm going to play 'spot the vagina'.

Twenty-three years old, no children

"The end of my piss flap dropped off"

It doesn't come up in conversation a lot, but I call mine fanny or piss flaps. I never looked at my fanny; that's the way we were brought up. Periods and things like that just weren't talked about.

When I was very young, I disliked it immensely when my inner lips started growing. I'd be walking to school and be really uncomfortable and I wanted to walk with my legs open because the bloody things were twisting in my knickers.

I thought I was abnormal because I'd never seen another one. Of course, nobody else said, 'Oh, my fanny's uncomfortable' – nobody would ever say that. Then my step-mum asked me why my knickers were wearing out at the gusset. It was because they were rubbing between my lips and my legs. I was really embarrassed and it felt almost like I was being asked if I'd played with myself. So I hated wearing knickers.

Just after we'd had sex, a boyfriend asked me when my vagina had dropped. I thought, 'What's he talking about? Is that what this is? Has my vagina dropped? Is that what all that loose skin is below my fanny?' That's how thick I was and I was 22 at the time. I think he'd never seen a woman with such long piss flaps, but even if he thought there was something wrong with me, he still fucked me. It was a very uncaring sort of thing to say to me.

I was naïve about my body, because I didn't have a real mother to talk to, only my step-mother. My real mother left when I was four. She was quite free with her... She had a boyfriend, then she had another boyfriend... Everyone said my younger brother wasn't my father's son, and after he was born my mother and father split up. So my father never spoke about her and certainly didn't encourage me meeting her. It was as if she was the Wicked Witch of the West. In those days if you divorced the other party then they were very badly thought of. My grandmother would say to me that I looked like my mother and I must be very careful because she was a naughty woman.

I got a book eventually, a few years later, called *The Mirror Within*, which says to get a mirror and look at your fanny. I thought, 'It's not very pretty!' *(laughs)* But the years rolled on, I've been married four times, it hasn't put anyone off me.

I developed a Bartholin's cyst. I avoided going to the doctor's about it, but eventually it was too invasive and painful. They sent me to the hospital and they did it then and there under local anaesthetic. I was on the chair and the doctor was cutting away at my leg and it was so big she said, 'Don't think plum, think grapefruit.' It burst and it went all over her. It was an awful experience. I was so embarrassed.

I was losing a lot of blood so they whisked me to the operating theatre. When I came to after the operation I could feel I'd been stitched up. They didn't do a good job at all. This is unbelievable but they'd stitched part of my piss flap to the cut. I know my labia are soft, floppy, thin, long and dangly, but I thought it amazing that a surgeon could stitch it to something else. Were his eyes shut? What was he doing?

The end of my piss flap went black and dropped off. It's like when we used to put elastic bands on lambs' tails in the field. It had dropped off. When I went for the check-up at the hospital I was laughing and asked if they could tell one of my piss flaps was now shorter than the other. It did make it a bit more interesting than it was before. And that was the end of that.

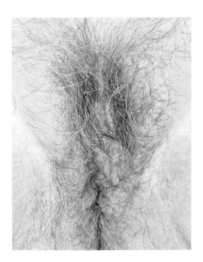

I don't bother with boyfriends now. I don't have sex thoughts. I joined Plenty of Fish at one point, the dating thing, and I did meet a man. I thought I'd have to be interested in sex – of course, when we had a few drinks we had sex – but he wasn't keen on sex either. I thought, 'Oh, thank goodness for that.' It was a bother.

Sixty-six years old, one child

"I was one of the lesbians who started a revolution in my town"

I was born in Ireland in 1975, the same year that contraception became legal. When I was growing up, there were a lot of things that people, but particularly women, could not talk about, because you just didn't talk about them.

If there is silence, we assume that there is a reason for the silence, and generally we imagine the reason connects with shame. I grew up internalising shame, rather than internalising a positive idea of womanhood.

My body felt like it was something that was mysterious and should be hidden away. Incorrect language was used for the vagina, if it was

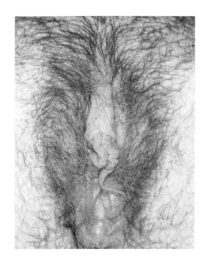

referred to at all, like 'private parts' or 'front bottom'. We were told to be careful around boys, but never in a specific way. Boys could go and pee outside, but I knew I had something that should be hidden.

I looked around for women like me and there weren't any women like me. I started to think, 'Perhaps I'm not supposed to be a woman, perhaps I should be a man instead?' I knew from when I was very young that I was different. So I felt disconnected from my vagina, and I also felt disconnected from girlhood and womanhood. That was quite frightening and lonely.

I knew from the age of about three that I was a lesbian, I just didn't know until I was 14 that lesbians existed. At 14, I realised that there were other women out there who felt like me. Till then, I knew that there was something missing and I couldn't name it.

I had three sisters who managed to do femininity really well. I think my mother always knew I was a lesbian and, yes, she did treat me differently. She paid me 20 quid one night to wear a skirt out. *(laughs)* It was hideous. She couldn't understand why I would never wear skirts, and why I was ashamed of my body. She wanted to change me.

I was constantly told by my mother that 'You are not allowed to go out there, you are not allowed out after this time,' where my brothers could. I received the message that boys are stronger and safer, and that girls are weak, they need to be protected.

I wanted to be invisible as a girl.

When I was a child, my world was turned upside down. I was raped by someone I really trusted. It caused a huge amount of chaos and upset which, at that age, I really didn't know how to deal with. It was ten years before I spoke about it, which meant no one else could help me either. Shame and silence work together in a really powerful way.

So, my first introduction to 'sex' was not my decision. Life became about self-preservation as a woman, not self-discovery. If a man rapes you, you then immediately blame yourself. When somebody has violated you in that way, and taken from you in that way, your self-worth is nothing. Yes I wanted to end my life, but differently to that, it made me not want to be alive.

Woman-only space was part of the recovery process for me. I could talk, and also listen and hear other women's experiences. Bizarrely, you can finally have a laugh, not about the situation but about certain things to do with it, like joking about never wanting to commit suicide by chucking your toaster in the bath, because you would be found with crumbs everywhere. I could finally feel nourished and experience vitality with other women.

One thing that I promised myself when I was growing up, was that I would understand my sexuality, live honestly about my sexuality, and not let the rape take everything away from me. The rape took part of myself away, but I wouldn't let it take my present *and* my future. That was a conscious decision. And it was quite hard work.

I grew up in a town where anyone homosexual left to go to Dublin or to another country. I had never had an experience with a woman when I decided to come out. I told my mum on Paddy's Day I was a lesbian, and the first thing she said was, 'You need to leave,' and I said, 'Why?' and she said, 'For your own safety.' She said she knew it wasn't my fault that I was a lesbian, that it must be something wrong with her and my dad.

When I came out, a lot of people questioned me very aggressively about how I knew I was a lesbian if I had never had a relationship with a woman. People were annoyed with me for not being ashamed. When I told people and asked them to tell everybody else, you could see the confusion. If I'd asked people to keep it a secret, it would have gone up and down Main Street in no time!

I decided to do it properly. I went on national radio. I went nuclear. It was a surprising thing to do in Ireland at that time, to talk using my own name. But it changed people in the town, it changed the town. No one could shame me about my sexuality. The whole environment changed radically and quickly. Women started coming out in my town. And there is the benefit of going nuclear. I was one of the lesbians who started a revolution in my town.

Being close to a woman's vagina, discovering the layers, the sensitivities, the responses... I don't think English has adequate words to describe it, I could do better in Gaelic maybe. They are softness alongside great power.

I'm always amazed by how little women know about it: about where it is, what it does, how you can stimulate it. If you have sex with somebody who has had a lot of sex with men, you can tell, because their

approach to this lovely, sensitive, powerful piece of our anatomy feels misunderstood.

We should talk more about the clitoris, that it has many times more nerve endings than the penis. What if women became sexually more powerful than men? What if women's sexuality overtook men's view of sexuality in our society? What if women did a sexual Brexit and took back control? And then said to men, you're only allowed near it if you know what you are doing, and we set up a kind of driver's licence? I think it would be useful.

There is a fear around the clitoris, because most men don't know where to find it and, if they do, they don't know what to do with it. You don't see many visual representations of the clitoris, because there is a social investment in it remaining shrouded in mystery, or being a second to the penis.

Orgasms fill you with strength and power and energy, then you become almost weak with ecstasy. To feel that, when you look into the eye of somebody that you are deeply in love with, is possibly one of the most cosmically powerful experiences. That makes struggling to own womanhood worthwhile.

Forty-two years old, no children

"I felt dirty and violated"

My relationship with my lady garden has changed. Now it is acceptance, but for a long time I wasn't happy with my body.

When I was seven, I was sexually abused by a family friend. I was naked, I was exposed, I was photographed, I was touched, I was violated. I had weapons put in my vulva, there was a knife. I was chained to a door. And I hated my body, I hated it for a long time. I felt unclean. I was unable to tell anybody for a long time. I remember feeling it was all my fault, that I must have brought this on myself, that I was a bad little girl.

It happened to my younger sister as well and she is the one who told our parents. There was disbelief. Then the attitude was that we wouldn't go to the police and it would be a secret, brushed under the carpet. It was the late 1970s.

I was about ten when it all came out. My dad couldn't handle it. He

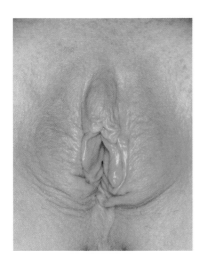

was a man of few words. He'd been brought up in two children's homes in the 1920s and 1930s and I know he had bad experiences. I do wonder if he was abused. I remember my dad being in the kitchen when he found out and he turned his back. I think he was crying. He went down the garden path. I just wanted to be his little girl, and I didn't think he would see me like that anymore. My childhood was lost.

There's another incident which happened earlier which I think ties in. I remember that once he wanted my sister and I to put swimming costumes on and he photographed us. There was another man there. It's so vague but I now wonder if he was part of a ring.

My teenage years were very quiet. I didn't really have proper teenage years. They were spent washing and showering, trying to wash it away. I couldn't connect with people. And then there was eating. In my late teens, I needed to gain control somehow and I did it with food. Not eating made me feel like I was getting something back. I lost a lot of weight. I have always been slender, and I have a thyroid problem now, but I hope I didn't permanently damage my body.

I didn't want my vulva to be seen or touched. It had to be hidden away because it felt dirty and violated. I didn't want to be more sexual, I didn't want the body to change. It's very naïve, but I thought if I stopped eating I would be a little girl again. I felt cheated that somebody had taken away what should have been a happy-go-lucky childhood.

I left school at 16. I could have pushed myself, but I didn't feel I had any value or deserved anything. So I just went on this government training scheme and got into work. But the wonderful thing was that through that I met my husband when I was 19. He was my first proper boyfriend. I hadn't been able to trust men before him, but there was something about him – he was a gentle soul. I got myself some counselling then, too. That was the beginning of me recovering and realising none of it was my fault.

We were both virgins. Despite what happened to me I was a virgin. But we grew together, we learnt together and explored each other. We completely trusted each other. It took a long time to actually accept my body and to love it. Birth, the children, my round stomach – I loved all

that. My husband and I are naturists and that has been so positive in helping me feel relaxed about my body and it's a wonderful community of people.

I do feel I've moved on amazingly in my body acceptance. Our children were brought up comfortable with their bodies and accepting of people's bodies – all ages, shapes, sizes. We have brought them up in a safe, open and honest environment. There's a lot of love in our house. We're there for them 100% and I know we've given them everything. I think they are wonderful human beings and they are going to do amazing things in society.

I haven't trusted my mum with them. She didn't believe me about the abuse and didn't protect me from it. My children have never had a sleepover with her and have never been alone with her. She's nice but I lost my trust in her. If my children were in danger I would be there in a shot and I would die for them.

I wish I could have been brave and gone to the police. But how do you do that as a seven-year-old? Or at ten? He was alive when I was in my early 20s and I regret not going to the police then. I've heard people say, why does it take so long for survivors to come forward? It does take time. It's very hard. After he died, my sister told me she found out where he was buried, and she went and spat on his grave. I say well done to her, because I wouldn't even be able to go near his grave.

I knew I was going to bring this up today, I mentally prepared myself. But the photograph was difficult. I remember his polaroid camera and him touching me. It went through my mind: 'Grim. Bedroom. Bed. Camera.'

This is about taking control. When the photographs were taken back then of my vulva, I was a seven-year-old child and I had no voice. Somebody did something to me for their own sexual gratification. Today I can tell my story and get the message across that I love my body now, with all its quirks. Today I felt in control, even though it was painful. If this helps bring more women forward to talk about what's happened to them, to seek the help they need, if it helps them to let go of shame, then I'm happy.

My husband always says to me, 'You're the strongest person I've ever met. I just wish you'd believe in yourself more.' It's hard, but I'm slowly getting there. It's a bit slower than other people, but I'll get there.

Forty-nine years old, two children

"My vagina wasn't mine for a really long time"

My parents are really liberal, open, cool people. They always talked about how sex was a really important thing between two people, not that it had to be with one person forever, but that the person you were having sex with should mean something to you. They made it sound like sex was a nice thing, a trust thing.

When I was 19, and on holiday, I was raped by the manager of the hotel I was staying in. At the time I went numb. I knew it had happened, I knew it was bad, but I came back from the holiday and just sort of brushed it under the carpet. I tried not to think about it as the years went by. My confidence levels plummeted. When I met a long-term

partner, I had difficulty with sex, and flashbacks. Physical feelings and emotions would take me back to that time.

I can't even count the ways that it has affected me. I feel so angry. I wish I knew what I would have been like if this had never happened to me. Instead, I've been depressed, anxious and felt negative about sex.

I can't even enjoy watching films or TV programmes because so many of them have sexual assaults. Everyone keeps saying I should watch *The Handmaid's Tale*, but I can't. I just can't. It's just too upsetting and triggering. I don't like how much people talk about 'triggering' but it's true.

The rape ended up taking over my life. In the end, I talked about it to my partner and he was brilliant. I eventually told my parents about it, but I didn't really want to because I didn't want to hurt them. Nobody wants to hear that that's happened to someone they love.

There are times when you wake up at 3 am, and you think, 'If I just hadn't done this, if I just hadn't drunk the alcohol, if I hadn't said that, been there...' But you can't think like that – those are the questions that ruin you.

I went from being a super-confident, happy young woman – I wore low cut tops, loved my boobs, I thought they were the best thing ever – to suddenly hating anything that was sexual about my body. I stopped wearing low-cut tops, I didn't want my boobs to be on show, I didn't want to draw any unnecessary attention to myself. I didn't want to be a sexual woman. I didn't want sex to be a part of my life because it had just been such an upsetting aspect of my life. I lost all body confidence. My relationship with my vagina just stopped.

I've been emotionally and sexually numb. I've had one long-term partner. I didn't feel that positive towards sex. It had absolutely nothing to do with him or what he was doing. I loved him, he was my best friend, a fantastic guy, but sexual situations and physical intimacy were so difficult. I didn't know how to understand the emotions I was feeling, I didn't know how to explain it to him. And this is the biggest shame. I have missed out on a huge part of life that would have been so fulfilling. I was so jealous of my friends at university because they could just enjoy sex.

I've been to therapy, had hypnotherapy, I meditate, do yoga and exercise, taken antidepressants and I've done all of the things that you get told to do. It does get better, but it's been such a fucking long journey. It happened when I was 19 and I'm 30 now. I want to have a life where it doesn't affect me. I'd like to have there be a time when it's not part

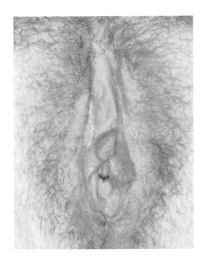

of me anymore. I don't think that's going to happen. I think it's changed me forever. But I do everything I can to turn the negativity into a positive thing. I'm a lot stronger and I work on a couple of projects that are about helping women that have gone through similar situations.

I'm in a much better space now than I was even a couple of years ago. Ironically, breaking up with that guy that I was with for so long taught me to be an independent and strong woman. I also think that I needed a break from having sex. After we broke up I was on my own for a good year and a half because I just wasn't interested in doing that sort of thing.

I'm currently in a relationship and the sex is great. I feel completely differently about it which is, oh, just such a relief. I really was worried that I was never going to enjoy sex. I can't begin to describe how fantastic it is now to feel more normal, and to just feel.

My vagina wasn't mine for a really long time. I felt like she was taken away from me after the rape. Now my body is mine and she is mine. And she's fabulous. I think my photograph is awesome. She looks so nice.

Thirty years old, no children

"I'm a 'Pleasure Warrior'"

I'm 50 and I've just started on HRT. I've got a patch stuck on my bum.

I've been peri-menopausal since I was about 40. My symptoms were itchy skin, palpitations and bone pain. Over the years, my skin has got far more sensitive, but in the evenings my face would flush, I would get hives on it, and it felt like ants were crawling all over my skin. It was a horrible feeling. To start with, my GP thought it might be my heart, then indigestion. I did ask if it was my hormones, but he didn't think so.

I was also losing clarity. Women talk about 'brain fog'. My mind would buzz, I couldn't concentrate and I felt very emotional. I'm lucky I work from home with my husband, because a lot of women are worried about going to their employer in case they lose their job. But really, employers just need to provide a fan, cool drinks and a bit of understanding.

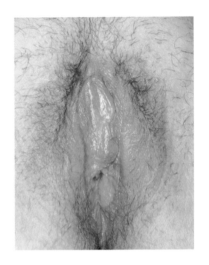

I've always had issues with vaginal dryness. Once I use lube I get wet, but the dryness got worse.

In the end I thought, 'I'm not putting up with this,' and I actually asked the GP surgery if they had GPs specialising in women's health. They did and I went to see one who was fabulous. Firstly, she listened to me. I have never experienced that and I had just this big bleurgh of things that came out. I was so relieved when she told me the itchy skin was due to being peri-menopausal, because I'd become worried I was allergic to gin and tonic. She prescribed me cream for the itching, an amazing organic lubricant called Yes, and antihistamines. She didn't think I was quite ready for HRT then.

Recently, I really felt I was ready for HRT and went back. I actually started blubbing. I'd promised myself I wouldn't cry but it had been so stressful. She prescribed me a patch. Within days I felt better! Now I put a patch on my bum twice a week that gives me oestrogen and progesterone.

I feel lucky. I know a lot of women who struggle to get an HRT prescription. I know it's not an exact comparison, but men get Viagra and women don't get HRT – there is definitely a gender bias in healthcare. We women are often told that PMS or menopause symptoms are all in our heads, or we're too young, or it's just normal.

I have read up on menopause and surrounded myself with menopause experts. I was a 'Menopause Warrior' for my friends. But when people ask what I do I feel like saying, 'I give women orgasms every day.' My husband and I own a sex toy company and we advise women about sex toys and lubricants. I'm a 'Pleasure Warrior'.

My husband and I have been together for 28 years. I got very lucky when I met him. Very, very lucky. He gave me my first orgasm at 23. I have struggled with vaginal dryness and vaginismus at various times. It's been closely related to stress. When I gave up my job when we moved to New York, the stress disappeared, and so did the vaginismus, but it can still rear its head.

Through the work I do, I discovered my G-spot. I know if I use a sex toy, or even during penetrative sex, I can have a G-spot orgasm.

It doesn't happen all the time. My clitoris is very sensitive, so I don't need very much stimulation to have a clitoral orgasm. I've discovered blended orgasms, from the clitoris and vagina, and I orgasm more. The clitoris tissue goes right round your vagina so that's what being stimulated. My husband knew his way around a vulva and clitoris. He'd done his reading and studying. We've had a very good sex life.

Because we own a sex toy company I'm lucky enough to try lots of different sex toys, so I've discovered different sexual sensations. But we also talk a lot about what we like, and fantasies that we share, and sometimes we carry them out together.

Pleasure continues. Our oldest customer that we know of is 95. Our customers love telling us their age. Sometimes a woman in her 80s will buy her first vibrator. Because a lot of these women won't go online, they buy from an advert. They'll phone us up and we talk to them. We've got people who are the 'dealers' in their nursing homes! We're sure they're buying on behalf of other people. We sell a lot of a certain basic vibrator, but then they'll come back and buy a toy for anal pleasure or something for their partner. Or bondage equipment. I love being asked by journalists, 'What do older people use?' Well, they use everything. I love that.

Fifty years old, three children

"I was born without a vagina or womb"

I haven't really looked at myself properly before, which is strange given my story. It's like a little creature, some sort of snail or a mollusc, or something like that that has a foot on it. I know I've got quite long inner labia because you can see from the front and you can see how they all curl up. Nice. Not too shabby. She's alright, she'll do.

I call it a 'minky' with my daughter, but a cunt with my friends or husband. Minky feels infantilising but cute, and cunt feels sexual and empowered.

I have three very close female friends and we have named our cunts after each other's mothers, in honour of them. So mine is also called 'Janet'. My friends are going to fucking love that Janet is in here.

I don't have a uterus, and a very close female friend helped me to come to terms with womanhood and missing a womb. She helped me to see the womb as symbolic. I am still a creative and complete woman

even if I don't have a womb and she connected me to 'cunt power'.

I have a rare congenital condition called MRKH. Women with MRKH have externally a normal vulva, clitoris and then a very short vagina, but no uterus, cervix, fallopian tubes, sometimes only one ovary and sometimes only one kidney. I have two ovaries and two kidneys. We are female. I release eggs and they are just reabsorbed into the body. I have boobs and the outside parts but no oven. I don't have periods. I would never be able to carry my own child because there's nowhere for it to be. We could have a child via IVF and surrogacy because there are eggs that can be extracted, and loads of women with this condition go down that route.

Mayer-Rokitansky-Küster-Hauser syndrome is named after four fucking men, of course, which irritates me. It's the surnames of people who named it I guess. The ownership is gross.

You get to age 13 and your friends are starting their periods and you start having the talks about periods and sanitary products. Around that age I started exploring myself, and I thought that what I had didn't match the diagrams I'd seen. But it wasn't as clear a realisation as that because I was a kid and I didn't have anything to compare it to. I can remember thinking, 'Okay, maybe I got something wrong.' A little bit later I found out about hymens and thought maybe I had a really strong one and maybe it needed a penis to break through it.

Another year went by, and another: my friends had red dots in their diaries and I didn't. I wanted the little wash bag with pads in. I told my mum I was worried. The first GP we saw didn't examine me but suggested I go on the pill to 'trigger things'. I tried that, and so began the hiding.

So I went on the pill and obviously nothing happened because I wasn't designed that way. I then got referred to a gynaecologist. I remember being in my school uniform. I was 15. I went in to meet the gynae, had an examination – the first time anyone had ever put fingers in my vagina and up my bum and felt around. It was horrid. Then he asked me to go for an ultrasound. The radiographer was frowning and I just watched her. When me and my mum went back in the gynaecologist said, 'This is a tough pill to swallow. You're never going to be able to carry your own children and you have a partially formed vagina, so we need to address that if you want to have a normal sex life. We're going to give you some time to think about it and then we'll get back in touch.' That was that.

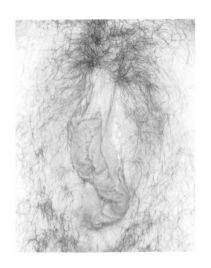

I remember burning with a desire to run out of there. I really didn't like the fact that he was a man, a middle-aged man, like my dad's age, telling me this stuff. I felt violated and I felt cheated and I think I felt quite angry. And really, really sad. I suppose in a way something made sense because I'd known that I wasn't... but I don't think I'd ever have even considered the fact that I might not be able to have children. That was the bit that was really hard. I became a lot more fucked up than I ever told anybody really.

The medical concern was sex – about not having a vagina that could fit a cock in it. The priority was to normalise my vagina for penetrative sex. I find that offensive because I orgasm clitorally. I was fine for years without a vagina, for God's sake, and I was with loads of men.

The standard treatment in the US is surgery to create a vagina. You take a skin graft from elsewhere and make a void and line it. It's quite problematic and prone to difficulties. In the UK it's dilator therapy. You stretch the bit of vagina you have with increasing sizes of phallic-shaped bits of plastic. I was really young and disgusted by it.

When I was 16, another gynaecologist offered to show me how to use the dilators, but I was grossed out by him. He had tremory hands. I just couldn't burrow into myself with this man-made thing. So they got packed away in a bag with a lot of feelings and hidden in a cupboard.

If I look back on those years I went into denial with the whole dilator thing but, in fact, I needed more than ever to be needed and wanted by men. So I made sure that I was always with a man. I went from relationship to relationship. Obviously I couldn't have penetrative sex, it was all hands and mouths. That was fine.

I used to put myself in such stupid situations. I would put it off until it was right at the last minute – already naked and in bed – and then explain that actually I can't have sex that way. Because I was scared and I needed that person to need me, because I needed to shore up a sense of self-worth. I didn't have that in me – I was looking for it. It's so sad, looking back now.

I used to worry about what would happen if someone tried to rape

me — if someone tried to rape me and they couldn't, would they just kill me? It's a really messed up thought.

Eventually I decided to face this. My GP put me in touch with a support group and specialist centre. And thank goodness! I went for a three-day stay and dilator therapy and counselling. A female clinical nurse specialist showed me how to do it. I wanted it to be a woman because I wanted someone who knows how a fanny is meant to be.

The dilation is painful. Imagine pressing really hard on an internal bruise. It took two months. I'd put headphones on and do it while listening to five tracks. There are different size dilators and you work towards one which is six inches. It wasn't nice, but I ended up with a vagina. I could not tell someone, and they wouldn't know.

I was 'fixed', as I affectionately call it, when I was 19 and then I went off travelling again. I met my now husband on that trip. I don't think I'd really thought about how I would become a mum massively, I was just more interested in exploring sexual freedom of a new kind. I tried to talk him out of being with me because I couldn't give him children that were his. I was still in a place of really low self-esteem. We had a two-hour chat on a rock. He's been a massive part of the whole journey of self-acceptance.

We both always knew we wanted to be parents and really early on talked about our options – adoption or IVF with a surrogate to carry our child. We couldn't really ever get away from our ethical belief that we should give a home to a child who already exists rather than using so many resources and science and risk. Also, the thought of someone else carrying a child and then having to hand it over.

There was a lot of sadness when I was in my 20s and I'd avoid pregnant women or feel sad when people would tell me they were pregnant. I would feel real grief when friends fell pregnant and then guilt for feeling grief at somebody else's really happy news. Fighting feelings of inadequacy has been a big part of the journey. When I was a teenager, I remember writing and thinking, 'I'm a woman but I can't make a baby,' and I felt pointless, literally worthless.

I spent many years convincing myself that I wasn't a real woman. I avoided the company of women, and would gravitate towards men. Now being a woman is absolutely about being part of the sisterhood. It means being really soft and really strong all at once. It means working hard to challenge a load of shit – social and cultural patriarchy and discrimination. Since I have become a mother I will not tolerate that

shit. I've become so much more angry, but it's not a destructive anger, it's a bold creative anger because I want to change things. My daughter deserves a better world. I think women are doing all the work, but it's part of the work of being a woman.

Thirty-six years old, one child

"My vagina has been worshipped"

I have a good relationship with my vagina and it has been appreciated a lot. Worshipped even. I was more self-conscious about having my hips and belly in a photograph than my vulva.

I looked in a mirror when I was a teenager and found out one of my labia is bigger than the other one. I didn't know if that was okay. It's important for women to see there is variety. Women might see each other naked sometimes, but we don't get a close-up look at a woman with spread legs.

I started masturbating very early, when I was three or four, but without knowing what it was. We had this long cushion and I would put it between my legs and hop along on the living room floor and it gave me some pleasure. At one point my parents said I shouldn't do it when guests were round, and only in my bedroom. They didn't judge me, although I had a feeling something wasn't quite right about it. But I kept

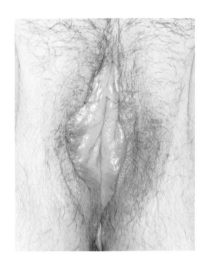

on doing it because I really enjoyed it. We called it 'hopsen', the German for hopping.

I had my first proper boyfriend when I was 14. I was really clear at that age that I didn't want to sleep with him, that I didn't want to have his penis inside of me. I always had a feeling I'd be ready when I was 16. He would stimulate me, lick me, appreciate me and make me come a lot. He gave me pleasure without end. I didn't want to explore him so much in return. What a good guy, huh? Our parents were so tolerant because they must have heard the noises – there was lots of noise involved – and that was all we were busy with all the time.

I met my next boyfriend when I was 16 and I was very in love with him. I knew very quickly that I wanted to sleep with him. Within the first couple of weeks I told my mum I wanted to go on the pill. She asked if maybe I should wait as it was so soon, but I just knew. I said, 'No, I know my period comes very soon. I know I need to start taking the pill on the first day of my period. I need the pill now, or do you want me to get pregnant?' I was really clear.

I slept with him within the first month of our relationship and it was a really beautiful experience. I enjoyed it so much. I remember him entering me and I was like, 'Oh my God, we are doing this and it's amazing.'

Just before I met the boyfriend I fell in love with, I was with a 21-year-old. He really wanted me to give him blow jobs and I really didn't like it, but I also didn't want to lose him so I felt a little bit forced to do it. I didn't enjoy it. If I don't love a man I just don't want to do it. If I love a man I can give blow jobs forever, and I love to learn what he likes. If I don't love the man nobody will get their cock in my mouth.

My optimum pleasure comes from the combination of the clitoris being stimulated and being penetrated at the same time. So it's really nice for me if a man licks me and puts his fingers in me, or if he has his penis in me and touches my clitoris.

I went to a Tantric conscious sexuality festival once and there was a little flyer up on the wall about a G-spot female ejaculation talk. It was the first time I'd been to such a festival, and I didn't know if I could go into a room with lots of women and men and look at my vulva and have a close look at the G-spot. But I went and it was amazing. The lecture on

the G-spot and on female ejaculation was fascinating. In school I had sex education three times and nobody ever told me about anything like that.

At the end of the lecture we were invited to look in a mirror at our vaginas and were shown how to press the G-spot. You could bring a partner with you, or be supported by a volunteer, but I was on my own and a bit shy, so I found a little corner and did it on my own.

If you squeeze in a certain way the whole thing comes out and you can see it through the vagina. I watched another woman and this is when I first saw another woman's vagina. She squeezed out her G-spot and this pink bit came out and it looked like a flower opening. She said it was one of the most tender moments ever in her life because she felt so open and wide sharing this with these people. It was absolutely respectful, very lovely. I can't really describe it.

I have experienced ejaculation twice in my life. The interesting thing is that when you ejaculate you don't necessarily orgasm. The G-spot gets stimulated in a certain way and a lot of fluid comes out. I think there's a thing in porn where it's called 'squirting' and I find that very disrespectful. Some men seem to be fascinated by it – maybe because it's a rare thing and they like the feeling of warm liquid on their penis, I don't know.

I have had a few younger lovers and it was obvious they had their sexual education through porn. It was not so accessible when I was younger. A bit of strangling – but it's not my thing – and anal penetration are great to have in a loving relationship, but some younger lovers have wanted to go straight into these things. I have talked to younger girls whose first sexual experience is anal, which is so sad.

I really feel the most important thing is to get more sex education in schools which is not delivered by teachers. It needs to go beyond the biology, and also be about love, intimacy, setting boundaries and not doing anything out of fear of losing a man. The first priority should be our relationship to ourselves and how to pleasure ourselves. I have talked to girls who have never masturbated before. How can you ask a man for what you want if you don't know what you like in the first place?

My partner has asked me several times to tell you how much he appreciates and loves my vagina. That touches me a lot, it's very sweet. 'Tell her how beautiful I find your vagina.' I hope that my story can convey how passionate and positive sex and love can be.

Forty-two years old, no children

"My vagina smells like 100 iPhones being unwrapped"

If I could go down on myself, I would. I tried it, and I can't. Why wouldn't you? Mine is wet, pink and inviting. It's often wet – ooh-la-la! It looks nice.

I masturbate every day, before work or before I go to bed, or while I'm drying my hair. I sometimes masturbate with my vibrator while I'm drying my hair because why not kill two birds with one stone? It's a time-saving thing. Sometimes, if I'm getting ready, I can feel in my vagina if I will be able to orgasm quickly.

On Saturday this guy went down on me and I came within about 30 seconds. He is very good at making me come. He looks at me during oral sex, and I always really like that. He absolutely adores my vagina, the

smell of it and how it looks. He says it's perfect. He actually says that it smells like 100 iPhones being unwrapped. It smells exciting.

I think as women we should embrace masturbation more. If I'm running late I might confess to my friends it's because I was masturbating, and they're like, 'Oh, for God's sake, not again.' But I enjoy doing it and why shouldn't I?

Good sex always has to involve an orgasm, even if it's a quickie. I'm probably not meant to say that, to be honest. I've got friends who'll say they had great sex, and then if I ask if they came, they'll say 'no', but it was still great. Am I missing something here? How can they say that it's good sex and they haven't come? I don't get it. One of my friends told me her boyfriend only goes down on her when it's her birthday. I was like, 'You've got to get out of there.' I don't think I could go out with someone who didn't go down on me. It's one of life's pleasures.

When I lost my virginity it was absolutely awful. I didn't tell the guy that it was my first time. It was sort of a one-night stand. I bled all over his sheets. I lied and I said, 'Oh, I think I've got my period,' instead of saying, 'You've just broken my hymen, mate.' I actually felt quite embarrassed that at 21 I was quite old to be losing my virginity.

Sadly, I'd say that bad sex has probably outweighed the good sex. It's in my mind when I've last had sex, and I don't like it to be too long. I think that's because of social pressure. Also, although I like masturbating there's something I miss about human touch. The pressure to have a fuck doesn't mean the sex will be good though. I've had sex with about 15 men – part of me thinks, 'Oh shit, is that nothing?' I've had a mixture of good and bad one-night stands. These days I pick my partners a bit more with myself and my own pleasure in mind. I think more about what I want in bed, not just the guy. That's come with age, experience and knowing my own body better.

I've had chlamydia twice and I know the people that gave it to me. They didn't tell me, which was delightful. I imagine one of them will have known he had it, because he used to sleep around a lot. I know the websites say there are no symptoms, but I knew in my own body something wasn't right. My vagina had a kind of heavy, cloudy feeling. It's hard to explain. There is a little bit of me that actually liked telling them that they had given it to me because I felt more responsible and respectful than them. I had the decency to tell them that they'd given it to me so that they wouldn't go off and fuck someone else and give it to them. Both times I was on the pill but I hadn't used condoms. I'd like to

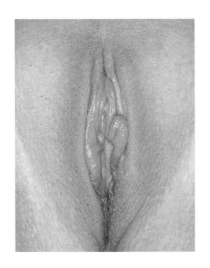

say that it taught me a lesson but it hasn't – I've had unprotected sex since then.

If porn was all about women having orgasms, real orgasms, I'd be watching it all the time – I wouldn't leave the house. I do watch porn, but not men and women. I watch two women because it turns me on a lot more than watching a man with his big throbbing spunk-covered penis and some poor little woman being fucked up the arse and faking it. I'm fascinated with breasts as well. I often search for women going down on women, big breasts, never men involved in it at all. Speed is important, if I want to come quickly then I don't want to watch some long narrative about some stepmother getting her young daughter-in-law off. I don't want to watch long narratives like that. I just want to get to the point, in about a minute and a half.

I want to have lots of orgasms. I wonder if on my 35th birthday I could give myself 35 orgasms. I think I probably could, but I'd be really hot and bothered afterwards and probably miss my birthday.

Thirty-four years old, no children

"I was in a civil war with my vulva"

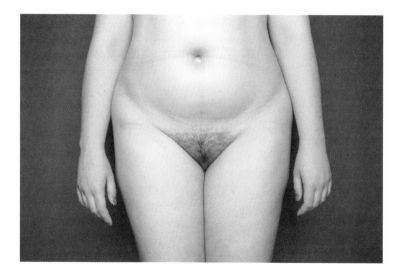

Oh boy, when I was growing up I was completely scared of my vagina. If I had to think about it or deal with it, for a medical reason, or my period, it would be a case of hold my breath and get on with it. It felt like a hugely scary portal to trouble. My vagina was trouble waiting to happen, that's how I'd describe it. *(laughs)*

My first big crush was Ron Weasley from *Harry Potter* – guilty as charged! I remember having a poster of him on my wall when I was 12 for about a week. I felt so 'convicted', to use an Evangelical word, that I took it down. That's the kind of level of sin we're dealing with.

The idea of 'purity' came from church and tele-evangelism. I was raised in an Evangelical Christian household. I told my mum I wanted a purity ring when I was 16. She took me to the shop and bought me one. She was almost reverential about it, and beautifully respectful of my decision.

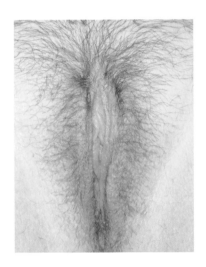

She didn't try and dissuade me, but didn't put any pressure on either.

I knew that sex before marriage was wrong and I was taught that if you want to be free from sin, you don't even open the door. Vaginas weren't talked about at church, and neither was masturbation.

My relationship with my vulva is complicated. I have a condition called vulvodynia. That essentially means I have a painful vulva. It's not a very helpful diagnosis. I experience a burning pain, which is unprovoked, and it is all the time. The best analogy I've come up with is a chemical burn, or nettle rash, or sunburn. It feels jagged, like a knife inside me.

When the pain started it was mortifying, to be honest. I started fidgeting a lot in class and on the train. As the years have gone on, I've gone from riding a bike to not riding a bike, wearing jeans to not wearing jeans. There are lots of little ways it affects me. At its worst the pain is truly debilitating. There have been times in my life when I have felt partially disabled. I didn't want to talk about my vulva with my friends, but they all know now, as you can't hide this kind of chronic pain. Vulvodynia often goes hand in hand with vaginismus, which I have too, which means penetration is painful.

I thought that I would never be able to have a relationship, that I wouldn't be loved or loveable. I felt very, very, broken. Sometimes I couldn't get out of bed, genuinely. Obviously penetrative sex would have been impossible if I was in a relationship. My relationship with my vulva has been incredibly strained. There have been times when I wanted to be smooth like a Barbie doll, and have nothing there, just be a torso.

I am a lot better now, but it's been a long time. I started having pelvic floor physiotherapy. I feel so awkward saying it, but there are these things called dilators, which are sort of training wheels, like stabilisers on a bike, and you gradually build up in size until you can tolerate something that looks remotely like it could be a penis. I suppose the best way I can describe them is like Russian dolls of dildos. You start using a very small one and you work your way up to be able to tolerate the next size up. The physio taught me to relax my muscles.

I'm now starting to feel like I'm on the same team as my vulva and that we are fighting against the pain together, rather than my vulva being an opponent that I can't vanquish. Before it felt like I was in civil war with my vulva. It sounds counterintuitive and awful but I've had to accept the pain and find compassion for my vulva.

When I went to university, I came across new ideas and... handsome men. I held on to my beliefs very staunchly. What led me to remove my purity ring was falling very much in love with my best friend. Everybody thought we would end up married, probably at a young age, in that typical Evangelical way. It turned out he was gay and I felt like everything I'd been waiting for just evaporated in front of my eyes. So I started questioning why I'd been waiting and what my faith meant.

I was studying theology at university and really critically analysing everything. I felt that I had to make space for the sexuality part of myself. I started seeing that withering away that part of myself wasn't worshipping anything.

When I graduated from the Russian doll dildos, I basically asked a lovely friend if he would do the honours. It was actually kind of brilliant because we had a great laugh, and it was a really super way of doing it. I'd always thought losing my virginity would be this wonderful, intense and romantic moment, but there was already so much intensity around the pain, that doing it with somebody who I knew was chilled was actually a really good thing for me.

So I was 23 when I lost my virginity. It was at my birthday and there had been drinks involved. I was already staying at his house, we were alone and it just sort of happened. We were in bed, in his bedroom, and I guess it was fairly vanilla. We'd talked about it before. We'd been out with each other in the past, so although we hadn't had sex, a lot of barriers had already been crossed.

I was nervous, but it was important to know that it was possible. I decided if there was pain, I'd deal with it tomorrow. I focussed on my breathing and being relaxed. The main thing is, it wasn't like this ceremonious cutting of a ribbon. He was quite forthright and we could have a laugh. I'm indebted to him for what he did. I feel like I made it sound like it was a proper chore – it was good and happened quite a few more times afterwards. *(laughs)*

There isn't a lot of research about vulvodynia – that is criminal – but there are some ideas suggesting a religious upbringing can have an effect on vulval health, and may lead to vaginismus and vulvodynia.

Your pelvic floor clenches up as a psychogenic response to shame. Your muscles go, 'No thank you very much, not for us.' Your muscles store stress and tension.

I don't identify as an Evangelical Christian any more, but I would still say that I have a faith. It's now at a place where I can synthesise sexuality and sensuality and not demonise the body.

I have a lot of respect for 17-year-old me and everybody else who, at that young age, feels so much conviction that they're willing to make such a huge lifestyle choice. My worry is that in my case I didn't know what I was rejecting. I hadn't thought it through. But sexuality and sensuality are part of human nature; it's not a bad thing, it's up to you what you do with it. My vulva is a gift and I want to be able to interact with her. I wish we hadn't been at war with each other for so long.

Twenty-five years old, no children

"My yoni is tight and lemony when I'm pregnant"

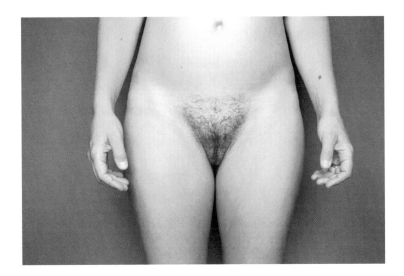

I went through five years of not being able to have orgasms. It was a bit scary. I felt like I would never come out of that.

My relationship with my yoni is quite good, but it's not very sexual. I've started using the word 'yoni' because vagina felt too medical. I don't feel ashamed of my yoni, and I don't mind it being seen. I feel quite comfortable with it. It doesn't give me pain. I don't have issues in that area that make me reject it. On the other hand, my relationship with it doesn't feel really positive, strong and loving. I have a neutral relationship with my yoni. I like to think of it as warm and opening. Sometimes it feels sexual, but I find I can tense up and shut down.

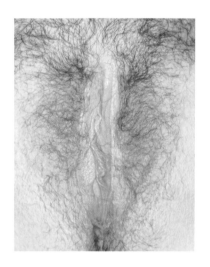

I don't really orgasm through penetrative sex. I think I have experienced it twice. I feel the build-up and then it shuts down. The build-up feels exciting and pleasurable. The shutting down is not a conscious thing, it's like something inside switches off or I burst into tears.

For a while, I wondered if I must have been been abused as a child to have these problems with sex and orgasm. I don't think I have. Over many years I have joined the dots, and I think I now know why I struggle with orgasm.

When I was about 13, and starting to explore my sexuality more, I would get into situations with much older men. I never felt like it was dangerous, but clearly it wasn't appropriate for me as a 13-year-old to be with men in their 20s or 30s or 40s. But I didn't know that. Then I sometimes got in trouble or told off. Now I know rationally that I wasn't in the wrong, they were, but part of me still struggles with it. I was told that I had the power and the allure, that I was seductive, and so I learnt that I was dangerous and to shut it down. Those men were doing more harm than good. It wasn't for me to have to decide that. It's wrong that it became my responsibility to know that. Those men should have known.

I feel sad and frustrated, especially now I'm in a long-term relationship with someone I really love. He is so patient. I'll be with him, and I feel orgasm coming and I think, 'Yes, I'm safe here and this is okay,' and then something else inside me goes, 'Shut down. It's not okay.' I wish I could share my sexuality more fully with him.

I'm pregnant with my second child. When I'm pregnant the whole internal landscape of my yoni seems to change. I think the smell becomes like sour lemons. I don't want to taste it on my fingers. My wee smell changes. I feel tighter too. Tight and lemony.

I was quite surprised about how my body came back after birth. Not sexually, obviously, I didn't feel sexual for a long time afterwards. I've had a couple of little stitches, but I didn't feel scarred from them in that way. My shape changed a little bit but not drastically. The thing that I really remember was the feeling of emptiness after my first baby came out. There was suddenly this big empty space inside me. It felt like jelly

inside as everything rearranged itself. Very weird. I didn't like that. Kind of a squeamish feeling.

I'm 17 weeks. Right now I feel really normal, I don't feel particularly pregnant at all. Although this morning I had the first flutterings of movement, which was really exciting. I wasn't expecting to feel it this early. It's lovely. There is a deep connection with the baby, 'Oh, hello in there. You're there.' I know I'm pregnant, I know I've got a baby, but the movements are the first time when I come into a relationship with it as its own little being. It's a separate person and it's here in me and that is amazing.

Forty-one years old, one child and 17 weeks pregnant

"I asked him to fist me"

I've spent a long time hating my vagina and I want to make peace with it. It was challenging to be photographed. In my head it was going to look like the meat counter at a deli shop. But it's not too bad. It's got character. It kind of looks like an oyster.

I must have been about 12 when I first looked at my developing vagina. One of my labia is longer than the other and I thought I was growing a penis. That's the only reasonable thing that I could come up with in my head. So I tried to cut it off with a pair of scissors. I thought it was a piece of dead skin, something like a fingernail. There was blood everywhere and it was extremely painful so I didn't succeed.

When I was 19, I nearly had labiaplasty on the NHS. I burst into tears with my GP because I hated it so much. This was before anyone had said the words 'designer vagina'. I had psychiatric evaluation and was

referred to surgeons. I was inspected by three surgeons at once, which was quite horrible. They weren't mean or anything, it just upset me that they were staring. In the end a friend persuaded me not to go through with it.

I think that there is even more of a sense now that vaginas should look like a paper cut and more women are going for labiaplasty. I'd like young women to understand that we all look different.

I told my partner about my hang-ups with my labia. He will spend a lot of time on it, going down on me, rubbing my clitoris slowly with the pad of his middle finger till I come. He spends a lot of time telling me how beautiful it is, not in a sanitised way, as in, 'It's a beautiful flower,' he'd be like, 'It's fleshy and succulent.' He's used the word 'meaty' once or twice, but not in a disgusting way, as in it's just this kind of delicious thing that he wants. I kind of like that – it made it sound sexy instead of gross. He worships my cunt.

He's 'dicknotised' me – the sex is up to another level. He's an extremely skilled lover. We've all had bad sex and gone to sleep in the wet patch and thought, 'What the fuck was that?' Or abusive sex, or your low-level, mediocre sex. Then you've got good sex which leaves you a bit tingly. But then, just occasionally, maybe with one or two partners in your whole life, something clicks. I feel safe to tell this lover my darkest desires and fantasies and he will help me act them out. I don't orgasm easily. I'm so much in my own head that I overthink things and become quite disconnected from my body. I'll be having sex with someone and have a random weird train of thought about what I'm going to have for my tea, or wondering what he's doing down there. But I'm not like that with this guy; it's like my pussy is very relaxed when I'm having sex with him.

He did this thing last time we met and I'd never experienced anything like that. He said that he was going to give me oral sex and he prepared the room and helped me lay down. He had my legs up on pillows and touched around the inside of my legs and my belly, and I was so aroused that before he was going to give me head he just put his penis in me and I orgasmed. I was that aroused and ready for it. As soon as he pushed into me I knew it was going to happen and I came like that. One thrust.

For a very long time I 'performed' in bed with partners, from faking orgasms to not vocalising how I felt. Or I didn't come, and that was crap. It's empowering to be able to ask this man for anything I want.

I asked him to fist me. I know it sounds brutal, but it wasn't, it was

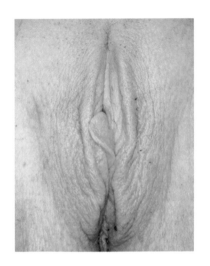

incredible. I really like finger penetration when a guy or woman is giving me head. In fact it's one of my favourite bits. I started wondering what it would be like if I had more. I felt quite embarrassed asking, because fisting sounds like a sexual joke punchline, or something that you hear about gay guys doing. I also feel shame about my vagina, because going back to school days, I distinctly remember overhearing boys talking about girls with massive vaginas or smelling bad, so you internalise an idea that they should be dainty and smell like an aerosol. I was really worried that if I could be fisted it would mean that I had this enormous, capacious cavern of a vagina. I knew that he was a safe person to explore this with. It took about an hour and a lot of oil, but yeah, it happened, and yeah, I enjoyed it. I orgasmed.

After a long disastrous relationship ended when I was 30, a part of me went, 'Oh my God, I can have sex again. Wow, okay – let's do this.' And then I heard about a sugar baby website, which is a very strange, grey area of sex work. It's grey because it doesn't tell you it's sex work, it tells you that it's just dating rich men. I thought, well, I'm having lots of sex and on dating sites anyway, why don't I try and date somebody who has loads of money? Give it a whirl.

One guy who was recently divorced wanted sex with somebody with no strings attached. He would give me £500 every time we met up. It was a surreal experience. He wasn't monstrously hideous, but he was definitely somebody that I wouldn't have had sex with otherwise. I was well aware the only reason I was having sex with him was because there was money involved. It wasn't bad sex, it wasn't great sex.

There was another guy who liked spanking. We arranged to have dinner together to talk about what would and wouldn't be OK. He was in his 60s, quite softly spoken, very well dressed, lived in Mayfair, rolling in money. He took me to a dungeon and spanked me for about half an hour. It made a noise but it didn't really hurt. In fact, waxing my legs to meet him hurt more than the spanking. There was no touching, no sex, and he gave me a thousand pounds.

We met a few times. I never felt unsafe. In fact, most of the time,

I tried not to giggle throughout, because the situation seemed ludicrous. But I don't want to make light of the situation that many people in the sex industry find themselves in, and I know that it's not all getting a grand for having your bum paddled in a dungeon for half an hour. I can't believe I got so much money for doing so little. I remember looking at these wads of cash and remembering the 14, 15-hour shifts I'd been doing on bars for minimum wage trying to get by.

I found doing sex work was an oddly horny experience sometimes. I was turned on by playing a role and serving someone. I had orgasms once or twice when clients went down on me. I might sound like a bad feminist, but I felt respected because I was a luxury item, whereas guys that I've had sex with for free have been very disrespectful and aggressive.

Thirty-six years old, no children

"Vagina felt like a dirty word"

I got nervous about the photograph today. In my mind I'm a strong, confident woman. In practice I nearly didn't show up. It feels edgy to share a part of myself that I feel like I am still getting to know.

Last night I was talking to my partner about whether I should shave my bikini line, or if I should wax. I've never waxed in my life but I was thinking about it for this! Then I thought, 'Wow, if I ever have a daughter or a granddaughter, what would I want her to see in this book?' I realised this should just be the real me. It is a practice to continuously love every piece of myself and I refuse to let my insecurity prevent me from doing things.

I say vagina even though it's not anatomically completely accurate. Vulva sounds a little awkward to me, but also it took me so long to be willing and confident to say vagina, that I try and say it as much as I can

now. Vagina felt like kind of a dirty word when I was growing up. I have the most wonderful family in the world, but menstruation, sex, bodies and vaginas were just not discussed.

I remember an encounter with a 14-year-old boy in his brother's convertible when a few friends and I had snuck out of the house one night. It was awkward, uncomfortable, fingers in places. I come from an area where people are sexual really young. When I was 12, so many of my friends were having sex. It just felt like, 'Oh, okay, I've hit this age and it's time and this is what my friends are doing and this is what I will do as well.' I think this experience combined with the first time I had sex caused me to disassociate from my vagina for quite a few years.

The first time I had sex was under the influence of a lot of alcohol. He was quite a few years older and I was a minor. This feels so uncomfortable to talk about. He got nervous afterwards that somehow he would get in trouble and he told people that I assaulted him. That story went round our friendship group for a little while. There I was, 16, so uncomfortable, with the bloodiest underwear, feeling really confused that all these people that I loved had the wrong idea…

After this, there was a part of me that I was just not able to respect. This isn't a 'woe is me' story, unfortunately this is a very normal initiation into being a woman. Most of my friends were doing the same sort of things.

I've done a lot of work around the experience, connecting more with other women and myself. Eventually I started to feel my vagina was part of my whole body.

When I was 24, I was diagnosed with cancer. I needed to have radiation and found out that my fertility could be affected and potentially I wouldn't be able to have children. That shook me. I have always known that I want children. I had a lot of anger, I had a lot of confusion, I had a lot of sadness. I had to start separating my fertility from my understanding of myself as a woman and that was really hard.

There were nights when I would look at my vulva in a mirror, trying to see if something was different. Having those moments on my own, thinking about it all, meditating and praying – even though I'm not sure what I believe in – I started seeing my body in a new way. I came to see my vagina and body as sacred; I understood we are capable of making tiny humans.

The relationship between me and my vagina, me and my uterus, me and my body, has been so tumultuous, loving. I have been told that

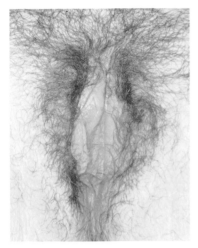

the chances are high that I will be able to have children, so that feels good.

I remember a time when I was about 21, when I thought to myself, 'Will I ever have sex without drinking first?' I'm now in a phenomenal relationship with a wonderful man. The way he appreciates me and loves me and meets my body every time we come together has given me the opportunity to do the same. Sometimes he looks at my vagina and it's almost like I can see it through his eyes and it just feels so beautiful. In those moments I think, 'How can my relationship with my vagina be complicated, because this is clearly the most beautiful thing in the world?'

Maybe part of that is just anatomy. I can't actually look at myself, I can't see my vagina. I can look in a mirror but it's not the same. There is a really precious piece of myself that I will never actually fully be able to see, but I see it through him.

I am more free and open in my body than I have ever been before, which is a combination of having a loving and open partner to share my life with, and also having cancer. Going through such an uncertain and painful time helped me be really clear about how I want to live my life and what I want to celebrate every day. Sex is certainly a big part of that. There is freedom and exploration in the way we are together. It feels right, it feels perfect.

Twenty-six years old, no children

"I'm a 47-year-old virgin"

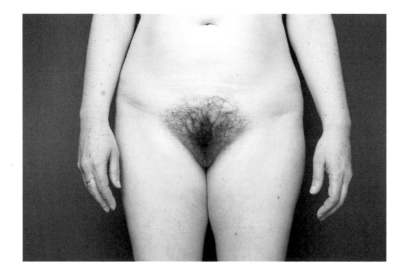

I call it ridiculous names, the slightly comical 'muff' and 'punani'. I don't like the word 'vulva' – it sounds too clinical and medical to me. When you're talking about an intimate part of your body, comedy is a way of distancing yourself and it lightens the atmosphere.

It's a part of me that has been neglected in my life. I don't go there – it's uncharted territory. I'm a virgin and I'm 47. I haven't had sexual intercourse. I've looked at it occasionally in the mirror but it's not been explored or commented on by anyone.

When I was about 15, my mum told me she didn't like her own and I could sense her disgust. She told me that hers was not pretty and that she had long lips. She told me I had inherited her lips. I had a feeling that she, and I, were freakish or ugly.

I grew up in a very hot climate. Before puberty there was a freedom in running around naked. I know I didn't feel shame then. I think the

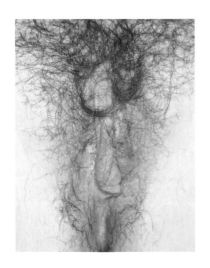

shame was inherited from my family, and how I felt about embracing femininity and sexuality as I went into puberty.

I grew up in a very Victorian family; my dad was born in 1936, but he was brought up by a much older father, so it was very 'children are seen but not heard' as well as 'women are seen but not heard.' I don't think I grew up feeling that I had much power over what I could do with my body and my femininity. After my dad died, I realised he wasn't comfortable with my burgeoning sexuality. This was unspoken.

I feel frustrated and impatient with myself that I haven't addressed my sexuality earlier. I think I'm heterosexual, but because I haven't had any direct sexual experiences I don't know. It's almost like being an adolescent at the age of 47. It's like I was frozen at 15 and I'm only just going through that exploratory period now. I have to forgive my younger self; she made the choices she made.

When I was a teenager, I played spin the bottle, but it was really just a mouthful of saliva. I didn't feel aroused. I kissed someone in my 30s. There was a guy working in the same office and we went to the pub together. As he got a bit more drunk he told me his whole life story, I gazed into his eyes, and we had a snog in the pub. Then he dragged me down an alleyway, had a grope and fondle and he was shivering. I didn't realise at that time, but he was getting excited. I was more excited by the rough readiness than the actual snogging, if that makes sense: the spontaneity, pulling someone into a dark alley and the illicit nature of it. I did feel aroused, and quite dreamy actually. I didn't want to eat any chocolate for about two weeks afterwards, I had that excited butterflies feeling.

I read a lot of romantic books, a habit from my teenage years. I like the happy-ever-after books, but some of them are erotic, what I call clit-lit, with alpha males who are SEALS or commandos, or whatever, rescuing someone. I am going to stop reading them; this is part of my vow. The fantasy and arousal in my head need to stop because I want to have real experiences with humans. I'm probably not the only woman who uses fantasy to excite herself, but I want to change.

I would masturbate reading these books, but I don't think I have had an orgasm. My friend said I would know if I'd had an orgasm. I've got excited,

but I don't think I've had a release or anything like that. I guess I didn't know that I was meant to continue on, but I think it's more that I've been afraid about loss of control.

All the things that I've done to not lose control, not let go, don't serve me now. It's like wearing ill-fitting coats – I've outgrown them and I feel I need to take them off. I've got a very good instinct for people, I don't need to protect myself so much. I was over-protected by my parents, which was out of love but it was very controlling. I want to take control, I want to choose. I want the power to start a relationship, to have control over my body, the power to end a relationship if I want. I need to break the habit of trying not to be hurt.

There is a stigma in being a virgin. The longer you leave it, it's like an albatross around your neck. Who can you go to when you are a 47-year-old virgin? I see myself as some sort of freak, even though I know there must be other virgins out there. Having sex and being mocked by someone is my worst possible fear.

I'm probably perimenopausal. I worry about fertility. Obviously I'm getting to a stage when it would be very hard for me to have a child, and I mourn that. My periods are still regular, but I know it's a ticking time-bomb.

Taking part in *Womanhood* is my way of trying to get reacquainted with this part of me. I want to change my attitude to myself and not see my vulva as freakish. I know that there is variety out there and it doesn't have to look uniform.

It's interesting to see my photograph... I didn't know it looked like that. I thought my lips were bigger and danglier, so that's interesting. They look smaller in the photograph than in my mind. Is that the clitoris at the top? Okay. In my mind my labia were a lot bigger so I think that's encouraging. So, my inner lips are not any bigger than some other women's?

I feel more accepting of myself now. I want to develop a loving relationship with my body. I'm hoping this is the start. I'm starting on a journey of exploring my sexuality and accepting all the parts of my body. I'm a vibrant, sensual woman. I have a lot of love to give but also I can receive it.

Forty-seven years old, no children

"In the last few years my lips have got bigger"

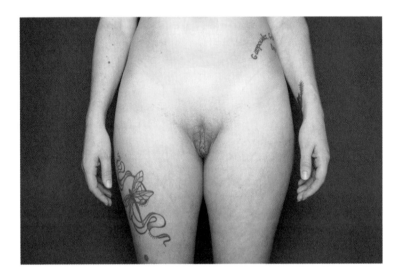

My relationship with my vagina has been changeable. When I was in my 20s, I was told by a partner that it was neat, tidy and quite pretty. Just in the last few years my lips have got bigger. I wasn't sure about the change and felt paranoid about how I looked. I'm 37 and I didn't expect them to change at this time of life. Are they body parts that just keep growing?

I spoke to my current partner about it and told him I felt paranoid. He was very reassuring. He said that he likes the fact that they're quite big because when he goes down on me it feels like they're kissing him back. It was a really nice thing to say and it did make me feel better. He's good like that.

I've never really looked in a mirror. It doesn't look from the photograph today to be oversized in any way; it looks normal.

I've always struggled with self-worth my whole life. It means I need quite a lot of reassurance, quite often, from a partner. I have been with my current partner for nearly three years and we're in a non-monogamous relationship. I never planned on this sort of lifestyle. Goodness, sometimes I wonder if someone with low self-esteem like me should really be doing this.

He's polyamorous so he has multiple partners and I date other people as and when I want to. I'm one of four partners.

He attempts to do non-hierarchical polyamory, so he considers all of his relationships to be equal; he doesn't have a primary partner. We all see him approximately once a week, but it depends what's happening. He and I went to a wedding together recently, so we were away for a few days, but sometimes it's just dinner one night around work. It's variable.

The key to non-monogamous relationships is open communication, being more honest than you've ever been in any other relationship about how you're feeling. I trusted him immediately, I've always trusted him, and so we are very open and honest. In a way, it has been brilliant for my self-esteem because I've been able to make myself more vulnerable. Jealousy happens though, because we're all human.

I know all of his partners to some degree, just because we're all part of the same, extended social group now. I have independent relationships with all of them, which I find makes it much easier, because then they're like a real person that I like rather than just this strange entity that takes time away.

I do want more of him though. I feel like there's an imbalance in our relationship because he's got four partners and I've got one. I'd quite like to have another partner but I find meeting people very difficult so that hasn't happened yet. I go on dates sometimes, but rarely go on second dates.

He uses condoms with all of his partners and he has very regular STI checks. I get checked about once a year too. The more times you get the STI checks done and the more times you get the clear results as well, the more you're like, 'No, we're definitely doing this right. It's fine.'

The other relationships that are really important in my life are female friendships. I've had close female friends my whole life and they've always provided advice, comfort and understanding. I can talk to my best friends about anything.

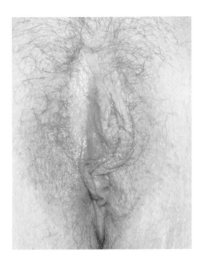

I've never been as confident as other people are in their bodies or their sex lives, and I thought it would be nice to support a project which might change that. There is no perfect female form, everyone's different.

Thirty-seven years old, no children

"I can't remember the last time I touched myself "

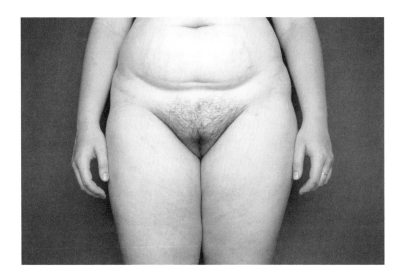

I used to be really shy about talking about it at all, and I would use all of those awful terms like 'my flower.' I try to say 'vagina' and 'vulva' now. It's interesting that if I am with a sexual partner I would still find it very hard to say vulva and vagina and for it to not just sound gross and weird. We don't have comfortable terminology.

I didn't register it as being part of who I am until quite recently. When we did sex education at school it all felt very distant. They told us to go home and look in a mirror and I remember doing that and feeling very ashamed. I looked in the mirror with sorrow and felt detached from it.

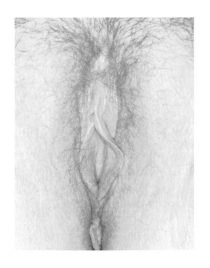

The lads at my high school used to make jokes like, 'Close your legs, it smells like fish,' to the girls all the time. I look back and wonder how much I internalised that. I think it made me ashamed and self-conscious.

I remember the first time I tried masturbating I was so shocked at the feeling and ashamed, that it almost felt like touching something hot. I obviously didn't burn my fingers but had a very instinctive repulsed reaction. That's how I felt about masturbation in my teens. I bought a Rampant Rabbit in my 20s.

When I started having sex, I don't think I masturbated at all because I felt like it wasn't a thing for me to do; it's something that somebody else should be doing. I didn't feel like I really owned my body and my sexuality. It scares the shit out of me as a feminist that I don't feel like I have the right to come.

I can't remember the last time I touched myself with my own hands. Why, what does that mean? Why is it okay for somebody else to touch me but not to be able to do it myself?

I had one partner who absolutely loved going down on women. I felt confident about it because he wasn't hesitant at all. I've come to realise that a lot of the time any hesitance is about confidence rather than gross body stuff. A lot of men don't feel confident about what to do when they go down there, and I've often assumed they don't like it or think I'm too hairy or whatever. I used to be quite tense about it. Even now, if my current partner seems like he's not enjoying it at any point, I just shut down completely and have to stop. The minute that the thought enters my head that I'm a bit sweaty, or I'm taking too long, or something's wrong, then the pleasure is gone, back to zero. I really enjoy giving head and that's really obvious when I do it. Maybe men need to make it just a little bit more obvious that they're enjoying it and it's not freaking them out.

I had such low self-esteem when I was younger. I was the tall, awkward, slightly foreign girl. I'm six foot. I think when I started to have sex and started to be attractive to boys I felt like my sense of self-worth was wrapped up in that. That put me in a lot of stupid situations and one particularly toxic relationship. When we were together I would

get so drunk and so high, that I would pass out and wake up in the morning knowing that he'd had sex with me while I had been completely unconscious. He would take photos of what he was doing. It was pretty messed up. That was my life for two years.

I think my low self-esteem and that terrible relationship have made me keep myself very busy, occupy myself to the point of burnout. It was easier than confronting all of this stuff.

I think my vagina finally wants to feel confident and accepted, particularly in sexual situations. I don't want to feel shame when somebody touches me, or if I touch myself. I think she wants to be embraced a little bit more and accepted as part of who I am. It's interesting. I was reflecting on the concept of womanhood before I came here and I've never really felt like that is very attached to my genitals or my vulva, because I've always kept it as far away as possible and I've never embraced it as being part of who I am.

The thought of getting my vulva out made me really uncomfortable, but I wanted to do this and be in control. I wanted to recapture the experience of being photographed naked with my consent and control, not like the experience where somebody did it without my knowledge or my consent.

Twenty-five years old, no children

"I had vulva cancer"

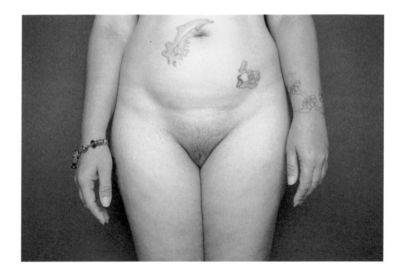

I would describe my vulva right now as mutilated. But we're ready for a new beginning.

I don't think my body used be relevant to my sense of womanhood, until my mum had breast cancer and had a mastectomy and I watched the emotional side of what she went through. Then I got vulva cancer and parts of me were cut away and I realised how much they were part of my female identity. I've got small breasts, I had a hysterectomy, and then I had parts of my vulva cut away. I felt less feminine.

Apart from my body, being a woman is about being independent, strong, having to do everything. I have to be a mother, I have to work, I have to look after the house. I think women are incredible. I try to be a good role model to my daughter and give 100%. We spread ourselves very thinly, don't we?

A lot of emphasis is put on the way women look as part of their identity. My daughter's 15 and she's already talking about when she's old enough to have lip plumpers, Botox and breast enlargement. I'm not so fussed about how I look. I would rather that people saw me for the person within.

My daughter screws her face up a little bit when I use the proper words, but I know how important it is to the use the right words and know where they are and what they mean. So many women aren't aware of what a vulva is. If I use the word and a woman doesn't know what it is, I can have a conversation about it, I can get onto the subject of awareness and self-checks. A lot of ladies never look at their vulva at all. I help run a support group and it's especially important with ladies from foreign countries to use the right words, in translation especially, if English isn't their first language.

I had a little bump on my labia minora for a couple of years, it wasn't painful and it didn't look odd. It was less than the size of a pea. It didn't bother me at all. I took more notice when my partner noticed it.

I thought I'd best go to the GP. He took a look and wasn't sure, so he asked another doctor to look. The second one said I had warts. I wasn't convinced. I was sent away with a steroid cream to try to see if it would get rid of this thing. It was as if it fed it: it tripled in size quickly, became very raised and like a flat disc. Then I became really worried.

So I went back and saw the same GP and this time he fetched a different doctor. They still weren't sure. I thought I'd better take myself to a GUM clinic because they have seen everything. The GUM clinic took one look and decided to biopsy it. Within a week I was back, and she said 'Right, you need to sit down. We've got the results.' It was the first time I had heard of vulva cancer. You don't get any sunshine down there.

It's very rare in somebody of my age, but it's becoming more prevalent due to HPV, human papilloma virus. I am HPV positive. It's believed to be the most common sexually transmitted disease, because it can just be skin-to-skin contact, you don't have to have full intercourse. Your immune system should fight it, and that's what happens for most people. So you can be HPV positive for three months and then your body fights it and it's gone. You might get it again. Unfortunately for some people who have lower immune systems, or they believe stress is a huge factor, and smoking is another factor for vulva cancer, sometimes your immune system just doesn't attack it.

I got an apology from my GP. They were sorry, but they said it's just

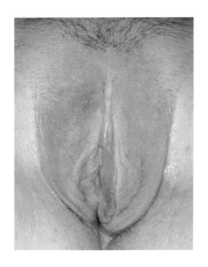

not something they would expect in somebody my age. The main thing for me was that they should be aware that it can happen to any lady at any age. I didn't want to sue them, or anything like that.

My daughter burst into tears when I told her, bless her. On the surface she copes very well. She doesn't tell a lot of people that Mum's ill, she just wants things to be normal. But she suffers with night terrors and they did get a little bit worse when surgery was coming up. She finds it very difficult to talk about. I'd say actually it's brought us closer together, because rather than doing the normal teenager thing, sat up in her room listening to music or going out with friends, she'll come and sit with me and talk to me about her day at school.

When you find out you have cancer, certain things become insignificant. You stop worrying about the drama in life. What's really important is my daughter, making memories with her, and a few good friends that I've got around me. My dog is so important to me. She's my nursemaid. She's very gentle with me. She gets up, she'll get up next to me, put her head under my arm and she'll snuggle in and she'll lick my hand, like a friend saying, 'Oh, it's okay. I'm here.' She's also stopped jumping up at me since my surgery as if she knows that the area where she would jump is a no-go zone now. She still jumps up at everyone else but she's stopped doing it to me. So she's very aware.

My only option was surgery. Part of my vulva was removed. I have six monthly checks and unfortunately I had a recurrence. When the consultant told me, I did feel, 'Oh, here we go again.' And then I made a joke with him that I'd do anything to keep seeing him because he is a lovely guy and the nurse laughed and what have you.

I had to have a second vulvectomy and more removed. Something that I discussed with my surgeon before both surgeries was please can we do everything possible to save my clitoris, because actually sexual gratification is very important to me. I enjoy sex. Luckily my clitoris has been saved. I was very lucky.

They had to take more tissue than they thought. I was worried about sensation and nerve damage, because I could feel numb areas, but I still

had my clitoris so I always had hope.

After the first surgery, ladies in my support group said, 'Don't look for a couple of months because there will be bruising, swelling, stitches, and it will not be an indication of what it's going to look like when things start to heal.' So of course I came home and looked straight away. I'm quite medically minded and I really needed to look at what I was dealing with. It looked quite angry. But I thought, 'Hey, that bit that was trying to kill me has gone so that's good. I've got a chance now at going back to normal.' It wasn't until a few months later when I was thinking about being sexually active again with my partner that I thought, 'What's he going to think about how it looks? Does it look mutilated?' He said it didn't bother him. We ended up separating, and my next partner never even noticed, so I know it definitely looks fine.

I'm on three month checks, and right now I'm waiting for the results. I'm hoping for clear margins again. I hope it's not invasive and hasn't gone into the lymph nodes or my vaginal canal.

I've got no sexual inclination at all at the minute, no libido. But give it a bit more time healing and then there might be something that piques my interest. I'm a sexual creature and I do have a desire to explore more sexual desires. It's a case of 'use it before you lose it'. It's a really important feature of me and being a woman. I don't want sex to be this thing where you lie back and think of England until the man is satisfied. I want it to be two people engaging in a sexual activity, and we both enjoy it, and ultimately I would like to orgasm.

I hope my vulva and I are going to have lots more fun. We got through this the first time. We are getting through it the second time. It could happen a third time, so I'm going to enjoy everything that I've got while I can.

Thirty-eight years old, one child

"My vagina would say 'Feed me!' if it could"

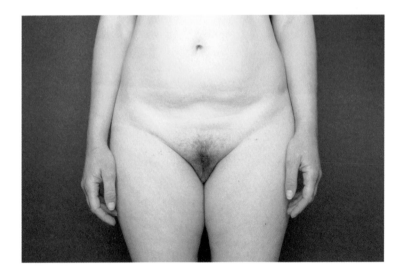

I think my vagina is brilliant. It's powerful and an immense source of pleasure if I can find the right guy to play the right tricks, a deep secret part of me, and it's delivered my two children into the world.

My vagina just wants more. I think it would say, 'Feed me!' if it could. You know, I'm mid-cycle right now. When women feel like this we should use those hormones and unleash chaos on the world.

Since I've had kids' I've always referred to it as 'vagina', even though that's not actually the correct term for the whole area. Recently, my little one was sat on the loo pulling her labia apart, going, 'Oh, so what does this bit do? And where does the wee come from? And is this where the babies come out?' She was five and the older one was just stood next to her brushing her teeth. This is just a normal conversation that we would have.

This is going to sound very strange, but I feel like being a woman is almost a superpower. I've always thought that women are amazing, and even more so now that I've brought two children into the world. Being pregnant, birth and bringing them up have been a privilege. I feel like pregnancy and birth give women amazing insight into primal areas of our personalities that maybe you don't get as a man.

For about a week, mid-cycle, I'm incredibly horny as well and I find it fairly easy to orgasm. That would be the time to be unleashed on a room of willing men – anything would be possible. I know my own body quite well and I'm not shy about saying, 'Do this, do that,' and making sure that I get fun out of it. I tend to need clitoral stimulation as well. I haven't had loads of sexual partners, but the ones that I've had have always been really attentive about my needs as well.

If I'd been a 17th-century courtesan I think I'd have been in orgies all the time for about a week in the middle of my cycle. That could be quite fabulous. I think it must be pheromones, or maybe I'm more flirtatious, but for that week I get more male attention. It's biology. Maybe my body knows I'm heading towards 40 and is in overdrive trying to pump out all of the eggs and have as many children as possible before it's no longer a possibility. I don't want the baby but I do want the sex!

I'm separated and my friends decided to put me on Tinder. None of us have ever done internet dating, but on a night of gin-fuelled silliness they took my phone away and set up a profile for me. After that we spent 45 minutes gaily swiping through people by committee. I think there were five of us, saying, 'Ooh yeah, he looks alright,' and arguments – 'Oh no, I'm not sure about him.', 'Well, what about him because there's some really good scenery behind him? He might take you on nice holidays.'

I had some matches and messages. You could waste so much time on Tinder, but you might as well meet up with someone who looks interesting for a date.

I was terrified before my first date. There were whole questions about what shall I do about my pubic hair? What does it say about me that I'm even thinking about this? The state of my vagina went through my mind. The vulva hasn't changed much, but my vagina has definitely been stretched and my pelvic floor muscles aren't what they were. How much will that impact sex and do guys even really notice? So all of these things went through my head. I was as nervous as a 16-year-old. But we had a lovely evening, and by the time it got down to the business end of things I don't think anyone could have cared less about what each

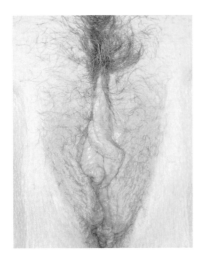

other's body was like because there was more of a connection. It wasn't the best sex that I'd ever had, but it was nice to know that I'm still desirable, and that everything was still in working order. He was very attentive, I didn't overthink it and I drank a lot of wine!

Thirty-nine years old, two children

"My partner absolutely loves my vulva"

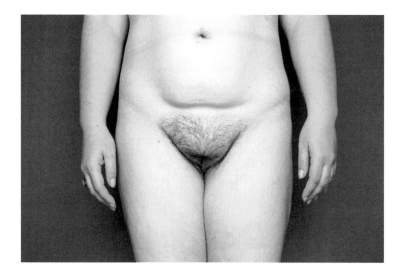

I have quite straight pubes and when they grow they tangle. It's a nightmare trying to trim down there yourself. So my partner trims my pubes for me. He trims them, then he washes them down afterwards and dries me with a towel. It's not sexual when he does it, it's just a caring, nurturing thing to do. I felt awkward the first time, but he said there was nothing to be embarrassed about.

My partner absolutely loves my vulva. He says that it's beautiful, it's unique. He's quite enamoured with it. I find it quite embarrassing sometimes, because as a woman you are programmed to think negatively about the way you look, compared to mass-produced porn which shows a certain type of vulva. The male gaze is inside our head, making us feel critical of what we're seeing.

He is a massive fan of oral sex. He would quite happily go down on

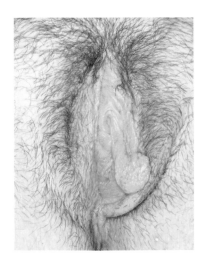

me for hours and have nothing else in return, it doesn't even have to lead to sex. He's just quite happy there. It's such an amazing thing. I enjoy it, although I almost had to get used to it. Again, as a woman, you feel like you should be the giving one, it shouldn't be about you, it should be about them. So, at first, it was an odd situation to have it the other way around and have the attention on me. He gets a lot of happiness from pleasing others. He's a very good one.

First and foremost I had to just put away how it looked. I used to hate the way I look because one of my labia is bigger than the other and it's not all tucked away. It's not just a hole, which is what it's basically portrayed as in porn. Now I like it more.

In porn it's a hole for someone else's pleasure. I know some women get pleasure from penetrative sex, and there is pleasure in that, but it's not the be all and end all. There are a lot of pleasure receptors elsewhere in the vulva and I think it's completely overlooked. In medical terms it's somewhere for a baby to come out or somewhere to put a speculum in. A vagina is seen as a hole, a void, when it really isn't a void to be filled. It's quite perfect and full in its entirety.

I don't put anything inside myself when I masturbate, I just touch my clitoris. I don't think masturbation is just a sexual thing; it can be for stress relief, or comfort, or because you're tired and it helps you sleep, or you might need to change tack in your head so you go and have an orgasm and come back down and carry on working. There are a million different reasons for masturbating other than just because you feel sexually frustrated.

I like to do it anywhere private. The whole risk thing doesn't really do it for me, so not public toilets or anything like that – generally at home. It can be outside, it can be in the garden, but somewhere private and peaceful.

I had screening results come back to say I had changes to my cervix and I had to go and have part of my cervix removed. I had a lot of letters explaining what to do, what not to do – it was very medicalised. I don't think I was prepared for the emotional fallout though. I felt damaged, attacked and vulnerable after the procedure. You get medical advice

about not having a bath, not having sex, don't put anything inside for six weeks, but not consideration for how you feel emotionally. There's nothing to support you in going through those feelings. Cervical smears are not glamorous, and they are uncomfortable, but at the end of the day you have to go. And in my case, what's worse? Having part of my cervix removed or being dead? You do what you have to do.

My vagina is strong, adaptable and beautiful. It's adaptable because it can be many things; it can be a place of comfort, it can be a place of birth, it can be a place of trauma, it can be a place of ecstasy, it can be anything and everything.

Thirty-five years old, no children

"I rocked a power muff"

I went through a long phase of rocking a power muff – a proper hairy, full hair growth situation. When it's hot I feel like being bald is the way to go. Sometimes I feel sexier when I'm all bald down there. I don't really have a preferred style – it's like how I'll change the hair on my head. I just had a wax and my skin has reacted to it. She doesn't look her normal self at the moment.

 I am pretty comfortable with my bits these days, but I'd say we fell out a lot when I was a teenager. I had a lot of pain during sex. I had to research it myself because the GPs didn't know what was wrong, and I think I had vaginismus. When my partner would try to have sex with me it would feel like there was a blockage in the way, like he couldn't get in and it was really painful. It wasn't a very good relationship and he would just force his way through it. I had consented to that, but it wasn't ideal. He used to get quite irritated with me for being upset about it. It seems ridiculous in hindsight,

but I used to feel like I was a failure as a female for not being able to have vaginal sex. I had it with quite a few partners too.

I think I felt stressed about sex because of society's slut-shaming views, and it made my body tense up. It wasn't just sex, it was too painful to get anything in there including tampons.

When I was 17, a partner asked me if I wanted to have oral sex, and I was like, 'Oh no, I don't do that,' like it was something really rude and extreme. I think he just went for it and then I thought it was great! So I started trying foreplay, and generally feeling less ashamed of my bits. I think before that I hadn't wanted anyone's face too near there. The more I got used to other people seeing my bits, and not minding what was there, the more comfortable I became, and the less stressed I was about having sex.

It took quite a few years for sex to become an easy thing. I'm a completely different person now. I've had a few wonderful, healthy relationships since then, with partners who were really understanding and took a lot of time getting to know my body.

I've mainly been in long-term relationships because of my issues with pain during sex. One-night stands with strangers wasn't something that worked well. When I tried it on a couple of occasions, people would just get to the entrance and I'd be like, 'Okay, no, that's going to hurt. I'm going to have to stop you there.'

I know I'm bisexual; I'm attracted to women but I've never had sex with a woman. Now it seems like this big intimidating thing and I find it very hard to meet women who are interested in other women. It's so much easier to meet men. A few times I've been interested in women, thought they are definitely straight, and then found out that they were interested in women after all. God, that's annoying. Maybe I should have tried. Then you get women who act like straight men and that can come across as quite creepy, a bit too forward.

Being a sexual health nurse has an impact on relationships. I see so many people that cheat and give their partners STIs. The amount of people who think that they have deep, honest, emotional relationships, but their partner has kept secrets from them... I've found that quite difficult. Knowledge about STIs does affect casual sex and dating. In the heat of the moment I can find myself trying to take a sexual history from someone, 'When was your last screening? Have you had any STIs in the past?'

Online dating is pretty bleak. I tend to be more attracted to people

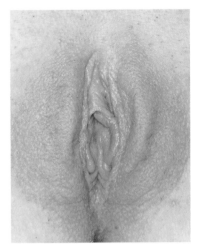

from conversation and their intellect, rather than just their physical appearance, so it doesn't work well for me. I read a really interesting book recently that said that you're supposed to treat online dating as the dancehalls of the modern age. You should see matching as seeing each other across the room: don't chit chat loads on the app, organise a date straight away, see if there's chemistry and, if there's not, throw them aside and try someone new. But it just seems like a lot of effort.

I suppose I've used online dating for a bit of an ego boost after break-ups. It gives you confidence when you match with lots of really interesting, attractive people.

When I had 'nurse' in my Tinder profile I got so many more inappropriate messages: men asking if could I examine their bits because there was something wrong with them; it's really not an erotic thing to have unhealthy bits! I do that all day at work, I don't need to see any more. People really fetishise nursing. So I had to take 'nurse' off my profile pretty quickly. I thought they would think I am a caring person and they just wanted the whole sexy nurse thing.

Twenty-four years old, no children

"He wanted my virginity as part of a magic ritual"

My vagina and I are friends; I think we're alright. We've got a long and complicated history.

I was abused when I was 13. It's taken me a very long time to call it abuse and even now, I still think, 'Well it wasn't typical abuse.'

I was really into biology. I went to the Natural History Museum in London and I bought a book in the gift shop about animals. It talked about a guy down south who took students on in the summer to help with research. I wrote to him when I was 13 to ask if I could come and stay and help with the other students? They wrote back and said I was too young, but I could come and meet them at a science fair with

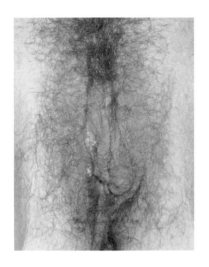

my family, which I did. I think at this point my parents probably felt reassured: he was well known in his field, they all seemed nice. Everyone decided I could go and stay with them.

The home was a polygamous set-up. He had a wife, a girlfriend he had a child with and another girlfriend. I think my parents must have known this, but I'm not sure. They were also naturists, and were normally naked at home. It was so different to my life at home. I was only 13 and very influenced by their philosophy. They believed that society is backwards and repressed and that they lived an open and accepting life, more in keeping with tribal cultures around the world. They presented the idea that in tribes older men would teach young girls about sex. I was 13 and he was in his 60s.

He would try and make me come with his fingers. They all expected this of me. It was conveyed to me somehow that only the right kind of girl would really be able to understand how sacred and spiritual this was. He would talk about how he had done this with some other girl who had been really into it. He never asked me to touch him or give him oral sex. That's why I didn't call it abuse for a long time.

It came to the point when he wanted my virginity as part of a magical ritual when I was staying with them. I felt pressure to submit to this, and in the end I did. It was very ritualistic. He penetrated me, but I don't remember it being like normal sex. I didn't feel any desire, I don't know if he did. He didn't come inside me. Obviously he must have got something out of it or he wouldn't be bloody doing it all. The next day the women were very much like, 'Oh you're a woman now,' and thought it was wonderful.

At the age of 15, my dad died and maybe I'd grown old enough to think about things differently. At home, I started to date boys my own age and that was when I began to understand how much was wrong with this set-up. I wrote them a letter, to finally say, 'Sorry, I can't do anything with you because my boyfriend wouldn't like it.' And that just freed me from it, when I hadn't been able to say 'no' for myself before. I told them I loved them, and they were like a family to me, but I saw the guy as a father figure, especially since my dad had died. They rejected me outright and said they wouldn't see me again; they said I was

behaving like a silly schoolgirl. I'd been visiting and staying with them for two years. I was devastated. I was hysterical when I read their letter at home.

That's when my mum found out about it. I don't think she knew how to react. My dad had died quite recently so she was probably very raw. She asked if I wanted to go to the police, but I didn't. I'm now the same age as she was then, and I have a daughter. Now I know that your parents are just as bloody clueless as anyone else. We've talked about it in recent years, and she still feels guilty, but she'll say how much I seemed to enjoy going there.

I have written a poem about when he used to touch me, about his fingers being old and dry. He was quite a tall man and he had long hands. As I'm getting older the people that I potentially date are getting older, and I find it hard to feel comfortable with men that are in their 50s because they instinctively make me feel uncomfortable.

I think the abuse affected my life and relationships. I've constantly been in relationships, often co-dependent. Right now is the first time I've been utterly single. I've always been attracted to maverick men and a sense of 'otherness' as well. My ex was abusive, but it took me a long time to see it.

Last year I met a woman and I was attracted to her. I didn't know if I would be able to do anything because I had never been sexual with a woman before. When it came down to it, I knew what to do because I know what I like. She's bisexual and she said to me that she's only ever come through sex with a man a couple of times, but with women she orgasms all the time. Women must have a better sense of how to pleasure another woman.

I realised I was in love with her and she backed off. It all blew me away, I didn't know if I was a lesbian or bisexual. I think I'm more attracted to women now. But as a single mother with very little childcare, it's not like the world has opened up for me – I don't really have many opportunities.

If I could, I'd choose for my next relationship to be with a woman because I don't trust men very much. I just think I'd be safer with a woman. I love being around other women – I feel comfortable with women. I still see men as a sort of slightly alien species; I've loved them but I've never found one where I feel really safe with them. It's hard to describe. My son, maybe.

Forty-two years old, two children.

"I feel like the cat who got the cream"

I had my first proper orgasm and ejaculated at the age of 23. I was really quite freaked out. The gentleman who was helping me was not freaked out at all, but we never talked about it after – he just left. He was a friend of a friend: we went for a drink, I took him home, we made out, got naked, we got on the bed and basically he started giving me cunnilingus, but using his fingers as well. I don't know if he was really particularly talented; I think he got lucky that it worked, to be honest.

The orgasm felt like a balloon was being blown up in my abdomen and then it gently popped, and then that's when I ejaculated. There was a sensation of warm energy coming out from my stomach. Afterward I thought, 'What the fuck just happened?' and I wanted it to happen again. Internet dating was just taking off at that time, and I dated different people, seeking to make the experience happen again.

I definitely have a type of person that I'm attracted to. It's usually

a slim white male. If I flipped it and a man said to me, 'My preference is a slim blonde white female,' I'd get angry because as a feminist I'd think, 'Well, shouldn't you just be open to anyone?' So I feel bad about it, because it's hypocritical. I think I am attracted to slim white men because they are the opposite of my father.

I like to hook up with people. I'm a very instinctual person. I pretty much know within the first five minutes whether or not I want to fuck them. It's so accepted that men can do this. I think there's still a hesitation to talk about women's pleasure. My plan is to have more sex. I've slept with about 40 people so far. I was brought up in a very traditional Christian household. My parents are East Asian. Basically, no sex before marriage and you're not supposed to touch yourself.

My partner and I opened our relationship in the last few years. The amount of time I invest in somebody else means less time investing in my partner or myself. I have found that men appreciate and are surprised by my assertiveness and confidence to say exactly what I want.

I'm a very curious person and I always want to learn something new. I am also a loving person so I don't ever want to do anything maliciously. I believe that we could turn a lot of things around if everyone were kind and loved each other and that everything you did came from that place. So even when I'm going out or when I'm fucking people, or whatever, I still care for that person as a human being. I invest my time as a gift to somebody else. I want to feel pleasure and I want that other person to feel pleasure. In that moment, no matter how long or short it is, that's what sustains me. I've asked myself what gives me joy, then I seek that out and it includes sexual pleasure. Once I realised it's about joy, I realised that there was no need to be ashamed of articulating it.

Good sex happens when there is a good connection. Usually that means the person can hold a conversation, I find them interesting, I find them attractive. They are not afraid to look me in the eye – not just during sex, but look me in the eye when they're talking to me.

The cheap ticket to good sex is knowing what you want and asking for it right away. I'm not pussyfooting around. I love men who have long, strong fingers and hands. I don't really care that much about the size of their penis, the shape and fit are more important. I love kissing. The pace is important to me. Sometimes I know when I walk into the room that I will need a slow pace for foreplay, or sometimes I just want to jump him and that's what will happen. So he will be very much led by me when

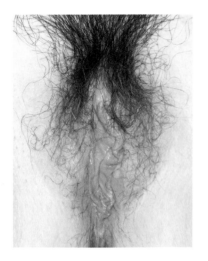

I walk into the room.

In the last two years, I have got into masturbation and that has helped me realise what I like. I have been experimenting with different types of vibrators and now I have a good rhythm and I can probably climax in a couple of minutes. I use one which looks like a lipstick. It has eight different settings, but to be honest I just love a full powerful buzz. When I saw the visual 3D representation of the clitoris, I realised that I can feel the blood flow increasing from the top tip of my clitoris and down the two sides into the space in between the walls of my vagina.

My cunt feels powerful. She'd basically say, 'I am the shit. I am amazing and I am power.' It's a secret; nobody knows about the power. I have the power to share or not to share.

When I walk by construction workers, whistling at the woman behind me – because I never get cat-called really – I think, 'They just don't know.' People make judgements about me all the time, because of the way I look and because I'm a person of colour and because I'm a woman. I feel like the cat who got the cream.

Thirty-nine years old, no children

"FGM took away my childhood"

We had a big party the day before I had FGM. I was born in Somaliland. When FGM happens it's celebrated. FGM stands for Female Genital Mutilation. Sometimes it's total removal of the clitoris, sometimes it's partial removal of the clitoris, removal of labia minora and labia majora. FGM is against the law.

Imagine you're seven years old and you're going to have this big party. A woman comes to do your henna, another woman comes to do your hair, all your friends come and you get gifts. I was actually given a watch. Every time that I look at a watch I think about the first watch I got before I was cut.

I awoke early on the morning of having FGM. The only way for me to explain is that it felt like Christmas. I did not know what was in store for me. I woke up so early that I went to my mum's room and I said, 'Mum, is it time yet?' and she just looked at me and she told me to go back to bed. I couldn't fall back asleep, I was waiting, waiting for this thing without even knowing what it was.

When the woman arrived she looked me in the eye and she said to me, 'Your little sister is going to go first. You need to make sure you are strong for her. Make sure you don't cry, because if you cry you're going to scare her, and the other children will bully you.' I became a woman, right there, at the age of seven. I became a woman for my little sister, because I didn't want her to be scared.

Then it was my turn. We were very lucky because my parents had money to afford local anaesthetic. The woman was not a doctor, she's an old woman and the most famous cutter in the whole city, and she has a needle and syringe to administer local anaesthetic. Other girls are cut without any medical assistance at all. I felt the needle going in. After that everything just went quiet. And after the procedure she looked at me and said, 'Now you are a woman. Make sure you don't walk too fast, make sure you look after yourself and make sure you pass urine, because if you don't pass urine you'll die.' And then she left.

Once the local anaesthetic came out of my system, I felt burning, and it was one of the most painful things I felt in my life. Imagine the feeling of burning hot oil poured on to you. My legs were tied together all the way down to my ankles, because we had Type 3 FGM, to stop our stitches coming out. I couldn't walk, so when I had to go to the toilet, my mum, and auntie, or one of my four brothers would carry me to the toilet and then take me back to my room.

Type 3 FGM means that my clitoris, labia minora and labia majora were removed. I was stitched all the way up. I had a hole no bigger than a matchstick to urinate and menstruate through.

All women in Somaliland go through this. All of my friends went through it. Once you have had FGM you're part of society, you're part of the community. If you didn't have it then your friends would say, 'Oh I don't want to play with you. When are you going to have FGM, when is it your turn?'. And so, for me and a lot of women, it's really not until later on in life that you realise that what happened was wrong.

I was in hospital because of FGM from 11 until 17 years old. My period was accumulating inside and it wasn't coming out, because of the tiny hole. I'm lucky my family could afford medical care. We even travelled overseas to get me help. FGM took away my childhood.

FGM also took away the ability to be a mother. I will never be able to carry my own child. What made me infertile is a combination of the FGM, the period accumulating, and all the operations to fix that. I had four abdominal operations and countless vaginal operations. That has left me with internal scarring.

How do I feel about not being able to have children? I am one of those people that says what doesn't kill you makes you stronger. Tomorrow's another day. I survived FGM and the complications that come with FGM. I'm sad that I can't experience what other women experience, but at the end of the day I am alive. There are children out there without a mum and dad, so me and my husband are going to adopt.

I have a wonderful husband. As a woman who has had FGM, I have a really nice sex life, yes I do. Do I have orgasms? Yes I do. Our sex life is amazing, because I have a man I share things with, and we talk. I wish every woman could have this. They take the clitoris, but you have to remember, the rest of the clitoris is still inside. You have to find where the nerves are and find out what works for you and take your time. Women don't realise how much of the clitoris is inside.

For most women who have FGM, their troubles carry on when

they are married. The husband has to force himself to open the woman. Remember, she has a hole the size of a matchstick. The women are torn up. Some might have third degree tears, and sometimes they don't have medical assistance so they die of infections and sepsis. There is pressure on the man not to take his wife to hospital or people will say he's not a real man. In Somalia, every time a woman gives birth she is stitched back up again. So if the woman had four children she'll have FGM four times, and the husband will tear her open again. For some women it's a cycle that never ends. Also for some women there are psychological effects, because they were held down as children and cut, so they can't see sex as something pleasurable.

FGM will be with me for the rest of my life. I can't have children. I still get the pain. I still get urine infections. I've just been diagnosed with early menopause. I have to change things. I have to speak up for the thousands of women who don't have a voice. I'm here to be a role model.

My nickname is 'The Vagina Woman' because I talk about vaginas every single day. I'm a sexual health nurse, always looking at vulvas and vaginas and testing. It is very, very therapeutic for me. I talk about vaginas like I'm talking about a cup of tea. It's become part of my life. We talk about sex, masturbation, you name it, every single thing that can go on in a sexual health clinic, we talk about it. I have broken a huge barrier as a woman from my cultural background.

I love my vulva and my vagina. Even though some of it was taken away, it's mine. We have to understand our bodies as women. I want every woman to know they can be free, talk about what they want, that their bodies are theirs.

Girls are cut to prove to a man that his wife is a virgin. FGM is an attempt to control a woman's sexuality. What we really need to realise is that cutting a woman's clitoris off is like cutting the end of a man's penis off.

Seriously, hands off our vaginas. Why can't we just live in peace? I want a world that is free of FGM, a world that is free from abuse of women and girls.

Forty years old, no children

Methodology

I wanted to include and represent women of all ages (18 was the minimum age for participation), ethnicity, sexual orientation, career, life experience, shape and size. It's important to remember that *Womanhood* is an art, not an academic, project. I was looking for willing participants in a sensitive project, who would have interesting tales to tell.

The participants were given information about the project and its aims, and signed a release form. Interviews were recorded, then transcribed verbatim. In the editing stage, word choices were not changed, although the text was shortened and rearranged to improve the flow.

The photographs were not altered in Photoshop, aside from a few identifying tattoos and birthmarks which participants requested to be removed. The photographs were shot consistently so they could be viewed comparatively and non-sexually.

I wrote a discussion guide to help me structure interviews where useful, but it was never strictly followed; conversations were allowed to flow according to the individual woman and her interests and experience. All women were asked what they think about their vulva.

18 of the women who participated in the book agreed to be part of a documentary for Channel 4. The photograph and interview were conducted in the same way, albeit with an all-woman film crew present. In addition, the director also interviewed the women after me to probe different subject areas specifically for the film as part of a collaborative process.

Acknowledgements

Thank you to all my family and friends for listening to me and encouraging me. Thank you to Martin, Maria, Zoë and Emily at Pinter & Martin for believing in *Womanhood* and bringing it to life. Thank you to Maggie for transcribing, Susan for editing and Allan for designing.

I would like to thank the very important women in my life: my mother, my sister, my niece, and my dear, close women friends. I'm lucky to know you all; you inspire and encourage me. And you make life more beautiful, fun and meaningful.

I remember Maria at Pinter & Martin specifically asking me if I would be able to find 100 women to take part in this project. That threw me. Would I? I couldn't have anticipated the open-hearted interest in this project and *Womanhood* was over-subscribed. My biggest thanks go to the 100 women who took part. You are brave, bold and beautiful. You help women reclaim womanhood on their own terms, in their own words.